T0349736

Götter – Gene – Genesis

Ina Wunn · Patrick Urban · Constantin Klein

Götter – Gene – Genesis

Die Biologie der Religionsentstehung

 Springer Spektrum

Ina Wunn
Institut für Theologie und Religionswissenschaft
Universität Hannover
Hannover
Deutschland

Constantin Klein
Abteilung Theologie
Universität Bielefeld
Bielefeld
Deutschland

Patrick Urban
Fakultät für Biologie
Universität Bielefeld
Bielefeld
Deutschland

ISBN 978-3-642-55331-8 ISBN 978-3-642-55332-5 (eBook)
DOI 10.1007/978-3-642-55332-5

Die Deutsche Nationalbibliothek verzeichnet diese Publikation in der Deutschen Nationalbibliografie; detaillierte bibliografische Daten sind im Internet über http://dnb.d-nb.de abrufbar.

Springer Spektrum
© Springer-Verlag Berlin Heidelberg 2015

Planung und Lektorat: Ulrich G. Moltmann, Frank Wigger, Bettina Saglio
Redaktion: Dr. Birgit Jarosch
Einbandentwurf: deblik Berlin

Gedruckt auf säurefreiem und chlorfrei gebleichtem Papier

Springer Spektrum ist eine Marke von Springer DE. Springer DE ist Teil der Fachverlagsgruppe Springer Science+Business Media
www.springer-spektrum.de

Vorwort

Liebe Leserin, lieber Leser,
Religion, egal welcher Couleur, ist ein Auslaufmodell – da war sich das 20. Jahrhundert ganz sicher. Vor allem der Fortschritt der Naturwissenschaften mit der Evolutionsbiologie an vorderster Stelle hatte Gott nicht nur entthront und obsolet gemacht, sondern ließ Religion als geradezu unsinnig erscheinen. Nicht anders dachten die Sozialwissenschaften, die davon ausgingen, dass Religion sich gegenüber der Wissenschaft nicht würde behaupten können und daher über kurz oder lang bis zur Bedeutungslosigkeit verblassen würde. Die tatsächliche Entwicklung gerade in den letzten Jahrzehnten zeigte jedoch völlig überraschend, dass Religion eine Renaissance erlebte und zu einem entscheidenden sozialen und politischen Faktor wurde, und dies allen modernen Erkenntnisfortschritten und allen rationalen Argumenten der Religionskritik zum Trotz.

Wenn also heute immer noch ein Großteil der Weltbevölkerung religiös ist, dann müssen, so meinen die Wissenschaftler, die Gründe dafür in der geistigen Grundausstattung, gewissermaßen der „Hardware", des Menschen selbst angelegt sein. Und weil diese Grundausstattung das Ergebnis eines langen Prozesses der Evolution ist, sind die Gründe dafür, warum unsere Hardware so ist, wie sie ist, in den evolutionären Bedingungen, unter denen sie entstanden ist, zu suchen. So lassen sich in groben Zügen die Annahmen zusammenfassen, die einen neuen Trend der wissenschaftlichen Auseinandersetzung mit dem Thema Religion kennzeichnen. Dieser Trend firmiert je nach fachlichem und methodischem Akzent unter verschiedenen Namen, darunter „Cognitive Science of Religion" (kognitionswissenschaftliche Erforschung von Religion), „Neurotheologie" oder „Evolutionäre Psychologie der Religion", und hat zum Ziel, umfassend aufzuklären, wie und warum im Verlauf der menschlichen Entwicklung Religion entstanden ist.

Tatsächlich ermöglichen neuartige Untersuchungsansätze, zum Beispiel experimentelle Simulationen zur Untersuchung der Wahrnehmung oder die bildgebenden Verfahren der Hirnforschung, interessante Einblicke ins menschliche Fühlen und Denken, die für das Verstehen von religiösen Phänomenen mehr als bedenkenswert sind und zu interessanten neuen Einsich-

ten geführt haben – wir werden im Rahmen dieses Buches immer wieder auf solche Ansätze eingehen. Aber auch in der Wissenschaft gibt es Trends und Moden (heute sind es eben die genannten kognitionswissenschaftlichen Ansätze), die gelegentlich dazu verführen, vorhandene und gesicherte Erkenntnisse aus anderen Fächern zu übersehen – mit dem Ergebnis, dem ersehnten Ziel, nämlich der Frage, wie und warum Religion entstanden ist, nicht näherzukommen.

Genau das ist aktuell im Zusammenhang mit der Frage nach der Religionsentstehung der Fall: Kognitionswissenschaftliche Ansätze schließen auf der Grundlage von Untersuchungen an heutigen Menschen und ihren explizit oder implizit religiösen Verhaltensweisen auf die Entwicklung von Religion im Zuge der Evolution zurück. Dabei versäumen sie es insbesondere, ihre Annahmen auf die archäologischen Indikatoren einer möglichen frühen Religion zu beziehen und widerspruchsfrei mit diesen abzugleichen. Dadurch bleibt letztlich offen, wann und wo denn eigentlich konkret die verschiedenen Erscheinungsformen von Religion im Verlauf der Evolution entstanden sein sollen. Auch der Vielfalt und Dynamik innerhalb der bekannten Religionsgeschichte wird ein solches Vorgehen nicht gerecht.

Die Tatsache, dass die aktuellen Ansätze zur Erklärung der Religionsentstehung nicht befriedigend sind, hat uns dazu bewogen, ein eigenes Buch zu schreiben, in dem wir versuchen, die Religionsentstehung auf der Grundlage naturwissenschaftlicher Erkenntnisse aus unserer Sicht darzustellen. Eine Entwicklungsgeschichte der Religion, die – wie im vorliegenden Buch – bei den ersten paläoanthropologisch gesicherten Spuren einsetzt und bis zur Entstehung der drei großen monotheistischen Religionen Judentum, Christentum und Islam führt, ist ein ambitioniertes Unterfangen. Um die Entwicklung eines solch komplexen Phänomens wie Religion zumindest in ihren Grundzügen nachzuvollziehen, haben wir bewusst in einem interdisziplinären Team gearbeitet, in das wir unseren jeweiligen fachlichen Hintergrund als Biologen, Psychologen und Paläontologen, aber natürlich auch als Religionswissenschaftler und Theologen einzubringen versucht haben. Unser Zugang unterscheidet sich also von den oben genannten Ansätzen nicht so sehr durch die wissenschaftlichen Bezugsdisziplinen, sondern dadurch, dass wir versuchen, so weit wie irgend möglich auf faszinierende Spekulationen zu verzichten und dafür auf der Basis gesicherter archäologischer, verhaltensbiologischer und psychologischer Erkenntnisse zu arbeiten. Grundlage ist dabei eine evolutionistische Auffassung von Religion. Das heißt wir gehen davon aus, dass sich Religion entwickelt hat, dass also die verschiedenen heutigen und historischen Religionen nicht irgendwann spontan entstanden sind, sondern sich jeweils aus Vorläuferreligionen entwickelt haben – nach Regeln, die genau wie die biologische Evolutionstheorie als Theorie formulierbar und natürlich

intersubjektiv überprüfbar sein sollten. Die völkerkundlichen Parallelen und Rückgriffe in die Märchen- und Sagenwelt, die wir im Verlauf der Darstellung immer wieder eingestreut haben, dienen in diesem Zusammenhang also lediglich der Illustration von ansonsten möglicherweise schwer verständlichen Sitten und ihren Funktionen.

Auch wenn das beschriebene Vorgehen eher vorsichtig anmuten mag, versuchen wir damit dennoch nicht weniger als eine vollständige Erklärung der Entstehung von Religion von ihren frühen Anfängen an bis hin zu religiösen Strömungen, die unsere Welt bis heute prägen. Tatsächlich sind wir mit unserer Einschätzung, ab wann das Phänomen Religion im engeren Sinne greifbar wird, aufgrund unserer Orientierung an den archäologischen Befunden vergleichsweise und begründet zurückhaltend und setzen die Religionsentstehung eher später an – nämlich für einen Zeitpunkt, zu dem sich tatsächlich entsprechende Hinterlassenschaften bzw. Artefakte finden. Aus unserer Sicht ist die Religionsentwicklung gerade durch das Paradox gekennzeichnet, dass ihr Verhaltensmuster zugrunde liegen, die verhaltensbiologisch teils sehr viel älter sind als der Mensch (z. B. Verteidigung des eigenen Territoriums als Lebensgrundlage), dass aber die Ausbildung eigentlich religiöser Verhaltensweisen innerhalb der Menschheitsentwicklung ein verhältnismäßig junges Phänomen darstellt. Menschheitsgeschichtlich gesehen fußt die Religionsentwicklung zunächst einmal auf biologischen Verhaltensdispositionen, die sich dann im Zuge der miteinander interagierenden biologischen und kulturellen Evolution in Richtung Religion entwickeln, um daraufhin eine eigene Dynamik zu entfalten: Religion entstand also aus anderen Verhaltensmustern heraus, um dann selbst unter wandelnden kulturellen Bedingungen zu evolvieren.

Im vorliegenden Buch versuchen wir, die wesentlichen Schritte dieser Entwicklung zu skizzieren, wobei die Kap. 1 bis 4 naturgemäß erst einmal die biologischen Grundlagen abstecken, die dann in ein erstes Symbolsystem münden, das wir heute als religiös bezeichnen. Die Eigendynamik der Weiterentwicklung dieses Symbolsystems hin zu den bekannten historischen Religionen beschreiben dann die Kap. 6 bis 13, während Kap. 5 sich den wissenschaftstheoretischen Grundlagen widmet. Dadurch ist es im Vergleich zu den übrigen Kapiteln etwas abstrakter und kann von Theoriemüden bei der Lektüre auch überblättert werden – die Darstellung der Religionsentwicklung lässt sich bei der Lektüre der übrigen Kapitel trotzdem gut nachvollziehen.

Dass im Rahmen einer Übersicht von Religionsentstehung und -entwicklung manche Entwicklungsverläufe, vor allem zum Ende hin, wenn sich die Religionsentwicklung zunehmend ausdifferenziert, nur gestreift werden können, liegt auf der Hand und ist in unserem Buch der Intention geschuldet, den Umfang des Überblicks lesbar zu halten. Das Buch kann nicht alle Details

in enzyklopädischer Breite darstellen. Vielmehr geht es uns in erster Linie darum, Ihnen als Lesern einen Überblick über die grundlegenden Mechanismen und Prozesse der Religionsentwicklung zu geben. Dennoch ist die Stofffülle angesichts des verhandelten Zeitraums von mehreren Jahrhunderttausenden, nicht zuletzt auch wegen des interdisziplinären Zugangs, immer noch beträchtlich. Um das Verstehen einzelner Thesen oder Theorien, Zeiträume und Kulturen zu erleichtern, gibt es neben dem Fließtext Informationskästen, die Hintergründe genauer beleuchten. Zur Illustration enthält das Buch zudem zahlreiche Abbildungen, die die beschriebenen archaischen religiösen Welten lebendig werden lassen sollen. Im Interesse des Leseflusses wurde auf ausführliche Literaturverweise im Text verzichtet; ein detailliertes Literaturverzeichnis für diejenigen, die sich ausführlicher mit der Religionsentstehung und -entwicklung auseinandersetzen wollen, findet sich am Ende des Buches. Wir hoffen, dass wir mit den genannten gestalterischen Maßnahmen Ihren Bedürfnissen als Leser entgegenkommen, und wünschen Ihnen eine aufregende und erhellende Lektüre!

Ina Wunn, Patrick Urban und Constantin Klein

Inhalt

1
Einleitung

Von Menschen und Affen

Östlicher Kongo, Virungaberge. Hohe, mit dichtem Urwald bestandene Berge reihen sich endlos bis zum Horizont. Im Hintergrund erhebt sich der mächtige Vulkan Nyamuragira, dessen Lava vor wenigen Jahren die Stadt Goma unter sich begrub und der auch heute immer wieder ein dumpfes Grollen von sich gibt. Manchmal entlässt er eine graue Wolke in den Himmel und wenige Minuten später rieselt feine Schlacke mit leisem Knistern auf das dichte Laubdach. Obwohl die Sonne bereits über dem Horizont steht, ist es im Wald dämmrig und leise, als atme eine unberührte und jungfräuliche Natur. Matter Dunst steigt aus feuchten Senken und bildet feine Schleier zwischen den hohen Stämmen.

Plötzlich stören laute Geräusche die Idylle dieses urtümlichen Paradieses, Äste brechen krachend unter schweren Tritten; mit lautem Schnauben und Kreischen bricht sich etwas Bahn, das groß und wild sein muss! Erschreckt fliegen ein paar Vögel auf, als sich das Unterholz teilt und *er* hervorkommt – ein mächtiger Silberrücken, unumschränkter Herr über einen Harem von Gorillaweibchen und ihren Nachwuchs. Vorsichtig nimmt er Witterung auf, schiebt dichtes Buschwerk beiseite und äugt umher, bevor er befriedigt grunzend die Lichtung betritt, auf die er seine Gruppe sicher führt. Hier wächst junger Bambus, eine Köstlichkeit, und mit Behagen machen sich Weibchen und Jungtiere über die saftigen Pflanzen her. Auch der Silberrücken greift zu, fasst Schössling um Schössling, deren weichen Kern er mit sichtlichem Genuss verspeist. Aber immer wieder unterbricht er seine Mahlzeit, äugt umher und sichert, während seine Familie die Leckerbissen genießt. Bald sind die Jungtiere gesättigt und wenden sich dem Spiel zu. Da gibt es ein Balgen und Jagen, ein Umhertollen und Übereinanderpurzeln; da gibt es Streit und Geschrei, bis ein Weibchen die Geduld verliert und einem der Schreihälse eine kräftige Backpfeife verpasst. Schmollend und keckernd zieht sich der Delinquent zurück. Ein anderes Jungtier, sehr klein noch, legt sich auf eine weiche, grasige Stelle, schiebt den Daumen in den Mund und nuckelt zufrieden.

Langsam kommt die Gruppe zur Ruhe; man ist gesättigt und ruht sich noch ein wenig aus, bevor der Silberrücken die Seinen zum Rückweg antreibt.

Getrennt durch einen gewaltigen, bewaldeten Höhenrücken findet sich eine zweite Lichtung, diesmal gesäumt von niedrigen, halbkugeligen Hütten aus lockeren Zweigen und Blattwerk. Einige Frauen machen sich an einer Feuerstelle zu schaffen, wo sie Wurzeln in der heißen Asche garen, während sich ihre Kinder mit dem Imitieren von Tierstimmen vergnügen. Lautes Gelächter belohnt die besonders gelungenen Versuche. In einiger Entfernung hocken zwei junge Männer am Boden. Bekleidet sind sie mit einem Lendenschurz aus Bast, der aus weichgeklopfter Baumrinde hergestellt wird. Zwischen ihren Händen drehen sie ein Gewebe aus Rindenfasern, in dem sich eine bräunliche, feuchte Masse aus Pflanzenmaterial befindet, und fangen den austretenden Saft mit einem großen Blatt auf. Anschließend werden Pfeilspitzen sorgfältig in den Extrakt getaucht, bevor sie über dem Feuer kurz erhitzt werden. Alles das geschieht mit äußerster Vorsicht, denn bei dem Pflanzensaft handelt es sich um Pfeilgift, ähnlich dem südamerikanischen Curare. Ritzt ein solcher Pfeil die Haut der Beute, tritt nach wenigen Sekunden eine völlige Lähmung ein; das Wild stürzt zu Boden und kann gefahrlos getötet werden. Nach erfolgreicher Jagd werden die Jäger das Wild aufbrechen und ein Stück des Herzens auf den Waldboden legen, als ein Dankopfer für den Herrn des Waldes, der das Tier in ihre Hände gegeben hat. Später dann holt einer der Männer eine Trommel hervor, ein anderer ein Saiteninstrument, und während die Männer musizieren, tanzen die anderen dazu, denn Singen und Tanzen ist ihre Leidenschaft (Abb. 1.1).

Der Urwald ist Heimat und Lebensraum für Gorillas wie für Pygmäen, der ihnen Unterhalt und Sicherheit bietet. Hier leben sie, der Silberrücken mit seinem Harem und dem Nachwuchs und die kleine Gruppe von Menschen. Sie suchen täglich ihre Nahrung, schützen sich vor möglichen Gefahren und ziehen ihren Nachwuchs auf. Manchmal ist ihr Verhalten so ähnlich – zum Beispiel wenn kleine Gorillas wie Menschenkinder am Daumen nuckeln oder Mütter die Nerven verlieren –, dass die Grenzen zwischen Mensch und Tier zu verschwimmen scheinen. So meinte übrigens nicht nur die berühmte Gorillaforscherin Dian Fossey, der ihre Schützlinge manchmal als die „besseren Menschen" erschienen, sondern auch die frühen portugiesischen Seefahrer und Händler waren sich keineswegs sicher, wo sie die Gorillas einzuordnen hatten: Sicherheitshalber schickte man ihnen eine Delegation und bot Geschenke an, in der Hoffnung, gewinnbringende Handelsbeziehungen knüpfen zu können.

Inzwischen ist bekannt, dass und warum die Portugiesen in diesem besonderen Fall mit ihren Bemühungen scheitern mussten, denn bei aller Ähn-

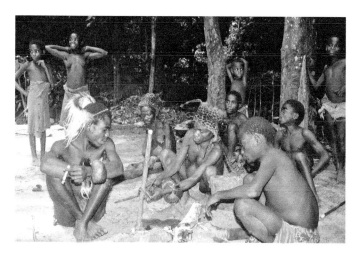

Abb. 1.1 Pygmäen am Mount Hoyo, Kongo. (© Karl Ulrich Petry; mit freundlicher Genehmigung)

lichkeit sind Gorillas eben doch keine Menschen, wenn sie auch mit herausragenden Fähigkeiten und großer Intelligenz ausgestattet sind. Gorillas und ihre nahen Verwandten, die Schimpansen und Orang-Utans, bilden mit dem Menschen zusammen die Familie der Menschenaffen (Hominidae). Ihre Ähnlichkeit mit dem Menschen verdanken sie einem langen gemeinsamen Stammbaum, bis sich irgendwann die Entwicklungslinien aufspalteten – zunächst in die Unterfamilien der Ponginae mit ihrem bekannten Vertreter, dem Orang-Utan, auf der einen und der Unterfamilie der Homininae mit den Gorillas, Schimpansen und Menschen auf der anderen Seite. Eine weitere Aufspaltung des Stammbaums vor etwa 6 bis 8 Mio. Jahren trennte dann zunächst die Gorillini von den Panini und Hominini, bis sich auch diese Entwicklungslinie wieder aufspaltete – in die Verwandtschaft des Schimpansen auf der einen und die des Menschen auf der anderen Seite. Und in diesem Zeitrahmen, irgendwann während der Millionen Jahre der Menschheitsentwicklung, muss sich das abgespielt haben, was den Menschen nicht nur befähigt, hochstehende materielle Kulturen zu schaffen, die ihn heute von seiner naturräumlichen Umwelt weitgehend unabhängig machen, sondern darüber hinaus auch das zu denken, was den Horizont seiner alltäglichen Erfahrung übersteigt: das Vorhandensein von Göttern und Geistern, von Kräften und Mächten, die auf das Leben des Menschen Einfluss nehmen oder die man vielleicht sogar beherrschen kann, wenn man nur die notwendigen Gebete und Zauberworte weiß.

Geschichtliches

Die Frage, wie und warum Religion entstand, hat Forscher fasziniert, seit der uneingeschränkte Glaube an eine auch im naturwissenschaftlichen Sinn wort-wörtliche Wahrheit der Bibel ins Wanken geriet. Vor allem die Philosophen und Naturforscher des Zeitalters der Aufklärung (17. und 18. Jahrhundert) hielten den christlichen Glauben ebenso wie alle anderen religiösen Vorstel-lungen für die noch unzulänglichen Versuche früherer Generationen, die Welt wissenschaftlich zu erklären. Wie das Wissen eines Kindes vom Klein-kindalter über die Zeit der Adoleszenz bis zum Erwachsenenalter kontinuier-lich wächst, so dachte man, hätten sich auch die Intelligenz und das Wissen der Menschheit von ihren Anfängen bis in die Gegenwart positiv entwickelt. Der frühe Mensch habe sich daher die Welt als beherrscht von Mächten und Kräften vorgestellt, die man mithilfe magischer Praktiken beeinflussen könne. Erst mit zunehmendem Intellekt sei dieser Glaube an Magie zunächst der Vorstellung von Göttern, dann von einem einzigen Gott gewichen, der die Geschicke der Menschen lenken sollte. Ganz zuletzt, so meinte man, führe dann der Einfluss der Wissenschaft zur Erkenntnis der wahren Zusammen-hänge und mache jede Art von Religion überflüssig.

Zur Zeit der französischen Revolution war es der Mathematiker und Philo-soph Antoine de Condorcet (Marie Jean Antoine Nicolas Caritat, Marquis de Condorcet, 1743–1794), der durch seine Analyse des Verlaufs der Mensch-heitsgeschichte zu dem Schluss kam, dass sich die gesamte Entwicklung der Menschheit über zehn Stadien von einer primitiven, magischen Praktiken verhafteten Horde über die polytheistischen Reiche der Antike bis in die lich-ten Höhen eines aufgeklärten republikanischen Zeitalters vollzogen habe.

Seine diesbezüglichen Ideen gingen völlig konform mit Vorstellungen der Biologie seiner Zeit, in der der große Biologe und Vordenker des Evolutions-gedankens Jean Baptiste de Lamarck (Jean-Baptiste Pierre Antoine de Monet, Chevalier de Lamarck, 1744–1829; Abb. 1.2) eine erste Theorie zum Arten-wandel entwickelte. Er ging davon aus, dass sich Lebewesen aufgrund eines inhärenten Vervollkommnungstriebes im Laufe ihrer stammesgeschichtlichen Entwicklung von primitiven Anfängen zu letztlich höchst komplexen Lebe-wesen entwickeln würden. Die logische Folge einer solchen Vorstellung von natürlicher Entwicklung im Sinne einer automatischen Höherentwicklung war, eine Perfektionierung auch für die Menschheit anzunehmen – und genau das hat Condorcet getan.

Auch wenn Lamarcks sogenannte Transformismushypothese in der Bio-logie immer umstritten war und auch bald durch die überzeugendere Selek-tionstheorie Charles Darwins und Alfred Russell Wallace' – über beide später mehr – abgelöst wurde, hatte sich eine ganz bestimmte Vorstellung in den

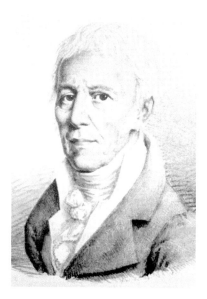

Abb. 1.2 Jean Baptiste de Lamarck. (Aus: © J. Pizzetta, *Galerie des naturalistes*, 1893)

Köpfen von Wissenschaftlern und zunehmend auch von Laien festgesetzt: die einer quasi automatischen Höherentwicklung allen Lebens im Lauf der Evolution. Und so blieb die ursprüngliche lamarckistische Vorstellung einer Höherentwicklung der Menschheit in weiten Teilen der Wissenschaft bestehen, wurde modifiziert und den gesellschaftswissenschaftlichen Erkenntnissen angepasst, ohne jedoch letztlich die ursprüngliche Aussage infrage zu stellen, dass der Fortschritt der Wissenschaften jede Form von Religion nach und nach überflüssig machen würde. Große und bis in die heutige Zeit einflussreiche Philosophen und Soziologen wie Auguste Comte (1798–1857) oder Karl Marx (1818–1883) nahmen die lamarckistische Hypothese als unumstößliche Tatsache und entwickelten auf dieser Basis eigene Modelle einer gesetzmäßigen Gesellschaftsentwicklung, in der die Vorstellung einer automatischen Perfektionierung der Gesellschaft in moralischer und wirtschaftlicher Hinsicht die entscheidende Rolle spielte. Religion war bei diesen Denkern nicht mehr gefragt, sondern höchstens noch „Opium des Volkes", wie es in Marx' Religionskritik heißt.

Gerade die Idee vom zwangsläufigen Aussterben der Religion schien durch die historischen Tatsachen bestätigt zu werden, wie nicht zuletzt die zahlreichen Kirchenaustritte der vergangenen Jahrzehnte und die abnehmende Relevanz christlicher (Moral-)Vorstellungen in der Öffentlichkeit zu belegen schienen. Umso erstaunter waren viele Wissenschaftler, als sie, ganz im Gegensatz zu ihren Voraussagen, in den letzten Jahren nicht nur eine zunehmende Häufigkeit religiöser Themen im öffentlichen Diskurs konstatieren, sondern auch

die Relevanz der Religionen in bewaffneten und unbewaffneten nationalen wie internationalen Konflikten zur Kenntnis nehmen mussten. Die wissenschaftliche Welt reagierte darauf mit Veröffentlichungen, die mit den Titeln wie *Die Wiederkehr der Götter* (Friedrich Wilhelm Graf), *Der Gotteswahn* (Richard Dawkins) oder *Denkverbot* (Hubertus Mynarek) das Phänomen einer neuen Religiosität erstaunt oder aber besorgt zur Kenntnis nahmen, ohne es jedoch schlüssig erklären zu können – ein Phänomen wohlgemerkt, das nach den Erkenntnissen der europäischen Geistesgeschichte seit der Aufklärung als irrational und erkenntnisfeindlich eingestuft worden war und dessen Widersinnigkeit man sich nicht erklären konnte. Wer sollte noch an Gott oder Götter glauben, wenn Biologen und Chemiker längst die Entwicklung des Lebens aus einfachsten Anfängen, aus der Ursuppe, hatten herleiten können; wenn Paläontologen längst die Missing Links gefunden und die Evolutionstheorie damit bestätigt hatten; wenn Physiker die Entstehung des Weltalls aus dem Urknall erklären konnten und heute Themen wie schwarze Löcher und dunkle Materie die Diskussion in Zusammenhang mit der Suche nach den Ursprüngen alles Seienden beherrschen?

Eine Antwort auf dieses Rätsel musste gefunden werden. Wenn Menschen trotz des hohen Niveaus der wissenschaftlichen Erkenntnisse, also „wider besseres Wissen", nicht von der Religion ablassen konnten oder wollten, musste der Fehler im System selbst, also im menschlichen Denken und Empfinden liegen. Die Kognitionswissenschaften, die Neurologie oder die Psychologie mussten dieses Rätsel lösen können.

Lösung Nr. 1 – der Behaviorismus

Einer der prominentesten Forscher, der sich mit dem Phänomen Religion von biologischer Warte aus kritisch auseinandergesetzt hat, ist der Biologe Richard Dawkins (*1941). In seinem Buch *Das egoistische Gen* führte er die Evolution der Organismen auf den Wettbewerb konkurrierender „egoistischer" Gene zurück und konnte auf diese Weise eine Reihe bislang unerklärlicher Phänomene wie zum Beispiel altruistisches Verhalten unter verwandten Individuen oder aber auch tödliche Aggressivität innerhalb der Arten erklären, die nicht in das bis dahin gültige Konzept vom Überlebenswillen des Individuums oder des Nutzens für die Art gepasst hatten. Das Thema Religion kommt bei Dawkins da ins Spiel, wo es um das Überleben unsinniger oder sogar schädlicher Ideen oder Überzeugungen geht: Analog zum Gen als Träger einer biologischen Information bezeichnete Dawkins ein sogenanntes Mem als Träger einer geistigen Information, die von Individuum zu Individuum weitergegeben wird. Genauso, wie sich Gene nicht darum scheren, ob ihre „Überlebens-

maschinen", also die Individuen, die sie letztlich hervorgebracht haben, prosperieren, kümmert es die Meme als Träger einer rein geistigen Information nicht, ob der von ihnen übermittelte Inhalt vielleicht für seinen Empfänger schädlich ist. Gerade Meme religiösen Inhalts, die zu Märtyrertum oder auch nur Zölibat aufrufen, sind nach Ansicht des Biologen Dawkins schädlich, da sie die erfolgreiche Fortpflanzung des Individuums, das sie befallen haben, verhindern.

Bereits mehr als eine Wissenschaftlergeneration zuvor hatte der renommierte Psychologe, Erforscher des Tierverhaltens und Begründer der Forschungsrichtung des Behaviorismus John B. Watson (1878–1958) Religion auf bloße Konditionierung zurückgeführt. In seinem berühmt gewordenen Artikel *Psychology as the behaviorist views it* (1913) hatte er gefordert, auch bei der Erforschung des Verhaltens von Menschen objektive, das heißt nachvollziehbare Methoden anzuwenden. Voraussetzung für diesen wissenschaftlichen Ansatz war eine Auffassung von Verhalten als bloße Reaktion auf äußere oder innere Reize. Methodisch wurde dieser Forderung allerdings in starkem Umfang durch Laborversuche an Tieren und weniger am Menschen Rechnung getragen. Gerade weil es der Behaviorismus aber ermöglichte, Verhalten unter objektivierbaren Laborbedingungen zu untersuchen, und weil er mit durchaus beeindruckenden Ergebnissen aufwarten konnte, prägte die Vorstellung, dass grundsätzlich jede Form von Verhalten entweder auf umweltbedingte Reize oder auf Lernen zurückzuführen sei, nicht nur die biologische, sondern auch die sozialwissenschaftliche Forschung.

Dass der Behaviorismus eine verhaltenswissenschaftliche Auseinandersetzung mit Religion eher behinderte als beförderte, liegt neben der ihm inhärenten Logik von Reiz und Reaktion allerdings auch am antireligiösen Affekt seiner Protagonisten. Führende Vertreter des behavioristischen Paradigmas, und dazu zählen neben John B. Watson vor allem auch B. Frederic Skinner und George Vetter, beurteilten eine religiöse Weltsicht als gefährliche Illusion, die überwunden werden müsse. Dementsprechend empfanden viele Behavioristen auch eine wissenschaftliche Auseinandersetzung mit religiösen Phänomenen als regelrecht anstößig. John B. Watson selbst etwa beschäftigte sich deshalb bis auf wenige kritische Anmerkungen bezüglich der Irrationalität religiöser Weltanschauungen und der Entmachtung und Ausbeutung Gläubiger durch religiöse Eliten nicht weiter mit der Thematik. Anders B. Frederic Skinner, der Hauptvertreter der Erforschung des instrumentellen oder operanten Konditionierens (Lernen anhand von Belohnung und/oder Bestrafung): Er publizierte dezidiert religionskritische Arbeiten, wobei er das behavioristische Reiz-Reaktions-Schema unmittelbar auf die Religion anwendete und religiöse Verhaltensweisen als Resultate operanter Konditionierungsprozesse erklärte.

Versuche mit der Skinnerbox

Die Versuche mit der Skinnerbox (Abb. 1.3) gehen davon aus, dass Lernen ein Resultat von entsprechenden Stimuli ist. Dabei ist es zweitrangig zu wissen, welche Vorgänge im Gehirn dem Lernen zugrunde liegen; wichtig sind die Resultate, nicht der Prozess. Eine wichtige Rolle spielt hierbei das positive oder negative Feedback über Belohnung und Bestrafung, das den Probanden konditioniert (operante Konditionierung).

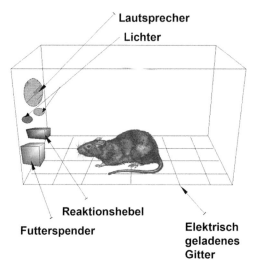

Abb. 1.3 Skinnerbox. (© V1nzorg; cc-by-sa-Lizenz)

Wie Watson verurteilte Skinner Religion als eine Weltanschauung der Unterdrückung und Ausbeutung, was er gemäß seinem eigenen Forschungsansatz als missbräuchliche Anwendung operanter Konditionierungsstrategien verstand. Quasi als Beweis führte er ein Experiment an Tauben an, bei denen er eine Art abergläubischer Verhaltensweisen feststellen zu können meinte. Skinner beobachtete, dass die Tauben, selbst wenn sie lediglich in regelmäßigen Intervallen von 15 Sekunden durch eine mit dem Käfig verbundene Apparatur Futter erhielten, während des Wartens auf die nächste Futterration sehr spezifische, für sie prinzipiell völlig funktionslose Verhaltensweisen ausbildeten. Sie drehten sich zum Beispiel um die eigene Achse, beugten sich hinab, bis sie fast den Käfigboden berührten, oder stießen mit dem Kopf an das Käfiggitter neben der Futterapparatur. Diese Verhaltensmuster wiederholten die Tiere, die ja den unmittelbaren „Erfolg" ihres Verhaltens feststellen konnten, zunehmend häufiger. Selbst wenn sie später völlig unabhängig von den neu erlernten Aktivitäten gefüttert wurden, blieben die Verhaltensformen der

Tiere häufig über einen längeren Zeitraum bestehen. Aufgrund dieser Beob-
achtung vermutete Skinner, dass viele religiöse Verhaltensmuster wie rituelle
Tänze, Gesten der Proskynese (Niederwerfen als Zeichen der Unterwerfung)
oder auch Selbstkasteiungen ebenfalls lediglich das Resultat von operanten
Konditionierungen sein könnten. Die Konditionierungen seien, so Skinner,
zunächst wie bei den Tauben womöglich gänzlich zufällig erfolgt, dann je-
doch über explizite und implizite Lernmechanismen durch Erwachsene an
ihre Kinder weitergegeben worden. Skinner selbst räumte zwar ein, dass der
Analogieschluss von Tauben auf Menschen nur mittelbar möglich sei, aber
dennoch hielt er seine Entdeckung des „abergläubischen" Verhaltens bei
Tauben für einen wesentlichen Schritt zum Verständnis der Entstehung der
Grundmuster religiösen Verhaltens.

Faktisch ist jedoch das operante Konditionieren kaum geeignet, die Kom-
plexität auch nur der schlichtesten bekannten Religionen zu erklären. Vor
allem die Reduktion von Verhalten auf reine Reiz-Reaktions-Schemata hatte
nicht nur zur Folge, dass innerpsychische und mentale Vorgänge gänzlich aus-
geblendet, sondern gleichzeitig die Möglichkeit angeborener bzw. genetisch
sowie kulturell ererbter Verhaltensweisen nicht in Betracht gezogen wurden.
Dies bedeutet jedoch das Ausklammern jedweder geschichtlichen Perspektive.
Dennoch soll nicht unterschlagen werden, dass der Behaviorismus durchaus
auch Stärken hinsichtlich der Erklärung von religiösem Verhalten hat, näm-
lich wenn es um die Frage geht, wie religiöse Lehren und Praktiken von den
Eltern an die Kinder weitergegeben werden, denn kindliche Lernprozesse fu-
ßen in der Tat noch stark auf operanten Konditionierungsmechanismen.

Lösung Nr. 2 – Kognitionswissenschaft und Neurotheologie

Während der Behaviorismus das Gehirn als Blackbox betrachtete, also den
Vorgängen im Gehirn keinerlei Beachtung schenkte, stützt sich die heutige
Forschung gerade auch auf die neurologischen Erkenntnisse der vergangenen
Jahrzehnte, um das Entstehen religiöser Vorstellungen im Gehirn zu erklä-
ren. Dabei wird vorausgesetzt, dass sich das menschliche Gehirn im relevan-
ten Zeitraum, also während der letzten 100.000 Jahre, zumindest in seinen
Grundstrukturen nicht entscheidend verändert hat, sodass kognitive Mecha-
nismen, die in den Jahrtausenden der Menschheitsentwicklung als Folge einer
biologischen Anpassung (Adaptation) entstanden sind, noch heute wirken.
Wenn man so will, haben wir also trotz aller kultureller und technischer Fort-
schritte in unseren Köpfen noch ein Steinzeitgehirn.

Im Gegensatz zur behavioristischen Forschungsrichtung, die in der ersten Hälfte des 20. Jahrhunderts dominierte, wird heute unter anderem versucht, die Entstehung religiöser Empfindungen und Verhaltensweisen auf der Grundlage neurowissenschaftlicher Untersuchungen zu erklären. Da es sich also um eine neurowissenschaftliche Auseinandersetzung mit religiösen Phänomenen handelt, wird diese Forschungsrichtung etwas irreführend auch Neurotheologie genannt, auch wenn es darin weniger um spezifische Glaubensinhalte gemäß den Lehren und Dogmen einer bestimmten religiösen Tradition geht, als vielmehr um die anatomischen und neuronalen Grundlagen von religiöser Erfahrung.

Einer der umtriebigsten Vertreter der Neurotheologie ist der amerikanische Mediziner Andrew Newberg (*1966). Aufbauend auf Studien an meditierenden Buddhisten und betenden Franziskanerinnen mittels bildgebender Verfahren postulierte Newberg zusammen mit dem Religionswissenschaftler Eugene d'Aquili (1940–1998), dass das menschliche Gehirn strukturell auf das Erleben mystischer Erfahrungen hin ausgerichtet sei. Darum müssten mystische Erfahrungen als Grundlage der Entwicklung aller daran anschließenden Versuche verstanden werden, solche Erfahrungen durch Rituale bewusst zu stimulieren und mittels mythologischer Erzählungen zu deuten, mithin also als der Ursprung von Religion gelten.

Das Problem dieser Argumentation ist zunächst einmal, dass mystische Erfahrungen allein keinerlei materielle Spuren hinterlassen, die sich archäologisch niederschlagen könnten. Insofern ist die Erklärung des Aufkommens von Religion anhand mystischer Erfahrungen zwar nicht direkt unplausibel, aber auch nicht durch Belege, die über die neurowissenschaftlichen Befunde an modernen Menschen hinausgehen, zu stützen. Nicht glaubhaft ist diese Position jedoch auch deshalb, weil die auf Erfahrung eines Absoluten ausgerichtete Mystik religionsgeschichtlich ein vergleichsweise junges Phänomen ist und erst in Zusammenhang mit den Hochreligionen erscheint.

Wie sieht es mit anderen aktuellen Versuchen aus, die Entstehung von Religion wissenschaftlich zu erklären? Auch die „Evolutionäre Psychologie" und die „Cognitive Science of Religion" stützen sich auf die Annahme, dass unser Gehirn im Wesentlichen nach denselben Mechanismen funktioniert wie das unserer Vorfahren vor 100.000 Jahren – und uns eben darum in unserer heutigen, hoch technisierten Welt gelegentlich in die Irre leitet. Nur liegt der Fokus hier nicht auf den anatomischen Strukturen des Gehirns und ihren Funktionen, sondern auf spezifischen Formen der menschlichen Informationsverarbeitung, den Kognitionen.

Eine solche angeblich religionsrelevante Fehlleistung des Gehirns, die zu Zeiten unserer Ahnen durchaus sinnvoll gewesen sein mag, ist eine Reaktion, die als HADD (*hyperactive agency detection device*) bekannt geworden ist. Das

Gehirn schreibt ein unbekanntes, beunruhigendes und im ersten Moment nicht zuzuordnendes Ereignis automatisch dem denkbar komplexesten und gefährlichsten Verursacher zu. Ein Beispiel: Hört ein Individuum im Dickicht ein Rascheln, ist es für einen nur unzureichend bewaffneten Steinzeitmenschen von Vorteil, sich zunächst in Sicherheit zu bringen, bevor er komplizierte Überlegungen darüber anstellt, ob lediglich ein Windstoß das Geräusch verursacht hat oder vielleicht doch ein feindlich gesonnener Mensch oder gar ein gefährliches Raubtier. Das Erkennen von Akteuren – möglicherweise feindlich gesonnenen – ist also eine entscheidende Fähigkeit im Kampf ums Überleben. Der beschriebene Mechanismus erklärt zunächst einmal vor allem die Nervosität und Fluchtbereitschaft von Kaninchen, Mäusen oder auch Sperlingen, deren Existenz ständig von Beutegreifern bedroht ist.

Beim Menschen wird die evolutiv verankerte Veranlagung, bei unerklärlichen Ereignissen einen (möglicherweise feindlichen) Verursacher anzunehmen, durch eine weitere Theorie ergänzt: die ToM (*theory of mind*). Diese Theorie beschreibt die Fähigkeit des Menschen, fremde Gefühls- und Bewusstseinszustände zu erkennen und nachzuempfinden und auf diese Weise nicht nur Gefühle wie Angst, Trauer oder Zorn bei einem Gegenüber auszumachen, sondern auch seine Reaktion mit großer Wahrscheinlichkeit voraussagen zu können. Zwar verfügen nach jüngsten Erkenntnissen der evolutionären Anthropologie (die vergleichende Erforschung der Entwicklung von Verstandesleistungen bei den Hominidae) auch die nichtmenschlichen Hominidae über eine rudimentäre ToM, aber bei keiner Spezies ist sie so differenziert ausgebildet wie beim Menschen.

In Kombination haben HADD und ToM sicherlich zum Überleben unserer Vorfahren beigetragen, indem ein potenzieller Feind nicht nur rechtzeitig erahnt, sondern ihm auch bestimmte Absichten (Angriff!) unterstellt werden konnten, die dann zum richtigen, das Überleben sichernden Verhalten unser Vorfahren und Verwandten geführt haben. In Zusammenhang mit der Frage nach der Entstehung von Religion sollen beide Faktoren jedoch gleichfalls eine entscheidende Rolle gespielt haben, indem nämlich Menschen auch natürlichen Phänomenen wie dem Sonnenaufgang, Gestirnkonstellationen oder Wetterphänomenen Bewusstsein, Absichten und damit Persönlichkeit zugeschrieben hätten, woraus dann der Götterglaube entstanden sei. Der Anthropologe Stewart Elliott Guthrie argumentiert zum Beispiel, dass die Architektur seines Gehirns den Menschen zwinge, in sich wandelnden Wolkengebilden Gesichter zu identifizieren, die dann automatisch als Akteure angesprochen würden – und damit eine Absicht zum Beispiel hinter dem Wettergeschehen angenommen worden sei. Andere Autoren (z. B. Pascal Boyer, Scott Atran, Justin Barrett) argumentieren ähnlich wie Guthrie und erklären über Mechanismen wie HADD und ToM, die in der Gehirnstruktur

verankert sind, den Ursprung von Religion. Spätestens an dieser Stelle ist Kritik angebracht. Würden Menschen, wie im Zuge der Theorien zu HADD und ToM postuliert, in den Wolken Gesichter erkennen oder Gestirnen Absichten unterstellen, so handelte es sich bei den entsprechenden Akteuren immer um menschenähnliche Wesen mit Persönlichkeit, also um Götter. Genau von diesen Göttern ist dann auch folgerichtig die Rede, wenn es um den Religionsursprung geht. Damit haben die genannten Theorien jedoch den fatalen Nachteil, dass sie im Widerspruch zu den historischen Fakten stehen. Am Anfang der Menschheitsgeschichte findet sich nichts von Göttern, von tempelähnlichen Strukturen für deren Verehrung oder Überresten von zugehörigen Opfern und Riten, sondern etwas ganz anderes: Bestattungen. Die ersten, den Horizont menschlichen Erlebens überschreitenden Ideen beschäftigten sich nicht mit Göttern, sondern mit etwas sehr Menschlichem: mit dem Tod, dem Sterben und dem Begräbnis. Erst 70.000 bis 80.000 Jahre nach diesen ersten Bestattungen tauchen, mit Hinweisen auf Bestattungsrituale, in Anatolien und der Levante Spuren von religiösen Aktivitäten auf, die deutlich machen, dass der Tod nun ganz klar mit Vorstellungen von einem Jenseits verknüpft wird. Unterstützt wird dieser paläoanthropologische Befund (Paläoanthropologie ist die Lehre von den vorgeschichtlichen Menschen) von den Erkenntnissen der Sozialwissenschaften. Es ist eine ausgemachte Tatsache, dass nicht jede Gesellschaftsform jede beliebige Religion haben kann. Wildbeuter glauben höchstens an einen Herrn des Waldes oder einen Herrn der Tiere (der darum keinesfalls in den Wolken zu finden ist, die man im dichten Wald oft gar nicht sieht). In ursprünglichen Ackerbaugesellschaften gibt es Vorstellungen von übermächtigen Ahnengestalten (Abb. 1.4) und erst die komplexen, arbeitsteiligen Gesellschaften der Antike mit ihren Königen, Priestern, Freien und Sklaven kannten regelrechte Götterhimmel mit Gestalten wie Zeus, Artemis und Hades.

Doch auch wenn sich Vertreter der Cognitive Science of Religion mit den Vorstellungen auseinandersetzen, die sich Menschen vom Tod und dem, was danach passiert, machen, erfordern die dabei zugrunde gelegten Annahmen oft noch zu viele Voraussetzungen und sind zu stark losgelöst von den archäologischen Befunden. Das zeigt sich beispielsweise bei den Arbeiten des amerikanischen Psychologen und Autors Jesse Bering (*1975) zur Entwicklung von Todesvorstellungen bei Kindern. Zusammen mit einigen Kollegen untersuchte Bering Kindergarten- und Grundschulkinder in Florida und Spanien. Die Forscher spielten den Kindern zunächst mit einem Puppentheater Geschichten vor: Eine kleine Maus verläuft sich im Wald, ist hungrig und durstig und trifft zu guter Letzt auf einen Alligator, der sie mit einem Happs verschlingt. Unmittelbar anschließend wurden die Kinder mit einem standardisierten Interview zum Befinden der Maus gefragt und ermittelt, wie viele

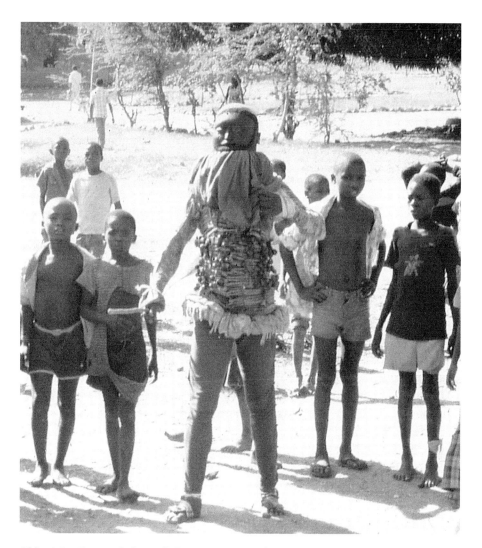

Abb. 1.4 Eine typische Religion von unstratifizierten Ackerbaugesellschaften. Der Lipikotänzer bei den Makonde Ostafrikas trägt eine Maske, die ihn als Vertreter der mächtigen Ahnenwelt ausweist. (© Karl Ulrich Petry; mit freundlicher Genehmigung)

Kinder der einzelnen Altersgruppen die verschiedenen Fragen nach dem Fortbestand der biologischen (Aufwachsen) und psychobiologischen Funktionen (Hunger, Durst, Müdigkeit), Wahrnehmungen (Riechen), nach Wünschen, Zielen (nach Hause gehen), Gefühlen (Liebe zur Mutter) und Verstandestätigkeit (Wissen um den eigenen Tod) verneint hatten. Dabei fanden Bering und seine Kollegen, dass die Kinder mit zunehmendem Alter zwar insgesamt weniger Fragen bejaht hatten, dass aber selbst unter den Elf- bis Zwölfjährigen die Hälfte der Kinder davon ausging, dass die Maus auch nach ihrem Ableben noch Wünsche und Gefühle hat. Für die Forscher ist dies ein Indiz dafür, dass

es im Kindesalter eine Phase gibt, die dafür prädisponiert, an eine seelische und/oder geistige unsterbliche Essenz des Menschen zu glauben, was für die allgemeine Affinität des Menschen zu Religion mit ursächlich sei.

Eine solche Schlussfolgerung berücksichtigt allerdings weder die Tatsache, dass das Christentum, mit gut 2,2 Mrd. Anhängern derzeit die am weitesten verbreitete Religion, konfessionsübergreifend die Auferweckung des Leibes nach dem Tod lehrt, die postmortale Existenz also gerade nicht auf Seele oder Geist beschränkt (auch wenn sicher nicht alle Gläubigen dieser Lehre kritiklos zustimmen). Noch kann diese Theorie erklären, warum man in einigen, ursprünglich vom Christentum geprägten und inzwischen säkularisierten Ländern wie in Skandinavien oder Osteuropa den Glauben an eine postmortale Weiterexistenz nur noch vergleichsweise selten findet. Mit seiner Annahme eines kulturübergreifenden Glaubens an die Fortdauer von Seele und/oder Geist ist Bering womöglich das Opfer seiner eigenen kulturellen Prägung geworden. In seiner akademischen Laufbahn war Bering ausschließlich an Universitäten im religiös konservativen amerikanischen Südosten, dem sogenannten *bible belt* (Bibelgürtel), sowie in Belfast, also im jahrzehntelang durch Konflikte zwischen fanatischen Protestanten und Katholiken gezeichneten Nordirland, tätig. Dass ihm in diesem Kontext die Religion schnell omnipräsent erscheinen konnte und auch viele der von ihm untersuchten Kinder selbst dann bereits religiös geprägt waren, wenn sie nicht aus einem religiösen Elternhaus stammten, ist zumindest wahrscheinlich.

Das grundlegende Problem der Arbeiten von Bering besteht aber darin, dass angenommen wird, es könne von den Beobachtungen an zeitgenössischen Kindern ohne Weiteres auf evolutionäre Grundlagen von Religion zurückgeschlossen werden. Dabei werden mehrere Jahrzehntausende der menschlichen Kultur- und Religionsgeschichte übersprungen und vergleichbare religiöse Vorstellungen wie die der Gegenwart auch für frühere Phasen der Menschheitsgeschichte unterstellt. Der Komplexität, Entwicklungsdynamik und vor allem der langen und differenzierten Geschichte von Religion wird dabei zu wenig Rechnung getragen. Zudem wird, wie oben bereits erwähnt, nicht mit den archäologischen Funden und Befunden abgeglichen, und damit bleibt unklar, in welcher Phase der Menschheitsgeschichte eine spezifische Vorstellung wie die vom Weiterleben der Seele/des Geistes nach dem Tod entstanden sein könnte und aufgrund welcher archäologisch nachweisbarer Hinterlassenschaften sich das belegen ließe. Der Weg müsste stattdessen vielmehr sein, von den vorhandenen archäologischen Funden und Befunden auszugehen, um auf dieser Grundlage nach den möglichen kognitiven Ursachen zu suchen.

Alle hier genannten Theorien sind eingängig, liefern wertvolle Denkanstöße für eine seriös arbeitende Wissenschaft und können zum Verständnis gerade auch solcher Religionen beitragen, die uns aus der Geschichtsschreibung

von der Antike bis heute bekannt sind. Doch sie haben eben einen entscheidenden Nachteil: Sie können leider nur wenig zur Klärung der Frage nach dem Ursprung der Religionen, nach dem „Warum" und „Wie", beisteuern, denn da widersprechen sie teils sehr deutlich gesicherten Befunden anderer wissenschaftlicher Disziplinen oder gar einander.

Ein kurzes Fazit dieses Ausflugs in die psychologische und kognitionswissenschaftliche Forschung: Die Herausforderung, der sich jeder Versuch, die Entstehung und frühe Geschichte von Religiosität und später von konkreten Religionen nachzuvollziehen, stellen muss, liegt also darin, zunächst einmal von vorliegenden archäologischen und paläontologischen Funden und Befunden auszugehen. Erst in einem zweiten Schritt ist dann danach zu fragen, inwieweit diese Funde vor dem Hintergrund des biologischen Erbes des Menschen, seiner Umwelt und seines Sozialverhaltens Hinweise auf die Entwicklung einer Religion geben. Das bedeutet, dass Erkenntnisse der Evolutionstheorie, der Soziobiologie, der Psychologie und vor allem der Verhaltensforschung mit den archäologischen und anthropologischen Fakten in eine sinnvolle Beziehung zueinander gesetzt werden müssen. Wie wir im Folgenden sehen werden, sind insbesondere die Erkenntnisse der Verhaltensforschung, einer etablierten Subdisziplin der Biologie, und ihre neuen Entwicklungen hilfreich, die tatsächliche Entstehung von Religionen zu verstehen.

Darwin und die Verhaltensforschung

Als Charles Darwin (1809–1882) sein epochales Werk *On the origin of species by means of natural selection* (1859; kurz: *On the origin of species*) veröffentlichte, war er sich der Tatsache sehr bewusst, dass weniger die revolutionär neue Denkweise in der Biologie die Aufmerksamkeit der Öffentlichkeit erregen würde, als vielmehr die daraus entstehenden Konsequenzen für das bisherige Weltbild, in dem der Mensch als Krone eines göttlichen Schöpfungsaktes gegolten hatte. Darwins folgende Werke *The descent of man* (1871) und *The expression of the emotions in man and animals* (1872) entthronten den Menschen endgültig und reduzierten ihn auf seine natürliche Stellung innerhalb der belebten Natur, auch, indem Darwin die geistigen bzw. psychosozialen Fähigkeiten des Menschen richtig als Ergebnis evolutiver Entwicklung herausstellte. Das letztgenannte Werk, das heute teilweise der Ethologie, teilweise auch der evolutionären Erkenntnistheorie zuzuordnen wäre, war von Darwin als weiterer Beleg für seine Auffassung von der gemeinsamen Abstammung des Menschen und der höheren Säuger verstanden worden. Ursprünglich hatte man den Ausdruck von Gemütsbewegungen umgekehrt als Beweis für die Sonderstellung des Menschen aufgefasst. So hatte der Physiologe Charles

Bell (1774–1842) noch die Ansicht vertreten können, dass die verschiedenen Gesichtsmuskeln des Menschen zu dem Zweck erschaffen worden seien, um ihm sein einzigartiges Mienenspiel zu ermöglichen. Demgegenüber konnte Darwin nachweisen, dass der Ausdruck von Gemütsbewegungen keineswegs ein menschliches Privileg ist, sondern sich auch im Tierreich bei zahlreichen Arten findet. Die anatomischen Grundlagen für dieses Mienenspiel, die Gesichtsmuskulatur des Menschen, war ebenfalls nicht als Sonderentwicklung anzusehen, sondern konnte auf homologe Muskeln der höheren Säuger zurückgeführt werden. Wenn sich auch die tierpsychologischen Folgerungen, die Darwin aus seinen Beobachtungen zog, später nicht mehr halten ließen, so hatte er mit dieser Studie doch sowohl einen weiteren Beleg für seine Evolutionstheorie gefunden als auch die Grundlagen für die moderne Verhaltensforschung gelegt.

Obwohl sich Darwins Evolutionstheorie trotz des theologisch-gesellschaftlichen Sprengstoffes, die sie enthielt, rasch durchsetzte, galt Gleiches nicht für seinen Ansatz hinsichtlich des Studiums des Verhaltens von Mensch und Tier. Stattdessen trat der Behaviorismus seinen Siegeszug an. Es waren – und das ist unter Biologen so gut wie unbekannt – ausgerechnet die Geisteswissenschaften, die Darwins Theorie für das Studium menschlichen Verhaltens fruchtbar machten, und das ausgerechnet in Zusammenhang mit der Religion.

Tatsächlich war es der renommierte Altphilologe Karl Meuli (1891–1968), der beobachtete, dass die Opferbräuche in so unterschiedlichen Kulturen wie dem antiken Griechenland, dem kaiserlichen Rom, heutigen Wildbeutergesellschaften und prähistorischen Jägerkulturen trotz der jeweils völlig verschiedenen sozialen Organisation dieser Kulturen, ökonomischen Grundlagen und naturräumlichen Umwelt in entscheidenden Punkten übereinstimmen – eine Beobachtung, die sich mit dem seinerzeit herrschenden (behavioristischen) Wissenschaftsparadigma von einem rein umweltbestimmten Verhalten nicht in Einklang bringen ließ. Im Gegensatz zu den zu seiner Zeit üblichen Auffassungen kam Meuli zu dem Schluss, dass den von ihm untersuchten Opferbräuchen der alten Griechen aus der Zeit Homers und Platons ein ererbtes Verhaltensmuster zugrunde liegen müsse, das von prähistorischen Kulturen bis in die Antike und darüber hinaus im kulturellen Kontext weitergereicht, also vererbt worden sei. Meuli führte dazu weiter aus, dass menschliches Verhalten einerseits über Generationen vererbt wird, also im kulturellen Kontext evolviert, sodass mit voller Berechtigung von einer kulturellen Evolution menschlichen Verhaltens gesprochen werden kann. Andererseits lassen sich aber auch bestimmte Universalien feststellen, die Teil des biologischen menschlichen Erbes sein könnten.

Diese evolutionistische Sichtweise war allerdings zu Meulis Zeiten in den deutschsprachigen Geisteswissenschaften nicht grundsätzlich neu. Auch der

Abb. 1.5 Aby Warburg. (© unbekannter Fotograf)

Hamburger Kunsthistoriker Aby Warburg (1866–1929; Abb. 1.5) hatte sich im Zuge seiner Erforschung unverständlicher Motive in den Werken der italienischen Renaissance mit Darwins *The expression of the emotions in man and animals* auseinandergesetzt und war zu dem Schluss gekommen, dass in der Angst nicht nur die Ursache der Religion, sondern der Auslöser aller kulturellen Leistungen überhaupt zu sehen sei. Konkretisiert hat Warburg diese Vorstellungen unter anderem in seinem berühmt gewordenen, zunächst nur als privater Vortrag gedachten Aufsatz *Schlangenritual*, in dem er vergleichbare Kultgewohnheiten um die Schlange in den unterschiedlichsten Kulturen von Arizona und Neu-Mexiko bis zum antiken Hellas (Dionysos- und Asklepioskult) nachwies. Damit fand der Kunsthistoriker Warburg im Rückgriff auf Darwins Ansatz zur Verhaltensforschung den Schlüssel zum Verständnis menschlichen (Kultur-)Verhaltens überhaupt und damit auch zur Antwort auf die Frage, wie und warum Religion entstanden ist und wie sie sich von ersten Anfängen zu der Fülle heutiger Religionen entwickelt hat – biologisch ausgedrückt: wie Religion evolviert ist.

2

Not lehrt beten – der Mensch im Altpaläolithikum und die Bedeutung der Angst

Vom Nutzen der Emotionen

Emotionen sind, wie ja bereits Darwin schlüssig belegen konnte, nicht nur ein Vorrecht des Menschen. Auch Tiere verfügen über eine große Bandbreite von emotionalen Regungen, die sie unverstellt zeigen. Welcher Hundehalter kennt nicht den Ausdruck schlechten Gewissens bei seinem Liebling, der statt ihn mit dem üblichen lauten Freudengebell zu begrüßen mit eingeklemmtem Schwanz vor ihm steht – bei einer Überprüfung des Sofas findet sich dann auch die typisch warme Stelle, auf der der Hund verbotenerweise während Herrchens Abwesenheit gelegen hat. Aber nicht nur Haustiere zeigen diese große Bandbreite an emotionalen Ausdrucksformen. Die britische Primatenforscherin Jane Goodall hat ihr Leben damit verbracht, das Verhalten von Schimpansen im tansanischen Gombe-Stream-Nationalpark zu erforschen. In der Beschreibung einer Gruppe von Schimpansenweibchen, die einem körperlich überlegenen Pavian seine Beute, ein von ihm erlegtes Wild, abjagt, wird der Facettenreichtum ihrer Schützlinge deutlich. Dabei greifen die Schimpansen tief in ihre Trickkiste: Sie zeigen nicht nur ihre furchteinflößenden Drohgesten, indem sie „gähnen", das heißt ihre Reißzähne zur Schau stellen und ihre Augen aufreißen, sodass man das Weiße darin sieht, sondern brechen auch in fürchterliches Kampfgebrüll aus, schütteln Zweige, ergreifen Stöcke, schlagen damit auf den Gegner ein und bewerfen ihn mit Steinen. Der Pavian, obwohl viel stärker und sogar in der Lage, einem angreifenden Leoparden lebensbedrohliche Verletzungen zuzufügen, resigniert und zieht sich zurück – aus Furcht und offensichtlicher Überzeugung, es bei Schimpansen mit einer überlegenen Spezies zu tun zu haben. Angst und Furcht haben jedoch auch die Schimpansen selbst, wenn sie spüren, dass ein schweres Unwetter heraufzieht, oder wenn sie sich einer konkreten Bedrohung durch einen Räuber oder feindliche Artgenossen ausgesetzt sehen. Umgekehrt zeigen sie die ganze Bandbreite positiver Emotionen wie Zuneigung, Freude und Triumph, wenn es um ihr soziales Miteinander, die Gemeinschaft zwischen

Mutter und Kind oder Geschwistern oder auch um Freundschaften innerhalb der Gruppe geht.

Emotionen sind nicht nur ein wesentlicher Teil menschlicher und tierischer Erfahrung, indem sie einerseits die Voraussetzung für soziale Beziehungen sind, andererseits aber auch vor möglichen Gefahren warnen und damit ganz entscheidend zum Überleben des Individuums beitragen, sondern sie erfüllen auch eine Reihe wichtiger Aufgaben, ohne die ein soziales Miteinander und in letzter Konsequenz die Herausbildung einer Kultur nicht möglich wären. So spielen Emotionen eine große Rolle bei kognitiven Prozessen. Entscheidungen werden kaum jemals aufgrund rein rationaler Überlegungen, sondern vielmehr auf der Basis emotionaler Eindrücke gefällt: Wir legen uns zum Beispiel spontan diesen niedlichen, knuddeligen Hund mit dem stumpfen Schnäuzchen (Kindchenschema) zu, obwohl wir genau wissen, dass er täglich, auch bei Regen und Schneematsch, ausgeführt werden will und während unserer Abwesenheit bestimmt – siehe oben – auf dem weißen Sofa liegen wird. Auch die Frage, ob man lieber zum Skilaufen in die Alpen oder zum Bummeln nach Venedig fahren sollte, wird auf der Grundlage von Emotionen gefällt. Wo habe ich die schöneren Erfahrungen gemacht, mit welchem Urlaubsziel verbinde ich die angenehmeren Gefühle? Und vermutlich werde ich für die Anreise doch den Zug nehmen, weil gerade ein Flugzeug meiner bevorzugten Airline abgestürzt ist und ich das durch nichts gerechtfertigte, aber deutlich vorhandene Gefühl habe, gerade diese Flugreise könne besonders unsicher sein. Emotionale Erfahrungen, so wenig rational sie scheinen mögen, sind für die Entscheidungsfindung unverzichtbar! Das bedeutet unter einem adaptiven Gesichtspunkt, dass emotional gesteuerte Reaktionen dazu beitragen, solche Handlungsalternativen auszuwählen, die sich bewährt haben; die also tatsächlich oder vermutlich positive Auswirkungen in Hinsicht sowohl auf unsere Reproduktion als auch auf unser Überleben haben.

Dazu gehört auch, dass Emotionen Aufmerksamkeit hervorrufen und man sich an sie erinnert – eine emotionale Rede oder ein die Emotionen ansprechendes Bild werden mehr Aufmerksamkeit hervorrufen und länger im Gedächtnis haften bleiben als emotional neutrale Vorträge. Wer erinnert sich schon an die im Rahmen eines Vortrags präsentierte Statistik zum desolaten städtischen Haushalt? Das Bild des maroden Kindergartens mit den traurig blickenden Kleinkindern bleibt dagegen dauerhaft im Gedächtnis haften.

Emotionen stärken zwischenmenschliche Bindungen. Gerade bei sozial lebenden Spezies bedeutet der Ausschluss aus der Gruppe oft nicht nur den sozialen, sondern auch den physischen Tod. Menschen und Affen werden sich daher hüten, Verhaltensweisen an den Tag zu legen, die die Gruppenstabilität und damit ihre eigene Existenz gefährden. Verhaltensweisen wie unbegründete Aggressivität, Betrügen oder der Diebstahl von Futter werden daher beim

Übeltäter eine Angst vor Ausschluss aus der Gruppe und damit Gefühle wie Schuld oder Scham hervorrufen. Latente oder positive Schuldgefühle führen letztlich dazu, möglicherweise lustvolle, aber gruppenfeindliche Aktivitäten zu unterlassen.

Wenn Emotionen so wichtig sind, heißt dies aber folgerichtig, dass das Erkennen und Deuten von Emotionen und daraus resultierender Signale und Verhaltensweisen von entscheidender Bedeutung ist. Vor allem der Gesichtsausdruck des Gegenübers – sei es Mensch oder Tier – gibt Auskunft über seinen Gemütszustand, seine Emotionen, und das kann entscheidend für das eigene Überleben sein. Der Ausdruck von Emotionen und ihre Lesbarkeit durch einen Dritten sind also wesentliche Elemente der nonverbalen Kommunikation und damit einer sicheren gegenseitigen Verständigung. Beim Menschen ist diese Fähigkeit so weit ausgebildet, dass bereits Säuglinge und Kleinkinder schon recht gut dazu imstande sind, auf Intentionen ihrer Mitmenschen zu schließen, deren nächste Verhaltensweisen vorauszuahnen und das eigene Verhalten darauf abzustimmen (*theory of mind*, ToM, vgl. Kap. 1; Abb. 2.1).

Aber auch schon bei Primaten ist die Fähigkeit zur Identifikation von Emotionen als Verhaltenssignale in einem bemerkenswerten Ausmaß vorhanden. Humorvolle Aspekte dieser Form des sozialen Miteinanders beschreibt Jane Goodall in Zusammenhang mit dem Versuch sexueller Annäherung zwischen einem Pavianweibchen und einem heranwachsenden Schimpansenmännchen, die beide ihre erwachende Sexualität ausprobieren möchten. Gesten und Gebärden sind in gewisser Weise eindeutig, weil das Ergebnis gemeinsamen Primatenerbes – man weiß, was der andere will! Andererseits sind sie aber durch artspezifisch-kulturelle Überlagerung nicht eindeutig genug und beide potenziellen Sexualpartner müssen ihr Verhalten mehrfach korrigieren, bis der „interkulturelle Liebesakt" klappt.

Entscheidend nicht allein für das Finden des richtigen Sexualpartners, sondern auch für die Versorgung des Nachwuchses ist, die Bedürfnisse des anderen frühzeitig und eindeutig zu erkennen. Dementsprechend kommunizieren nicht nur Tiere, sondern auch die noch sprachlosen Menschenkinder ihre Bedürfnisse und Wünsche nonverbal. Geschrei und vor allem auch ihr Gesichtsausdruck geben dem Betreuer klare Auskunft zur Gemütslage des Nachwuchses. Aber nicht nur hinsichtlich der erfolgreichen Aufzucht der Kleinen ist die nonverbale Kommunikation von emotionalen Befindlichkeiten von Bedeutung, sondern auch bezüglich einer möglichen Reaktion eines erwachsenen Gegenübers: Menschen meiden üblicherweise finster blickende Personen und wenden sich denen zu, die entweder fröhlich wirken oder deutlich machen, dass sie Zuwendung benötigen. Auf diese Weise lässt sich das Verhalten des Gegenübers übrigens auch effektiv beeinflussen: Selbst unter Schimpansen

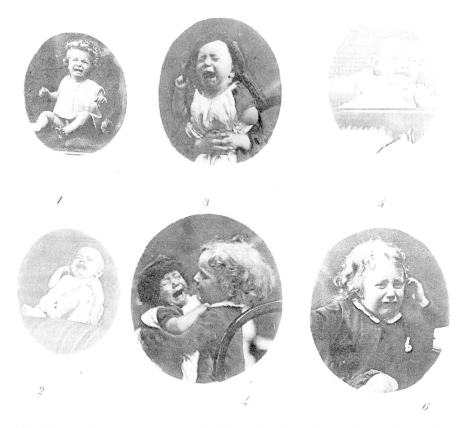

Abb. 2.1 Ausdruck von Trauer und Wut beim Kleinkind. (Aus: © Charles Darwin, *Der Ausdruck der Gemütsbewegungen bei dem Menschen und den Thieren;* 1877)

hat ein freundliches Lächeln oder eine Unterwerfungsgeste eines rangniederen Tieres dieses vor manchem Angriff bewahrt.

Die kulturgenerierende Bedeutung von Angst und Angstbewältigung

Der Gesichtsausdruck, aber auch Gesten und Körperpositionen, zum Beispiel das aggressive Präsentieren der Genitalien zur Abwehr feindlicher Übergriffe (mehr dazu in Kap. 4), haben also eine wichtige Funktion im Zusammenhang mit dem Überleben und einer erfolgreichen Fortpflanzung, insbesondere für die Aufzucht des Nachwuchses und das soziale Miteinander. Dies gilt für alle Säuger, vor allem aber für Primaten, bei denen die Gemütsbewegungen außerordentlich differenziert sind und damit passgenaue Antworten zulassen. Gesten wie das Drohstarren – man sieht das Weiße in den weit aufgerissenen

Augen – und das Präsentieren der Reißzähne sind bekannte Mittel der nonverbalen Kommunikation, werden vom Gegenüber unmittelbar verstanden und rufen automatisch angepasste Reaktionen hervor. Dies gilt für Menschen ebenso wie für unsere Verwandten, die nichtmenschlichen Mitglieder der Familie der Menschenaffen. Im Unterschied zu Schimpansen und Gorillas haben sich diese Symbole nonverbaler Kommunikation beim Menschen jedoch verselbstständigt. Plötzlich, relativ kurz nach Beginn des Jungpaläolithikums (jüngere Altsteinzeit) finden sich in den berühmten Bilderhöhlen Frankreichs Zeichen, die der nonverbalen Kommunikation entnommen sind und offensichtlich dem Schutz vor feindlichen Eindringlingen galten.

Aber bereits ein Menschheitszeitalter zuvor, im Mittelpaläolithikum (mittlere Altsteinzeit, ca. 200.000 bis 40.000 Jahre vor heute), das in Europa vom Erscheinen des Neandertalers geprägt wurde, hatte sich im Vergleich zum Altpaläolithikum etwas geändert: Die Gattung *Homo* war nun in der Lage, Zeichen zum Zweck der Kommunikation zu benutzen, und zwar nicht nur Zeichen als körpereigene Ausdrucksformen, sondern auch Zeichen und Symbole, die nun eigenständig als künstlerische Ausdrucksmittel eingesetzt wurden. Das, was Aby Warburg in der Kunst mit „Psychologie des menschlichen Ausdrucks" bezeichnete, nämlich die Verwendung von Symbolen in künstlerischen Darstellungen und Handlungen, war hiermit geboren. Davor liegen jedoch Jahrtausende der Menschheitsentwicklung, in denen frühe Menschenformen zwar ihre Werkzeuge hinterließen und damit Einblick in ihr Kulturschaffen ermöglicht haben, Spuren symbolischen Denkens und Handelns finden sich aber zunächst einmal nicht.

In diesem Zusammenhang war Aby Warburg einer der ersten, der die enge Verbindung von existenzieller Angst und Furcht vor dem eigenen Sterben mit der Ausbildung von Kultur und Religion nicht nur erkannte, sondern auch detailliert am Beispiel einer indianischen Kultur beschrieb. Warburg betrachtete die Angst im Sinne des Bewusstseins einer Fragilität und Endlichkeit der menschlichen Existenz als den entscheidenden Faktor nicht nur für die Entstehung von Religion, sondern aller kulturellen Leistungen überhaupt – dies als Resümee seiner völkerkundlichen und kunstgeschichtlichen Forschungen, die ihn immer wieder auf die Bedeutung des großen universellen Themas Angst und Angstbewältigung stießen.

Exemplarisch hat Warburg dies in seinem berühmten Vortrag mit dem Titel *Schlangenritual* dargelegt, in dem er die Ergebnisse einer Forschungsreise zu den Puebloindianern Arizonas in den Jahren 1895 bis 1896 verarbeitet hat. Diese Indianer – die Hopi – lebten zur Zeit seiner Reise bereits seit Jahrhunderten auf den kargen Hochplateaus, den Mesas (Abb. 2.2), wo sie trotz des schwierigen, durch extreme Trockenheit geprägten Klimas erfolgreich Ackerbau betrieben und eine ganz eigene Kultur hervorbrachten, in der ihre weltan-

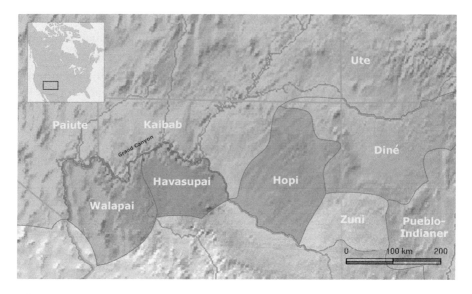

Abb. 2.2 Siedlungsgebiet der Puebloindianer. (© Nikater)

schaulichen Vorstellungen eine große Rolle spielten. Aus dem reichen Schatz an Brauchtum, Ritualen und religiösen Vorstellungen griff Aby Warburg ein Motivpaar heraus, an dem er die Rolle existenzieller Angst in Zusammenhang mit der Mythologie und der praktizierten Religion deutlich machte: Blitz und Schlange.

Die Hopi stellen sich den Kosmos als großes Haus mit treppenförmigem Dach vor. Bildliche Darstellungen zeigen Seitenwände, darüber den treppenförmigen, von zuckenden Blitzen gekrönten Giebel, darunter einen Regenbogen über dichten Wolken, aus denen Regen strömt. Abbildungen dieser kosmologischen Vorstellungen waren bei Warburgs Reise allgegenwärtig. Sie fanden sich an der Wanddekoration im Zimmer seines luxuriösen und damit gar nicht mehr volksnahen Hotels in der Stadt Santa Fé, auf Kinderzeichnungen und sogar auf den Wänden der kleinen katholischen Gotteshäuser, in denen allsonntäglich die Priester versuchten, die alten „heidnischen" Gewohnheiten ihrer indianischen Schäfchen zu verteufeln und auszurotten. Ursprünglich zierten diese Darstellungen des Hopiuniversums die Wände der unterirdischen Andachtsräume, der Kiwas. Hier fand sich auch der Blitzaltar mit der Blitzschlange. Die Schlange war und ist in der Hopikultur wegen ihrer blitzartig zuckenden, letztlich also blitzförmigen Gestalt und Fortbewegungsweise das lebende Symbol für den Blitz, der wiederum Anzeiger für das nahende Gewitter und damit den lebenspendenden Regen ist. An diesem und vergleichbaren Altären vollzogen die Hopi noch zu Warburgs Zeiten ihre Opferhandlungen, um damit das Eintreffen des Regens sicherzustellen.

Aber nicht nur am Altar versuchten die Hopi, das Wettergeschehen zu beeinflussen. Besonders eindrucksvoll war für Warburg das berühmte Schlangenritual, das im Monat August stattfindet, also in der Jahreszeit, in der mit den Regenfällen über die Ernte und damit die Nahrungsgrundlage des gesamten folgenden Jahres entschieden wird. In einer mehrtägigen Zeremonie werden hier die Klapperschlangen zunächst gefangen, dann gebadet und in einer unterirdischen Kiwa bewacht, um beim Höhepunkt der Zeremonie auf ein Sandbild geschleudert zu werden, auf dem wiederum Schlangen die wesentlichen Motive darstellen. Zuletzt werden die Schlangen wieder ergriffen, in einem Tanz herumgetragen und als Boten in die Ebene entlassen. Hintergrund der Handlung ist der Mythos von einem Heros der Hopi, der in grauer Vorzeit eine Reise in die Unterwelt antrat, die ihn zuletzt in die Schlangenkiwa führte, in der das Wetter gemacht wird. Von dort kehrte er mit zwei Schlangenmädchen zurück, die ihm Kinder gebaren – die mythischen Vorfahren der Schlangentänzer und der Schlangen. Im Schlangenritual, so der weltanschauliche Hintergrund, ergreifen die Nachfahren jener Schlangenmädchen ihre Geschwister, die sie mithilfe des Rituals in die mythische unterirdische Kiwa schicken, um dort den Regen zu machen.

Die Zusammenhänge zwischen Ritualhandlung, religiösen Bildern, dem Mythos der Unterweltsreise, der Schlange und dem Wettergeschehen deutet Warburg wie folgt: Das Leben auf den trockenen Hochebenen ist hart. Nahrungsgrundlage und Garant für das Überleben ist der Mais, dessen Gedeihen von den jährlich im Sommer einsetzenden Regenfällen abhängt. Das Ausbleiben der Sommergewitter wäre für die Hopi lebensbedrohend; ein Wissen, das ihre fragile Existenz täglich begleitet. Diese existenziellen Ängste verarbeiten die Hopi kulturell sowohl in ihrer religiös motivierten bildenden Kunst als auch aktiv im Ritual, wobei diese Handlungen ihnen helfen, die existenzielle Bedrohung symbolisch zu fassen und damit eine innerliche Distanz zu gewinnen. Warburg nennt dies den „Denkraum der Besonnenheit".

Dem heutigen Menschen ist unter den modernen Lebensbedingungen oft nicht mehr bewusst, wie zentral existenzielle Ängste, insbesondere die Sorge ums schiere Überleben, noch bis vor wenigen Generationen waren. Bevor die heutige Medizin eine erfolgreiche Bekämpfung vieler Krankheiten möglich gemacht und sich infolge der Verbesserung der hygienischen Bedingungen die Lebenserwartung enorm erhöht hatte, wurden die meisten Menschen oft nur 35 bis 40 Jahre alt. Bis in die Neuzeit hinein war zudem die Kindersterblichkeit allgemein sehr hoch; über die Hälfte der Kinder erreichte das 14. Lebensjahr nicht. Während diese Verhältnisse in den Industrienationen glücklicherweise weitgehend überwunden sind, trifft man in einigen Teilen der Dritten Welt allerdings bis heute auf solche Bedingungen. Für unsere Thematik ist entscheidend, welch enorme Präsenz damit der Tod in früheren Zeiten grund-

sätzlich hatte. Während heute hierzulande die meisten Menschen in höherem Alter in Krankenhäusern oder Pflegeeinrichtungen versterben, war der Tod früher allgegenwärtig. Damit war den Menschen auch die eigene Sterblichkeit sehr viel stärker bewusst und sie mussten sich dementsprechend sehr viel intensiver mit ihren existenziellen Ängsten auseinandersetzen (möglicherweise liegt in dem hier beschriebenen Prozess eine der stärksten Ursachen der Säkularisierung).

Im Hinblick auf grundlegende Voraussetzungen der Religionsentwicklung haben Wissenschaftler unterschiedlichster Disziplinen immer wieder die Notwendigkeit, existenzielle Ängste zu bewältigen, als Motor für die Entstehung von Religion beschrieben. „Von allen Ursprüngen der Religion ist das letzte Grundereignis des Lebens – der Tod – von größter Wichtigkeit", formulierte etwa der polnisch-britische Ethnologe Bronislaw Malinowski (1884–1942). Der amerikanische Philosoph Ernest Becker (1924–1974) sah in der Ausbildung eines Weltbildes die einzige Möglichkeit des Menschen, auf die existenzielle Verunsicherung, die das Bewusstsein seiner eigenen Sterblichkeit in ihm hervorruft, zu reagieren (für sein 1973 auf Englisch veröffentlichtes Buch *Die Überwindung der Todesfurcht* erhielt er 1974 posthum den Pulitzerpreis). Für den österreichisch-amerikanischen Soziologen Thomas Luckmann (*1927) ist der Tod die größte Erfahrung von Transzendenz, die zur gesellschaftlichen Ausbildung von „Weltansichten" führt. Selbst der religionskritische Vater der Psychoanalyse, Sigmund Freud (1856–1939), gestand der Religion zu, dem Menschen angesichts der Gefahren und Wechselfälle des Lebens Schutz und den letztlich guten Ausgang zuzusichern.

Bleibt also die Frage nach dem „Wann"

Warburg ist also mit seiner Folgerung aus kunsthistorischen und völkerkundlichen Studien, in der Angst den entscheidenden Motor der Kulturentwicklung zu sehen, nicht allein geblieben. Wie Warburg zeigen konnte, sind für die Hopi neben der Sprache auch die Bildkunst und das Ritualhandeln wichtige Medien, um sich mitzuteilen und auszudrücken. Mit ihrer Hilfe konkretisierten sie zunächst einmal ihre Ängste und fassten sie in Bilder, machten sie damit also greifbar und letzten Endes auch beherrschbar.

Die Kenntnis der entwicklungspsychologischen Grundlagen ist den Forschungsarbeiten des Entwicklungspsychologen Jean Piaget (1896–1980) zu verdanken. In der kindlichen Entwicklung, insbesondere in der Lebensphase bis zum Schulalter (null bis sechs Jahre) spielen sensomotorische Erfahrungen eine große Rolle bei der Begriffsbildung. Das gemalte Bild und das spiele-

rische Zeremoniell (als kindliches Einüben der Ritualpraxis) resultieren in neuen Erkenntnissen, die anschließend mithilfe der Sprache über einen Prozess der Bewusstmachung und Reflexion zu neuen Begriffen und einem erweiterten Weltbild führen („vom Begreifen zum Begriff"). Zugleich entsteht mit der Benennung eine grundlegende Möglichkeit, zuvor nicht Verfügbares zu kontrollieren, indem Unbekanntes in etwas Bekanntes überführt wird. Das reduziert die Ängste, die mit dem Ungewissen und Nicht-Verfügbaren verbunden sind.

Der Prozess der Ausbildung einer kulturellen Semantik steht in einer gewissen Analogie zu dieser Entwicklung: Viele mythologische Erzählungen spiegeln noch die Bedeutung wider, die der Benennung von Unbekanntem zukommt. So schafft Gott in den biblischen Schöpfungserzählungen Ordnung, indem er das, was er schafft, zugleich auch benennt – Tag, Nacht, Himmel, Land und Meer –, und Adam erzeugt Ordnung, indem er jedem Tier einen Namen gibt. Alte Märchen und Sagen kennen noch das Motiv, dass jemandes Namen zu kennen zugleich Gewalt über ihn einbringt – teils mit tragischen Folgen (Lohengrin), teils mit erlösenden (Rumpelstilzchen). Gerade Wortbedeutungen, aber auch bildkünstlerische Symbole lösen sich im Lauf der Zeit aus ihrem ursprünglichen Kontext und entwickeln sich von der Beschreibung eines konkreten zu der eines abstrakten Inhalts (vgl. Kap. 4). Auch dahinter steht die grundlegende Erfahrung von Kontrollierbarkeit: Über das, was ich malen, schnitzen oder anderweitig gestalten kann, kann ich in einem gewissen Umfang auch verfügen.

Darin liegt ein entscheidender Unterschied zum tierischen Verhaltensrepertoire, in dem abstraktes Denken und die Fähigkeit zur Symbolisierung nicht enthalten sind. So intelligent, so emotional unsere Primatenverwandtschaft auch ist, so deutlich sie bei konkreten Anlässen auch Furcht zeigt und so intensiv sie Gefühle von Trauer beim Verlust eines nahen Angehörigen fühlt – unsere Verwandten sind doch nicht in der Lage, ihre Erlebnisse und Gefühle zu reflektieren oder in Symbole zu fassen. Dies ist, bei aller Intelligenz und Ähnlichkeit, ein Vorrecht der Gattung *Homo*. Daraus resultiert nun die entscheidende Frage – die Frage nach dem „Wann". Ab wann, ab welchem Stadium der Entwicklung, waren die Vorfahren des heutigen Menschen in der Lage, Symbole zu entwickeln und zu verstehen? Wann wurde der „*Homo symbolicus*" geboren?

Unsere blutrünstigen(?) Vorfahren

Diese Frage, die sich letztlich darum dreht, wann unsere Vorfahren tatsächlich menschlich zu handeln und zu denken begannen, treibt Forscher bereits seit Generationen um. Noch der kongeniale Begründer der Evolutionstheorie, Al-

Abb. 2.3 Alfred Russell Wallace. (Aus: © The Darwin-Wallace celebration held on thursday. 1st July, 1908, by the Linnean Society of London)

fred Russell Wallace (1823–1913; Abb. 2.3), glaubte annehmen zu müssen, dass sich zwar die belebte Natur nach den von Darwin und ihm entdeckten Prinzipien der Selektion entwickelt habe, dass der Mensch aber durch einen göttlichen Schöpfungsakt entstanden sei.

Erst die Funde menschlicher Fossilien – die übrigens bereits der vom Theologen zum Atheisten gewandelte Charles Darwin in Afrika vermutet hatte – machten deutlich, dass auch die Entstehung des Menschen nach denselben Gesetzmäßigkeiten abgelaufen sein musste, wie sie generell für die belebte Natur galten. Es ist heute allerdings kaum vorstellbar, welche leidenschaftlichen Kontroversen mit diesen Funden und ihrer Deutung verbunden waren, deren heftigste sich um den Neandertaler drehte. Hier schaltete sich seinerzeit sogar der berühmte Pathologe Rudolf Virchow ein, der klarstellte, dass es sich bei dem gefundenen Skelett lediglich um die Überreste eines heutigen Menschen mit krankhaften Knochenveränderungen handelte und der damit, wie wir heute wissen, einen massiven Fehler beging. Ähnlich heftige Diskussionen entspannen sich um einen weiteren aufsehenerregenden Fund.

1924 hatte man dem südafrikanischen Anatomen und Paläoanthropologen Raymond Arthur Dart (1893–1988) Fossilien aus dem südafrikanischen Steinbruch Buxton in der Nähe von Taung zugestellt, die Dart nach eingehender Untersuchung als Vorläufer des Menschen einordnete und mit dem wissenschaftlichen Namen *Australopithecus africanus* bezeichnete. Um seine

damals noch revolutionäre Argumentation zu stützen, dass es sich bei dem „Kind von Taung" um einen Vormenschen handele, suchte Dart in der Umgebung des Fundes gezielt nach Spuren typisch menschlichen Verhaltens und glaubte, dies anhand von tierischen Knochenfossilien und Bodenschwärzungen im selben Ablagerungshorizont (der Bodenschicht, in der sich die Ablagerungn befinden) nachweisen zu können. Sein Argument war, dass sich der noch unzivilisierte Mensch, so zum Beispiel die ihm bekannten Buschmannkulturen, im Gegensatz zu den nichtmenschlichen Hominiden vorwiegend von der Jagd ernähre. Ließe sich also nachweisen, dass auch der *Australopithecus* gejagt und noch dazu seine Beute am Feuer geröstet habe, könne man seiner Deutung der Knochenfossilien kaum mehr widersprechen.

Es ist eine der Ironien der Wissenschaft, dass Darts systematische Zuordnung des kindlichen Schädels zu einer neuen frühen Menschengattung bis heute Bestand hat. Seine Argumentation, der *Australopithecus* sei ein Jäger gewesen, muss allerdings als widerlegt gelten. Die Häufung der in der Umgebung der menschlichen Fossilien gefundenen tierischen Knochenfossilien war, wie man heute weiß, das Ergebnis sedimentologischer Prozesse, und die dunklen Verfärbungen, in denen Dart die Überreste von Lagerfeuern unserer jagenden Vorfahren gesehen hatte, entpuppten sich als Manganschwärzungen. Trotzdem hatten Darts Vorstellungen von einem jagenden Vorfahren über viele Jahrzehnte Bestand und prägten das Bild vom frühen Menschen: Der *Australopithecus* und die folgenden Bindeglieder zum Jetztmenschen galten zumindest als tüchtige und erfolgreiche Jäger, die, angetrieben von immerwährendem Hunger und Blutdurst, ihrer tierischen und möglicherweise auch menschlichen Beute auf den Fersen waren. Es war dann leicht, diesem Bild weiter Farbe zu verleihen, indem man Vermutungen über das Weltbild dieser „urtümlichen Wilden" anstellte. Da die unmittelbaren Fundstellen in dieser Hinsicht wenig Aufschluss geben konnten, griff man gern in den bunten Fundus der Völkerkunde, stattete unsere Vorfahren mit den interessantesten Eigenschaften aus und dichtete ihnen ein hochkomplexes Weltbild an, in dem Schamanismus und Jagdmagie die harmloseren, Menschenfresserei und Schädelkult die brutaleren Varianten darstellen. So finster *Australopithecus* und Co. in diesen frühen Entwürfen auch erscheinen mögen, so ist ihnen doch eines gemeinsam: Symbolhandlungen und ein komplexes Weltbild, in dem sich Akteure – zum Beispiel das Jagdwild – durch rituelles oder magisches Handeln beeinflussen lassen. Dies setzt allerdings eine bereits hohe Intelligenz voraus, die die Möglichkeiten selbst so intelligenter Tiere wie Schimpansen oder Gorillas bei Weitem überschreitet. Zwar lässt sich die Intelligenz unserer Vorfahren nicht mehr direkt messen, aber immerhin erlauben die Schädelfunde klare Rückschlüsse auf die jeweiligen Gehirngröße und diese wiederum annähernde Hinweise auf die Intelligenz der jeweiligen Spezies. Und

spätestens an dieser Stelle wird deutlich, dass dieser kleine *Australopithecus* mit einem Hirnvolumen von ungefähr 400 cm³ kaum in der Lage gewesen sein dürfte, komplexe Gedanken zu Magie, Zauberei oder jenseitigen Welten zu entwickeln (zum Vergleich: das Gehirnvolumen des modernen Menschen, des *Homo sapiens*, beträgt etwa 1350 cm³).

Der Stammbaum des Menschen

Bereits der Geologe Charles Lyell hatte in seinem Werk *Geological evidences of the antiquity of man* (1863) die Frage nach dem Missing Link, nach der stammesgeschichtlichen Verbindungsform zwischen Mensch und Affe, aufgeworfen und damit eine gezielte Suche nach menschlichen Fossilien ausgelöst. Inzwischen kann die Paläoanthropologie mit einer großen Zahl von Funden aufwarten und die Linie unserer Vorfahren bis ins Miozän (23 bis 5 Mio. Jahre vor heute) zurückverfolgen. Auch wenn heutige Entdeckungen eines frühen Vertreters der Hominini in der Öffentlichkeit nicht mehr zu solch leidenschaftlichen Diskussionen wie zu Darwins und Virchows Zeiten führen, ist den jeweiligen Entdeckern doch immer noch große wissenschaftliche und mediale Aufmerksamkeit sicher, denn was kann interessanter sein als die Frage nach unserem „Woher"?

Das bislang älteste Fossil in unserer Ahnenreihe, der *Sahelanthropus tchadensis* (Abb. 2.4), wurde 2002 im Tschad (Zentralafrika) von einer französischen Forschergruppe um Michel Brunet entdeckt und auf ein Alter von 6 bis 7 Mio. Jahren datiert. Noch im selben Jahr wurde der stammesgeschichtlichen Einordnung des Fundes als bislang älteste Form im menschlichen Stammbaum durch ein amerikanisches Forscherteam widersprochen, das den *S. tchadensis* eher als Vertreter miozäner Homininae und damit als Vorläufer heutiger Schimpansen und Gorillas sehen wollte. In der bis heute kontrovers geführten Diskussion spielen einerseits fortschrittliche, also menschenähnliche Merkmale – besonders der Zähne –, andererseits ursprüngliche Merkmale eine Rolle, die eine letztlich sichere Zuordnung des *S. tchadensis* an die Wurzel des menschlichen Stammbaums zwar wahrscheinlich, aber nicht sicher erscheinen lassen. Wie auch immer zukünftige Forschergenerationen – wenn weitere Funde möglicherweise neue Erkenntnisse gebracht haben – in dieser Frage entscheiden mögen, fest steht, dass der *S. tchadensis* dem Ursprung des menschlichen Stammbaums nahe steht und bereits Eigenschaften zeigt, die für die weitere Entwicklung zum heutigen Menschen entscheidend sein sollten. Wenn man zu diesem Zeitpunkt jedoch bereits auf ein forciertes Gehirnwachstum hofft, wird man enttäuscht: Unser mutmaßlicher Vorfahre hatte

Abb. 2.4 *Sahelanthropus tchadensis.* (© Didier Descouens; Creative Commons Attribution-Share Alike 3.0 Unported license)

mit 320 bis 380 cm^3 Schädelinnenvolumen ein Gehirn von der Größe heutiger Schimpansen, denen er auch in der Körpergröße entsprach.

Nur zwei Jahre zuvor hatte ein französisch-kenianisches Forscherteam in den Tugenbergen (Zentralkenia) mit vereinzelten Zähnen und Knochen von *Orrorin tugenensis* den bis dahin ältesten Vertreter des menschlichen Stammbaums gefunden, der vor 6 Mio. Jahren die Galeriewälder rund um Wasserflächen bevölkerte und vermutlich bereits aufrecht ging. Dagegen wirkte die Skelettkonstruktion des etwa 4,4 Mio. Jahre alten *Ardipithecus ramidus*, gefunden zwischen 1992 und 1994 in der an Menschenfossilien so reichen Awashregion in Äthiopien, noch recht affenähnlich, auch wenn er als der unmittelbare Vorfahre der Australopithecinen (abgeleitet von der Gattung *Australopithecus*) gilt (Abb. 2.5).

Mit den Australopithecinen begann nun eine Zeit forcierter Evolution. Vertreter des *Australopithecus* schlugen unterschiedliche Wege der Anpassung ein und es entstand eine Vielzahl von Arten, die 4 bis 2 Mio. Jahre vor unserer Zeit die afrikanischen Buschwälder und Savannen bevölkerten und dort neben den Vorfahren der heutigen Gorillas und Schimpansen lebten.

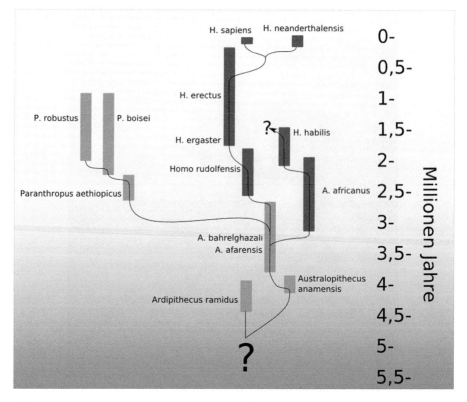

Abb. 2.5 Stammbaumhypothese zur Entwicklung des Menschen unter Berücksichtigung klima- und biogeografischer Überlegungen. Angelehnt an die Interpretation der gegenwärtigen Fundlage durch Friedemann Schrenk. (Aus: © *Die Frühzeit des Menschen. Der Weg zu Homo sapiens.* Verlag C. H. Beck, 1997; mit freundlicher Genehmigung)

Das zuerst entdeckte Exemplar der Gattung *Australopithecus* war eben jenes „Kind von Taung", mit dessen Beschreibung sich Dart plötzlich im Zentrum kontroverser Diskussionen sah. In den folgenden Jahrzehnten folgte eine Reihe weiterer, oft spektakulärer Entdeckungen im Bereich des ostafrikanischen Grabens, darunter der 1959 von Mary Leakey in der tansanischen Olduvaischlucht geborgene Schädel eines *A. boisei* und das zu fast einem Viertel erhaltene Skelett eines weiblichen *A. afarensis*, das 1974 im äthiopischen Hadar vom amerikanischen Paläoanthropologen Donald Johanson entdeckt und unter dem Namen „Lucy" bekannt wurde (Abb. 2.6). Gerade an den beiden letztgenannten Arten zeigt sich eine Schwierigkeit, der sich Paläoanthropologen schon bald ausgesetzt sahen, nachdem die Anzahl der zum *Australopithecus* gestellten Fundexemplare zugenommen hatte und ihre systematische Stellung diskutiert werden musste. Neuere Erkenntnisse machten bald deutlich, dass nicht alle Australopithecinen als Vorfahren der Gattung *Homo* in Be-

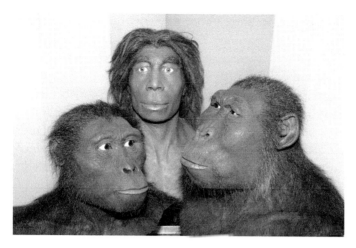

Abb. 2.6 Modellierte Köpfe von Urmenschen im Hessischen Landesmuseum in Darmstadt. Links ein *Australopithecus afarensis* („Lucy"), in der Mitte ein *Homo neanderthalensis* und rechts ein *Australopithecus boisei*. (Wissenschaftliche Rekonstruktionen; © W. Schnaubelt/N. Kieser (Wildlife Art) für das Hessische Landesmuseum Darmstadt/picturealliance/dpa)

tracht kamen, sondern dass die robusten Arten offensichtlich den Weg einer Spezialisierung gegangen waren: Sie hatten auf den weltweiten Klimawandel mit zunehmender Trockenheit durch eine besondere Anpassungsleistung reagiert, die es ihnen ermöglicht hatte, auch harte und hartschalige Nahrung zu nutzen, während die grazile Linie der Australopithecinen auf Vielseitigkeit und möglicherweise höhere Intelligenz setzte. Als Vorfahren des modernen, heute lebenden Menschen (*H. sapiens*) kommen nur Lucys Nachfahren in Betracht, sodass man inzwischen dieser Erkenntnislage Rechnung getragen und die einstmals als „robuste Australopithecinen" bezeichneten Vertreter einer eigenen Gattung, *Paranthropus*, zugeordnet hat (Abb. 2.5).

Noch am Fuß des menschlichen Stammbaums stehend, hatten die Australopithecinen mit einem Volumen von 400 bis 550 cm^3 ein nur unwesentlich größeres Gehirn als heutige Schimpansen, denen sie im Übrigen auch hinsichtlich ihrer Körpergröße zwischen 1,00 und 1,60 m noch recht nahestanden. Auch in Sachen Fortbewegung hat man offensichtlich gern auf Bewährtes zurückgegriffen und sich in den Galeriewäldern oft noch auf den Bäumen aufgehalten; nur gelegentlich probte man das aufrechte Gehen auf dem Boden. Werkzeugnutzung oder gar Werkzeugherstellung konnten für die Australopithecinen nicht nachgewiesen werden, ganz zu schweigen von irgendwelchen Hinweisen auf die Verwendung von Symbolen.

Ebenso verhielt es sich möglicherweise mit dem Nachfahren des *A. africanus*, dem *Homo rudolfensis* (2,4 bis 1,8 Mio. Jahre vor heute), dem ersten Vertreter unserer eigenen Gattung, der 1972 von einer Forschergruppe

um Richard Leakey bei Koobi Fora in Kenia gefunden wurde. Endgültige Klarheit über die systematische Zuordnung des Fossils ergaben jedoch erst weitere Funde, unter anderem auch ein von dem deutschen Paläoanthropologen Friedemann Schrenk 1991 in Malawi gefundener Unterkiefer. Dieser machte klar, dass sich die dem *H. rudolfensis* zugeschriebenen Fossilien vor allem hinsichtlich der fehlenden Augenwülste und der Stellung des Unterkiefers so deutlich von den Australopithecinen und dem etwa zur selben Zeit lebenden *H. habilis* unterschieden, dass sie zu Recht in eine eigene Gattung gestellt wurden. Unter dem *H. rudolfensis* haben wir uns einen Vorfahren vorzustellen, der sicherlich vorwiegend aufrecht ging, um 1,50 m groß war, etwa 45 bis 50 kg wog und möglicherweise bereits Werkzeuge benutzte, die in zeitgleichen oder doch nur wenig jüngeren Schichten am Turkanasee in Kenia gefunden wurden. Auch für den *H. rudolfensis* bestätigten sich Darts Vermutungen hinsichtlich des erfolgreichen Jägers nicht: Unser Urahn ernährte sich vorwiegend vegetarisch.

Nur der Vollständigkeit halber sei hier *Homo habilis* erwähnt, der noch vor wenigen Jahren von Paläoanthropologen in die ursprüngliche Abstammungslinie des Menschen gestellt wurde. Der *H. habilis*, der vor 2,1 bis 1,5 Mio. Jahren die ostafrikanischen Galeriewälder bewohnte, wurde ebenfalls 1959 von Mitgliedern des Forscherteams um Louis Leakey entdeckt und beschrieben. Vor allem Ritzungen an Knochen der Begleitfauna, die als Schnittspuren gedeutet wurden, führten zu dem Schluss, dass sich *H. habilis* bereits teilweise von Fleisch ernährt habe. Ursprüngliche Vermutungen, dass der *H. habilis* ein direkter Vorfahre des *H. ergaster* und damit des Menschen sei, sind inzwischen widerlegt.

Um einen direkten Vorfahren dürfte es sich jedoch bei dem als „Turkana Boy" bekannt gewordenen Fund aus dem kenianischen Koobi Fora handeln, der zunächst auf ein Alter von 1,6 Mio. Jahre datiert und zum *H. erectus* gestellt worden war. Heute wird der Turkana Boy zu *H. ergaster* gestellt, eine Art, die sich durch ein relativ großes Gehirnvolumen von 700 bis 900 cm^3 auszeichnet und deren Skelett bereits für ein ausdauerndes Laufen auf zwei Beinen geeignet war. Möglicherweise hat diese Art schon Werkzeuge – aus der sogenannten Oldovankultur – benutzt und ihre Nahrung durch Fleisch ergänzt, wobei man auch hier nicht dem Irrtum verfallen sollte, der *H. ergaster* sei ein tapferer Jäger gewesen. Wahrscheinlicher ist auch hier, dass unser Vorfahre wie die anfangs beschriebenen Schimpansen erfolgreichen Jägern die Beute streitig gemacht und sich mit den Steinwerkzeugen Fleischfetzen aus dem Kadaver geschnitten hat: Unsere Vorfahren waren vermutlich nichts anderes als Kleptoparasiten!

Mit dem *H. erectus* hat dann zum ersten Mal ein Vertreter der Gattung *Homo* den afrikanischen Kontinent verlassen und in einem Siegeszug ohne-

gleichen die alte Welt erobert. Diese Leistung wurde unter anderem auch durch die inzwischen deutlich größere Intelligenz und damit Anpassungsfähigkeit dieser Spezies möglich, deren Abgrenzung zum *H. habilis* und *H. ergaster* übrigens noch diskutiert wird. Offensichtliche Werkzeugnutzung, die Verwendung von Feuer und ein deutlich „menschenähnlicheres" Aussehen haben über den Kreis der Paläoanthropologen hinaus fasziniert – auch, weil diese Spezies als der unmittelbare Ahne sowohl des *H. neanderthalensis* als auch des *H. sapiens*, unserer eigenen Spezies, gilt.

Noch im 19. Jahrhundert fanden erste Grabungen im südlichen Asien statt, wo der deutsche Biologe und begeisterte Darwinanhänger Ernst Haeckel (1834–1919) die Wiege der Menschheit vermutet hatte. Und tatsächlich gelang es dem niederländischen Anthropologen und Militärarzt Eugène Dubois (1858–1940) im Jahre 1891, auf der indonesischen Insel Java erste Überreste eines menschenähnlichen Fossils zu finden, das nach diversen Namensänderungen heute der Spezies *H. erectus* zugeordnet wird und ihren Holotyp darstellt.

Holotypen, Syntypen, Neotypen

Als Holotyp oder Holotypus wird in der Biologie und der Paläontologie ein Exemplar eines Taxons bezeichnet, das der Erstbeschreibung zugrunde liegt (im Fall des H. erectus auf Artebene). Jedes einzelne Merkmal, das in der Erstbeschreibung zu finden ist, bezieht sich folglich auf dieses vorliegende Individuum, welches auch Typusexemplar genannt wird. Anhand des Holotyps können nun Abgrenzungen zu anderen Individuen derselben Art, sprich Variationen, oder aber auch zu anderen Arten vorgenommen werden.

Nach Veröffentlichung der Erstbeschreibung ist der in ihr beschriebene wissenschaftliche Name des Typs allein gültig. Für jede Art gibt es einen Holotyp. Dennoch gibt es Ausnahmen, zum Beispiel wenn ganze Sammlungsreihen angelegt wurden. In einem solchen Fall nennt man die jeweiligen Exemplare Syntypen. Geht ein Holotyp verloren oder wird zerstört, so wird ein neues Exemplar zum Typ bestimmt, der sich dann Neotyp nennt.

Weitere Funde folgten in den ersten Jahrzehnten des 20. Jahrhunderts. Darunter ist auch der Pekingmensch, der 1921 zunächst von Otto Zdansky und Mitarbeitern, nach ersten Veröffentlichungen und einer großzügigen Zuwendung von der Rockefellerstiftung ab 1927 bis 1937 dann von Davidson Black, Pei Wenzhong und Jia Lanpo in der Höhle von Zhoukoudian bei Peking ausgegraben wurde. Vor allem der fragmentierte Zustand der insgesamt 14 Schädel bzw. Schädelfragmente, 14 Unterkiefer, mehr als 150 Zähne und zahlreicher Skelettreste regte die Fantasie von Wissenschaftlern und Laien gleichermaßen an und führte zu der Vermutung, es hier mit den Überresten kannibalischer Mahlzeiten und Belegen für einen frühen Schädelkult zu tun

zu haben. Tatsache ist dagegen, dass die aus verschiedenen Schichten und von etwa 40 Individuen stammenden Fossilien ein Alter von 400.000 bis 770.000 Jahren haben, die Individuen Werkzeuge vom Oldovantyp benutzten und über ein Schädelvolumen von bis zu 1059 cm³ und mehr verfügten, das sind zwei Drittel des Schädelvolumens des heutigen Menschen. Weitere Merkmale, unter anderem des Skelettes – konkret eines fast vollständig erhaltenen Beckens eines weiblichen *H. erectus* aus Äthiopien, das deutlich macht, dass der *H. erectus* mit einem Gehirnvolumen von 32 bis 36 % eines Erwachsenengehirns geboren wurde (Mensch 28 %; Schimpanse 40 %) –, geben Hinweise auf die intellektuellen Fähigkeiten des *H. erectus*. Dies bedeutet, dass die Phase der Kindheit beim *H. erectus* zwar noch deutlich kürzer als beim *H. sapiens*, aber schon deutlich länger als bei *Australopithecus* gewesen sein muss, und das lässt wiederum Rückschlüsse darauf zu, dass starre ererbte Verhaltensmuster zugunsten eines neuen, im jeweiligen kulturellen Kontext zu erlernenden Verhaltens zurücktraten. Anders ausgedrückt: Der *H. erectus* war bereits ungewöhnlich lernfähig und diese Fähigkeit ermöglichte ihm, neue Lebensräume erfolgreich zu erobern, neue Kontinente zu besiedeln, sich an unterschiedliche klimatische Verhältnisse erfolgreich anzupassen und dementsprechend auch neue Ernährungsstrategien zu entwickeln. Es wundert daher nicht, dass der *H. erectus* schon bald fortschrittliches Steinwerkzeug vom Acheuléentyp herstellte, die Faustkeile, deren Herstellung kompliziert ist und darauf schließen lässt, dass entsprechende Techniken von Generation zu Generation weitergegeben wurden. Endgültige Klarheit über die Ernährungsweise des *H. erectus* brachte jedoch ein sensationeller Fund bei Schöningen (Niedersachsen), wo in einem Braukohletagebau Holzspeere wie auch ein beidseitig zugespitztes Wurfholz geborgen werden konnten, die sich auf ein Alter von 400.000 Jahren datieren und damit dem *H. erectus* (bzw. dem *H. heidelbergensis*, dem Bindeglied zwischen *H. erectus* und *H. neanderthalensis*) zuordnen ließen. Nicht nur die Waffen selbst, sondern auch die damit vergesellschafteten Überreste von mehr als 15 Wildpferden belegen eindrucksvoll, dass der *H. erectus* zumindest seit diesem Zeitpunkt ein erfolgreicher Großwildjäger war – einschließlich der damit verbundenen intellektuellen und sozialen Fähigkeiten, derer es bedarf, um Jagdstrategien zu entwickeln und miteinander abzustimmen.

Der *H. erectus* war demnach nicht nur intelligent, und zwar sicherlich deutlich intelligenter als heutige Schimpansen und Gorillas, sondern zeigte auch Eigenschaften und Verhaltensweisen, die menschentypisch sind und sich bei unseren nächsten Verwandten nicht finden lassen. Dazu gehören die systematische Nutzung von Feuer zur Nahrungszubereitung sowie die Herstellung effektiver und komplizierter Waffen, deren Herstellungstechnik sorgfältig tradiert wurde. Der *H. erectus* lebte als Jäger und Sammler – ihm ein für

Wildbeuter typisches Weltbild zu unterstellen, wäre demnach nicht abwegig. Mögliche Hinweise auf symbolträchtige Handlungen haben sich jedoch nicht nachweisen lassen. Zwar hat es immer wieder Behauptungen – einschließlich entsprechender Veröffentlichungen (dazu später mehr) – gegeben, die den Zustand der Fossilien auf kannibalische oder rituelle Praktiken zurückführen wollten, letztlich aber ließ sich keine dieser Vermutungen verifizieren, im Gegenteil. Kratzer, die man als Spuren von Steinwerkzeugen gedeutet hatte, entpuppten sich als Hyänenverbiss, als Schliff durch Transport im Geröll oder Sediment oder gar als das Resultat nachlässiger Ausgrabungsmethoden. Auch Belege für ein Kunstschaffen im Sinne des Warburg'schen Symbolhandelns ließen sich für diese frühe Menschenspezies bisher nicht nachweisen, obwohl inzwischen auch in Europa eine ganze Reihe früher Rastplätze und Siedlungen gründlich untersucht worden sind.

Der entscheidende Schritt zum „*H. symbolicus*" wurde daher ganz offensichtlich von *H. erectus* noch nicht getan.

3

My cave is my castle – Neandertaler, Territorialität und Tod

Die Menschenfressergeschichte

Es gibt wohl kaum eine Spezies der Gattung *Homo*, deren Bild in der öffentlichen Meinung so stark von Sensationslust geprägt ist wie das des Neandertalers. Meist erscheint er als tumber Rohling und nur gelegentlich lässt sich ein Forscher dazu hinreißen, unserem Verwandten zarte Gefühle zuzuschreiben. Noch vor wenigen Jahren – im Anschluss an einen Vortrag über den angeblichen Kannibalismus bei Neandertalern auf einem paläontologischen Symposium – wurden wir von einer seriösen englischsprachigen Zeitschrift um ein Interview zu diesem Thema gebeten. Als wir aber deutlich gemacht hatten, dass keine der neueren Untersuchungen die These vom Neandertalerkannibalismus stützte, nahm man von dem Interview Abstand. Damit hatten die Journalisten eine absolute Fehlentscheidung getroffen, denn ebenso aufregend wie Geschichten vorzeitlicher Menschenfresser sind die abstrusen Umstände, die zu diesem perfiden Rufmord an den Neandertalern geführt haben.

Nicht unwesentlich für diese Entwicklung ist der Zeitpunkt der Entdeckung des ersten Neandertalers im Jahre 1857, zwei Jahre bevor mit Darwins *On the origin of species* die Frage des Artenwandels in den Blickwinkel der Öffentlichkeit rückte. Entdeckt wurde das namengebende Neandertalerskelett in der Kleinen Feldhofer Grotte im Neandertal bei Düsseldorf im Zuge von Steinbrucharbeiten (Abb. 3.1).

Glücklicherweise gelangte der Fund in die Hände des Wuppertaler Lehrers und Naturforschers Johann Carl Fuhlrott, der dessen Bedeutung sofort erkannte und zusammen mit dem Bonner Anatomieprofessor Hermann Schaaffhausen das Ergebnis ihrer anatomischen Studien auf der Generalversammlung des Naturhistorischen Vereins der preußischen Rheinlande und Westfalens vorstellte (Abb. 3.2). Sie beschrieben den Neandertaler ganz richtig als frühen Bewohner Europas, der hier noch vor den Kelten und Germanen gelebt habe. Unabhängig davon, dass diese evolutionistische Sichtweise noch vor Darwins entscheidender Veröffentlichung die gelehrte Welt zunächst überforderte, prägten Fuhlrott und Schaaffhausen das Bild vom Neandertaler für mehr als 100 Jahre. Um das zeittypische und aus heutiger Sicht abenteu-

Abb. 3.1 Die Neanderhöhle 1835. (Aus: © J. H. Bongard, *Wanderungen zur Neander-höhle*, 1835.)

Abb. 3.2 Rekonstruktion des Neandertalers nach der Erstbeschreibung von H. Schaaffhausen. (Aus: © H. Schaaffhausen, *Der Neandertaler Fund*, 1888)

erlich verzerrte Bild zu verstehen, muss man sich vor Augen halten, dass es zu Fuhlrotts und Schaaffhausens Zeiten keinerlei Literatur über die Stammesgeschichte des Menschen gab – weder *On the origin of species* noch *The descent of man* waren geschrieben worden. Allerdings hatten geniale Biologen wie Carl von Linné (1707–1778) oder Georges Cuvier (1769–1832) bereits eine damals revolutionäre Systematik auf der Basis der Morphologie sowie der Anatomie entwickelt. Außerdem hatten französische Wissenschaftler wie Étienne Geoffroy Saint-Hilaire (1772–1844) und Jean Baptiste de Lamarck das Thema Artenwandel bereits in eine breitere Öffentlichkeit getragen. Die Einstufung seines Fundes als „vorsintflutlicher Mensch" war für Fuhlrott da-

her eine logische Folge der biologischen Erkenntnisse seiner Zeit, denn er und Schaaffhausen zeigten sich in einer Weise informiert und auf der Höhe eines revolutionären biologischen Wissensstandes, die offensichtlich etliche ihrer Zeitgenossen überforderten.

In diesem Zusammenhang half den Autoren ihr biologisches Wissen zwar bei der systematischen Einordnung des Fundes, es konnte aber bei damaligem Kenntnisstand dem Bild vom Vormenschen, von seinen Lebensgewohnheiten und seinem Umfeld kaum Farbe verleihen. Zur weiteren Deutung griffen Fuhlrott und Schaaffhausen daher auf anerkannte Quellen zurück: die geisteswissenschaftliche Literatur ihrer Zeit, in der die Altphilologie und die Theologie das wissenschaftliche Paradigma absteckten. Gerade hatte eine moderne Naturwissenschaft mit so großen Geistern wie dem Paläontologen Georges Cuvier oder dem Geologen Charles Lyell (1797–1875) die Sintflutgeschichte verifizieren können: Ablagerungen im Pariser Becken hatten deutlich gemacht, dass Teile Europas in der Vorzeit überschwemmt gewesen sein mussten (geologisch hieß dieses Zeitalter Diluvium). Und dass zu diesen sagenhaften Zeiten unheimliche Gestalten vor allem die nördlichen Gefilde bewohnt haben mussten, belegten die Schriften des klassischen Altertums, die voll waren von Geschichten wilder, menschenfressender Barbaren. Damit waren Charakter und geistige Fähigkeiten des Neandertalers ein für alle Mal umrissen und kommenden Forschergenerationen blieb nur noch, ihre Entdeckungen in das Bild eines blutrünstigen Wilden einzufügen.

Übrigens dauerte es noch mehr als ein Jahrzehnt, bis der Neandertaler als vorzeitlicher Mensch anerkannt war. Eine unrühmliche Rolle spielte in dieser Hinsicht der bahnbrechende Pathologe Rudolf Ludwig Karl Virchow (1821–1902), der sich als erklärter Gegner der Evolutionstheorie illegal Zugang zu Fuhlrotts Material verschafft und dieses als Überreste eines krankhaft deformierten, modernen Menschen gedeutet hatte.

Der Mensch – Krone der Schöpfung?

Das vielleicht größte Hindernis auf dem Weg zur Anerkennung des *H. neanderthalensis* als frühe Menschenart war die noch fest verwurzelte und von der Kirche vehement verteidigte Vorstellung, der Mensch sei als Krone der Schöpfung von Gott geschaffen. Die Möglichkeit, dass der Mensch affenartige Vorfahren gehabt haben könnte, erregte die Gemüter derartig, dass es bei einer Diskussion über Darwins Evolutionstheorie zwischen seinem Anhänger Thomas Henry Huxley und dem anglikanischen Bischof Wilberforce zu gegenseitigen persönlichen Beleidigungen kam und die Sitzung in einem allgemeinen Tumult endete.

Bereits 1832 waren Knochenfunde aus Belgien als Fossilien eines „diluvialen Menschen" gedeutet worden, wenige Jahre später folgte ein recht gut erhaltener Schädel auf Gibraltar und 1864 erhielt der Neandertaler von dem Geologen William King seinen wissenschaftlichen Namen, *Homo neanderthalensis*. Aber erst, nachdem 1886 in einer Höhle im belgischen Spy zwei fast vollständig erhaltene Neandertalerskelette gefunden worden waren, konnte sich die Idee von der Existenz einer zweiten – frühen! – Menschenart im allgemeinen Bewusstsein durchsetzen.

Homo neanderthalensis – eine anthropologische Standortbestimmung

Inzwischen, nach eineinhalb Jahrhunderten anthropologischer Forschung und einer Vielzahl von Skelettfunden, hat sich das Bild vom Neandertaler entscheidend gewandelt. Anthropologen gehen heute davon aus, dass sich der „klassische" Neandertaler aus zierlicheren Vorläufern, aus Formen um den *H. heidelbergensis*, entwickelt hat, die sich wiederum auf den *H. erectus* zurückführen lassen.

Zu den ältesten in Europa geborgenen Vorläufern des Neandertalers, von einigen Forschern als Ante-Neandertaler bezeichnet, zählen der Schädelfund von Steinheim an der Murr (der Vertreter der Gattung *Homo* wird auch als *H. steinheimensis* bezeichnet), Funde von Swanscombe in England, Petralona in Griechenland und Vértesszöllös in Ungarn, alle 200.000 bis 400.000 Jahre alt. Funde des frühen Neandertalers – 90.000 bis 200.000 Jahre alt – stammen aus Krapina in Kroatien, dem deutschen Weimar-Ehringsdorf, Saccopastore in Italien, Forbes Quarry auf Gibraltar und Altamura in Italien. Der „klassische" Neandertaler, der Europa vor 90.000 bis 30.000 Jahren besiedelte, ist inzwischen mit zahlreichen Funden, darunter aus dem namensgebenden Neandertal, aus Salzgitter-Lebenstedt in Deutschland, aus Engis und Spy in Belgien, vom Monte Circeo in Italien, von Gibraltar, aus Usbekistan, aus Kurdistan und Israel sowie von zahlreichen Grabungsstätten in Frankreich bekannt, die vor allem in Zusammenhang mit der Diskussion um Neandertalerbestattungen von Bedeutung sind.

Nach ersten Überlegungen, dass sich neben dem Neandertaler auch der moderne Mensch (*H. sapiens*) aus frühen europäischen Formen vom Typ *H. steinheimensis* entwickelt haben könnte, ist man heute der begründeten Ansicht, dass die Entwicklung des Menschen in Europa einen Sonderweg eingeschlagen hat, der den extremen Bedingungen der Eiszeiten Rechnung trug. Der Neandertaler war mit seiner gedrungenen Körperform, seinen dick-

wandigen Knochen und großen Körperkraft, ja sogar mit seinem überdurch-
schnittlich großen Gehirn an das Leben in extremer Kälte perfekt angepasst.

Neandertalerintelligenz – ein Spiegel der Forschungsgeschichte

Nach seinem unglücklichen Start konnte der Neandertaler sein Image als keu-
lenschwingender Rohling nur mühsam ablegen. Hinderlich auf dem Weg zu
einer nüchternen Bestandsaufnahme waren das jeweilige Wissenschaftspara-
digma der Zeit sowie die weltanschaulichen und politischen Auffassungen der
Ausgräber, die zumindest in der Frühzeit der anthropologischen Forschung
keine Fachwissenschaftler, sondern mehr oder weniger gelehrte und begeis-
terte Laien waren. Sie betrieben auf der Suche nach einem bahnbrechenden
Fund eine Art Schatzsuche, beachteten dabei die Vergesellschaftung ihres
Fundes kaum und dokumentierten die Ausgrabungen nur ungenau oder gar
nicht. Aber auch die emotional geführten Kontroversen um Darwins Evo-
lutionstheorie und eine damit fälschlicherweise verknüpfte Vorstellung von
einer aufsteigenden menschlichen Kulturentwicklung belasteten die vor-
urteilsfreie Erforschung des Neandertalers, den man damals als Vorfahren des
heutigen Menschen ansah (Abb. 3.3). Während Anhänger einer materialis-
tisch-evolutionistischen Auffassung den Neandertaler einer frühen und damit
notwendigerweise religionslosen Kulturstufe zuordnen wollten, glaubte eine
Gruppe von französischen Forschern um die studierten Theologen und daher
als „Abbés" titulierten Amédée und Jean Bouyssonie sowie Henri Breuil, Be-
lege für intentionelle Bestattungen bei Neandertalern und damit Indizien für
frühe Religiosität beibringen zu können.

 Mehr als zwei Forschergenerationen später hatte sich die Diskussion um
die Menschlichkeit des Neandertalers kaum verändert. Es waren antikoloniale
Bewegungen in den 1970er-Jahren, in deren Folge der Neandertaler mensch-
lichere Züge gewann. Unter anderem hatten gerade wieder phylogenetische
Überlegungen zur Stellung des Neandertalers im menschlichen Stammbaum
dazu geführt, ihn als potenziellen Vorfahren des europäischen *H. sapiens* zu
werten und ihn damit als nicht allzu verschieden vom modernen Menschen
einzustufen. Regelrechte Begräbnisse mit angeblich nachgewiesenen Beiga-
ben wie Blumen im Grab von Shanidar (Irak) schienen zu bestätigen, dass
sich das Fühlen und Denken des Neandertalers kaum von dem des Jetztmen-
schen unterschied. Dann allerdings machten wenige Jahre später Ergebnisse
molekularer DNA-Analysen deutlich, dass der Neandertaler doch als eigene
Menschenart betrachtet werden muss, der wieder artspezifische psychosoziale,

Abb. 3.3 Karikatur von Darwin. Diese bekannte Karikatur erschien am 22. März 1871 im Magazin *The Hornet* und trug den Titel „A venerable Orang-Outang. A contribution to unnatural history"

also primitive, Eigenschaften zuzugestehen waren. Heute dagegen ist man der Überzeugung, dass es im Verbreitungsgebiet des Neandertalers durchaus zum sogenannten *interbreeding*, das heißt der Kreuzung von Neandertalern und *H. sapiens*, gekommen sein muss und Kreuzungen generell im menschlichen Stammbaum eine nicht zu unterschätzende Rolle gespielt haben (Abb. 3.4).

Wie stark diese Diskussionen auch eine vorurteilsfreie Untersuchung von Neandertalerfundplätzen behindert haben, zeigt das Beispiel der Vogelherdhöhle auf der Schwäbischen Alb, in der man 1931 erste Fossilien entdeckte. Neben Fossilien des Neandertalers und des modernen Menschen (*H. sapiens*) fand man dort steinzeitliches Werkzeug und Kunstgegenstände, darunter eine Knochenflöte, die man selbstverständlich mit dem modernen Menschen in Verbindung brachte. Erst eine neue Altersbestimmung, die die Skelettreste des modernen Menschen auf ein Alter von etwa 4000 Jahren datieren, Werkzeuge und Neandertaler jedoch auf 30.000 Jahre vor heute, ließ berechtigte Zweifel an der Auffassung aufkommen, das Auftreten von Kunst in Europa sei an das Erscheinen des modernen Menschen gekoppelt.

Ähnlich wie das Kunstschaffen wurde auch die Frage der Sprachfähigkeit des Neandertalers kontrovers diskutiert: Zwar verfügte er nachweislich über hochpotente Waffen, mit deren Hilfe er erfolgreich Jagd auf Großwild machen konnte – auch in größeren Gruppen, deren Aktionen koordiniert werden mussten. Seine Kleidung war genäht, und zwar so, dass sie ihm in

Abb. 3.4 Der Neandertaler. (Rekonstruktion des Neanderthalmuseums Mettmann; © picture alliance/B. Boensch, Arco Images GmbH.)

den eisigen Wintern während der Eiszeit ausreichend Schutz vor der Witterung bot. Er bereitete seine Nahrung auf dem Feuer zu, schmückte sich mit Ketten und bemalte seinen Körper und: Er tradierte und kommunizierte alle diese Fähigkeiten. Und trotz dieser Belege für ein reiches Kulturschaffen und eine hohe Intelligenz sprachen ihm Wissenschaftler die Fähigkeit zur verbalen Kommunikation rundweg ab. Erst als Forscher im Jahre 1983 in der Kebarahöhle in Israel den etwa 60.000 Jahre alten, gut erhaltenen Skelettrest eines Neandertalers fanden, musste man auch diesbezüglich umdenken. Neben Brust, Wirbelsäule, Armen und Händen fand sich ein Zungenbein, eine knöcherne Struktur, an der eben jene Bänder und Muskeln ansetzen, die der Zunge ihre zum Sprechen notwendige Beweglichkeit verleihen.

Alle Indizien sprechen demnach dafür, dass sich der Neandertaler hinsichtlich seiner intellektuellen Fähigkeiten, seines Fühlens und Denkens nicht vom *Homo sapiens* und damit vom heutigen Menschen unterschied – bis auf eines: Er lebte deutlich früher. Dieser Umstand ist allerdings so wesentlich, dass er an dieser Stelle ausführlich erörtert zu werden verdient. Im Lauf der Evolution des Menschen erforderte der häufige und rasche Klimawechsel verstärkte Anpassungsleistungen. Dies war in Afrika im Zuge der geoklimatischen Ereignisse die zunehmende Trockenheit, die zur Ausbildung der unterschiedlichen *Australopithecus*-Arten und ihrer Nachfahren führte, wobei die grazilen Vertreter der Unterfamilie der Australopithecinae nicht auf einen angepassten

Kauapparat, sondern auf höhere Vielseitigkeit und Intelligenz setzten (vgl. Kap. 2). In Europa diktierte dann die rasche Abfolge von extremen Kalt- und Warmzeiten die Richtung der Anpassung. Eine sich ständig verändernde naturräumliche Umgebung führte dazu, dass starre Verhaltensmuster zunehmend abgebaut und durch ein Verhalten ersetzt wurden, das im jeweiligen kulturellen Kontext von jedem Individuum erlernt wurde. Anders ausgedrückt: An die Stelle des über den langsamen biologischen Weg vererbten Instinktverhaltens trat nach und nach im sozialen Kontext erlerntes und damit rasch korrigierbares Verhalten, das die schnelle Anpassung des Menschen an sich verändernde naturräumliche Gegebenheiten ermöglichte. Der Mensch wurde intelligent. Lernen im kulturellen Kontext wurde die Grundlage seines Erfolgs, und dabei spielte die Sprache eine wesentliche Rolle. In diesem Zusammenhang ist jedoch zu berücksichtigen, dass letztlich die Summe der kulturell vermittelten menschlichen Erfahrungen zur Zeit des Neandertalers, also im Mittelpaläolithikum, das Niveau der späteren Generationen noch nicht erreicht bzw. andere Schwerpunkte hatte. Man stand gewissermaßen dem Anfang menschlichen Kulturschaffens noch recht nahe, auch wenn entscheidende Erfindungen bereits gemacht und sich grundlegende Traditionen bereits etabliert hatten.

Dazu gehörte das Wissen um die Nutzung des Feuers, um intelligente und raffinierte Jagdtechniken, um Zelt- und Hausbau und um Werkzeugherstellung. Es ist hochkompliziert, aus Feuersteinknollen die scharfen und effektiven Faustkeile herzustellen, die als das typische Neandertalerwerkzeug und charakteristisch für ihre Kulturstufe, das Moustérien, gelten. Und es ist eine bahnbrechende Erfindung, ein solches Werkzeug an der Spitze eines Schaftes zu befestigen, um das so hergestellte Gerät dann als Steinbeil oder Lanze zu nutzen. Diese Fertigkeiten, die hohe Intelligenz und großes handwerkliches Geschick voraussetzen, müssen von Generation zu Generation weitergegeben worden sein – in Sozialverbänden, in denen man sich nachweislich um Kranke sorgte, sie pflegte, und in denen man auch dauerhaft Behinderte, die sicher nicht selbst jagen konnten, nicht im Stich ließ. Zur Intelligenz, zur Fähigkeit des Kulturschaffens, kamen also offensichtlich soziale Kompetenz und Eigenschaften wie Mitmenschlichkeit und Fürsorge. Wenn also zu Beginn dieses Buches die Fragen „Ab wann waren unsere Vorfahren fähig zu symbolischem Denken?" und „Wann wurde Religion möglich?" gestellt wurden, dann ist die Antwort eindeutig: Spätestens mit dem Mittelpaläolithikum hatte der frühe Mensch alle Fähigkeiten, die die Voraussetzungen für symbolisches Denken und Handeln sind, er konnte jedoch zunächst noch nicht auf entsprechende Überlieferungen und Traditionen zurückgreifen. Wie der Faustkeil musste auch Religion zunächst einmal „erfunden" werden, und hier haben unsere kulturellen Vorfahren Erstaunliches geleistet.

Zeittafel: Kulturepochen der Altsteinzeit

Altpaläolithikum	2,5 Mio. bis 200.000 Jahre vor heute
Afrika	
Oldowan	2,5 bis 1 Mio. Jahre vor heute
Acheuléen	1,6 Mio. bis 200.000 Jahre vor heute
Europa	
Protoacheuléen	1,2 Mio. bis 500.000 Jahre vor heute
Acheuléen	600.000 bis 100.000 Jahre vor heute
Mittelpaläolithikum	
Moustérien	200.000 bis 40.000 Jahre vor heute
Jungpaläolithikum	40.000 bis 12.000 Jahre vor heute
Aurignacien	40.000 bis 28.000 Jahre vor heute
Gravettien	28.000 bis 22.000 Jahre vor heute
Solutréen	21.000 bis 18.000 Jahre vor heute
Magdalénien	18.000 bis 12.000 Jahre vor heute

Angebliche Kulthandlungen des Neandertalers

Bevor allerdings die tatsächlichen geistigen und schöpferischen Leistungen des Neandertalers gewürdigt werden können, gilt es, auch hier Vorurteile zu beseitigen, die mit der Entdeckungsgeschichte einschließlich der zeitgenössischen Diskussion um die Evolutionstheorie und einer vermuteten gesetzmäßigen Kulturentwicklung eng verknüpft sind.

Es entsprach nämlich ganz dem allgemeinen Zeitgeist, dass man Funde von Fossilien eiszeitlicher Höhlenbären mit dem Neandertaler in Verbindung brachte, als zu Beginn des 20. Jahrhunderts der Amateurarchäologe Emil Bächler in den Alpen eine Höhle entdeckte, in der er auf reiche Lager fossiler Bärenknochen stieß. Mehrere miteinander vergesellschaftete Bärenschädel wiesen offensichtlich nicht nur dieselbe Orientierung an ihrem Fundort auf, sondern schienen darüber hinaus in einer Art Steinkiste deponiert worden zu sein. Damit war die These vom Bärenknochenkult geboren und schien sich auch in den folgenden Jahren immer wieder zu bestätigen. Erst heute machen neuere Untersuchungen und sorgfältige Grabungsmethoden deutlich, dass die Ansammlung von Bärenknochen auf sedimentologische Prozesse – den Transport durch Höhlengewässer – zurückzuführen ist, während Ritzungen und Lochungen an den Fossilien die Resultate der Aktivitäten hungriger Hy-

änen sind, die zur Zeit des Neandertalers zusammen mit Höhlenbär, Höhlenlöwe und anderen, heute ausgestorbenen Spezies die Fauna bereicherten.

Auch ein angeblicher Schädelkult ist immer wieder behauptet worden, so zum Beispiel im Zusammenhang mit Grabungen bei Weimar-Ehringsdorf in den Jahren 1908 bis 1925. Indiz für diese Behauptung waren angebliche Hiebmarken an den geborgenen Schädeln. Inzwischen hat eine Nachuntersuchung ergeben, dass sowohl die damaligen Ausgrabungstechniken, die Dokumentation der Funde, die Präparation und die Auswertung auch der postcranialen (nicht zum Schädel gehörigen) Skelettteile sehr zu wünschen übrig ließen. Dementsprechend ergab die Neubearbeitung der Skelettfunde ebenso wenig Hinweise auf eine ehemalige Schädeldeponierung wie bei weiteren zeitgleich ausgegrabenen Funden von Neandertalern und ihren Vorfahren. Auch die angeblich eindeutigen Indizien für einen Schädelkult in der Grotte Guattari am Monte Circeo in Italien erwiesen sich letztlich als nicht haltbar. Hier hatten ursprünglich Arbeiter in einer der hinteren Höhlenkammern einen auf der Seite liegenden Neandertalerschädel inmitten eines Steinkranzes gefunden. Der Schädel wies im Schläfenbereich eine Verletzung auf, die man für die Todesursache des Individuums hielt. Beschädigungen an der Schädelbasis deutete man als künstliche Erweiterung des Hinterhauptsloches. Bis heute gilt der Schädelfund aus der Grotte Guattari als unzweifelhafter Beleg für gruseliges kultisches Handeln des Neandertalers und damit als typisch für seine noch krude und barbarische Religiosität. Allerdings zeigte auch hier die Neubearbeitung des Fundes, dass stereotype Vorstellungen vom Neandertaler zunächst zu einem typischen Fehlurteil geführt hatten, denn im Gegensatz zu früheren Annahmen sind auch hier die Verletzung der Schläfenregion sowie der posterioren Schädelgrube durch Raubtierverbiss, vermutlich durch Hyänen, entstanden.

Der wissenschaftsgeschichtliche Hintergrund, der dem Neandertaler Höhlenbären- oder Schädelkulte unterstellte, ist auch verantwortlich für den angeblichen Nachweis weiterer obskurer religiöser Praktiken, die das geistige Leben des Neandertalers bestimmt haben sollen. Rund 30 Jahre nach der Erstbeschreibung durch Fuhlrott und Schaaffhausen schienen sich die damaligen Vermutungen über die kannibalische Lebensweise des Neandertalers zu bestätigen, als der Paläontologe Dragutin Gorjanović-Kramberger (1856–1936) im Jahre 1899 im kroatischen Krapina eine systematische Großgrabung durchführte, die zur Entdeckung eines regelrechten Knochenlagers des Neandertalers führte. Trotz der bahnbrechenden Leistungen des in Deutschland ausgebildeten Paläontologen, der unter anderem die neue Röntgentechnik für die Bearbeitung der Funde nutzte, konnte auch er sich von dem ursprünglich gezeichneten Bild des Neandertalers nicht lösen. Für Gorjanović-Kram-

berger waren der Zustand der menschlichen Fossilien und die Fossildichte die entscheidenden Indizien, die dafür sprachen, dass er auf die Opfer eines Jagdzuges auf Artgenossen gestoßen war. Inzwischen ist jedoch bekannt, dass die in Krapina geborgenen Neandertaler nicht gemeinsam einem Überfall oder auch nur einem Unglück zum Opfer gefallen waren, sondern dass ihre Gebeine nach und nach über viele Jahrtausende zusammen mit Höhlensedimenten eingelagert wurden, die zwischen 80.000 und 130.000 Jahre alt sind. Erschwerend für jede Diagnose kommt hinzu, dass die Ausgräber damals mit Dynamit arbeiteten, der fraktionierte Zustand der Knochenüberreste also kaum ein Indiz für die Todesursache darstellt. Letztlich akkumulierten die Toten von Krapina also ebenso wie die „verdächtigen" Bärenschädel im Verlauf natürlicher Sedimentationsprozesse in der Höhle, wo sie bis zur Entdeckung durch eifrige Paläoanthropologen ihre vorläufig letzte Ruhestätte fanden.

Damit könnte das Thema Kannibalismus beim Neandertaler vom Tisch sein, wenn es nicht auch in neuerer Zeit Entdeckungen gegeben hätte, die entsprechenden Spekulationen neue Nahrung verliehen haben. Dazu gehörte in jüngerer Zeit die als Sensation gefeierte Veröffentlichung eines französisch-amerikanischen Anthropologenteams um Alban Defleur und Tim White, die an 100.000 bis 120.000 Jahre alten Neandertalerfossilien aus Moula-Guercy in der Ardèche eindeutige Schnittmarken festgestellt hatten. Da in denselben Schichten auch die Überreste von erlegtem Wild gefunden wurden, konnte sich die Population hier also nicht in einer akuten Notsituation befunden haben, die zum Kannibalismus geführt hatte – also anders als bei dem noch nicht einmal sehr weit zurückliegenden, tragischen Flugzeugabsturz eines chilenischen Rugbyteams in den Anden im Jahr 1972. Es wundert daher nicht, dass Wissenschaftler der Frage nach den Ursachen der Ritzungen an Neandertalerknochen nachgingen und sich in diesem Zusammenhang auch der alten Funde noch einmal annahmen. Und tatsächlich stellte sich heraus, dass einige der vorhandenen Kratzer vor allem an den Schädeln nur so erklärt werden können, dass hier mit Steinwerkzeugen manipuliert und möglicherweise die Kopfhaut entfernt wurde – das gilt für einen Schädel aus Krapina ebenso wie für den Holotyp des Neandertalers, den Mann aus der Kleinen Feldhofer Grotte im Neandertal, aber auch für Befunde am modernen Menschen (*H. sapiens*), die in ein sehr viel jüngeres Zeitalter gehören. So zeigt neolithische Bandkeramik Bestattungen, die deutlich machen, dass noch sehr viel später, etwa um 5000 v. Chr., Tote entfleischt und ihre Überreste dann erst bestattet wurden. Damit erschienen die Manipulationen an Neandertalerknochen – meist an Schädeln – in einem ganz neuen Licht. Nicht mehr blutrünstige Menschenjagden sollten für die archäologischen Spuren verantwortlich sein, sondern eine Sitte, wie sie bei vielen noch ursprünglich lebenden Völkern bis heute verbreitet ist: die Sekundärbestattung.

Abb. 3.5 Tau-Tau, die Ahnenfiguren der Toraja. (© Karl Ulrich Petry; mit freundlicher Genehmigung)

Sekundärbestattungen bei ursprünglich lebenden Völkern

Eine solche Sekundärbestattung auf der indonesischen Insel Sulawesi, zu der wir vor Jahren einmal als Gäste geladen waren, haben wir an anderer Stelle sinngemäß wie folgt beschrieben:

> Für die Toraja, jenes Volk im Hochland Sulawesis, dessen Gäste wir sein durften, ist der physische Tod nicht das Ende der individuellen Existenz. Der Tote wird daher zunächst in einen Sarg gebettet, der im Hause aufbewahrt wird. Dort wird er weiterhin wie ein allerdings in seiner Handlungsfähigkeit eingeschränktes Familienmitglied behandelt; das heißt man teilt ihm die neuesten Nachrichten aus dem Dorfleben mit und vergisst auch nicht, etwas von den täglichen Speisen für ihn bereitzustellen. Erst nach Ablauf mindestens eines Jahres werden die Überreste dann endgültig im Rahmen einer aufwendigen Feier beigesetzt. In der Zwischenzeit wurde eine Statue mit den Zügen des Verstorbenen angefertigt, in der seine Bildseele nach der endgültigen Beisetzung Platz nehmen kann. (Abb. 3.5)

Dieser zweite Teil der Bestattung, bei der der Verstorbene rituell in die Totenwelt eingegliedert werden soll, wird mit großem Aufwand gefeiert. Es wird ein Festplatz mit Galerien für die Zuschauer errichtet, Speisen und Unmengen von Palmwein werden gezapft, zahllose, wunderbar fette Hängebauchschweine müssen für die Gästebewirtung ihr Leben lassen, und zuletzt wird eine Anzahl von Wasserbüffeln rituell geschlachtet – ihre mit dem Blut vergossene Lebenskraft soll die Lebenskraft des Verstorbenen ersetzen und ihm so ein Weiterleben in der Totenwelt ermöglichen. (Wunn 2002)

Bereits dieser knappe Aufriss eines Totenbrauchtums, wie es in unterschiedlicher Ausprägung vom indonesischen Archipel über die Salomoninseln bis ins nördliche Asien verbreitet ist, macht eines deutlich: Hier handelt es sich um komplizierte Rituale, die mit ausgefeilten Jenseitsvorstellungen verknüpft sind und die man sich nicht einmal unter größten Mühen am Anfang einer Religionsentwicklung vorstellen kann. Zur Erinnerung: Auch religiöse Vorstellungen gehören mit zur kulturellen Überlieferung, müssen also tradiert worden sein und sich irgendwann einmal aus solchen einfachsten Formen entwickelt haben, die innerhalb der natürlichen Vorstellungswelt des Neandertalers lagen. Die auch unter Wissenschaftlern weit verbreitete Sitte, sich bei unerklärlichen Fundsituationen nach Belieben aus dem bunten Garten der Völkerkunde zu bedienen, ist im Fall des Neandertalers auch insofern hinfällig, weil die komplexen Bestattungsrituale, die zwingend mit Sekundärbestattungen verknüpft sind, nur für frühe Ackerbauern, also sesshafte Völker, nicht aber für Wildbeuter bekannt und sinnvoll sind (dazu später mehr). Eine Erklärung für die Bearbeitung der Schädel ist daher nicht im Umfeld von Sekundärbestattungen zu finden, wohl aber generell in Zusammenhang mit Bestattungen.

Bestattungen bei den Neandertalern

Inzwischen dürfte kaum noch überraschen, dass nicht nur Fragen bezüglich des Schädelkultes, der Bärenopfer und des Kannibalismus im Zusammenhang mit dem Neandertaler, seiner Kultur und seinem Weltbild kontrovers diskutiert wurden. Auch die Frage, ob er bereits seine Toten bestattete, faszinierte seit Beginn der Neandertalerforschung und spaltete die wissenschaftliche Gemeinschaft. Vor allem in Frankreich konnten Forscher wie die Abbés Amédée und Jean Boyssonie, Denis Peyrony oder Louis Capitan – allesamt keine Fachleute im eigentlichen Sinne, sondern Laien und erklärte Liebhaber der Urgeschichte – zu Beginn des 20. Jahrhunderts eine Reihe von angeb-

lichen Neandertalerbegräbnissen freilegen. Diese heizten die Spekulationen um dessen Weltanschauung weiter an, vor allem, da die Lage der Skelette und die Vergesellschaftung der Funde mit Werkzeugen oder Überresten der damaligen Fauna weitreichende Schlussfolgerungen über komplexe Jenseitsvorstellungen befeuerten. Aus heutiger Sicht sind auch diese Ausgrabungen, wie viele der frühen Neandertalerfunde, schlecht dokumentiert, sodass eine Überarbeitung nur selten zu klaren Ergebnissen kommt. Grabstätten sind unter diesen alten Befunden kaum eindeutig zu identifizieren; in einigen Fällen weisen lediglich Indizien auf eine absichtliche Deponierung des Toten. So ist für La Ferrassie in Frankreich die intentionelle Bestattung von mehreren Individuen wahrscheinlich, Hinweise auf besondere Totenriten oder Bestattungspraktiken gibt es jedoch entgegen den ursprünglichen Behauptungen nicht. Auch von Grabbeigaben kann nicht die Rede sein, denn keines der gefundenen Artefakte lässt sich eindeutig einer Bestattung zuordnen; vielmehr stammen alle aus dem an Fundstücken reichen Einbettungshorizont, also nicht dem Grab selbst, sondern dem Umfeld, in dem der Neandertaler auch lebte und seine Lebensspuren hinterließ. Ähnlich stellt sich die Situation in La Chapelle-aux-Saints dar. In Le Moustier, wo sich 1908 das Skelett eines etwa 15-jährigen Neandertalers und sechs Jahre später die Überreste eines noch jüngeren Kindes fanden, lassen ungenaue Beschreibungen nur den Schluss zu, dass es sich vermutlich um Bestattungen gehandelt hat. Auch der erste in Deutschland geborgene Neandertaler wurde wohl bestattet oder der Tote zumindest bewusst deponiert. Die Überreste dieses etwa 60-jährigen Mannes sind in der Folgezeit wiederholt untersucht worden. Interessant im Zusammenhang mit der Frage möglicher Bestattungspraktiken sind die oben erwähnten Schnittspuren im Stirn- und Hinterkopfbereich, die für Manipulationen am Toten sprechen.

Weniger obskur, aber kaum weniger sensationell war es, als der amerikanische Paläoanthropologe Ralph Solecki in den 1960er-Jahren im irakischen Shanidar ein Neandertalergrab fand. Eine ungewöhnlich hohe Konzentration von Blütenpollen im Grab legte den Schluss nahe, der Verstorbene sei nicht nur bestattet, sondern ihm seien auch Blumen mit ins Grab gegeben worden. Seit bekannt geworden ist, dass die persische Rennmaus, deren Knochen man gleichfalls in der Grabstätte gefunden hat, diese Blüten vermutlich Jahrtausende später zum Auspolstern ihrer Nester eingeschleppt hatte, sind jedoch auch an dieser Deutung Zweifel aufgetreten.

Letztlich kann man bei einer sorgfältigen Sichtung der fraglichen Veröffentlichungen wohl davon ausgehen, dass der Neandertaler (und der zeitgleich existierende moderne Mensch, der *H. sapiens*) seine Toten bestattete, und das vermutlich sogar häufiger, als die geringe Zahl der eindeutig nachgewiesenen

Neandertalerbegräbnisse angibt. Es ist mit einer beträchtlichen Anzahl inzwischen zerstörter Höhlenbegräbnisse zu rechnen, ebenso mit Bestattungen im Freiland, von denen nicht einmal mehr Spuren zurückgeblieben sind. Doch gibt es selbst bei idealen Fundverhältnissen und sorgfältiger Bearbeitung keinerlei Hinweise auf irgendwelche mit den Bestattungen verknüpften Rituale, Kulthandlungen oder auch nur Totenbrauchtum. Neandertaler kannten offensichtlich keinerlei Sitten, die über das Deponieren des Toten oder seine Beisetzung in einer flachen Grube hinausgingen.

Dennoch scheint das Bild eines lediglich leichenentsorgenden, mittelpaläolithischen Individuums zu kurz zu greifen. Wenn es nur um Fragen der Hygiene oder Sicherheit geht, reicht es aus, den Toten aus dem unmittelbaren Umfeld zu entfernen, wie es bei manchen heute noch ursprünglich lebenden Völkern üblich ist. Hyänen und Wölfe werden die Kadaver dann sofort beseitigen. Wenn man sich die Mühe gemacht hat, Gruben auszuheben oder vorhandene Vertiefungen zu nutzen, den Toten abzudecken und so seine materiellen Überreste vor der Zerstörung durch Räuber und Aasfresser zu schützen, spricht dies für deutlich weiterreichende Vorstellungen und Absichten.

Angst vor Auslöschung?

Naheliegend wäre unter diesen Umständen die Frage, ob die Neandertaler ihre Toten möglicherweise davor bewahren wollten, in Vergessenheit zu geraten. Wenn man sich aufgrund der durch Erde geschützten körperlichen Überreste noch einige Generationen lang an einen Verstorbenen erinnern konnte, überdauerte ein Teil von ihm also für eine gewisse Zeitspanne lang den Tod. Das könnte eine erste, rudimentäre Idee von partieller Unsterblichkeit vermittelt haben. Dies wiederum bedeutet für die Hinterbliebenen einen gewissen Trost, weil der Abschied von dem Verstorbenen dadurch etwas von seiner Endgültigkeit verliert. Zwar sind wir damit noch weit von ausgefeilten Vorstellungen eines Jenseits entfernt, denn solche Überzeugungen setzen bereits eine Idee vom Leben nach dem Tod voraus. Die Vorstellung, dass der physische Tod nicht identisch mit dem Ende der Existenz sein muss, ist jedoch eine große Hilfe bei der Bewältigung der schlimmsten mit dem Tod verknüpften Befürchtung, nämlich der Angst vor vollständiger Auslöschung.

Aus psychologischer Perspektive lassen sich verschiedene Dimensionen der Angst vor Sterben und Tod unterscheiden. Da sind einerseits Ängste, die sich auf den Prozess des Sterbens, damit verbundene Schmerzen oder Verlassenheit beziehen. Andererseits gibt es Ängste, die mit dem Tod selbst verbunden sind, so die Angst vor dem Ungewissen, vor dem, was danach kommt (z. B.

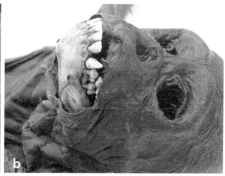

Abb. 3.6 Eine Schimpansenmutter trägt ihr totes, mumifiziertes Kind mit sich herum. (Foto © Dora Biro. Aus: Biro et al. (2010), Chimpanzee mothers at Bossou, Guinea carry the mummified remains of their dead infants. *Current Biology*, 20, R351-R352, Elsevier; mit freundlicher Genehmigung)

vor einem göttlichen Gericht), vor Toten (Nekrophobie) und eben auch die Angst vor der völligen Auslöschung. Dabei ist die Angst vor der Auslöschung relativ basal, weil sie noch nicht die Vorstellung von einem Weiterleben nach dem Tod voraussetzt. Sie stellt eine Form von Furcht dar, die als Überlebensinstinkt bereits bei Tieren besteht und beim Neandertaler erstmalig ins Bewusstsein gedrungen sein dürfte. Auch Reaktionen von Trauer um den Verlust eines Artgenossen lassen sich bereits bei manchen höheren Tieren feststellen, zum Beispiel bei Hunden, Elefanten und insbesondere den nahen Verwandten des Menschen, den übrigen Vertretern der Hominidae. Vor wenigen Jahren erregten unter Primatenforschern verschiedene Fotos und Filme Aufsehen, die Trauerreaktionen und Versuche der Trauerbewältigung bei Schimpansen eindrucksvoll illustrierten. So wurde in Guinea eine Schimpansenmutter dabei beobachtet, wie sie den von der Sonne bereits weitgehend mumifizierten Körper ihres verstorbenen Kindes weiter mit sich herumtrug, Fliegen von ihm verscheuchte und ihn für die Nacht mit in ihr Nest nahm, wo sie ihn eng an sich drückte (Abb. 3.6). Auch andere Mitglieder der Schimpansengruppe suchten weiterhin den Körperkontakt zu dem verstorbenen Jungtier.

Trauerreaktionen gehören demnach bereits zum Primatenerbe. Verbunden mit einem höher entwickelten Bewusstsein und einer steigenden Selbstreflexion dürften sie beim Neandertaler erstmals zu einem frühen Nachdenken über den Tod geführt haben. Die größere kognitive und emotionale Komplexität der Neandertaler im Vergleich zu ihren Vorläufern hat dann womöglich nicht nur zu Bemühungen geführt, die Erinnerung an einen Verstorbenen lebendig zu halten, sondern irgendwann auch zu dem Bedürfnis, sich eine Weiterexistenz des Toten, in welcher Form auch immer, vorzustellen.

Ein ganz neuer Aspekt: Territorialität

Bleibt nun die Frage nach dem Sinn der Manipulationen an den Schädeln, die sich weder in den Kontext eines profanen oder rituellen Kannibalismus noch der Sekundärbestattungen sinnvoll einfügen lässt. Und doch müssen diese Schädelpräparationen einen Sinn gehabt haben, denn zu oft wiederholen sich in der Literatur entsprechende Hinweise und zu gleichmäßig sind die Befunde über das Verbreitungsgebiet des Neandertalers verteilt, um die zufälligen Produkte einiger irregeleiteter Individuen zu sein.

Hier kommt die Verhaltensbiologie ins Spiel – konkret deren Erkenntnisse zum Territorialverhalten, das für viele Tierarten und letztlich auch den Menschen charakteristisch ist. So kämpfen bereits Gallenblattläuse um Territorien, wenn es darum geht, den besten Platz für die Eiablage zu finden. Die Siegerin beansprucht dann auf dem umkämpften großen Blatt den Platz mit der besten Nährstoffversorgung direkt am Stielansatz, während sich das unterlegene Insekt mit einem uninteressanten, kleineren Blatt mit eventuell geringerer Nährstoffzufuhr zufriedengeben muss. Die Sicherung eines Territoriums dient hier also der Chancenoptimierung bei der Aufzucht des eigenen Nachwuchses. Gleiches gilt für viele Vogelarten, die vor allem während der Brutzeit territorial sind, so der Schwarzstorch, der durch aggressives Klappern, Flügeltanz oder akrobatische Flugkunststücke mögliche Konkurrenten aus seinem Revier vertreibt. Auch der so hübsche kleine Eisvogel mit seinem blau schillernden Gefieder kann rabiat werden, wenn es um die Verteidigung seines Territoriums geht. Er droht zunächst mit angelegtem Gefieder und geöffnetem Schnabel, kann das Ganze aber auch bis zu regelrechten Drohduellen steigern, bei denen sich die Konkurrenten hoch aufgerichtet mit ausgenbreiteten Schwingen gegenübersitzen, und im extremsten Fall kommt es zum Kampf. Zuletzt sucht der Unterlegene das Weite, während der Sieger zurückbleibt. Auch hier geht es um Ressourcen, denn nur ein genügend großes Areal oder ein ausreichend langer, fischreicher Bachabschnitt garantieren die erfolgreiche Aufzucht der nächsten Schwarzstorch- oder Eisvogelgeneration. Die genannten und weitere Beispiele zeigen, dass die Sieger im Wettbewerb um ideale Brut- und Wohngebiete in den Genuss entscheidender Reproduktionsvorteile kommen – ein Grund, warum einmal besetzte Reviere energisch gegen Eindringlinge verteidigt werden. Hier haben Beobachtungen gezeigt, dass erstaunlicherweise fast immer der bisherige Reviereigentümer siegt, entweder, weil er größer ist bzw. dank seines Revierbesitzes über mehr Energiereserven verfügt, oder aber, weil er mehr zu verlieren hat, als der Eindringling gewinnen kann. Letztere Erkenntnis nennt man auch die Payoffasymmetrie, ein Ergebnis der Spieltheorie.

Aber nicht nur Insekten und Vögel, auch unsere nahen Primatenverwandten, zum Beispiel die zu den Altweltaffen gehörende Brazzameerkatze (*Cercopithecus neglectus*), die in Afrika von Nordost-Angola über Kamerun, Äquatorialguinea und Gabun bis nach Uganda, Kenia und Südwest-Äthiopien verbreitet ist, zeigt ein ausgeprägtes Territorialverhalten. Brazzameerkatzen leben in lichten Laubwäldern, im tropischen Regenwald, in Akazien- und Galeriewäldern in kleinen Gruppen von bis zu zehn Tieren, die ihre Besitzansprüche an ihr bis zu zehn Hektar großes Territorium mit unterschiedlichen Mitteln kommunizieren. Zu diesen Mitteln gehört das Markieren ihrer Umgebung mit Sekret aus einer Brustdrüse. Besitzansprüche werden jedoch auch mit Lauten und visuellen Signalen mitgeteilt, wie einem lautstarken Gebrüll, dem Starren als Drohgebärde sowie dem „Gähnen" erwachsener Männchen, wobei die Eckzähne gezeigt werden. Das Zurückziehen der Lippen und Zeigen der Zähne, ein Grinsen oder Lächeln, dienen dagegen der Beschwichtigung. Territorialität wird jedoch auch verbal kommuniziert: Ein tiefes Brummen macht auf die Verletzung einer Reviergrenze aufmerksam, vor allem, wenn fremde Männchen versuchen, in das Revier einzudringen.

Ausgeprägte Territorialität, die sich bis zu mörderischen Kriegszügen steigern kann, hat Jane Goodall auch von „ihren" Bonobos im Gombe-Stream-Nationalpark berichtet. Hier kontrollieren Gruppen von umherschweifenden Männchen die Grenzen des Reviers, das sie im Notfall energisch verteidigen. Bei ihren Streifzügen zerstören sie Schlafnester von Tieren aus anderen Gruppen, wobei sie Droh- und Imponiergesten zeigen. Das gleiche Verhalten zeigen sie, wenn sie auf fremde Nachbarn treffen. Dann stoßen sie laute Rufe aus, schütteln Zweige, trommeln auf Baumstämmen und werfen Steine nach den Eindringlingen. Diese sind gut beraten, sich rasch zurückzuziehen, wenn sie nicht Opfer eines gewalttätigen Angriffs werden wollen. Wird bei solchen Attacken ein Junges von seiner Mutter getrennt, droht ihm ein grausiges Schicksal: Es wird getötet und gefressen.

Bei aller Territorialität sind die Grenzen von Territorien jedoch nicht unbedingt fest. Die Verhaltensbiologie beschreibt einen sogenannten Schimpfbereich, in dem bevorzugt Drohverhalten gegen den Nachbarn gezeigt und der von den verteidigenden Tieren möglichst nicht verlassen wird. Dieses etablierte Schimpfverhalten dient dazu, die Stärke des Gegners und die zu erwartende Gegenwehr abzuschätzen, mit dem Resultat, dass die möglicherweise stärkere Gruppe langfristig ihr Revier auf Kosten der schwächeren Gruppe ausdehnt.

Nicht nur unsere Primatenverwandten, auch wir selbst sind territorial, wie ein rascher Blick auf unsere Alltagskultur zeigt: Die schlimmsten Fehden entstehen zwischen Nachbarn, wenn sie das Gefühl haben, ihre Grundstücksgrenze werde nicht respektiert; sei es, dass fremdes Laub auf den eigenen Rasen

Abb. 3.7 Territorialität und Hierarchie (Ranking) beim Parkplatz eines Golfclubs in Niedersachsen. Vermeintlich Ranghöhere (Präsident, Vorstand, Sekretär) beanspruchen ihren persönlichen Parkplatz – obwohl genügend Parkraum vorhanden ist!

fällt, die eigene Einfahrt dem Nachbarn als Wendeplatz dient oder Nachbars Waldi auf der Suche nach Wühlmäusen das geliebte Blumenbeet durchpflügt oder dort gar seine Notdurft verrichtet (Abb. 3.7).

Und auch wir Menschen kennen, analog zum Gebrüll der Affen, eine mit akustischen Mitteln ausgetragene Auseinandersetzung um Reviergrenzen. Ein Mitglied des Autorenteams erinnert sich da an mit großer Ausdauer ausgetragene Schlachten – Maria Callas contra Punkrock (Sieger: die Callas). In diesem Zusammenhang mag gleichfalls interessant erscheinen, dass akustische Reviermarkierungen auch in ernsten Fällen eingesetzt werden, so bei der Abwehr somalischer Piraten vor der ostafrikanischen Küste. Hier ist es westliche Popmusik, die potenzielle Aggressoren in die Flucht schlägt. Nach dem Gesagten überrascht es nicht, wenn Ethnologen aggressives Territorialverhalten auch bei Jäger- und Sammlervölkern festgestellt haben; dies übrigens entgegen älteren Auffassungen, die noch durch Rousseaus Idee vom edlen Wilden geprägt waren, nach der Wildbeutergruppen die ausgedehnten Landstriche friedlich bevölkern, gemeinsam die natürlichen Ressourcen schonend nutzen und auf mögliche Interessenkonflikte mit Ausweichen reagieren.

Die tatsächlichen Verhältnisse sind – leider – anders und dokumentieren auch hier die nur allzu menschliche Bereitschaft, Konflikte mit Gewalt auszutragen. Eine in den frühen 1970er-Jahren, in der großen Zeit der friedliebenden Flower-Power-Bewegung, durchgeführte Untersuchung von 99 Lokalgruppen von Wildbeutern aus 37 Kulturen zeigte, dass sich zwei Drittel aller Gruppen aktuell im Krieg befanden, weitere ihre Kriegszüge erst kürzlich

unter dem Druck einer Zentralregierung eingestellt hatten und keine auf eine völlig friedliche Vergangenheit zurückblicken konnte. Selbst die grönländischen Inuit, die in einem extrem dünn besiedelten Teil unserer Welt leben, begeben sich in Lebensgefahr, wenn sie in das Jagdrevier eines Gruppenfremden geraten, und auch die als friedlich bekannten Pygmäen beanspruchen Waldreviere als Jagdbezirke, deren Grenzen sie respektiert wissen wollen. Selbst die Buschleute der Kalahari verteidigen ein von ihren Vorfahren geerbtes Sippengebiet, vor allem die Bereiche, in denen die für sie so wichtige Feldkost, wild wachsende Nahrungspflanzen, gedeiht. Die Abgrenzung gegen konkurrierende Gruppen benachbarter Reviere geht so weit, dass man sich selbst als „rein" und „perfekt", die anderen aber als „gefährlich" und „mörderisch" beschreibt. Wollen oder müssen Angehörige einer fremden Gruppe kurzzeitig ihr Lager aufschlagen, müssen sie formal um Erlaubnis fragen.

Territorialität bei unseren Vorfahren

Wenn also unsere nahen Affenverwandten territorial sind und um Reviergrenzen kämpfen, wenn unsere eigene Spezies von der Kalahari bis zu Nachbars Gartenzaun Reviergrenzen verteidigt, kurz, wenn Territorialität ein wesentlicher Teil des Primatenerbes ist, ist es naheliegend, das gleiche Verhalten auch für Menschen des Paläolithikums anzunehmen. Neandertaler waren Wildbeuter, die erfolgreiche Jagdzüge durchführten. Ein großes Revier, das sie bei ihren Streifzügen durchwanderten, sicherte ihnen und ihren Familien ausreichend Nahrung sowie geeignete Siedlungs- und Rastplätze unter Felsvorsprüngen oder in Höhleneingängen. Auch die Ausbreitung des Menschen von seiner ursprünglichen Heimat Afrika in das unwirtliche, eisige (in den Eiszeiten) oder nasse (in den Warmzeiten) Europa dürfte maßgeblich durch territorialen Druck entstanden sein, der umherschweifende Gruppen zwang, sich am äußersten Rand des bisherigen Verbreitungsgebietes immer wieder neuen Lebensraum in Form von Jagd- und Sammelrevieren zu erschließen. War ein solches Revier erst einmal von einer Sippe besetzt, wurden die Eigentumsverhältnisse eindeutig kommuniziert und dokumentiert. Nicht alle damit verbundenen Verhaltensweisen lassen sich heute rekonstruieren. Sollten kleine Gruppen von Neandertalern an ihren Reviergrenzen patrouilliert haben, lässt sich das heute kaum noch feststellen. Auch über Drohgesten und eventuelle Schmählieder wissen wir nichts. Wir wissen jedoch um einen eindrucksvollen Brauch, mit dem die Neandertaler sehr deutlich machten, dass sie ein Revier beanspruchten, und zwar legitimerweise: Sie bestatteten ihre Toten und/oder deponierten zur Bekräftigung deren Schädel, wie dies besonders eindrücklich an den Bestattungen von La Ferrassie (Frankreich) ab-

zulesen ist. Hier fand man in einer Grotte acht Tumuli, also Grabhügel, wobei unter einem ein Kleinkind begraben worden war. Unmittelbar benachbart, unter einem Abri (Felsüberhang), wurden die Überreste eines etwa dreijährigen Kindes entdeckt, dessen Schädel man abgetrennt und unter einer Steinplatte deponiert hatte.

Gerade das Demonstrative dieser Handlungen, das Aufschütten von Tumuli und das Abtrennen und Deponieren eines Schädels, machen deutlich, dass es hier um mehr als nur Pietät oder gar das Entsorgen eines Leichnams ging. Auch in Teshik-Tash in Usbekistan weist ein Neandertalergrab eindeutig auf eine bewusste Deponierung hin, und die Höhle von Skhul im Karmelgebirge (Israel) muss über einen längeren Zeitraum immer wieder sowohl als Begräbnisplatz als auch als Aufenthaltsort genutzt worden sein. Nicht zuletzt dokumentieren die offensichtlich bearbeiteten Schädel aus dem Neandertal und aus Krapina, dass der Neandertaler bzw. der gleichzeitig existierende moderne Mensch, der *H. sapiens*, seine Toten zu bestatten und gelegentlich ihre Schädel sichtbar zu deponieren pflegte – und das an Stellen, die er auch immer wieder als Wohnplatz nutzte.

Diese demonstrativen Handlungen erscheinen dann sinnvoll, wenn man sie mit dem Verhalten heutiger oder historischer Wildbeutervölker vergleicht. So haben Untersuchungen des Anthropologen Roy Rappaport bei den Eipo und Tsembaga Neuguineas gezeigt, dass diese Völker ihr Territorium durch den Anbau sakraler Pflanzen, vor allem aber durch Schädeldeponierungen markieren. Schädel oder aber deren Abbildungen spielen bei vielen ursprünglich lebenden Völkern eine wichtige Rolle. In diesem Zusammenhang beschreibt der bedeutende deutsche Ethnologe Karl von den Steinen (1855–1929) die „Tatauierungen" (Tätowierungen) der Marquesainsulaner, deren Muster zu seiner Zeit als gänzlich unverständlich galten. Durch sorgfältigste Untersuchungen und den Vergleich verschiedener Kunst- und Gebrauchsgegenstände konnte von den Steinen belegen, dass sich die Grundmuster von einer Ahnenfigur ableiteten, die auf den Gräbern der Familienvorstände errichtet wurde, und diese wiederum ahmten bis in die Einzelheiten Totenschädel nach.

Auch in Afrika spielten die Schädel von Verstorbenen eine große Rolle. Als sich im 18. Jahrhundert die Yao, von den expandierenden aggressiven Zulu unter Druck gesetzt, in Richtung ihres heutigen Siedlungsgebietes östlich des Nyassasees in Bewegung setzten, führten sie wie selbstverständlich die Schädel ihrer Ahnen mit sich.

Dieses uns heute so abstrus anmutende Verhalten ist im Zusammenhang mit Territorialität sinnvoll. Was kann, wenn es darum geht, den Anspruch auf ein Stück Land oder auf ein Jagdrevier zu rechtfertigen, überzeugender sein, als der Verweis auf ein legitimes Erbe, und zwar durch einen Hinweis auf die Vorfahren, die das Land bereits vor Generationen in Besitz genommen hat-

ten? Wenn wir heute einen Grundbucheintrag, einen Kaufvertrag oder einen Erbschein präsentieren, so erfüllte vor rund 90.000 Jahren das Begräbnis und, noch besser, der Schädel des Verstorbenen dieselbe Aufgabe. Manche Völker, vor allem in der Australis, haben ihre gesamte Weltanschauung auf diesem Grundgedanken, nämlich legitimes Eigentum über die Vorfahren zu belegen, aufgebaut. Sie führen ihre Herkunft auf einen mythischen Ahnen zurück, der das Land in grauer Vorzeit in Besitz genommen hat und nun darüber wachen soll. Überzeugend wird die Deutung, dass es sich bei den Grabstätten und vor allem Schädeldeponierungen der Neandertaler um Zeichen territorialer Ansprüche handelt, auch durch den weiteren Verlauf der frühen Menschheitsgeschichte. Schädeldeponierungen ziehen sich durch die gesamte Prähistorie (Urgeschichte) und werden uns noch öfter beschäftigen. Vom schwäbischen Ofnet über das palästinische Jericho bis ins anatolische Çatal Hüyük sind die Schädel der Verstorbenen Ausdruck territorialer Ansprüche, und erst im Zuge einer eigenständigen kulturell-religiösen Evolution werden sie mehr und mehr zum Ausdruck religiöser Vorstellungen.

4

A forest of symbols: der *Homo sapiens* während des Jungpaläolithikums

Unsere Vorfahren betreten die Bühne

Im Jahre 1967 veröffentlichte der wegen seiner aufsehenerregenden Thesen ebenso berühmte wie angefeindete Anthropologe Victor W. Turner einen Buchband, in dem er die Sitten und religiösen Bräuche eines afrikanischen Volkes – der Ndembu – im damals britischen Rhodesien analysierte und die Bedeutung des religiösen Lebens für das soziale Miteinander herausstellte. Der eigentliche Skandal an dieser Geschichte war, dass sich nicht nur die angeblich magischen Praktiken und abergläubischen Handlungen dieser Afrikaner als hoch symbolische und effektive Bearbeitung sozialer Konflikte entpuppten, sondern dass Turner gleiche Muster auch in den angeblich so zivilisierten und rational strukturierten europäischen Gesellschaften feststellte. Für die beschriebene afrikanische Kultur galt: Beschneidungen im Zuge von Pubertätsriten, Heilungsrituale und auch Feste im Zyklus der Jahreszeiten waren voller Symbolhandlungen, die sich zu einem sinnvollen Ganzen fügten und sowohl für die Konstanz der gesellschaftlichen Ordnung als auch für ihren dynamischen Wandel verantwortlich waren. Das, was Turner als einen *forest of symbols*, als einen Wald von Symbolen, bezeichnete, ließ sich demnach nicht mehr als eine Folge unsinniger Handlungen einer unterentwickelten Gesellschaft abtun, sondern musste als hoch intellektuelles Konstrukt und genuine Kulturleistung angesehen werden. Diese steuert gleichermaßen bis heute das gesellschaftliche Miteinander sowohl bei afrikanischen Bauern als auch bei den europäischen Industrienationen. Bereits eine Gelehrtengeneration zuvor hatte der Philosoph Ernst Cassirer (1874–1945) deutlich gemacht, dass nicht nur Wissenschaft und Sprache, sondern auch Mythos, Kunst und Religion die Wirklichkeit oder das, was der Mensch für die Wirklichkeit hält, formen und damit konstituierende Elemente menschlicher Existenz sind.

Nachdem der Neandertaler das Opfer eines perfekten Rufmordes geworden war, von dem er sich auch nach über 100-jähriger Forschungsgeschichte

nur mühsam erholen konnte, kam zunächst nur einer als Träger solch entwickelter kultureller Leistungen in Betracht: der anatomisch moderne Mensch, der *Homo sapiens*!

Diese Annahme schien zur Fundsituation zu passen. Um 40.000 Jahre vor heute fand die Neandertaleridylle, so waren sich Paläoanthropologen und Archäologen noch bis vor Kurzem einig, zeitgleich mit dem Vordringen des *H. sapiens* nach Europa ihr Ende. Es war kein jähes oder gewaltsames Ende nach blutigen Schlachten oder heimtückischen nächtlichen Überfällen, wie ein pessimistisches Menschenbild möglicherweise nahelegen könnte, sondern ein langsames Zurückgehen der Neandertalerpopulationen zugunsten der Neuankömmlinge. Forscher spekulierten lange, welche Eigenschaften den modernen Menschen zur überlegenen Spezies machten, und sie hatten die Konkurrenz um einen zunehmend knapperen Lebensraum ins Spiel gebracht. Hier, im direkten, sich über einen Zeitraum von ca. 10.000 Jahren erstreckenden Wettbewerb, sollten angeblich die fortschrittlichere materielle Kultur des *H. sapiens*, die ihm eigene Fähigkeit zum abstrakten und symbolischen Denken sowie das überlegene Sozialverhalten die entscheidende Rolle gespielt haben. Obwohl eine solche Auffassung zweifellos auf einem Gedankengut fußt, das stark von den alten Vorurteilen vom tumben und barbarischen Neandertaler geprägt ist, gibt sie doch im Großen und Ganzen eine immer noch weit verbreitete Meinung wieder.

Neueste Forschungen, so z. B. an mitochondrialer DNA (mtDNA; diese DNA mutiert auf sehr konstante Art und Weise und ist somit ein wichtiger Bestandteil der molekularen phylogenetischen Forschung, die den Verwandtschaftsgrad sehr genau widerspiegelt) des Neandertalers, belegen allerdings, dass die Neandertalerpopulationen bereits vor dem Eintreffen des anatomisch modernen Menschen in Europa unter Druck geraten waren (möglicherweise durch extreme Klimaschwankungen), ausdünnten und schließlich ausstarben, während die Neuankömmlinge, deutlich später als zunächst angenommen, nun die frei gewordenen Lebensräume besiedelten. In Europa dürfte es ein Nebeneinander der beiden Menschenspezies nur für kurze Zeit (vielleicht für 3000 bis 5000 Jahre) bzw. nur regional begrenzt gegeben haben.

Die Menschenspezies, die tatsächlich erst ab 37.000 Jahren vor heute nach Europa einwanderte und sich dort so überaus erfolgreich ausbreiten konnte, hatte sich in Afrika aus dortigen *H. erectus*-Populationen entwickelt. Hier ließ sich eine Evolutionslinie von einem frühen archaischen *H. sapiens* (500.000 bis 200.000 Jahre vor heute) über einen späteren archaischen *H. sapiens* (200.000 bis 100.000 Jahre vor heute) bis zum modernen *H. sapiens* (seit etwa 100.000 Jahren) nachweisen, dessen letzte Vertreter von den in Europa bekannten jungpaläolithischen Formen nicht mehr zu unterscheiden sind.

Von Afrika aus drang der anatomisch moderne Mensch über Vorderasien in Richtung Europa vor und stieß bereits dort, in Vorderasien, vor rund 100.000 Jahren auf den Neandertaler, der inzwischen sein Verbreitungsgebiet von Europa aus Richtung Südosten ausgedehnt hatte. Wie entsprechende Funde in Skhul bei Haifa (1931), in Tabun (1967–1972) oder Kebara (um 1930 und 1982) zeigen, lebten hier Neandertaler und anatomisch moderne Menschen für einen Zeitraum von 50.000 Jahren in unmittelbarer Nachbarschaft. Dass es zu Kontakten und auch zum Kulturaustausch kam, gilt als sicher. Die Beziehungen zwischen den beiden gleichzeitig existierenden Menschenspezies beschränkten sich jedoch nicht auf bloße Kulturkontakte. Ein Anteil von einem bis zu vier Prozent der für den Neandertaler spezifischen Gene, die auch im Genom anatomisch moderner Menschen Eurasiens nachweisbar sind, legt nahe, dass es gelegentlich zur Kreuzung (*interbreeding*), das heißt zu Sexualkontakten gekommen sein muss.

Ebenso komplex wie das Thema des Aussterbens des Neandertalers und der Besiedlung Europas durch den anatomisch modernen Menschen, der nach seinem Fundort Abri de Cro-Magnon (Dordogne) auch Cro-Magnon-Mensch genannt wird, ist die Frage, wer während des Übergangs zwischen Mittel- und Jungpaläolithikum jeweils Träger welcher steinzeitlichen Kultur war. Auch ist eine einseitige Kulturdrift vom *H. sapiens* zum *H. neanderthalensis* keineswegs für jeden Fundort belegt, sondern einige der zum Jungpaläolithikum (und damit zum *H. sapiens*) gehörenden Aurignacienindustrien (das Aurignacien ist die älteste Kultur des Jungpaläolithikums; mit Industrien bezeichnet man seine charakteristischen Werkzeuge) haben sich vermutlich vor Ort aus Vorläuferkulturen entwickelt. Das ausgehende Mittelpaläolithikum war also offensichtlich eine Zeit großer Heterogenität. Die vielleicht naive Vorstellung, es habe mit dem Beginn des Jungpaläolithikums – gleichgesetzt mit dem Erscheinen des anatomisch modernen Menschen – so etwas wie eine jungpaläolithische Revolution gegeben, in deren Zuge dann plötzlich all die positiven Eigenschaften auftraten und nachweisbar wurden, die der moderne Mensch als Krone der Schöpfung so gern für sich reklamiert, muss infrage gestellt werden.

Bereits der Mensch des Mittelpaläolithikums hatte die entscheidenden Entdeckungen gemacht, auf der die nun einsetzende explosionsartige kulturelle Entwicklung aufbauen konnte. Nachdem spätestens vor 70.000 Jahren das Sprachvermögen (vgl. Kap. 3; maßgeblich für diese Feststellung war der Fund eines Zungenbeins eines Neandertalers) und damit auch die Fähigkeit zur Bildung abstrakter Begriffe und Gedanken vorhanden war, begannen offensichtlich Prozesse, die diese neuen Möglichkeiten voll ausschöpften. Dieses erfolgte ganz im Sinne einer biologischen Radiation, die immer dann einsetzt,

wenn ein entscheidender evolutiver Schritt einen völlig neuen Lebensraum erschließen kann.

In intellektueller Hinsicht wurde ein solch völlig neuer Raum – in diesem Fall der Denkraum – offensichtlich zwischen 40.000 und 15.000 Jahren vor heute entdeckt und spielerisch erschlossen. Dabei müssen nicht nur die intellektuellen Fähigkeiten des jungpaläolithischen *H. sapiens* eine Rolle gespielt haben, sondern auch die ökonomische und ökologische Umwelt, in der er sich bewegte, war für die weitere Entwicklung ideal.

Klimatisch ging es auf die letzte Eiszeit zu, das heißt das Klima in Europa wurde wieder trockener und vor allem kälter. Langsam dehnten sich die Gletscher von Skandinavien kommend in Richtung Mitteleuropa aus. Gleichzeitig schoben sich von den Bergmassiven Eismassen zu Tal, von Norden in südlicher Richtung bis zum heutigen Fluss Weichsel und von den Alpen in nördlicher Richtung bis zum heutigen Fluss Würm, sodass beim Eishöchststand um 20.000 Jahre vor heute nur ein schmaler eisfreier Korridor blieb. Die Vegetation passte sich an. Es starben nicht nur zahlreiche wärmeliebende Pflanzen aus, sondern auch der Charakter der Landschaft änderte sich. Offene Flächen, vergleichbar den heutigen Tundren und Kältesteppen, breiteten sich aus und boten dem Jäger freie Sicht auf die großen, durchziehenden Wildherden. Hunger dürften unsere Vorfahren zur damaligen Zeit also kaum gekannt haben. Es überrascht daher nicht, wenn Funde der Überreste eiszeitlicher Jagdzüge deutlich machen, dass man mit der Beute sehr großzügig verfahren ist und nur die besten Fleischstücke nutzte. Die Kälte hat noch einen weiteren, vielleicht nicht unmittelbar naheliegenden Vorteil: Kälte ist gesund! Wer jemals in den Tropen war und erlebt hat, wie rasch sich dort kleinste Wunden wie Insektenstiche infizieren und zu riesigen Infektionsherden entwickeln, wird das sofort nachvollziehen können. In eisigem Klima haben Bakterien schlechte Karten. Infizierte Verletzungen, Erkältungen und Infektionskrankheiten dürften wegen der Kälte, natürlich aber auch wegen der geringen Bevölkerungsdichte, erheblich seltener als heute gewesen sein. Unsere Vorfahren waren demnach gesund, litten nicht unter Nahrungsmangel und hatten Zeit – die besten Voraussetzungen, sich mit den schönen Dingen des Lebens zu beschäftigen. Und dafür waren die Grundlagen, wie wir gesehen haben, bereits erarbeitet. Das Handlungsrepertoire von territorialen Jägern und Sammlern, ihr Alltag, ihre Auseinandersetzung mit der Umwelt, die Begrifflichkeiten, ihr in Ansätzen entwickeltes Totenbrauchtum und ihr Kunstschaffen waren von vorangegangenen Generationen entwickelt worden und bildeten nun die Basis für jene kulturellen Entwicklungen, die dem heutigen Menschen höchste Bewunderung abnötigen.

Der Mensch wird zum Künstler – Höhlenmalerei

Die Vorstellung, dass das Erscheinen des anatomisch modernen Menschen eine Art kulturelle Revolution ausgelöst haben könnte, die das Denken und Handeln des Menschen auf eine ganz andere, fortschrittliche Stufe katapultierte, wird verständlich, wenn man den Blick nicht nur auf Innovationen bei der Werkzeugherstellung lenkt, sondern die Kunst in den Fokus nimmt. Vor allem was die Parietalkunst anbelangt, beginnt das Jungpaläolithikum mit einem Paukenschlag, wie er eindrücklicher nicht sein könnte: Um 34.000 Jahre vor heute wurden in einer Höhle in Frankreich die ersten Bilder gemalt. Die großflächigen Wandmalereien sind von einer solchen technischen Perfektion, wie man sie für eine so frühe Kulturstufe nicht erwartet hätte. Etwa 20.000 Jahre lang blühte diese Kunst, um dann gegen Ende des Magdaléniens von der Bildfläche zu verschwinden bzw. einer Kunstform Platz zu machen, die sehr viel schematischer und künstlerisch längst nicht mehr so anspruchsvoll und ausgefeilt wirkt, wie die so unmittelbar aus dem Nichts in künstlerischer Vollendung aufgetretene Höhlenmalerei. Die Qualität der Malereien erstaunte umso mehr, als das herrschende kunstgeschichtliche Paradigma die Vorstellung nahelegte, die Malerei habe sich erst im Lauf der Jahrhunderte von einfachsten Anfängen über schematische Darstellungen zur lichten Höhe des Naturalismus und der Perspektive vorgearbeitet und dann in der Renaissance einen ersten Höhepunkt erreicht. Grundlage einer solchen Meisterschaft sei die Intellektualität und Loslösung von geistiger Bevormundung gewesen, die gerade in der Renaissance durch die Wiederentdeckung der Antike und durch die damit verbundene, fast aufklärerische Geisteshaltung möglich geworden sei.

Aufsteigende Kunstentwicklung?

Die Vorstellung einer aufsteigenden Kunstentwicklung geht zunächst auf den Hofmaler der Medici, Giorgio Vasari (1511–1574), zurück, der die Kunst als erster einer geschichtlichen, wertenden Betrachtung unterzog. Auf Vasari fußend, sah Johann Joachim Winckelmann einen ersten Höhepunkt der Kunst in der griechischen Antike, der es gelungen sei, größtmögliche Schönheit in der Skulptur abzubilden. Vor allem in der zurückhaltenden und auf alles Laute verzichtenden Darstellung stärkster menschlicher Emotionen, wie bei der Laokoongruppe, sah Winkelmann sein Ideal von „edler Einfalt, stiller Größe" verwirklicht.

Vor einem solchen wissenschaftstheoretischen Hintergrund müssen die Werke der Höhlenkunst allerdings überwältigend wirken. Da gibt es in der Grotte

Abb. 4.1 Pferdedarstellung in der Grotte Chauvet. „In der Stille der Höhle von Chauvet". John Berger analysiert in der Chauvet-Höhle eine Wandmalerei. (© Ministère de la Culture. Foto: ARTE France. Picture alliance/obs)

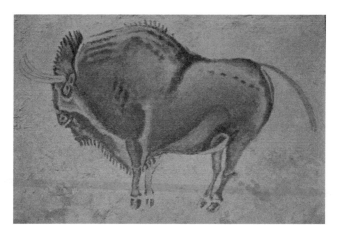

Abb. 4.2 Bild eines Auerochsen in der Höhle von Altamira. (© picture alliance/akg images)

Chauvet (Abb. 4.1), jener erst 1994 entdeckten Höhle an der Ardèche (Frankreich), über 400 teilweise großflächige Darstellungen von Tieren und Symbolen; das Alter der Malereien, die mit Holzkohle, Rötel und Ocker ungemein gekonnt ausgeführt wurden, konnte auf ein Alter von 32.000 bis 35.000 Jahren datiert werden. Jünger, aber nicht minder beeindruckend, sind die Darstellungen in den Grotten von Cougnac (Alter: 16.000 bis 25.000 Jahre), Pech Merle (Alter: 16.000 bis 20.000 Jahre), Lascaux (Alter: um 17.000 Jahre), Niaux (Alter: um 13.500 Jahre) oder Altamira (Alter: um 15.000 Jahre; Abb. 4.2) und andere.

Das vollendete handwerkliche Können, die künstlerische Qualität und der hohe ästhetische Wert der Bildnisse konnten demnach nur eines bedeuten: Sie mussten Ausdruck einer hoch entwickelten Geisteshaltung sein, die verschlüsselten Abbilder eines reichen geistigen Lebens, das sich in symbolischen Darstellungen offenbarte! Diese Symbole galt es nun zu entschlüsseln, um auf diese Weise die Botschaften zu entziffern, die uns unsere Vorfahren hinterlassen haben. Da uns aber ein direkter Zugang zur Bilder- und Geisteswelt der damaligen Künstler, der eiszeitlichen Jäger, verschlossen ist, musste auch hier wieder der bunte Garten der Völkerkunde herhalten, um durch den Vergleich mit heutigen Jägern, konkret sind es Buschmannkulturen, den geistigen Horizont der damaligen Zeit zu erhellen. Demnach hätte es sich um den künstlerischen Niederschlag eines schamanistischen Weltbildes gehandelt, das den Hintergrund für das Denken und Handeln unserer Vorfahren abgegeben hätte.

Eine solche Sichtweise, so reizvoll sie auf den ersten Blick auch sein mag, greift in mancherlei Hinsicht zu kurz. Zunächst einmal unterstellt sie abendländische Sehgewohnheiten: Die Bilder sollen etwas bedeuten! Im christlich geprägten Abendland ist man es so sehr gewohnt, dass Bilder religiöse oder geistige Inhalte mehr oder weniger verschlüsselt darstellen, dass man sich Malen als lustvolles Spiel mit Form und Farbe nicht mehr vorstellen kann. Dabei wird für die Bilderhöhlen unterstellt, dass die einzelnen Motive bzw. Bildelemente inhaltlich miteinander zusammenhängen. Tatsächlich stammen sie aber oft aus völlig unterschiedlichen Zeiten und bilden nur scheinbar mit anderen Motiven ein Bildensemble. Darüber hinaus hat die überragende künstlerische Qualität einzelner Tiermotive den Blick für die Tatsache verstellt, dass keineswegs alle Zeichnungen gelungen, groß und eindrucksvoll sind, im Gegenteil. Bei der überwiegenden Mehrzahl handelt es sich um rasch hingeworfene Umrisse, übereinandergemalte oder nachgezogene Figuren, nicht identifizierbare Zeichen, Handabdrücke, makkaroniähnliche Linien oder auch Fratzen und Chimären, an denen Forscher immer wieder herumgerätselt haben. Ganz offensichtlich hat die Schönheit einzelner Bildnisse die Forscher geradezu verführt, die eiszeitlichen Höhlenbildnisse mit Bedeutung zu überfrachten.

Gerade die makkaroniähnlichen Linien könnten sich hinsichtlich einer Deutung und entwicklungsgeschichtlichen Einordnung der Höhlenmalerei als bedeutsam erweisen, denn sie sind keineswegs auf die Eiszeit oder auf Bilderhöhlen beschränkt, im Gegenteil. So ist gegenwärtig das Hauptgebäude des niedersächsischen Landtags mit einem Nebengebäude durch einen uncharmanten und recht niedrigen unterirdischen Tunnel verbunden – an seiner Decke finden sich die gleichen, mit den Fingern gezogenen Linien, wie 20.000 und mehr Jahre davor in den tunnelähnlichen Durchgängen der Bilderhöhlen!

Abb. 4.3 Mondgesicht in der Höhle Les Trois Frères (Frankreich). (Zeichnung: Karolina Rupik nach Lorblanchet)

Ähnliches – also die Überfrachtung mit angeblichen Bedeutungsinhalten durch den heutigen Betrachter – gilt für die meisten Menschendarstellungen. Sie ähneln verblüffend Zeichnungen von heutigen Kindern, und auch das allen Eltern, die jemals von ihren Sprösslingen mit einem Bild bedacht wurden, bekannte „Mondgesicht" ist darunter (Abb. 4.3). In beiden Fällen, bei der Kinderzeichnung wie bei der Höhlenmalerei, wollten die Künstler einerseits sichtbare Spuren hinterlassen, andererseits spontan ein Gefühl in Aktion umsetzen.

Ganz offensichtlich handelt es sich also zumindest bei einem großen Teil der eiszeitlichen Höhlenbildnisse um so etwas wie Graffiti: eine zweckfreie Form von Malerei, die vom sogenannten *tag*, einem Namenskürzel bzw. Markenzeichen des Künstlers, bis zu großformatigen *characters* reicht. Interessant ist in diesem Zusammenhang, dass es sich bei Letzterem um die bildhafte Darstellung von Fantasiefiguren, Chimären, aber auch Realitätsausschnitten handelt.

Graffiti ist heute, gelinde ausgedrückt, umstritten. Hausbesitzer, die die Wände ihres Eigenheimes auf diese Weise verziert sehen, reagieren selten erfreut, sondern sind eher geneigt, das Kunstwerk als Sachbeschädigung einzuordnen. Dann aber stellt sich die Frage, was die meist jungen illegalen Künstler dazu bewegt, viel Zeit und Geld für etwas zu investieren, das ihnen bestimmt keine Belohnung, sondern im Zweifelsfall großen Ärger eintragen wird. Eine Forschergruppe ist dieser Frage nachgegangen und kam zu dem höchst eindrucksvollen Ergebnis, dass der Reiz dieser Form von künstlerischer Betätigung in der Aktivität selbst liegt. Die Künstler wollen Ideen verwirklichen, Gefühle zum Ausdruck bringen, inneres Erleben so materialisieren, dass es für die Außenwelt dauerhaft sichtbar wird, sie wollen sich ihres Könnens vergewissern und sich mit anderen messen. Gerade Konkurrenz- und Prestigedenken spielt beim Graffiti eine unerwartet große Rolle, denn auch hier, wenn

der Künstler lustbetont und reflexionsfrei in der Tätigkeit aufgeht, will er sich mit seinem Werk in Szene setzen, andere übertrumpfen und Ruhm ernten.

Es bedarf keiner großen Mühe, auch die Eiszeitkunst als frühe Graffiti zu erkennen. Das Malen um seiner selbst, um einer lustvollen Tätigkeit willen, bei der man inneres Erleben zum Ausdruck bringen und, bei großer Künstlerschaft, der Bewunderung der Gruppenmitglieder sicher sein kann, ist eine naheliegende Option für Jäger und Sammler, die nicht nur genügend Zeit hatten, ihren Neigungen nachzugehen. Ihr inneres Erleben hat sicherlich nach Ausdrucksformen verlangt – Ausdrucksformen, die ihnen noch kein Mythos und kein Ritual vorgegeben hatten, sondern die in dieser frühen Phase menschlichen Kulturschaffens ganz neu erarbeitet werden konnten und sollten.

Dieser Befund wird von Untersuchungen des Psychologen Nicholas Humphrey (*1943) gestützt, der die Motive der eiszeitlichen Bilderhöhlen mit den Zeichnungen eines autistischen Mädchens verglich und feststellte, dass gerade die dem Autisten fehlende Fähigkeit des Konzeptionalisierens zu künstlerischen Ausdrucksformen führt, die denen der paläolithischen Maler entsprechen. Die perspektivischen Darstellungen in den Bilderhöhlen sind seiner Ansicht nach der Ausdruck von starken Emotionen und momentanen Eindrücken, die bildkünstlerisch festgehalten werden und so dabei helfen, aus der Fülle der Impressionen Gemeinsamkeiten herauszuarbeiten und damit erste begriffliche Einheiten zu bilden (vgl. Kap. 2). Auch bei den Höhlenmalereien werden also sensomotorische Erfahrungen gemacht, die dann wiederum bei der Begriffsbildung eine große Rolle spielen. Das Malen der Bilder führt zu neuen Erkenntnissen, die anschließend mithilfe der Sprache über einen Prozess der Bewusstmachung und Reflexion zu neuen Begriffen und einem erweiterten Weltbild führen. Gerade Wortbedeutungen, aber auch bildkünstlerische Symbole lösen sich im Lauf dieses Prozesses aus ihrem ursprünglichen Kontext und entwickeln sich von einem konkreten zu einem abstrakten Inhalt. In diesem Zusammenhang hilft das kontinuierliche Spiegeln von Gefühlen, sich seiner selbst bewusst zu werden, sich sicher zu fühlen und die eigene Situation zu reflektieren. Gerade Letzteres dürfte – auch im Warburg'schen Sinn – eine nicht zu unterschätzende Rolle gespielt haben. Trotz erfolgreicher Jagdmethoden war das Leben des jungpaläolithischen Jägers mit großer Wahrscheinlichkeit unsicher. Es hing ab vom regelmäßigen Erscheinen des Jagdwildes, möglicherweise durchziehender Herden und dem glücklichen Verlauf von mehr oder weniger ungewollten Begegnungen mit überlegenen tierischen Gegnern wie Auerochse, Wollnashorn oder Löwe. Existenzielle Ängste dürften ein ständiger Begleiter dieser Jäger gewesen sein – Ängste, die sie kulturell auch in ihrer bildenden Kunst verarbeiteten (über andere, möglicherweise sprachliche Verarbeitungsmuster wissen wir nichts).

Auch hier halfen die künstlerischen Aktivitäten, die existenzielle Bedrohung symbolisch zu fassen und damit eine innerliche Distanz, den Warburg'schen „Denkraum der Besonnenheit", zu gewinnen.

Perspektivische Darstellungen, das Erfassen eines Lebewesens in der Bewegung und damit das Festhalten eines Momentausschnittes der Wirklichkeit sind übrigens nicht nur auf die Bilderhöhlen beschränkt, sondern finden sich auch als Strichzeichnungen auf Schiefertafeln. Rund 20.000 Jahre nach Entstehen der ersten Bilderhöhle hielten Jäger, die der Kulturstufe des Magdalénien zuzuordnen sind, in einem Lager auf der Rheinterrasse beim heutigen Gönnersdorf herausragende Ereignisse auf diese Weise fest. Damit hinterließen sie uns Einblicke in ein Leben, in dem der Durchzug einer Mammutherde – es waren die letzten ihrer Art – und Tanzfeste emotionale Höhepunkte darstellten, die man künstlerisch auf den in unmittelbarer Nähe gewonnenen Schieferscherben festhielt.

Der biologische Hintergrund – Kommunikation und Ranking

Graffiti und Höhlenmalerei erscheinen hier in erster Linie als reine *l'art pour l'art* und lustvolle Betätigung von Wildbeutern, denen die erfolgreiche Jagd einerseits und lange dunkle Winterabende andererseits einen Freiraum für künstlerische Betätigung bescherten. Doch die Verhaltensbiologie mischt den bekannten Wehrmutstropfen in dieses Idyll des sich zweckfrei betätigenden frühen Künstlers, indem sie feststellt, dass letztlich die Kunst im Dienste der Selbstdarstellung steht und damit keineswegs zweckfrei ist. Wenn es das Forscherteam bei der Untersuchung jugendlicher Graffitisprayer noch in Erstaunen versetzte, dass unter jungen Menschen, die ihre Kunst auch als Angriff auf die herrschenden gesellschaftlichen Normen sehen, der Leistungs- und Wettbewerbsgedanke eine herausragende Rolle spielte („ich will besser sein als mein Mitbewerber, ein anderer Künstler oder ein anderer Graffitisprayer"), so ist dieser Gedanke den Verhaltensbiologen längst vertraut. Ästhetische Selbstdarstellung gehört im Tierreich zum Werbeverhalten, und was das äußere Erscheinungsbild nicht selbst hergibt, wird über Hilfsmittel erreicht. So beschreibt Jane Goodall eine Situation, in der es einem ranghohen Schimpansenmännchen gelang, mit zwei von der Forschungsstation erbeuteten leeren Ölkanistern einen enormen Lärm zu schlagen und damit ein Display hinzulegen, das alles Ästeschütteln und Gebrüll seiner Konkurrenten deklassierte und ihm damit seine herausragende Stellung in der Gruppe sicherte. Stiller und mehr im Sinne ästhetischen Verhaltens geht der Maibaumlaubenvogel

vor. Um Weibchen anzulocken, baut er eine Hochzeitslaube aus Moos, die er nicht nur mit Blüten dekoriert, sondern vor der er zusätzlich einen Wall aus Blüten und Früchten errichtet und auf diese Weise ein wahres Kunstwerk erschafft. Nun gehört der Wettbewerb unter Schimpansen mit dem Ziel, einen möglichst hohen Rang in der Gruppenhierarchie einzunehmen, nicht unbedingt in den Bereich von Kunst oder Ästhetik, dient aber letztlich demselben Ziel, nämlich der Optimierung von Fortpflanzungsmöglichkeiten. Genau wie eine hohe Position dem Schimpansenmännchen den sexuellen Zugang zu möglichst vielen Weibchen ermöglicht, demonstriert die Kunstfertigkeit des Maibaumlaubenvogels seine Tüchtigkeit und Überlegenheit über seine Konkurrenten und macht ihn so zu einem begehrenswerten Brutpartner.

Auch Menschen ist ein solches Verhalten nicht fremd. Der Humanethologe Irenäus Eibl-Eibesfeldt (*1928) erwähnt in diesem Zusammenhang die Eipo, ein Volk auf Neuguinea, die Netze, die wie Rucksäcke auf dem Rücken getragen werden, unter anderem auch deshalb anfertigen, um Steinbeilrohlinge damit zu bezahlen. Den Wert dieser Netze steigern sie, indem sie mehr Arbeit investieren – durch Vergrößerung der Netze, Verkleinerung der Maschen oder farbige Bastverzierungen. Besonders schöne und zusätzlich mit Federn geschmückte Netze werden dann von den Männern bei Tanzveranstaltungen als Schmuck getragen. Bei den Hin, einem verwandten Volk, ist die Entwicklung hin zum Schmucknetz so weit fortgeschritten, dass das Netz zu einem völlig funktionslosen bandartigen Träger von buntem Federschmuck mutiert ist und nur noch als Zierde für seinen Träger dient. Die Yali dagegen investieren viel Zeit und Arbeit in die Herstellung von fein polierten und verzierten Äxten, die dann nicht mehr ihren eigentlichen Zweck erfüllen, sondern Zahlungsmittel sind, also Reichtum darstellen.

Selbstdarstellung über Kunst, über das Produzieren eines ästhetischen Mehrwertes, gehört demnach zum menschlichen Erbe. Objekte der Kunst, deren Herstellung Zeit und Mühe gekostet hat, sagen etwas aus über das Vermögen nicht nur des Künstlers, sondern auch der Gruppe, die die Kunstwerke hervorbrachte. Sie sind daher geeignet, die Gruppe positiv darzustellen und im Wettbewerb mit anderen Gruppen optimal zu positionieren: Kunst ist eben auch ein Imponierorgan!

Drohen und Beschwichtigen

Imponieren und positive Selbstdarstellung der Gruppe durch eindrucksvolle Kunstwerke zeigen, dass es in den jungpaläolithischen Bilderhöhlen nicht nur um das Malen als lustvolle Betätigung, um die Reflexion starker Emotionen und bewegender Eindrücke ging – wenn sich zum Beispiel ein Jäger einem

Abb. 4.4 Handnegative in der Höhle El Castillo (Spanien). (Pedro Saura; © picture alliance/dpa)

Auerochsen in Angriffsstellung gegenübersah – sondern es ging auch um den Wettbewerb mit anderen Gruppen und das Hinterlassen eines deutlichen Zeichens: Wir waren hier und wir sind fähig zu den hier dokumentierten Leistungen! Eine solche Aussage dient der Demonstration des eigenen Vermögens und der eigenen Stärke und dokumentiert vor allem einen Anspruch, nämlich auf die Höhle selbst als Refugium und auf das sie umgebende Territorium. Unterstrichen wurden solche Ansprüche durch eindeutige Zeichen, die in der Verhaltensbiologie als Abwehrzeichen bekannt sind. In diesem Zusammenhang taucht in den Bilderhöhlen immer wieder ein Motiv auf, über das unter Vorgeschichtsforschern gerätselt wurde: der Handabdruck (Abb. 4.4).

Ob in El Castillo in Kantabrien (Spanien), ob in den französischen Grotten Pech Merle, in Cosquer oder in der Grotte Chauvet – allenthalben finden sich die Abdrücke oder Negative menschlicher Hände, und immer zeigt die Hand die gespreizten Finger. Interessant ist das Alter der Handzeichen: In El Castillo wurde einer der Abdrücke auf ein Alter von 40.000 Jahren datiert, würde also demnach noch vom Neandertaler stammen.

Handzeichen gehören in der Vorgeschichtsforschung zu den rätselhaften Motiven, denn zu wenig scheinen sie in das Schema einer hoch entwickelten Kunst zu passen, in der die perspektivischen und naturnahen Tierbildnisse Ausdruck einer komplexen mythischen Geisteswelt und der angebliche

Abb. 4.5 Bedeutung von Schildern. Links. Baustellenzeichen, das nichtautorisierten Personen das Betreten untersagt. Rechts: Hinweis auf eine Ambulanz am Strand von Tel Aviv (Israel). Bei Letzterem hat sich das ursprüngliche Abwehrzeichen bereits zum apotropäischen Symbol gewandelt. (Foto links: © Phototom/fotolia.com)

Niederschlag schamanistischer Handlungen sein sollen. Weniger rätselhaft ist das Handzeichen für den Verhaltensforscher. Hier gehört die abweisend vorgestreckte, gespreizte Hand zu den bekannten Abwehrgesten, die sprach- und kulturunabhängig von allen Menschen universell verstanden werden. Die Handbewegung, die als Geste der Zurückweisung, des „Halt!" und der Abwehr zu verstehen ist, ist eine formalisierte Bewegung des Wegschiebens und möglicherweise ontogenetisch daraus hervorgegangen. Darstellungen der Abwehrhand beschränken sich keineswegs auf steinzeitliche Höhlen, sondern sind weltweit zu finden: Angefangen von keltischen Votivfiguren über Kanzelschmuck in der Pfarrkirche von Gropina (Toskana) bis zu balinesischen Tempelwächterfiguren zeigt die erhobene Hand Abwehr.

Von besonderem Interesse ist in diesem Zusammenhang ein Zeichen, das auf deutschen Baustellen zu finden ist, um nichtautorisierten Personen den Zutritt zu verwehren (Abb. 4.5). Die Abwehrhand bedeutet hier klar und eindeutig: „Betreten der Baustelle verboten!" Die gleiche Signalwirkung sollten auch die Handnegative und -positive in den steinzeitlichen Bilderhöhlen erzielen. Die Abwehrhand auf der Höhlenwand signalisierte ebenfalls nicht mehr und nicht weniger als „Das Betreten dieses Platzes ist nichtautorisierten Personen verboten", war also ein klares Zeichen zur Unterstreichung eines territorialen Anspruchs. Diese Deutung wird unterstrichen durch Höhlenzeichnungen, die den Abwehrcharakter der erhobenen Hand betonen und durch weitere Drohgesten verstärken. In den Höhlen von Gourdan und La Madeleine (Frankreich) oder Hornos de la Peña (Spanien) finden sich Darstellungen ithyphallischer Männer mit erhobenen Händen, die Eindringlinge abwehren sollen.

Die Symbolik des phallischen Präsentierens, die hier zusätzlich bemüht wird, dient an dieser Stelle nicht der Betonung des Geschlechtlichen, sondern ist vielmehr ein entscheidendes Ausdrucksmittel für Dominanz, das im Drohimponieren seine Wurzeln hat. Sowohl bei Meerkatzen als auch bei Pavianen wird phallisch gedroht, wenn sich Eindringlinge der Gruppe nähern – die Männchen bekommen eine Erektion, drohen also letztlich damit, den Eindringling zu vergewaltigen. Umgekehrt antworten unterlegene Tiere auf eine solche Drohgeste mit Unterwerfungsgesten, indem sie beispielsweise ihr Hinterteil präsentieren und damit zum Aufreiten auffordern, ohne dass der Geschlechtsakt tatsächlich stattfindet. Das Ganze dient also vielmehr der sozialen Kommunikation.

Auch unter Menschen ist phallisches Drohen weit verbreitet. Auf Neuguinea tragen die Yale eine Peniskalebasse, die den Penis künstlich verlängert. Dringen ungebetene Besucher in das Gebiet der Yale ein, lösen sie die Schnur, die den Penisköcher hält, sodass der grotesk verlängerte Penis bedrohlich auf und nieder schwingt. Es bleibt beim Menschen allerdings nicht nur beim Drohen: Wenn Hirtenjungen im Atlas das Missgeschick widerfuhr, dass ihnen Vieh abhanden kam, wurden sie zur Strafe von ihren Kameraden vergewaltigt. Bekannt ist auch das Schicksal des britischen Offiziers und Abenteurers Lawrence of Arabia, der das gleiche Schicksal durch einen türkischen Gouverneur als Strafe für seine subversive Tätigkeit gegen das osmanische Reich erleiden musste.

Die phallischen Figuren der paläolithischen Bilderhöhlen wie der berühmte Zauberer aus Les Trois Frères, der phallische Mann aus Altamira oder gar eine Aufreitszene aus Les Combarelles sind demnach wirkungsvolle Droh- und Abwehrzeichen, deren Wirkkraft durch die Kombination mit Hörnern oder Tierklauen noch gesteigert wird (Abb. 4.6).

Bei den menschenähnlichen, phallischen oder ithyphallischen Darstellungen, die durch Hörner oder dominanzsignalisierende Tierattribute verfremdet wurden, handelt es sich daher nicht, wie immer wieder behauptet, um Schamanen, deren komplexes Weltbild sicherlich erst viel später entstanden ist, sondern um Droh- und Abwehrfiguren, die genau wie die Handzeichen Fremde und Eindringlinge von der Höhle fernhalten sollten, also ganz klar ein Zeichen von Territorialität darstellen.

Die Macht des Weiblichen – Frauenfigurinen

Die Reihe der Kunstwerke, die über die Freude am Schaffensakt und über den Imponierwert des Kunstwerks hinaus als Bedeutungsträger und Signal dienen, wird, abgesehen von wenigen Vorläufern, ab dem Gravettien (28.000 bis

Abb. 4.6 Phallische Drohfiguren aus den Höhlen Les Trois Frères (Frankreich) sowie Altamira (Spanien) und eine präcoitale Szene aus Les Combarelles. (Zeichnungen: Karolina Rupik nach einer Kopie von C. Barriere)

22.000 Jahre vor heute) durch kleine Frauenfigürchen erweitert, die hinsichtlich ihrer Schutzfunktion ein Äquivalent zu den ithyphallischen Zeichnungen und Ritzungen darstellen. Der ethologische Hintergrund ist das weibliche Schamweisen, das heißt das demonstrative und oft obszöne Präsentieren der weiblichen Scham als Droh- und Spottgebärde, das Verhaltensbiologen sowohl bei Kindern als auch bei Wildbeutervölkern, zum Beispiel den südafrikanischen !Ko ausgemacht haben. Das Präsentieren des Steißes dagegen

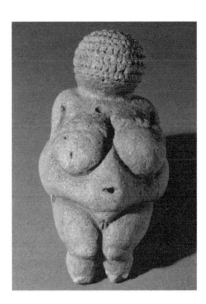

Abb. 4.7 Venusfigur von Willendorf. (Naturhistorisches Museum Wien; © picture-alliance/akg-images/Erich Lessing)

ist eine Aufforderung zum Aufreiten, also ein Unterwerfungsgestus, der nicht notwendigerweise als tatsächliche Aufforderung zum Sexualakt, sondern zur Beschwichtigung gemeint ist. Beruhigende und beschwichtigende Wirkung soll auch das Präsentieren der entblößten weiblichen Brust haben, die für jeden Menschen während seiner Säuglingszeit die Quelle von Wohlbefinden, Trost und Glück darstellte und auch im Erwachsenenalter unwillkürlich entsprechende positive Gefühle hervorruft.

Die ersten Frauendarstellungen, meist kleine, kaum 10 cm große Figurinen, bemühen genau diese beruhigenden und beschwichtigenden ethologischen Signale. So zeigen die sogenannten Venusfiguren eine üppige Steiß- und Schenkelregion und häufig gewaltige Brüste (Abb. 4.7). Beispiele sind die älteste (Alter: 35.000 bis 40.000 Jahre) bisher gefundene Venusfigur vom Hohle Fels bei Schelklingen (Süddeutschland) mit nicht nur großen Brüsten, sondern auch deutlich sichtbarer, obszön präsentierter Schamspalte, das Halbrelief der Venus von Laussel (Alter: 25.000 Jahre) mit sehr großen Brüsten und der zur Scham weisenden Hand (das ist der bekannte Schamweisegestus) und die Figurine der Venus von Willendorf, ebenfalls mit großen Brüsten und überdeutlich dargestellten äußeren und inneren Schamlippen. Die Liste der Beispiele könnte beliebig erweitert werden.

Allen Figürchen ist gemeinsam, dass sie bei bewundernswerter künstlerischer Genauigkeit hinsichtlich der anatomischen Details des Körpers, vor allem also Brust-, Hüft- und Schamregion, den Gesichtszügen keine Aufmerksamkeit widmen – es ging also offensichtlich nicht darum, bestimmte

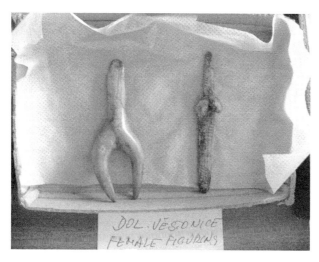

Abb. 4.8 Fundstücke aus Dolní Věstonice (Tschechien). Die Figurine ist auf die obszöne Spreizhaltung und Brüste reduziert. (© Naturhistorisches Museum Brünn)

Personen zu porträtieren. Dies ist kaum verwunderlich, denn bei den Frauendarstellungen steht ganz eindeutig die Signalwirkung im Vordergrund: Die betonte Scham, die breite Gesäßregion und die üppigen Brüste sind beschwichtigende Signale, die nun in einer Figur zusammengeführt und festgehalten werden, die ganz eindeutig eine apotropäische (Unheil abweisende) Funktion hat. Dies gilt für die Venus von Laussel, die ursprünglich ein Abri (Felsüberhang) beschützte, wie für die Venus vom Hohle Fels, die als Amulett um den Hals getragen wurde, und die Venus von Willendorf, die man mit ihren spitz zulaufenden Beinen in den Boden steckte – sie alle hatten wie ähnliche Figuren ihrer Zeit eine klare Schutzfunktion. Noch eindeutiger wird der Sinn dieser Figürchen, wenn man sich ihre stilistische Entwicklung, die sie über die Jahrtausende hinweg durchlaufen haben, anschaut: War die Venus vom Hohle Fels noch recht ungeschlacht, zeigen sich die Venusfiguren des Gravettien naturalistisch, zumindest was die Körperregionen anbelangt, die die Künstler darstellen wollten. Im Verlauf der weiteren Entwicklung wird auf Naturalismus immer weniger Wert gelegt; vielmehr werden die Körperstellen, von denen die gewünschte Signalwirkung ausgeht, also Brüste und Steiß, immer stärker betont. Die Entwicklung führt so weit, dass die entsprechenden Amulette zuletzt auf bloße Brüste oder Stäbchen mit Scham oder Steiß reduziert werden und damit kaum noch als Frauenfigurinen zu erkennen sind (Abb. 4.8–4.10).

Die Figürchen dienten also dem Schutz eines Unterschlupfes, einer Behausung oder ihres Trägers. Dabei werden sowohl Droh- und Spottgesten als auch Submissions- und Beruhigungsgesten bemüht, die manchmal, so im Fall

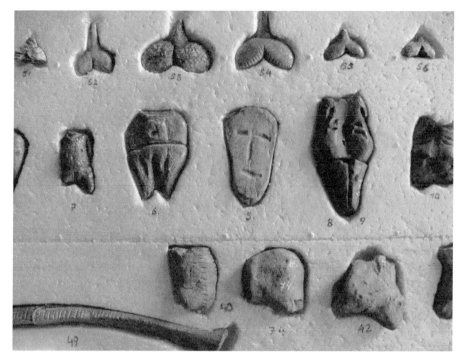

Abb. 4.9 Brustamulette aus Dolní Věstonice (Tschechien). (© Anthropologisches Museum Brünn)

Abb. 4.10 Eine auf den Steiß reduzierte Figurine aus Dolní Věstonice (Tschechien). (© Anthropologisches Museum Brünn)

der Venus von Laussel, in einer Figur zusammengeführt werden, um so die beabsichtigte Wirkung zu verstärken.

Betrachtet man die Höhlenbildnisse und die bewegliche Kleinkunst, so ist die Entwicklung künstlerischen Schaffens und geistiger Fähigkeiten, die der Mensch in den rund 20.000 Jahren durchlaufen hat, nicht zu übersehen und für die Antwort auf die Frage nach der Entstehung religiösen Gedankengutes

nicht unwesentlich. Dienen die ältesten Bildnisse noch reiner Selbstdarstellung durch Imponieren und dokumentieren einen territorialen Anspruch, sollten die ersten Figurinen vielleicht noch Eindringlinge beschwichtigen, so haben die späteren Frauenfigürchen eindeutig eine apotropäische Funktion, die sich nicht mehr nur gegen einen konkreten Eindringling, sondern gegen das Übel allgemein richtet. In dem oben beschriebenen Denkraum hat sich auf dem Umweg über die künstlerische Betätigung offensichtlich eine Begriffsbildung vollzogen, in der Bedrohung und Übel als feste Begriffe, als sprachliche und gedankliche Manifestation von Angstgefühlen, genauer gefasst und damit beherrschbar wurden. Gegen Angst, nun nicht mehr vor konkreten Personen oder Ereignissen, sondern eine Angst existenzieller Natur, konnten Frauenbrüste und Stäbchenfigurinen als wirksame Amulette eingesetzt werden. Interessant ist in diesem Zusammenhang, dass der empfundene Schutz über die Entwicklungsreihe Beschwichtigungsgestus–Schutzfigur–apotropäisches Amulett stets mit weiblichen Attributen assoziiert wurde; eine Entwicklung, die sich im Neolithikum, der Jungsteinzeit, fortsetzt und letztlich zu Vorstellungen von Muttergottheiten führt, wie in den folgenden Kapiteln ausgeführt werden wird.

Zurück zu Ranking und Territorialität – Bestattungen

Weniger dramatisch und auffällig als in der Kunst verlief der Übergang vom Mittel- zum Jungpaläolithikum in Sachen Bestattungen. Die Sitte des Bestattens von Toten – oft, nachdem man ihre Gebeine von verweslichen Teilen gesäubert hatte – wurde fortgeführt und ausgebaut. Hatte man sich im Moustérien, also zur Zeit des Neandertalers, noch damit begnügt, flache Gruben auszuheben, den Leichnam darin zu bergen und ihn dann mit Steinen abzudecken, begann man im Jungpaläolithikum damit, das Grab selbst sargartig mit Steinplatten auszukleiden, und möglicherweise auch, die Grabstätte mit rotem Ocker zu bestreuen. Letzteres ist allerdings insofern fraglich, weil die Jungpaläolithiker Ocker gern und reichlich auch im Alltag nutzten, der Ocker also auch aus ganz anderen Gründen in die Grabstätten gelangt sein könnte, und weil die Ausgräber gelegentlich rote Horizonte der chemischen Bodenbildung fälschlich als Ockerstreuungen bezeichneten. Nicht zu leugnen ist allerdings, dass mit den Bestattungen nun mehr Aufwand getrieben wurde. In einem Grab bei Brünn war der Tote nicht nur im Schädelbereich mit mehr als 600 Gehäusen von Zahnschnecken (Reste einer bestickten Haube?), sondern zusätzlich mit Knochenscheiben und großen, flachen Ringen geschmückt worden.

Auch bei einem jungpaläolithischen Begräbnisplatz bei Saint-Germain-de-la-Rivière war eine junge Frau vermutlich in prächtiger, mit Schneckenhäusern verzierter Kleidung bestattet worden. Eine besonders aufwendige und schöne Bestattung wurde von Sungir, 200 km östlich von Moskau, bekannt. Der Fund wird in das Soungirien/Kostenkien gestellt und entstammt damit einem Zeithorizont, der sich mit dem westeuropäischen Gravettien parallelisieren lässt. Hier fanden sich die aufwendig geschmückten Gebeine eines Mannes, dessen Skelett von mindestens 1500 Elfenbeinperlen übersät war – diese vermutlich ursprünglich die Verzierung kostbarer Kleidung – zusammen mit reichen Grabbeigaben, zum Beispiel Elfenbeinarmbändern und besonders schön gearbeiteten Silexwerkzeugen. Häufig befinden sich die Bestattungen in der Nähe von Feuerstellen; ein Beleg dafür, dass man die Toten immer noch dort bestattete, wo man auch lebte, mit den Bestattungen also einen territorialen Anspruch verband.

Im Unterschied zum Moustérien, wo man mit dem Grab auf die Legitimität des Besitzes eines Unterschlupfes und des umgebenden Reviers aufmerksam machte, wurden nun Bestattungen auch zum Anlass, einen prestigeträchtigen Mehrwert zu produzieren. Nicht nur wurden die Gräber durch Grabausbauten aufwendiger, sondern auch der Verstorbene selbst wurde mit kostbaren, weil in zeitintensiver Arbeit hergestellten Gewändern, Schmuckgegenständen und Waffen beigesetzt und stellte auf diese Weise eindrücklich zur Schau, dass sich die Hinterbliebenen diesen Verlust an wertvollen Gegenständen leisten konnten.

Völkerkundliche oder historische Parallelen zu diesem im Paläolithikum gepflegten Brauch, die Bedeutung und Macht einer Gruppe einerseits durch Verschwendung und Vernichtung von Gütern, andererseits durch aufwendige Bestattungen darzustellen, finden sich reichlich. Besonders eindrucksvoll ist die Schilderung eines Wikingerbegräbnisses durch den arabischen Reisenden Ahmad ibn Fadlān, nach der man den Verstorbenen auf einem Schiff zur letzten Ruhe bettete, das man mit kostbaren Gegenständen ausgestattet hatte, und dann dieses Schiff in Brand setzte. Unabhängig von Bestattungen haben die Prunk- und Imponierfestivitäten nordwestamerikanischer Indianer Berühmtheit erlangt, die beim sogenannten Potlatch nicht nur ihre Gäste üppig bewirten und beschenken, sondern auch wertvolle Güter vernichten, indem sie sie zerbrechen und ins Meer werfen. Verschwendung in Zusammenhang mit Bestattungen dient demnach der Selbstdarstellung der Gruppe, die deutlich macht, dass sie zum einen mit dem Begräbnis Anspruch auf einen Platz und ein Territorium erhebt und dass sie zum anderen wirtschaftlich in der Lage ist, auf schöne und wertvolle Güter zu verzichten.

In Zusammenhang mit Bestattungen ist noch eine kurze Bemerkung hinsichtlich des Brauches der Schädeldeponierungen anzufügen, die deutlich

macht, dass das Markieren eines Territoriums mit den Schädeln Verstorbener ein weiterhin gepflegter Brauch blieb, der sich vom Moustérien bis weit in das Neolithikum und gelegentlich bis in historische Zeiten zog. So sind beispielsweise von den Fundstellen Le Placard fünf Schädelkalotten und von Isturitz (beide Frankreich) weitere bearbeitete und deponierte menschliche Schädel bekannt. Besondere Aufmerksamkeit erregte der aus dem Magdalénien stammende Schädel einer jungen Frau von der Fundstelle Mas-d'Azil, der 1961 geborgen werden konnte und sich dadurch auszeichnet, dass die Augen durch ovale Knochenscheibchen ersetzt worden waren.

Die *costly signaling*-Theorie

In der Biologie wird ein solch aufwendiges, demonstratives Verhalten von der *costly signaling*-Theorie – eine Theorie, die ein besonders kräftezehrendes Verhalten erklärt – beschrieben. Ein Beispiel: Lange hatte man sich die hohen, kraftzehrenden Sprünge, die Springböcke unmittelbar im Angesicht von Jägern wie Löwen oder Leoparden vollführen, nicht erklären können. Inzwischen geht man davon aus, dass der Zweck dieser eigentlich riskanten (und kostspieligen) Verhaltensweise ist, Angreifern zu signalisieren: „Versuch es erst gar nicht – gegen meine gute Physis kommst Du ohnehin nicht an."

Mit diesen Bestattungsbräuchen müssen nicht unbedingt schon konkrete Jenseitsvorstellungen verknüpft gewesen sein. Aus psychologischer Sicht ist naheliegend anzunehmen, dass mit dem Hinterlassen von Grabbeigaben auch das Gefühl verbunden war, noch etwas für den Verstorbenen getan zu haben. Dadurch ließen sich das eigene Unbehagen und die Angst vor der eigenen Sterblichkeit, die durch die Konfrontation mit dem Tod ausgelöst wurden, zumindest ein wenig besser bewältigen. Die damit einhergehende Erleichterung kann gut zur Verstärkung und Beibehaltung des Brauches, den Toten ihre Habseligkeiten mitzugeben, beigetragen haben. Gerade wenn sich die eigenen Ängste durch die Grabbeigaben besser bewältigen ließen, ist auch die Annahme plausibel, dass sich im Lauf der Jahrhunderte die Vorstellung entwickelt hat, der Verstorbene nutze die ihm ins Grab gelegten Beigaben (z. B. Silexklingen, Speere und Pfeile als Jagdwaffen, Knochennadeln und Schaber als Handwerkszeug zur Bearbeitung von Fellen zur Kleiderherstellung) auch. Die damit verbundene Vorstellung eines Weiterlebens nach dem Tod kann dann ihrerseits wieder die Bewältigung des Verlustes und der eigenen Ängste unterstützt haben – es ist nicht alles aus! Diese ersten Empfindungen der Entlastung von Ängsten, die mit der Endgültigkeit des Todes verbunden sind, müssen für unsere Vorfahren außerordentlich wohltuend gewesen sein.

Und ist ein Jenseitsglaube dann erst einmal vorhanden, lassen sich schnell weitere Details ergänzen: Die Ausstattung mit prächtigen Kleidern und Schmuck sichert dem Toten Anerkennung und die ihm zustehende Stellung auch in einer jenseitigen Welt. Aus Praktiken, die der Sicherung eines Territoriums dienten und gleichzeitig das Ansehen einer Gruppe stärken sollten, könnten auf diese Weise spekulative weltanschauliche Überlegungen über die postmortale Existenz entstanden sein, die letztlich zu ersten Vorstellungen von einem wie auch immer gearteten Jenseits führten – einem Jenseits, in dem der Verstorbene sinnvollen Gebrauch von den ihm mitgegebenen Gütern machen konnte.

5
Evolution: ein kleiner Exkurs in Sachen Wissenschaftstheorie

Was ist eigentlich Evolution?

Kaum eine wissenschaftliche Theorie hat das Denken der letzten beiden Jahr hunderte so entscheidend beeinflusst wie die Evolutionstheorie, im Jahre 1858 zum ersten Mal von Charles Darwin und seinem kongenialen Zeitgenossen Alfred Russell Wallace in einem gemeinsamen Thesenpapier, dem *joint paper*, veröffentlicht. Die Autoren machten nicht nur glaubhaft, dass die Entstehung der Arten das Resultat eines Entwicklungsvorgangs ist, der sich über riesige Zeiträume erstreckt, sondern sie konnten anders als ihre wissenschaftlichen Vorgänger auch die Mechanismen dieses Artenwandels schlüssig und nachvollziehbar erklären. Gerade dieser letzte Punkt war der entscheidende Schritt, der für die Biologie den Durchbruch in der auch damals bereits leidenschaftlich diskutierten Frage des Artenwandels bedeutete. Der große deutsche Biologe und Zeitgenosse Darwins, Ernst Haeckel (1834–1919), brachte es auf den Punkt:

> Sämtliche Naturforscher und Philosophen […] gelangten im besten Fall zu der Anschauung, dass alle verschiedenen Thier- und Pflanzen-Arten, die zu irgendeiner Zeit auf der Erde gelebt haben und noch jetzt leben, die allmählich veränderten und umgebildeten Nachkommen von einer einzigen, oder von einigen wenigen, ursprünglichen, höchst einfachen Stamm-Formen sind […]. Aber keiner von jenen Natur-Philosophen gelangte dazu, diesen Grund-Gedanken der Abstammungs-Lehre ursächlich zu begründen, und die Umbildung der organischen Species durch den wahren Nachweis ihrer mechanischen Ursachen wirklich zu klären. Diese schwierige Aufgabe vermochte erst Charles Darwin zu lösen, und hierin liegt die weite Kluft, welche denselben von seinen Vorgängern trennt. (Haeckel 1902)

Ergänzend wäre hier nur noch einzufügen: „und Alfred Russell Wallace", denn es ist letzterem zu verdanken, dass die Bedeutung von Isolationsmechanismen als entscheidend für das Entstehen neuer Arten erkannt wurde.

Wallace und die Evolutionstheorie

Den entscheidenden Schritt in Richtung Evolutionstheorie tat Wallace 1858 in seinem berühmten Essay *On the tendency of varieties to depart indefinitely from the original type*, das zusammen mit Schriftpassagen von Darwin in demselben Jahr bei der Londoner Linnean Society eingereicht und als *joint paper* veröffentlicht wurde. Hier konnte Wallace zum ersten Mal die Frage, wie aus Varietäten selbstständige Arten entstehen, schlüssig beantworten. Varietäten, so Wallace, unterscheiden sich sowohl im Habitus als auch im Verhalten von der Stammform. Diese kleinen Unterschiede genügen, die Varietäten auch unter gewohnten Umweltbedingungen mehr oder weniger erfolgreich sein zu lassen. Eine entscheidende Rolle spielt nach Wallace' Auffassung in diesem Zusammenhang die Ernährungsfrage: Die Varietäten, die das Nahrungsproblem am erfolgreichsten lösen können, werden gegenüber anderen Varietäten einen gewissen Vorteil haben; von ihren Nachkommen werden vergleichsweise weniger sterben. Da die Größe einer Population von ihrer Fähigkeit, Nahrung zu sammeln, gesteuert wird, und nicht etwa von ihrer Reproduktionsfähigkeit, wird sich die erfolgreichere Varietät auf Kosten der weniger erfolgreichen vermehren. Ändern sich nun auch die Umweltbedingungen, zum Beispiel durch Nahrungsmittelknappheit, werden Individuen aller Varietäten sterben, die weniger erfolgreichen jedoch in überdurchschnittlicher Anzahl, sodass zuletzt alle minderen Varietäten einschließlich der Stammform ausgestorben sein werden. Lediglich die erfolgreiche Varietät überlebt. Verbessert sich anschließend die Ernährungslage wieder, kann sich die überlebende Varietät bis zu einer Individuenzahl vermehren, die der Größe der Ausgangspopulation entspricht. Auf diese Art und Weise hat die ursprüngliche Varietät die Ausgangsform ersetzt und stellt nun die neue Art dar. Die Wiederholung dieses Vorgangs führt über einen längeren Zeitraum zu einer progressiven Entwicklung der Arten und zunehmender Abweichung vom Ausgangstypus.

Ebenso weitreichend wie seine Forschungen zum Artkonzept ist die Entdeckung der Funktion der Isolationsmechanismen, wie Wallace sie in seinem Artikel *On the law which has regulated the introduction of new species* zum ersten Male beschrieb. Ohne das Auftreten von Isolationsmechanismen ist eine Speziation, das heißt das Aufspalten einer Art in mehrere Tochterarten, nicht möglich. Obwohl Charles Darwin den Wandel der Arten in der Zeit schlüssig nachweisen konnte, gelang ihm keine überzeugende Analyse des Problems der Vervielfältigung der Arten, ein Versäumnis, das auf Darwins mangelndes Verständnis für das Wesen der Art zurückzuführen ist.

Populär wurde die Evolutionstheorie jedoch erst ein Jahr später mit Darwins Werk *On the origin of species*, das in gesellschaftlichen Debatten für reichlich Zündstoff sorgte, aber auch das Denken in anderen Wissenschaften befruchtete und Einzug in die Geistes- und Sozialwissenschaften hielt (vgl. Kap. 1). Heute durchzieht eine sich am allgemeinen Sprachgebrauch orientierende biologistische Terminologie wissenschaftliche wie nichtwissenschaftliche Diskurse und Publikationen gleichermaßen: Ausdrücke wie

Konkurrenz, Vererbung, Höherentwicklung und Selektion spielen eine große Rolle bei allen Prozessen, bei denen man eine wie auch immer geartete Veränderung, einen Wandel oder eine Entwicklung zu beobachten meint, sodass Schlagworte wie „Die Evolution des Universums" oder „Die Evolution der Gesellschaft" oder gar „Die Evolution der Evolutionstheorie" gang und gäbe sind, ohne dass dabei überprüft würde, ob sich die Evolutionsmechanismen, die einer postulierten gesellschaftlichen oder kosmischen Evolution zugrunde liegen sollen, von den biologischen Evolutionsmechanismen unterscheiden – und wenn ja, inwiefern!

Gerade die Frage nach dem Geltungsbereich der Evolutionstheorie ist aber von entscheidender Bedeutung in einer Zeit, in der man durch einen inflationären Sprachgebrauch glaubt, den Begriff Evolution auf alles anwenden zu können, was sich im Lauf der Zeit verändert. Hier sind Klärungen nötig. Die Evolutionstheorie – dies ist eine zwar triviale, aber dennoch wesentliche Bemerkung – ist eine biologische Theorie, das heißt, sie wurde für die Biologie formuliert, und ihr Geltungsbereich erstreckt sich auf die belebte Natur, deren Wandel in der Zeit sie erklärend beschreibt. Die Suche nach einer solchen Theorie setzte im 17. Jahrhundert ein, als sich in der Aufklärung das wissenschaftliche Interesse sämtlicher Disziplinen, vor allem auch der Geschichtswissenschaft und einer beginnenden Gesellschaftswissenschaft, historischen Prozessen zuwandte, die man zunehmend auch im Bereich der belebten Natur nachweisen zu können glaubte. Vor allem die zu jener Zeit boomende geologische und paläontologische Forschung konnte sehr bald belegen, dass die Arten keineswegs stabile Einheiten sind, sondern sich im Lauf der Geschichte, konkret der Erdgeschichte, ebenso wandeln wie die politischen Systeme im Verlauf der Menschheitsgeschichte. Die empirische Feststellung eines Artenwandels über die Zeit und die Veröffentlichung dieser Beobachtung erregte zwar ungeheures Aufsehen, stellte aber noch lange keine Theorie dar, denn die Mechanismen, die diesen Artenwandel bewirken, blieben zunächst unverstanden. Von den zahlreichen, aber durchweg noch unbefriedigenden Lösungsansätzen dieser Zeit seien hier nur Georges Cuviers Katastrophentheorie (veröffentlicht 1798), Etienne Geoffroy Saint-Hilaires Umwelttheorie (veröffentlicht 1833) und die bereits erwähnte Vervollkommnungstheorie von Jean-Baptiste de Lamarck (veröffentlicht 1809) genannt. Der Durchbruch gelang erst den oben bereits erwähnten kongenialen Biologen Alfred Russell Wallace und Charles Darwin, die in ihrem *joint paper* von 1858 die Ursachen des Artenwandels und der Anpassung analysieren und benennen konnten.

Die Aussagen der Evolutionstheorie können heute, mehr als 100 Jahre nach ihrer Erstformulierung, wie folgt zusammengefasst werden: Die Individuen einer Population unterscheiden sich in zahlreichen Merkmalen, Phänotypen vermehren sich in Abhängigkeit von den Bedingungen des jeweiligen Milieus unter-

schiedlich erfolgreich, und das Maß der Tauglichkeit ist erblich und wird von einer Generation auf die nachfolgende übertragen. Damit, so macht der große Evolutionsbiologe und Vater der Synthetischen Evolutionstheorie Ernst Mayr (1904–2005) deutlich, ist Evolution in der Biologie ein zweistufiger Prozess:

> Der erste Schritt besteht in der Herstellung von Variation in jeder Generation, das heißt von zahllosen genetischen oder phänotypischen Varianten, die als Ausgangsmaterial der Selektion dienen können; diese variable Population wird dann dem Prozeß der Auslese ausgesetzt. Dieser erste Schritt der Produktion von Variation ist vollkommen unabhängig vom tatsächlichen Ausleseprozeß, und doch wäre Selektion ohne die kontinuierliche Wiederherstellung von Variabilität nicht möglich. (Mayr 1991)

Gerade dass Evolutionsmechanismen voneinander unabhängig greifen, ist für die Aussage der Evolutionstheorie von eminenter Wichtigkeit. Es bedeutet nämlich, dass Evolution blind ist. Evolution kennt kein Ziel und schon gar keine Höherentwicklung. Eine Generation stellt eine bestimmte Anzahl von Individuen bereit, die sich aufgrund einer Zufallskombination der elterlichen Gene in entscheidenden Details unterscheiden. Die Selektion, gesteuert von den Umweltbedingungen einerseits und vom Zufall andererseits, bestimmt, welche Varietäten sich erfolgreich fortpflanzen: Nicht nur mangelnde Eignung bestimmt den Misserfolg. Auch äußere Ereignisse wie Katastrophen oder Unglücksfälle können die potenziell bestgeeigneten und erfolgversprechenden Varietäten einer Spezies ausmerzen.

Evolution im eigentlichen, das heißt biologischen Sinn ist demnach nicht nur einfach Formenwandel im Lauf der Geschichte, sondern das Ergebnis eines sehr spezifischen Prozesses. Es ist daher auch keineswegs möglich, jede Veränderung über die Zeit als Evolutionsgeschehen zu charakterisieren, wie es in den letzten Jahren Mode geworden ist. Im Gegenteil: Die Feststellung von Wandel ist nur die Voraussetzung, um die folgenden Fragen des „Warum" und „Wie" an das zu untersuchende Material heranzutragen.

Wenn also im Folgenden von Evolution menschlichen Verhaltens, von kultureller Evolution oder von der Evolution der Religionen gesprochen wird, bedeutet das zunächst nur die Beschreibung eines historischen Wandlungsprozesses, dessen Gesetzmäßigkeiten einer eigenen Betrachtung zu unterziehen sind.

Die Evolution des Menschen

Der Mensch ist allerdings zunächst nichts anderes als das Ergebnis eines biologischen Evolutionsprozesses, an dessen Anfang der gemeinsame Vorfahre von Mensch und seinen äffischen Verwandten stand. Und was aus der Retros-

Abb. 5.1 Der Stammbaum des Menschen nach Haeckel (1874). Es wird deutlich, dass Haeckel die Evolution des Menschen als Ergebnis einer zielgerichteten Höherentwicklung verstanden hat. (Aus: E. Haeckel, *Natürliche Schöpfungsgeschichte*, 1868)

pektive wie eine planvolle, zielgerichtete Entwicklung in Richtung auf den intelligenten Menschen, den *Homo sapiens* im eigentlichen Wortsinn, aussieht, ist nicht etwa ein großer Entwurf der Natur, sondern das Zufallsergebnis einer Folge von Adaptationen an wechselnde Lebensbedingungen, bei denen sich die homininen Varianten als die zumindest erst einmal weiterführende Lösung erwiesen haben (Abb. 5.1).

Das Cope'sche Gesetz

Nach Beobachtungen an Fossilreihen glaubte der US-amerikanische Paläontologe Edward Drinker Cope (1840–1897) in Evolutionslinien eine Tendenz zur Zunahme der Körpergröße feststellen zu können, wie sie sich beispielsweise bei den Pferdeartigen zeigt. Als Gründe für die Größenzunahme führte er den innerartlichen Konkurrenzkampf an, bei dem nicht nur größere Individuen kleinere dominieren, sondern zusätzlich den Vorteil ökonomischer Stoffwechselbedingungen haben. Letzteres kommt besonders in kälteren Gebieten zum Tragen.

Die Vorfahren des Menschen waren relativ große Primaten, die die Galeriewälder, offenen Wälder und baumbestandenen Graslandschaften des afrikanischen Kontinentes besiedelt haben. Eine charakteristische, auch bei anderen Fossilreihen zu beobachtende Tendenz zur Zunahme der Körpergröße nach dem Cope'schen Gesetz führte bei unseren Urahnen zu erhöhtem Nahrungsbedarf und damit zur Vergrößerung des Nahrungseinzugsgebietes, aber auch zur Entwicklung der physiologischen Voraussetzungen, weit verstreute und möglicherweise nur saisonal nutzbare Nahrungsquellen zu erreichen. Gleichzeitig ändert sich mit zunehmender Größe auch die Räuber-Beute-Beziehung: Man wird seltener Beute, ist aber in der Lage, selbst größere Beutetiere zu jagen und damit das potenzielle Nahrungsspektrum noch einmal zu vergrößern. Die mit der zunehmenden Körpergröße gleichfalls einhergehende Langlebigkeit führt im Allgemeinen zu längerer Trächtigkeit bzw. Schwangerschaft und anschließend längeren Entwicklungsphasen des Nachwuchses, was wiederum ein längeres Lernen im sozialen Kontext und damit die Weitergabe individueller Erfahrung ermöglichte; letzteres ist auch ein Ergebnis der mit der zunehmenden Körpergröße einhergehenden Hirnvergrößerung.

Erdgeschichtlich war dieser Zeitraum durch die Ausbildung des Afrikanischen Grabensystems und den Rückgang der Regenwälder infolge eines globalen Temperaturrückgangs charakterisiert, sodass sich in rascher Folge unterschiedliche und nicht dauerhaft stabile Biotope herausbildeten (Isolation). Diese wiederum erzeugten einen wechselnden Anpassungsdruck, dem die frühen Hominini mit unterschiedlichen Anpassungsstrategien begegneten, von denen der Übergang zur Omnivorie einer der erfolgreichsten war. Weit davon entfernt, erfolgreiche Jäger zu sein, haben unsere Vorfahren ihren Proteinbedarf als Aasfresser, genauer als Kleptoparasiten, gedeckt, indem sie erfolgreichen Räubern die Beute streitig machten (vgl. Kap. 2). In diesem Zusammenhang stellte die Verwendung erster Steinwerkzeuge zum Zerlegen der Kadaver einen enormen Schritt dar, der die Evolution des Menschen entscheidend beeinflusste: Ab diesem Zeitpunkt bestimmten Wechselwirkungen zwischen Mensch, Kultur und Umwelt die weitere Entwicklung der Hominini, ohne dass diese auf die Vielfalt der Anpassungsstrategien verzichteten. Die Stammbaumentwürfe der Paläoanthropologen machen deutlich, wie viele Spielarten des frühen Menschen in den vergangenen 6 Mio. Jahren Afrika und anschließend Eurasien bevölkerten und damit erfolgreich auf unterschiedlichen Selektionsdruck reagierten, auch und vor allem durch ein überproportional großes und leistungsfähiges Gehirn, das sie zunehmend unabhängiger von den rasch wechselnden Umweltbedingungen machte.

Spätestens mit diesem Zeitpunkt – der Herstellung erster Werkzeugkulturen durch den Menschen – spielt das menschliche Kulturschaffen in der Evolution eine entscheidende Rolle, indem es bedeutend zu seiner biologischen

Fitness beitrug. Zur biologischen Evolution des Menschen kommt als eine wesentliche und im Lauf der Jahrtausende zunehmend wichtige Komponente die kulturelle Evolution hinzu, und beide sind miteinander auf vielfältige Art und Weise verknüpft und beeinflussen sich gegenseitig. Spätestens zur Zeit des Neandertalers ergeben sich aus biologischer und kultureller Evolution enorme Synergieeffekte, die bei gleichzeitiger steter Verbesserung der sozialen Organisation (Familienbildung, starke Partnerbindung, Brutfürsorge, Weitergabe von tradiertem Wissen und persönlichen Erfahrungen), letztlich die Charakteristika des Menschen ausmachen, nämlich Kognition und Bewusstsein.

Damit gehorcht die Evolution des Menschen genau genommen jedoch nicht mehr ausschließlich dem biologischen Evolutionsgesetz, bei dem das Bereitstellen von Varietäten von der an das Zufallsprinzip geknüpften Kombination der elterlichen Gene abhängig und damit nicht steuerbar sein soll – soweit die synthetische Evolutionstheorie. Umso bedeutender ist die Rolle der kulturellen Evolution, die auf der Weitergabe kollektiver Erfahrungen im sozialen Kontext beruht, letztlich also wegen der Möglichkeit der Vererbung erworbener Eigenschaften (nicht aber wegen des von Lamarck postulierten inhärenten Vervollkommnungstriebes, den es nämlich auch hier nicht gibt!) lamarckistische Züge trägt.

Vermittlung von kultureller Information

Die Vermittlung kultureller Information geschieht grundsätzlich nach den Prinzipien des Lernens, insbesondere klassischer und instrumenteller Konditionierung sowie Beobachtungslernen bzw. Lernen am Modell.

Klassische Konditionierung

Klassische Konditionierung ist das Erlernen neuer Verhaltensweisen auf einen neuen, ursprünglich neutralen Reiz hin. In religionsgeschichtlicher Perspektive könnten auf diese Weise zum Beispiel Abwehrsymbole, die auf Territorialansprüche verweisen, erlernt worden sein, indem eine Sippe, die ihren Wohnort durch entsprechende Symbole gekennzeichnet hatte, mögliche Eindringlinge zusätzlich mit Waffen und Drohungen vertrieben hat. Da die Eindringlinge die Abwehrsymbole zunehmend mit der realen Erfahrung der Vertreibung verbanden, war es irgendwann für die Sippe nicht mehr notwendig, ihr Territorium ganz real zu verteidigen – bereits die Abwehrsymbole lösten bei den Eindringlingen Angst aus und motivierten sie zum Rückzug. Auf diese Weise hätten die Eindringlinge die Bedeutung spezifischer kultureller Zeichen erlernt.

Instrumentelle oder operante Konditionierung

Instrumentelle oder operante Konditionierung ist das Erlernen neuen Verhaltens durch Belohnung und/oder Bestrafung. Auch durch instrumentelle Konditionierung lassen sich kulturelle Symbole erlernen: Das konnte (und kann bis heute) durch die schlichte Vermittlung der Zeichenbedeutungen oder die Be-

lohnung und Bestrafung von Kindern durch ihre Eltern. In kollektiver Perspektive konnte die instrumentelle Konditionierung aber ebenfalls zum Erlernen kultureller Chiffren führen, wenn zum Beispiel bei Begegnungen von verschiedenen Sippen bestimmte Signale (Kleidung, Schmuck, Werkzeuge) entweder als feindlich oder als friedlich gedeutet und die Reaktionen je nachdem als Bestrafung (Kampfhandlungen) oder Belohnung (Tauschhandlungen) erfahren wurden.

Beobachtungslernen bzw. Lernen am Modell

Beobachtungslernen bzw. Lernen am Modell erfolgt vor allem dadurch, dass jemand das Verhalten eines anderen beobachtet, nachahmt und sich dadurch selbst aneignet. Dieser Prozess vollzieht sich insbesondere, wenn das beobachtete Modell attraktiv ist (in der Vorzeit z. B. ein Sippenältester oder ein erfolgreicher Jäger) und wenn der Erfolg seines Verhaltens evident ist. Verfügte ein attraktives Modell beispielsweise über Kulturwissen, das ihm die korrekte Dechiffrierung von kulturellen Zeichen erlaubte, so war es wahrscheinlich, dass andere versuchten, sich dieses Wissen und die damit korrespondieren Verhaltensweisen ebenfalls anzueignen (dieses Phänomen lässt sich heute noch an jeder Universität beobachten, an der wissbegierige Studierende ihren Professoren nicht nur im Wissen, sondern auch im Habitus nacheifern).

Die von der biologischen Evolution abweichenden Gesetzmäßigkeiten der kulturellen Evolution wurden von dem italienischen Populationsgenetiker Luigi Luca Cavalli-Sforza (*1922) im Zuge von Untersuchungen zu den Zusammenhängen von genetischer Verwandtschaft und Sprachverwandtschaft der verschiedenen Völker erarbeitet, ohne dass sich seine Erkenntnisse in den aktuellen Modellen zur kulturellen Evolution bislang niedergeschlagen haben.

Nach Cavalli-Sforza ist die kulturelle Information prinzipiell denselben Mechanismen unterworfen wie die biologische, in den Genen festgeschriebene Information. Während das Genom durch Reduplikation und Weitergabe von Generation zu Generation übermittelt wird, geht die kulturelle Information von den Nervenzellen im Gehirn eines Individuums auf die eines anderen über, wobei Abweichungen bei der Informationsweitergabe und -verarbeitung zum Auftreten von Varietäten führen. Während jedoch die genetische Informationsweitergabe durch die Rekombination des genetischen Materials der Eltern auf den Zufall angewiesen ist, sind kulturelle Veränderungen durchaus auch als gewollte und zielgerichtete Innovationen möglich. Information durch Kommunikation (verbale Kommunikation und Nachahmung) ist das Medium, mit dessen Hilfe kulturelles Wissen weitergegeben wird. Dazu gehören Techniken der Jagd und der Werkzeugherstellung genauso wie ethische Forderungen und soziale Normen, aber auch ästhetisches Verständnis, Kunst, Erzähltradition und möglicherweise eine religiöse Überlieferung: Auch die „symbolischen Formen" des Philosophen Ernst Cassirer – Sprache, mythisches Denken und Phänomenologie der Erkenntnis – sind der kulturellen

Evolution unterworfen und beeinflussen ihrerseits die weitere Entwicklung des Menschen, indem sie selbst wiederum auf die Kognition zurückwirken.

Kulturelle Information wird nicht nur vertikal, das heißt von den Eltern an die Kinder, sondern auch horizontal zwischen Angehörigen derselben oder nachfolgender Generationen weitergegeben. Eindrückliche aktuelle Beispiele sind heute die Erziehung in der Schule und die Massenmedien, bei denen die Menge der übermittelten Informationen um ein Vielfaches höher ist, als sie zwischen Eltern und Kindern ausgetauscht werden kann. Es ist also letztlich die Art der Informationsvermittlung, die über die Dynamik des Informationsflusses entscheidet. Ein vorwiegend vertikaler Informationsfluss von den Eltern auf das Kind wird eher die konservativen Tendenzen verstärken, während ein horizontaler Informationsfluss Möglichkeiten der Neuerung und des Wandels eröffnet.

In den modernen Gesellschaften hat sich die kulturelle Evolution durch die inzwischen vielfältigen Möglichkeiten der Kommunikation enorm beschleunigt. Ein fast unbegrenzter Informationsfluss ist heute mithilfe einer Vielzahl von Medien, angefangen vom Buch über Radio und Fernsehen bis zum Internet, aber auch durch die verstärkte Mobilität (Migration, Tourismus) jederzeit möglich. Gleichzeitig treten wichtige Isolationsmechanismen, angefangen von geografischer Isolation, zum Beispiel auf Inselgruppen oder in abgelegenen Gebirgstälern, bis zu religiöser Isolation durch eventuelle Meidungsgebote, in den Hintergrund.

Wie Cavalli-Sforza anhand empirischer Untersuchungen zeigen konnte, wurde kulturelles Wissen in der Geschichte der Menschheit über viele Jahrhunderte fast ausschließlich vertikal von den Eltern an die Kinder vererbt; als eine Folge wandelten sich die Kulturen unter stabilen Umweltbedingungen nur sehr langsam. Unter diesen Bedingungen gilt: Erst wenn sich Gruppen durch einen Wandel der naturräumlichen, wirtschaftlichen oder sozialen Umwelt vor neue Herausforderungen gestellt sehen, neigen sie zu verstärkter Variabilität, das heißt, sie sehen sich zu Verhaltensänderungen gezwungen, die reflektiert werden, und diese Reflexionen sind es, die sich im Kunstschaffen des Menschen ab dem Übergang von Mittel- zum Jungpaläolithikum zeigen.

An diesem Punkt kommt die Unterschiedlichkeit des Erbgangs zwischen Kultur und Biologie zum Tragen: Kultur kann auf Umweltveränderungen direkter und gezielter reagieren, die Veränderungen sind auf dem Weg der Kommunikation erheblich „fortpflanzungsfähiger", als es der langsamere biologische Fortpflanzungsgang ist, und genau das ist der Grund, warum die kulturelle Evolution hinsichtlich ihrer Auswirkungen auf die menschliche Existenz die biologische Evolution inzwischen überflügelt hat.

Die Biologie der kulturellen Entwicklung: Kulturethologie

Während Cavalli-Sforza klar die Kommunikation als den entscheidenden „Fortpflanzungsmechanismus" der kulturellen Evolution benannt hat, blieb es dem Begründer der sogenannten Kulturethologie, Otto Koenig (1914–1992), überlassen, sowohl die Dynamik als auch die Richtung des Wandels kultureller Phänomene zu beschreiben und schlüssig zu erklären. Dabei definierte er sein Fach als „eine spezielle Ausrichtung der allgemeinen vergleichenden Verhaltensforschung (Ethologie), die sich mit den materiellen und ideellen Produkten (Kultur) des Menschen, deren Entwicklung, ökologischer Bedingtheit und ihrer Abhängigkeit von angeborenen Verhaltensweisen sowie mit entsprechenden Erscheinungen bei Tieren vergleichend befasst" (Koenig 1970).

Bei seinen detaillierten Untersuchungen, beispielhaft durchgeführt jeweils an der Entwicklung von Uniformen und am Augenmotiv, gelang es ihm, eine Reihe von Regelmäßigkeiten herauszuarbeiten, die sich im Zuge der historischen Entwicklung immer wieder feststellen lassen. Dazu gehören eine Tendenz zur Beibehaltung funktionslos gewordener Objekte, die dann in den Symbol- oder Dekorationsbereich abgleiten; eine Tendenz zur sogenannten Luxurierung, was bedeutet, dass aus einfachen Linien Wellen- oder Zickzacklinien bis zu Blütenformen werden; dann der Schwund von Innenstrukturen bei Betonung der äußeren Form oder aber das genaue Gegenteil: Die Innenstruktur wird betont und die äußere Form aufgelöst. Ebenfalls tritt, vor allem bei ornamentalen Formen, regelmäßig ein Hang zur Lateralsymmetrie auf und gleichzeitig eine Tendenz zur Verarmung weniger wichtiger oder nicht wahrnehmbarer Objektteile. Eine wesentliche Beobachtung gerade im Hinblick auf Religion ist, dass ein Wandlungsstopp eintritt, wenn Kulturgüter oder Menschengruppen aus ihrer Heimat in eine fremde Umgebung geraten, was mit der Sorge um Identitätsverlust einerseits bzw. dem Erhalt des fremdländischen Reizes andererseits erklärt wird.

Ein eindrucksvolles Beispiel für den Wandel eines Motivs ist das Auge, das Koenig in *Urmotiv Auge* (1975), so der Titel seines wichtigen, die Kulturethologie begründenden Buches, vergleichend analysiert. Hier entschlüsselt er allgegenwärtige Muster und Verzierungen vom Miribota (Paisleymotiv) über die Spirale bis zum Flügel antiker Fabelwesen, die sich letztlich als stilisierte Augendarstellungen entpuppten (Abb. 5.2). Ursprung dieses Musters ist die Abbildung des aus der Verhaltensforschung bekannten drohstarrenden Auges mit gefahrenabwehrender Wirkung.

Das Drohstarren, verhaltensbiologisch hervorgegangen aus dem starrenden Blick, mit dem ein Raubtier seine Beute fixiert, bevor es zupackt und sein

Abb. 5.2 Vom zusätzlichen apotropäischen Augensymbol (Gelenkauge) zu den Flügeln von Fabelwesen. (Zeichnungen: Karolina Rupik nach Otto Koenig)

Opfer verschlingt, ruft bei dem potenziellen Opfer automatisch Angst und Schrecken hervor. Diese Wirkung machen sich Abwehrzeichen und Amulette in Augenform zunutze, die auf diese Weise, nämlich durch Drohstarren, Übles, vor allem aber auch den bösen Blick, abhalten sollen (Abb. 5.3).

Ein weiteres charakteristisches Beispiel: Der Völkerkundler Karl von den Steinen erregte zu Beginn des 20. Jahrhunderts in der Fachwelt mit einer bemerkenswerten Arbeit über seine Interpretation der Tatauierungen, mit denen sich die Marquesainsulaner schmückten (Abb. 5.4), beträchtliches Aufsehen. Eine Untersuchung der komplizierten und vielfach verschlungenen Muster ergab, dass die angeblich nur zu Zierzwecken arrangierten abstrakten Muster letztlich auf Schädeldarstellungen zurückzuführen waren. Die optische Dominanz der vielfach abgewandelten und heraldisch skelettierten Schädelmuster war eine Folge der enormen gesellschaftlichen Bedeutung des aufwendigen Begräbnisrituals in der Gesellschaft der Marquesaner, der anschließenden Verehrung der Verstorbenen und der künstlerischen Verarbeitung und Symbolisierung dieser wichtigen Ereignisse im religiösen und sozialen Leben.

Festzuhalten bleibt, dass die bildkünstlerische Vergegenwärtigung semantischer Zeichen eine eigene Evolution nach spezifischen Regeln durchläuft, die über die oben angeführten Regelhaftigkeiten hinaus mit dem Schlagwort „vom Zeichen zum Muster" charakterisiert werden kann.

Für unsere Fragestellung ist bedeutsam: Dieselben von Otto Koenig und ein halbes Jahrhundert zuvor von Karl von den Steinen beschriebenen Entwicklungen ethologischer Motive in der Kunst, die ihrerseits Rückschlüsse auf das Weltbild der Künstler zulassen, lassen sich auch in der Vorgeschichte ausmachen.

Abb. 5.3 Gefahrenabwehrendes Augenamulett im Bazar von Jerusalem. Als *staring eye* schützt es zuverlässig vor dem bösen Blick

Im Jungpaläolithikum erfüllten Frauenstatuetten mit ihren beschwichtigenden, gefahrenabwehrenden Signalen des Brustweisens und der Darbietung des Steißes apotropäische Funktionen. Im Lauf der Entwicklung dieser Form weltanschaulicher Kunst wurden die weniger wichtigen Körperteile der kleinen Venusfigürchen, das heißt also solche ohne Signalfunktion, immer weiter reduziert, bis zunächst ein Stab mit überproportioniertem Steiß und vergleichsweise kleinen Brüsten und zuletzt nur noch Steiß oder aber ein Stab ausschließlich mit Brüsten übrigblieb, bis dann endlich auch noch der ursprünglich den Körper andeutende Stab fortfiel (Abb. 5.5).

Die Evolution kulturellen Verhaltens am Beispiel der Parietalkunst

Zurück zur Parietalkunst, deren Entwicklung durch einen Qualitätsverlust gekennzeichnet sein soll, zumindest wenn man der landläufigen, bis weit in die Romantik hinein gültigen Vorstellung folgt, dass Kunst möglichst naturalistisch, das heißt perspektivisch und dynamisch, zu sein habe, ihr Ziel größt-

Abb.84. ALTER KRIEGER LANGSDORFFS. BLUETE DER SCHACHORNAMENTIK UND KUPPENMUSTER.
1804. Kupfer X. ⁴/₅ d. Orig. Vgl. S. 141.

Abb. 5.4 Ein tatauierter Krieger. (Aus: © Karl von den Steinen, *Die Marquesaner und ihre Kunst,* 1925–1928)

mögliche Schönheit sei und sie sich im Laufe ihrer Entwicklungsgeschichte auf dieses Ziel kontinuierlich zubewegt habe.

Anders ist die Entwicklung jedoch zu beurteilen, wenn man – wie hier – nicht von Vorstellungen ausgeht, die von bestimmten Sehgewohnheiten und Bewertungskriterien der Kunstgeschichte geprägt sind, sondern verhaltensbiologische und kulturethologische Erkenntnisse zugrunde legt, nach denen die jungpaläolithische Parietalkunst einerseits frühe Graffiti mit dem Ziel der Selbstdarstellung und des Imponierens ist, andererseits aber auch Projektionsfläche für ethologische Zeichen und Signale zur Kennzeichnung des Territoriums und vor allem zur Abwehr von Konkurrenten.

Diese frühe eiszeitliche Kunst entwickelte sich in den folgenden Jahrtausenden, fand zu einem anderen Stil und entdeckte vor allem ganz neue Mög-

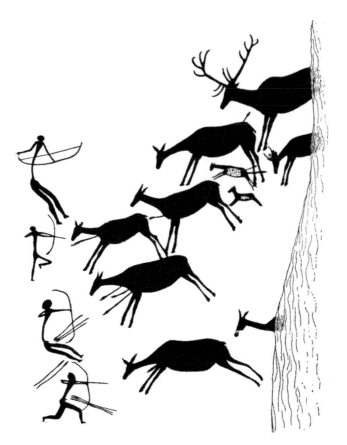

Abb. 5.5 Darstellung einer Hirschjagd in der Cueva de los Caballos. (Nach: H. Obermaier, P. Wernert, *La pinturas rupestres del Barranco de Valltorta*, 1919)

lichkeiten, nämlich die der Darstellung von Geschichten – Kunst begann zu erzählen! Weit davon entfernt, immer nur steif und unbeholfen zu sein, hatte eine inzwischen gereifte Fähigkeit zur begrifflichen Abstraktion dazu geführt, dass nicht mehr ausschließlich Individuen, sondern vielmehr Typen dargestellt werden konnten, die man nun zu Bildensembles mit bis dahin unbekannten Aussagen kombinierte: In der Cueva de los Caballos in der spanischen Levante (Valltorta-Schlucht, Provinz Castellón) wird beispielsweise eine Treibjagd dargestellt, bei der eine Gruppe wartender Bogenschützen eine Herde Rotwild stellt (Abb. 5.5). Anders als noch im Paläolithikum war der Künstler nun in der Lage, eine Begebenheit zeichnerisch darzustellen und damit für potenzielle „Leser" festzuhalten. Zu diesem Zwecke wählte er bekannte Bildelemente, die er so arrangierte, dass sie eine klare Aussage zulassen: Hier hat man so wie gezeigt Hirsche gejagt.

Der Wandel der Parietalkunst vom naturalistischen Graffito zu einem auf bekannte Stilmittel zurückgreifenden, erzählenden Bild lässt sich besonders

Abb. 5.6 Der Honigsammler aus der Cueva de la Araña. (© Achillea. Gnu Public Licence)

gut auf der iberischen Halbinsel nachverfolgen. Während im Paläolithikum naturalistische Tierdarstellungen im Vordergrund stehen und die seltenen Menschendarstellungen unbeholfen und lieblos wirken, tauchen mit dem Mesolithikum stilisierte, aber in den Proportionen perfekte Darstellungen von Menschen in Bewegung auf – häufig in gestrecktem Lauf, ausgestattet mit Waffen und Kleidung. In der Cueva de la Araña ist ein Honigsammler dargestellt, der ein Bienennest plündert (Abb. 5.6), während in Les Dogues (Bordeaux) ein Kampfgeschehen zwischen zwei Gruppen von Bogenschützen dokumentiert wird.

All diese Zeugnisse einer gewiss nicht primitiven Parietalkunst erzählen Geschichten von wichtigen Ereignissen aus dem Alltag von inzwischen mesolithischen Jägern: Treibjagden, das Sammeln besonders begehrter Nahrungs-

Abb. 5.7 Entwicklung von Menschendarstellungen mit Signalfunktion. Links: Menschendarstellungen der nacheiszeitlichen spanischen Felskunst. Rechts: Zeichen auf Kieseln von Mas d'Azil

mittel, gesellschaftliche Ereignisse (so z. B. eine Tanzszene aus dem Barranco de los Grajos) und nicht zuletzt gewaltsame, bewaffnete Auseinandersetzungen, die eines deutlich machen: Die Frage der Territorialität, des Besitzes eines Territoriums mit genügend natürlichen Ressourcen, war überlebenswichtig und durchaus Anlass für feindselige Begegnungen zwischen rivalisierenden Gruppen.

Aber auch die Tradition der bildkünstlerischen Vergegenwärtigung ethologischer Signale wird weiter gepflegt und führt – ganz im Sinne der von Otto Koenig herausgearbeiteten Regeln – zu Stilisierungen, Abstraktionen und Vereinfachungen, sodass ohne Kenntnis des Ausgangsmotivs eine sinnvolle Zuordnung und Deutung der Zeichen gar nicht möglich wäre. Bedeutsam sind in diesem Zusammenhang Darstellungen sowohl von phallischen (drohenden) Männern als auch von schampräsentierenden, also ebenfalls drohenden Frauen, die in der nacheiszeitlichen spanischen Felskunst immer wieder als bekannte Abwehrzeichen auftreten und auf Territorialbesitz aufmerksam machen. Im Lauf der Jahrhunderte erfahren sowohl Männer- als auch Frauendarstellungen eine Stilisierung insofern, als auch hier die unwichtigen Körperteile, also die ohne Signalwirkung, weggelassen werden, bis zuletzt nur noch ein Bogen für die Beine steht, ein Strich für den Penis bzw. eine Zackenlinie für Beine und Schamlippen (Abb. 5.7).

Die extrem vereinfachte Form der Darstellung sexuellen Drohens findet sich letztendlich auch als Motiv auf den Kieseln im südfranzösischen Mas d'Azil, einer bekannten und namengebenden Fundstelle des ausgehenden Paläolithikums (Azilien, ca. 14.300 bis 11.600 Jahre vor heute; Abb. 5.7). Ähnlich wie die vollplastischen, stabförmigen Frauenfigurinen des Paläolithikums dienten die mit Abwehrzeichen bemalten Kiesel als Amulette, um das Übel von ihren Trägern fernzuhalten.

6

Bedrohte Lebenswelten und Sicherung des Territoriums: Schädeldeponierungen und erste feste Siedlungen

Erste Veränderungen in Europa

Bereits gegen Ende des Paläolithikums hatte ein dramatischer Klimawandel eingesetzt: Es wurde wärmer. Die riesigen Inlandeismassen schmolzen ab, der Meeresspiegel stieg an und in Europa wichen die bisher offenen Tundren und Steppen, über die die großen Tierherden gezogen waren, dichten Wäldern, in denen Elch, Rothirsch, Reh und Wildschwein nun ein verborgenes Dasein führten. Dieser Klimawandel hatte für die inzwischen hoch spezialisierten eiszeitlichen Rentier- oder Pferdejäger einschneidende Folgen, denn die Jagd auf die Tiere in dichten Wäldern ist aufwendiger und weniger erfolgverspre-chend als die Jagd auf durchziehende Herden in offener Landschaft. Wie ein-schneidend dieser Klimawandel für die damaligen Menschen gewesen sein muss, zeigt sich einerseits am deutlichen Rückgang der Bevölkerungsdichte im ausgehenden Magdalénien (ca. 18.000 bis 12.000 v. Chr.), andererseits an dem im vorherigen Kapitel beschriebenen Wandel des einstmals so beeindru-ckenden Kunstschaffens in eine Richtung, die der heutige Betrachter, geprägt durch ein aus der Renaissance stammendes Kunstverständnis, als Niedergang deutet.

Dabei war diese Zeit des Übergangs von hoch spezialisierten und erfolg-reichen Wildbeutern hin zu sesshaften Ackerbauern keineswegs eine Periode des Stillstands. Vielmehr setzte gerade im Bereich der Geräteherstellung eine Dynamik ein, die deutlich macht, dass die Jäger auf die Veränderung ihrer Lebensbedingungen mit großer Kreativität reagierten und zu innovativen Ge-räten wie Mikrolithen (kleine retuschierte Klingen), Äxten, Quer- und Schei-benbeilen, Harpunen, Hacken, Reusen, Fallen, Netzen und Körben griffen, um in einer sich rasant veränderten Umwelt neue Nahrungsressourcen, dar-unter zunehmend Pflanzennahrung, zu erschließen.

Mit gutem Grund darf angenommen werden, dass sich der Wandel in den Lebensbedingungen zusammen mit einem durch den Anstieg des Meeres-spiegels verkleinerten Lebensraum auch im Miteinander der umherschwei-

fenden Wildbeutergruppen niedergeschlagen hat. Wie wir heute wissen und hier bereits dargelegt haben, ist Territorialität auch unter Jägern und Sammlern eine Selbstverständlichkeit und lässt sich anhand der Bestattungen und Schädeldeponierungen bereits für den Neandertaler belegen. Gerade in Zeiten, in denen nachweislich ein gewisser Bevölkerungsdruck herrscht, wird die Sicherung von Territorien und ihre Verteidigung zur Notwendigkeit. Dass dies auch für das Mesolithikum in Europa gilt, belegt das Erscheinen von ersten archäologischen Kulturen, das heißt, es gibt nun erstmals klar abgrenzbare Verbreitungsgebiete bestimmter Gerätestile, die ein starkes Indiz für eine durch die Rivalität konkurrierender Gruppen erzwungene, nachlassende Mobilität sind.

In dieses Bild passt, dass man sich altüberkommener und bewährter Symbole bediente, um die Rechtmäßigkeit territorialer Ansprüche zu belegen – der Bestattungen. Die meisten dieser Begräbnisse waren allerdings unspektakulär und unterscheiden sich nicht von den Begräbnissen im Jungpaläolithikum. Der Verstorbene wurde einzeln, oft in Seitenlage, beigesetzt und genau wie im Paläolithikum mit Grabbeigaben ausgestattet, die den Schluss nahelegen, dass man an eine Weiterexistenz im Jenseits geglaubt hat. Interessant ist in diesem Zusammenhang, dass es offensichtlich keinerlei geschlechts- oder altersspezifische Unterschiede gegeben hat: Bestattet wurden Männer, Frauen und Kinder, also nicht irgendein bevorzugter Personenkreis von möglicherweise bedeutenden oder sonst in irgendeiner Weise herausragenden Personen. Sicherlich wurden nicht alle Toten bestattet; dazu ist die Zahl der aufgefundenen mesolithischen Gräber zu klein.

Auch eine weitere, aus dem Mittel- und Jungpaläolithikum bekannte Sitte wurde beibehalten: die des Mazerierens, also des Entfleischens der Leiche. So wurden bei Schmöckwitz (Berlin) vier mit Rotsand aufgefüllte Gruben entdeckt, von denen drei Gräber waren. Die Lage der Gebeine, die sich nicht mehr im ursprünglichen anatomischen Verband befanden, deutete darauf hin, dass man die Knochen zunächst mazeriert und erst dann verschnürt und beigesetzt hat. Bei dieser Form der Bestattung könnte wieder die Hoffnung zugrunde gelegen haben, den Leichnam durch ein solches Präparieren vor dem völligen Verwesen bewahren zu können und ihm damit ein Weiterleben in einer jenseitigen Welt zu ermöglichen.

Dass jedoch auch andere alte, aus dem Paläolithikum stammende Verhaltensmuster bis ins Mesolithikum überlebten, also offensichtlich im jeweiligen sozialen Kontext überliefert wurden und dabei zum Teil starke regionale Abwandlungen erfuhren, macht eine heute befremdlich erscheinende Begräbnisform deutlich. Um 8000 v. Chr. herrschten in der Umgebung des Nördlinger Rieses, zumindest nach unserer heutigen Auffassung, offenbar dramatische Sitten. Der Tübinger Forscher Robert Rudolf Schmidt (1882–1950)

stieß in der Großen Ofnethöhle, die er in den Jahren 1901, 1905, 1907 und 1908 untersuchte, auf zwei Nester mit menschlichen Schädeln. Die reich geschmückten Schädel, die überwiegend von Frauen stammten, waren mit durchbohrten Hirschzähnen und Muscheln prächtig dekoriert. Mehr als die aufwendige Ausstattung hat jedoch die Tatsache, dass sich sowohl Unterkiefer als auch Halswirbel noch im anatomischen Verband befanden, dass die Toten also regelrecht geköpft wurden, bevor man ihre Schädel bestattete, die Fantasie von Forschern beflügelt, sodass sie sich zu Aussagen von Opfertod und Kannibalismus hinreißen ließen. Nachuntersuchungen haben jedoch bestätigt, dass es sich hier lediglich um eine Bestattungssitte handelt, deren Ursprung im Mittelpaläolithikum zu suchen und die demnach eine Abwandlung der bereits vom Neandertaler geübten Sitte ist, die Schädel der Toten einer besonderen Behandlung zu unterziehen und dann möglicherweise an prominenter Stelle zu deponieren. Auch aus dem Hohlenstein-Stadel (einer Karsthöhle des Hohlensteins) wurden mesolithische Bestattungen isolierter Schädel bekannt. Hier handelt es sich um drei Kranien (Schädel) mit anhaftenden Halswirbeln, ein Hinweis darauf, dass auch hier die Köpfe gewaltsam vom restlichen Körper getrennt wurden. Weitere vergleichbare Funde stammen von der Hexenküche im Kreis Nördlingen und vom Mannlefelsen im elsässischen Oberlarg, sodass der Schluss naheliegt, dass die hier beschriebene Form von Kopfbestattungen eine in Südwestdeutschland und angrenzenden Gebieten verbreitete Sitte war und die Schädel nach uralter Tradition Ansprüche auf ein Territorium deutlich machten.

Die Totenvorstellungen selbst gingen jedoch sicherlich bereits weit über das Dokumentieren rein territorialer Ansprüche hinaus. Die Tatsache, dass die Schädel in Höhlen deponiert worden waren und man in den Höhleneingängen Opfergaben gefunden hat, belegen, dass die Höhlen nun als Eingänge zur Unterwelt verstanden wurden, in der die Verstorbenen weiterexistierten und von den Lebenden versorgt werden mussten.

Hier ist also zum ersten Mal Religionsentwicklung direkt sichtbar und nachvollziehbar: Offensichtlich haben die Manipulationen an den Schädeln der Verstorbenen, also die noch aus dem Paläolithikum stammenden Handlungsmuster, letztlich zu Vorstellungen geführt, die wir heute der Welt des Religiösen zuordnen. Demnach hätten konkrete existenzielle Ängste um die Sicherheit und Tragfähigkeit des Territoriums in demonstrativen Handlungen, nämlich der Betonung der Rechtmäßigkeit eines Territorialbesitzes durch Schädeldeponierungen, resultiert. Diese Handlungen wurden bewusst wiederholt und ihre Wirksamkeit überprüft. Dabei wurde die Signalwirkung von konkurrierenden Gruppen offensichtlich verstanden und der Territorialbesitz mehr oder weniger respektiert. Auf diese Weise wurde der Usus der Schädeldeponierungen im Sinne der instrumentellen Konditionierung ver-

stärkt, sodass er über die Jahrhunderte erhalten blieb. Irgendwann wurde
dann vermutlich die positive Wirkung des Signals den Schädeln oder den
in ihnen weiter bestehenden Kräften der Verstorbenen zugeschrieben, über
deren Weiterleben nach dem Tod sich immer konkretere Vorstellungen he-
rausbildeten. Da die ersten, noch vagen Vorstellungen vom Weiterleben der
Toten ebenfalls mit positiven Effekten verbunden waren (bessere Bewältigung
der Trauer über den erfahrenen Verlust, Abschwächung der eigenen Angst vor
Auslöschung), wurden auch sie weitergegeben und dabei mit der Zeit immer
detailreicher ausgeschmückt. Über einen längeren Zeitraum hinweg entwi-
ckelte sich also aus der Praxis der Schädeldeponierungen ein Geschehen mit
festgelegtem und erweitertem Bedeutungsinhalt, das von allen Beteiligten als
konventionalisierter Zeichenträger verstanden wurde. Dabei half die aktive
Verarbeitung der existenziellen Ängste im Zuge einer inzwischen bereits ritua-
lisierten Form von Bestattung unseren Vorfahren, die existenzielle Bedrohung
symbolisch zu fassen, durch das eigene, aktive Handeln ein Gefühl besserer
Kontrollierbarkeit der Situation zu erlangen und damit eine innere Distanz
zum Geschehen im Warburg'schen Sinn zu gewinnen.

Zur selben Zeit in der Levante ...

Nicht nur in Mitteleuropa widmete man den Schädeln der Verstorbenen be-
sondere Aufmerksamkeit. Zur selben Zeit, in der die Wildbeuter Europas ihre
Jagd- und Sammelstrategien änderten, neue Werkzeugtechniken entdeckten
und sich im Bereich des Geistigen jenseitige Welten erschufen, in denen ihre
Toten offenbar wirkmächtig weiterexistierten, veränderten sich auch im öst-
lichen Mittelmeerraum die Lebensbedingungen der Menschen, hier aber zu-
nächst durchaus zum Positiven. Die im Zuge der Erwärmung abschmelzen-
den Gletscher und Inlandeismassen setzten nämlich weltweit enorme Wasser-
mengen frei, die in die Atmosphäre gelangten, und damit wurde das Klima
deutlich feuchter. Das heißt, dass in den heute trockenen und wasserarmen
Landstrichen des Nahen Ostens und Anatoliens zur damaligen Zeit nahezu
ideale klimatische Verhältnisse herrschten. Es mögen diese idealen Lebens-
verhältnisse gewesen sein, die es den Menschen im Epipaläolithikum – ein
Mesolithikum gibt es hier nicht; also in einer Zeit des Übergangs vom Paläoli-
thikum mit seiner noch aneignenden Wirtschaftsweise zum Neolithikum mit
produzierender Wirtschaftsweise – ermöglichten, auf das Herumschweifen zu
verzichten und sich niederzulassen. Was auch immer letztlich die Gründe da-
für gewesen sein mögen, dass um 10.000 v. Chr. Menschen in einer Region,
die als der „fruchtbare Halbmond" bekannt ist (Abb. 6.1), nach und nach
sesshaft wurden, Tatsache ist, dass in dieser Zeit von Palästina über Anatolien

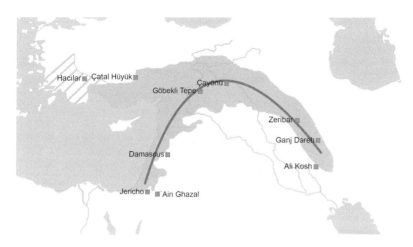

Abb. 6.1 Gebiet des fruchtbaren Halbmonds

bis in den Irak erste feste Siedlungen entstanden, deren Bewohner sich zu-
nächst noch vom Jagen und Sammeln ernährten, dann aber – möglicherweise
im Zuge eines weiteren Klimawandels in der nun wieder kälteren Dryaszeit
– zunehmend dazu übergingen, sowohl das bislang nur eingesammelte Wild-
getreide anzubauen als auch das ehemalige Jagdwild zu domestizieren – kurz,
vom Jäger und Sammler zum Ackerbauern zu werden.

Zu den frühesten festen Siedlungen gehören zwei Ausgrabungsstätten in
der Nähe Jerichos, deren Ursprünge sich bis ins zehnte vorchristliche Jahrtau-
send zurückdatieren lassen und die natürlich – wegen der geografischen Nähe
zum biblischen Jericho und dem Bericht über seine Eroberung durch Josua
– über den Kreis von Archäologen hinaus auf großes Interesse stießen. Um
es kurz zu machen: Es handelte sich bei den ausgegrabenen Stätten sicherlich
nicht um das biblische Jericho, dessen Eroberung – für die es übrigens kei-
nerlei archäologische Belege gibt – dann auch um etliche Jahrtausende später
stattgefunden haben müsste.

Beginnen wir mit Tell es-Sultan, dem Ort, der zwischen 1952 und 1958
von der britischen Archäologin und Tochter eines Bibelwissenschaftlers Dame
Kathleen Mary Kenyon (1906–1978; Abb. 6.2) ausgegraben und zunächst
fälschlich mit dem biblischen Jericho identifiziert wurde. Überraschend an
diesem Fund war für die damalige Zeit, dass diese Siedlung zwar ein völlig
neolithisches Gepräge trug, allerdings die sonst im Neolithikum allgegenwär-
tigen Tonscherben vermissen ließ. Kenyon war hier also auf etwas neues, auf
einen inzwischen als präkeramisches Neolithikum (engl. *pre-pottery neolithic*,
PPN) bekannten Horizont gestoßen, der sich weiter in PPNA und PPNB
differenzieren ließ und dem weitere, noch ältere Siedlungsphasen vorausge-
gangen waren.

Zeittafel: Kulturfolge im Epipaläolithikum und Neolithikum in der Levante

Epipaläolithikum	12 000 bis 9500 v. Chr.
Kebarien, Natufien, Khiamien	
präkeramisches Neolithikum	9500 bis 6400 v. Chr.
PPNA	9500 bis 8800 v. Chr.
PPNB	8800 bis 7000 v. Chr.
PPNC	7000 bis 6400 v. Chr.
keramisches Neolithikum	6400 bis 5800 v. Chr.
Umm-Dabaghiyah-Kultur	6000 bis 5800 v. Chr.
Hassunakultur	5800 bis 5260 v. Chr.
Samarrakultur	5500 bis 5000 v. Chr.
Übergang zum Chalkolithikum	5800 bis 4500 v. Chr.
Halafkultur	5500 bis 5000 v. Chr.
Obedkultur	5000 bis 4000 v. Chr.
Chalkolithikum	4500 bis 3600 v. Chr.
Urukkultur	4000 bis 3100/3000 v. Chr.

In Tell es-Sultan (Abb. 6.3) entdeckte Kenyon mächtige Mauern und einen Turm, auf den eine Treppe führt – architektonische Elemente, die sie zu der vorschnellen Identifikation als biblisches Jericho veranlasst hatten. Allerdings ist die tatsächliche Bedeutung dieser Bauten bis heute stark umstritten, und vor allem der im hiesigen Kontext entscheidende Fund, nämlich Begräbnisse von zwölf Individuen am Fuße gerade jener Treppe, passt nicht zu einer Verteidigungsanlage. Die Skelette blieben nicht die einzigen Funde dieser Art. Insgesamt wurden die Überreste von 491 Menschen geborgen, 200 Skelette waren vollständig erhalten.

Überraschender als die Tatsache, dass man in dieser Zeit innerhalb der Häuser bestattet hat, und zwar möglicherweise einen ausgesuchten Personenkreis von überdurchschnittlich häufig jüngeren Menschen, war, dass sich die Schädel der Toten häufig nicht mehr im ursprünglichen anatomischen Verband befanden. Man hatte sie vom restlichen Skelett getrennt und daneben niedergelegt – allerdings erst, nachdem man sie einer besonderen Behandlung unterzogen hatte. Mit einer Mischung aus Lehm und Gips hatte man die Gesichtszüge der Verstorbenen naturgetreu (?) nachmodelliert und die Augen überdies durch eingesetzte Kaurischnecken rekonstruiert (Abb. 6.4).

Abb. 6.2 Dame Kathleen Kenyon (stehend), die Entdeckerin des neolithischen Jericho. (© Vassilios Tzaferis; Creative Commons Attribution-Share Alike 3.0 Unported license.)

Die Sitte der separaten Bestattung übermodellierter Schädel blieb jedoch nicht auf Tell es-Sultan beschränkt. Auch die Nachbarsiedlung 'Ain Ghazal kann mit ähnlichen Funden aufwarten. 'Ain Ghazal entwickelte sich aus bescheidenen Anfängen im PPNB in den folgenden Jahrhunderten zu einer für damalige Verhältnisse bedeutenden Siedlung, die in ihrer besten Zeit um die 2000 bis 3000 Einwohner gehabt haben muss. Die Menschen lebten in lehmverputzten Lehmziegelhäusern mit rechteckigem Grundriss, die aus einem quadratischen Hauptraum und einem schmaleren Vorraum bestanden; der Fußboden aus einem Kalkestrich wurde offensichtlich alle paar Jahre erneuert. Zu den angebauten Feldfrüchten gehörten frühe Weizensorten, Gerste und Hülsenfrüchte. Auch die Ziege war bereits domestiziert, obwohl die Jagd auf Wildtiere noch eine große Rolle spielte. Ab 6500 v. Chr. setzte der Niedergang der Siedlung ein, vermutlich, weil die Felder wegen zu intensiver Nutzung ihre Fruchtbarkeit eingebüßt hatten.

Wie die Bewohner von Tell es-Sultan begruben auch die Bewohner von 'Ain Ghazal ihre Toten bevorzugt unter dem Fußboden der Wohnhäuser, und

Abb. 6.3 Grabungsstätte Tell es-Sultan bei Jericho. Im Vordergrund das alte Mauerwerk. (© Berthold Werner.)

wenn Verstorbene doch ihre letzte Ruhestätte außerhalb der Häuser gefunden hatten, entnahm man diesen Grabstätten später den Schädel, um ihn gesondert im Haus zu bestatten. Allerdings wurde nicht jedem Toten diese sorgsame Behandlung zuteil. Viele Skelette fanden sich zusammen mit den üblichen Hausabfällen in Abfallgruben, in denen man sie beigesetzt hatte – eine Praktik, die belegt, dass das Deponieren der Schädel wie im Paläolithikum einen besonderen Verweischarakter hatte, wobei die Praktiken nun zunehmend ausgefeilter wurden, auch, weil die mit der Behandlung des Toten einhergehenden Jenseitsvorstellungen offensichtlich komplexer wurden.

In zwei Gruben jeweils in der Nähe von Gebäuden mit möglicherweise gesonderter Funktion wurde eine Anzahl von Ganzkörperstatuetten – einmal waren es zwölf und einmal elf – sowie eine Reihe von Büsten gefunden (Abb. 6.5). Die Statuetten sind mit 80 bis 90 cm etwa halb so groß wie ein erwachsener Mensch, und die Gesichter sind mithilfe von eingesetzten Kaurimuscheln und Bitumen lebensnah nachmodelliert. Auch hier handelt es sich sicherlich um die bildkünstlerische Vergegenwärtigung von Toten im Rahmen eines Rituals. Mehr dazu in den folgenden Kapiteln.

’Ain Ghazal und Tell es-Sultan sind nicht die einzigen Siedlungen aus der Zeit des Übergangs zwischen Paläolithikum und Neolithikum, in denen sich übermodellierte Schädel und größere Statuetten fanden. Eine Reihe weiterer

Abb. 6.4 Übermodellierter Schädel von Jericho. (© Rockefeller Museum, Jerusalem)

Fundstellen gibt es im Bereich des Jordangrabens und der Ebene um Damaskus, wo entsprechendes Totenbrauchtum verbreitet war.

Illustre Bestattungssitten

Zurück nach Europa. Tatsächlich waren es vor allem die Bestattungen und die damit verbundenen, sich sukzessive entwickelnden, zunehmend konkreten Jenseitsvorstellungen, die den Menschen des Mesolithikums jenen „Denkraum der Besonnenheit", also die psychischen Möglichkeiten eröffneten, sich sowohl mit ihrer naturräumlichen Umwelt als auch mit Konkurrenten konstruktiv auseinanderzusetzen und auf diese Weise zum Schöpfer geistiger Welten zu werden. Dies zeigt besonders eindrücklich das Beispiel der Fundstätte Lepenski Vir (Serbien; Abb. 6.6).

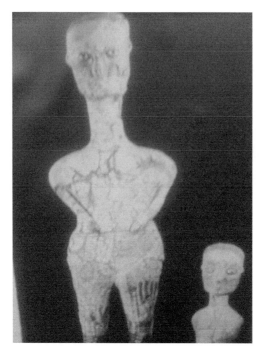

Abb. 6.5 Statuetten von 'Ain Ghazal. (© Rockefeller Museum, Jerusalem)

Lepenski Vir (6500 bis 5500 v. Chr.), im Tal des Eisernes Tor genannten Donaudurchbruchs an der Grenze zwischen Rumänien und Serbien gelegen, wurde in einer Zeit des Übergangs vom Mesolithikum zum Neolithikum besiedelt. Seine Bewohner ernährten sich noch als Jäger und Sammler, waren aber bereits sesshaft – eine Lebensweise, die durch die reichen natürlichen Ressourcen dieser Gegend möglich war. Bekannt wurde der Ort durch seine einzigartige Architektur, für die es unseres Wissens keine Parallele gibt, denn im Unterschied zu den sonst durchweg rechteckigen Hausgrundrissen neolithischer Siedlungen in Europa – in Anatolien werden wir andere Grundrisse kennenlernen – zeigten die Häuser von Lepenski Vir einen trapezförmigen, streng schematischen und genauen maßstäblichen Vorgaben gehorchenden Grundriss, der in einem ebenso strengen Siedlungsplan mit der Ausrichtung aller Gebäude zur Donau seine Entsprechung fand. Auch das Innere der zeltartigen Hauskonstruktionen zeigte eine strenge Regelhaftigkeit: Im Mittelpunkt des Heimes befand sich ein großer, sorgfältig mit Kalkplatten ausgelegter, rechteckiger Herd. Dieser Herd war offensichtlich in jeder Hinsicht das Zentrum des Hauses, denn an seiner rückwärtigen Seite waren Steine, ursprünglich Flussgerölle, deponiert worden, die aber durch Bearbeitung andere Gestalt und Bedeutung bekommen hatten. In einige dieser Geröllsteine

Abb. 6.6 Die konservierte und überdachte Ausgrabungsstätte von Lepenski Vir (Serbien). (© Philipp Weigell; Creative Commons Attribution-Share Alike 3.0 Unported license.)

hatte man Vertiefungen eingearbeitet und sie so zu Näpfchen umfunktioniert, die geeignet waren, Speisen oder Flüssigkeiten aufzunehmen, während aus anderen Geröllen Figurinen und Statuetten mit entweder anthropomorphen oder theriomorphen Zügen geworden waren.

Für den damaligen Ausgräber Dragoslav Srejovic (1931–1996) blieb die Haus- und Siedlungsarchitektur ein unverständliches Rätsel, wenn er sich auch sicher war, dass sie eine „Welt im kleinen ein mikrokosmisches Modell eines ganzen Weltbildes" (Srejović 1973) darstellt.

Wie dieses Weltbild ausgesehen haben könnte, wird allerdings unmittelbar deutlich, wenn man die Hausarchitektur in Beziehung zu den Bestattungen in Lepenski Vir setzt. Bestattet wurde, ganz den alten, noch aus Neandertalerzeit stammenden Traditionen folgend, dort, wo man auch lebte. Das war nun nicht mehr in einer Höhle oder unter einem Abri, sondern in noch zeltartigen, aber schon festen Wohnhäusern, und zwar so, dass die Toten ihre letzte Ruhestätte in unmittelbarer Nähe des zentralen Herdes unter dem Kalksteinestrich der Wohnbauten fanden. Auch die Lage der Toten ist von Bedeutung, denn sie wurden meist auf dem Rücken liegend und mit angewinkelten, aber gespreizten Beinen bestattet, sodass der Körperumriss ein Trapez bildete, und genau diese Trapezform nahm die Hausarchitektur wieder auf.

Die Hausarchitektur richtete sich demnach nach dem idealen Grabgrundriss – entscheidend beim Hausbau waren also nicht die praktischen Bedürfnisse der Lebenden, sondern der Umriss des Toten in seiner unterirdischen Welt, zu der nun nicht wie in Ofnet ein Höhleneingang, sondern der Herd den Zugang zum Totenreich darstellte. Hier am Herd fanden dann auch folgerichtig die bearbeiteten Gerölle ihren Platz, denen die Bearbeiter die Züge menschlicher Totenschädel gaben. Die eiförmigen Geröllskulpturen von Lepenski Vir erfüllen daher dieselbe Aufgabe wie die deponierten Schädel in den südwestdeutschen Höhlen, unter den Abris der jungpaläolithischen Künstler oder den Wohnstätten der Neandertaler: Sie weisen auf die Legitimität von Territorialbesitz hin. Gerade die Lage der Siedlung auf einer Flussterrasse in einem Gebiet, das reichliche Nahrungsressourcen bot, muss ein attraktiver Platz gewesen sein, dessen Besitz man anderen unmissverständlich deutlich machen wollte.

Die eiförmigen Steinskulpturen aus Flussgeröllen gehen jedoch über die bloße Nachahmung von Totenschädeln hinaus und kombinieren deren Züge mit den semantischen Zeichen, wie sie bereits von den jungpaläolithischen Venusfiguren oder von Höhlenbildern bekannt sind. In Lepenski Vir fanden sich die bereits erwähnten Kopfskulpturen mit riesigen Glotzaugen oder leeren Augenhöhlen und aufgerissenen Mäulern als Porträts der Schädel der Verstorbenen, die aber darüber hinaus auch so bekannte Abwehrgesten wie Drohstarren, Zähneblecken oder sexuelles Drohen durch Präsentieren einer grotesk vergrößerten Vulva zeigen (Abb. 6.7).

Hier zeigt die Kombination eines in einem Kunstgegenstand vergegenwärtigten Abbildes des Toten, möglicherweise auch gedacht als Sitz seiner Persönlichkeit und Kräfte, mit probaten Abwehrsignalen, dass ein solches Totenbrauchtum traditionell dazu diente, einen territorialen Anspruch zu unterstreichen: Die allgegenwärtigen Abwehrgesten wie Drohstarren, Zähneblecken und sexuelles Drohen sind geeignet, feindliche Eindringlinge zurückzuweisen, während der Hinweis auf Ahnen die Legitimität eben jenes Anspruchs unterstreicht. Es ist sicherlich kein Zufall, dass eine Gesellschaft, die gerade sesshaft geworden ist, den Anspruch auf eben erst okkupierten Ressourcen mit dem Hinweis auf legitimes Erbe einerseits, aber auch auf höhere und damit nicht mehr hinterfragbare Mächte andererseits besonders betont.

Aber zu diesem Zeitpunkt ist schon mehr gemeint, wie ein genauerer Blick auf die Rolle des Herdfeuers als Eingang zur Unterwelt deutlich macht. Der häusliche Herd war offensichtlich inzwischen zu einem heiligen Ort geworden, in dessen unmittelbarer Nähe die Toten bestattet wurden. Hier befand sich auch der Platz ihrer Vergegenwärtigung und Verehrung, wo ihnen in den Napfsteinen Speiseopfer dargebracht wurden. Ethnografische Parallelen können hier vielleicht die inhaltlichen Zusammenhänge etwas erhellen: Für die

Abb. 6.7 Schamweisende Geröllskulptur aus Lepenski Vir (Serbien). (© Mazbln; Creative Commons Attribution-Share Alike 3.0 Unported license.)

als Wildbeuter lebenden Ainu auf Sachalin gilt der Herd eines jeden Hauses als Eingang zum Jenseits und zur Unterwelt. Die Ahnengeister werden dementsprechend als die „unter dem Herd Wohnenden" bezeichnet. Zum sozialen Aspekt der herausragenden Bedeutung des Herdfeuers sagt das Handwörterbuch des deutschen Aberglaubens:

> Mit der Einbeziehung des Feuers in das Hausinnere und mit Gestaltung und Entwicklung der festen dauernden Feuerstätte im Haus selbst, geht diese Feuerverehrung vielfach und in zunehmendem Maße auf die Herdstelle und auf den Herd über, was sich übrigens nicht nur kultisch, sondern auch sozial und volksrechtlich bedeutsam auswirkt. Die Herdstelle wird dadurch einerseits zum festen, bleibenden Wohnsitz des seit Urzeiten heiligen Feuers, andererseits aber auch zum bindenden Mittelpunkt der Herdgenossen, zum Kern der festen Menschensiedlung, zum Altar und Symbol der Herd- und Hausgemeinschaft, der Familie […]. (Bächthold-Stäubli und Hoffmann-Krayer 2000)

Eine ähnliche Bedeutung scheint dem Herdfeuer in Lepenski Vir zuzukommen. Bereits in den ältesten Schichten fällt die Sorgfalt, mit der man die Feuerstelle anlegte, auf. Die baulichen Maßnahmen gingen weit über das Anlegen einer profanen Zwecken dienenden Kochgelegenheit hinaus. Die Begräbnisse der Verstorbenen in der Nähe dieser Stelle belegen überdies einen Zusammenhang zwischen Herdfeuer und Totenwelt. Letztendlich ist das Aufstellen von

Bildnissen der Toten in Herdnähe ein Indiz, dass diese Stätte als Verbindung zwischen der Welt der Lebenden und dem Reich der Toten angesehen wurde, und das bedeutet, dass jetzt klare Vorstellungen von einer Unterwelt existierten, in der die Verstorbenen weiterlebten. Nur so machen auch die Napfsteine Lepenski Virs und die Opfergaben von Ofnet Sinn: Die Toten galten als real existent und mussten weiter versorgt werden. Im Gegenzug erhoffte man sich von ihnen als den Angehörigen einer tellurischen Welt Unterstützung – dazu aber an anderer Stelle mehr.

Der Verweis auf zeitliche Kontinuität durch intramurale Bestattungen, die Kombination der Ahnenfiguren (Geröllskulpturen) mit semantischen Zeichen und die herausragende Bedeutung des Herdes einschließlich seiner Lage direkt über den Bestattungen machen deutlich, dass sich im Übergang von Mesolithikum zum Neolithikum, also von der aneignenden zur produzierenden Wirtschaftsweise und zur Sesshaftigkeit, weltanschauliche Vorstellungen ausbildeten, deren Fokus einerseits immer noch stark auf der Betonung der Territorialität, vor allem der Legitimität territorialer Ansprüche lag, in der man das bloße Dokumentieren von Territorialansprüchen aber schon weit hinter sich gelassen hatte: Was auch immer vorher als heilig gegolten haben mag – wenn überhaupt –, nun wurden es die Verstorbenen, die Bewohner einer wirkmächtigen Unterwelt, begraben an dem Ort, an dem sie gelebt hatten. Ihre Erscheinungsform als drohende Figuren macht deutlich, dass ihr Aggressionspotenzial immer noch gegen mögliche Eindringlinge gerichtet war, die den Bewohnern des Hauses ihren legitimen Besitz womöglich hätten streitig machen können, die aber gleichzeitig als apotropäische Figuren dienten, die in der Lage waren, Böses von den Dorfbewohnern fernzuhalten.

Der Herd in Volksmärchen und Sagen

Dass sich Vorstellungen von der häuslichen Feuerstelle als Eingang zur Totenwelt bis heute erhalten haben, machen Sagen und Volksmärchen deutlich, wie das von den Gebrüdern Grimm aufgezeichnete Märchen „Von einem, der auszog, das Fürchten zu lernen". In diesem Märchen wird ein junger Taugenichts, der unbedingt wissen will, was das Gruseln ist, auf ein verwunschenes Schloss geschickt, wo er von allerlei grausigen Gestalten bedrängt wird. Das Märchen erzählt:

> Wie Mitternacht herankam, ließ sich ein Lärm und Gepolter hören, erst sachte, dann immer stärker, dann war's ein bisschen still, endlich kam mit lautem Geschrei ein halber Mensch den Schornstein herab und fiel vor ihm hin. ‚Heda!‘, rief er, ‚noch ein halber gehört dazu, das ist zu wenig.‘ Da fing der Lärm von

frischem an, es tobte und heulte, und fiel die andere Hälfte auch herab. ‚Wart‘, sprach er, ‚ich will dir erst das Feuer ein wenig anblasen.‘ Wie er das getan hatte und sich wieder umsah, da waren die beiden Stücke zusammengefahren, und saß da ein gräulicher Mann auf seinem Platz. ‚So haben wir nicht gewettet‘, sprach der Junge, ‚die Bank ist mein.‘ Der Mann wollte ihn wegdrängen, aber der Junge ließ es sich nicht gefallen, schob ihn mit Gewalt weg und setzte sich wieder auf seinen Platz. Da fielen noch mehr Männer herab, einer nach dem andern, die holten neun Totenbeine und zwei Totenköpfe, setzten auf und spielten Kegel. Der Junge bekam auch Lust und fragte: ‚Hört ihr, kann ich mit sein?‘ ‚Ja, wenn du Geld hast.‘ ‚Geld genug‘, antwortete er, ‚aber eure Kugeln sind nicht recht rund.‘ Da nahm er die Totenköpfe, setzte sie in die Drehbank und drehte sie rund. ‚So, jetzt werden sie besser schüppeln‘, sprach er ‚heida, nun geht's lustig!‘ Er spielte mit und verlor etwas von seinem Geld, als es aber zwölf schlug, war alles vor seinen Augen verschwunden. Er legte sich nieder und schlief ruhig ein. (Grimm und Grimm 1977)

Dass diese Besucher aus der jenseitigen Welt, die ursprünglich die Totenwelt, aber auch die Welt der Geister und übermächtigen Wesen ist, über übernatürliche Kräfte verfügen, Zugang zu erstrebenswerten Gütern haben und sich den Lebenden gegenüber gern großzügig erweisen, macht ein Volksbrauch deutlich. Sankt Nikolaus kommt am sechsten Dezember und bringt den Kindern Geschenke – und in England benutzt er einen traditionellen Weg aus der Anderswelt: Er kommt durch den Kamin, über die heimische, ursprünglich heilige Feuerstelle, die nichts anderes ist als der Zugang zur Totenwelt.

7

Aedifico ergo sum – Ich baue, also bin ich

Bekannte Signale …

Während Europa und die Levante darin wetteiferten, ihr Territorium durch den Verweis auf die Verstorbenen und damit die Legitimität des Anspruchs auf Jagdreviere und Ackerland zu sichern, ging man zur selben Zeit in Anatolien ganz neue Wege, die sich dennoch auf alte Sitten und damit ererbte Verhaltensmuster zurückführen lassen.

Obwohl auch hier das Totenbrauchtum eine entscheidende Rolle spielte, müssen wir doch in diesem Zusammenhang zunächst auf die Bilderhöhlen und die Kleinkunst des Paläolithikums zurückkommen; auf Graffiti und ethologische Signale im Dienste einer sicheren Kommunikation, die bildkünstlerisch vergegenwärtigt wurden, sich also in der bildenden Kunst niederschlugen und so die Zeiten überdauert haben. Dies gilt vor allem für Europa. Während sich im europäischen Jungpaläolithikum eine blühende Parietal- und Kleinkunst herausbilden konnte, die uns heute einen klaren Einblick in das Lebensgefühl und das Weltbild der eiszeitlichen Jäger vermittelt, blieben die Levante und das südöstliche Anatolien in dieser Hinsicht stumm. Erst im Natufien tauchten dort figürliche Darstellungen auf, die sich aber *in puncto* künstlerischer Qualität in keiner Weise mit den Artefakten des Nordens messen können.

Berühmte Ausnahme ist eine kleine, etwa 10 cm große Figurine (Abb. 7.1), die von Beduinen in einer der Höhlen von Ain Sakhri im Wadi Khareitoun in der Nähe von Bethlehem gefunden wurde und in ein Museum gelangt war, wo sie 1933 von dem damaligen französischen Konsul René Neuville entdeckt wurde. Inzwischen ist bekannt, dass die Figur in das Natufien zu datieren ist und es sich bei dem Fundort um eine ehemalige Wohnhöhle handelt. Dargestellt ist offensichtlich ein Liebespaar beim Geschlechtsakt, bei dem sich allerdings weder Gesichtszüge feststellen lassen noch das Geschlecht den beiden Liebenden konkret zuzuordnen ist. Andererseits sind jedoch die primären Geschlechtsmerkmale selbst deutlich sichtbar: Während man von oben weibliche Brüste erkennen kann, erscheint von unten eine Vagina und in der Schmalansicht stellt die Figur einen Penis dar. Insgesamt zeigt die Fi-

Abb. 7.1 Die Liebenden von Ain Sakhri. (© The Trustees of the British Museum; mit freundlicher Genehmigung.)

gurine also in raffinierter Anordnung diejenigen Signale, die auch die deutlich älteren, sogenannten Venusstatuetten des europäischen Paläolithikums als apotropäische Amulette charakterisieren. Die gleiche Aufgabe dürfte auch dieses kleine raffinierte Kunstwerk erfüllt, darüber hinaus jedoch sicherlich auch dem Künstler große Freude bereitet haben.

Göbekli Tepe

Figurinen mit apotropäischer Funktion dürften den inzwischen mit jungpaläolithischer Kunst vertrauten Leser ebenso wenig überraschen wie Darstellungen wilder und furchteinflößender Tiere, mit denen die Menschen, die gerade im Gebiet des fruchtbaren Halbmondes sesshaft wurden, ihre Häuser genau so schmückten wie die Jungpaläolithiker des westlichen Europas ihre Höhlen und Abris oder die magdalénienzeitlichen Rentierjäger bei Gönnersdorf ihre Tontafeln. Hier wie dort waren es starke und gefährliche Tiere, Sinnbilder für Wildheit und ungebändigte Kraft, die bevorzugt abgebildet wurden.

Ähnlich in Göbekli Tepe (Abb. 7.2), jener berühmten Siedlung in der Provinz Şanlıurfa in der südöstlichen Türkei, wo der Archäologe Klaus Schmidt in verschiedenen Grabungskampagnen die Überreste einer Siedlung ausgra-

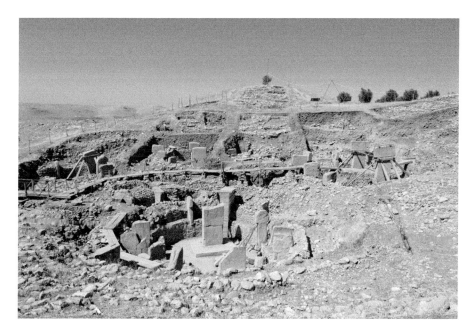

Abb. 7.2 Göbekli Tepe, Şanlıurfa. (© Teomancimit; Creative Commons Attribution-Share Alike 3.0 Unported license.)

ben konnte, die in das PPNA und PPNB datiert und damit den Anfang der sesshaften Lebensweise im südöstlichen Anatolien dokumentiert.

Der Tell, also der aus den Überresten der alten Siedlungsschichten gebildete Hügel von Göbekli Tepe, liegt auf einem etwa 750 m hohen Bergrücken in unmittelbarer Nachbarschaft der alten Stadt Şanlıurfa, dem antiken Edessa und überragt die Ebene von Harran und das Einzugsgebiet des sich aus Karstquellen speisenden Flusses Balikh, einem der Zuflüsse des Euphrat. Obwohl die Gegend heute trocken und unwirtlich erscheint, legen zahlreiche Wadis und Trockentäler nahe, dass hier vor Zeiten sehr viel lebensfreundlichere Verhältnisse herrschten und man sich das Gebiet im frühen Neolithikum üppig begrünt und bewaldet vorstellen muss. Hier also, in einer einstmals fruchtbaren und wasserreichen, heute allerdings verkarsteten Gegend, blühte zu einem Zeitpunkt, zu dem die Menschen erstmals begannen, sesshaft zu werden und dauerhafte Siedlungen zu errichten, ein Gemeinwesen, das die Forscher in mancher Hinsicht verblüffte und vor unlösbar scheinende Rätsel stellte. Am Anfang der Sesshaftigkeit, so lautete die stillschweigende Annahme, mussten leichte Behausungen gestanden haben – irgendetwas zwischen Zelt, Hütte und festem Haus, das die Entwicklung vom Leben als umherziehender Wildbeuter zum sesshaften Bauern dokumentierte, und genau diese Erwartungen

erfüllten viele protoneolithische Siedlungen auch – man denke nur an das hier bereits erwähnte Lepenski Vir. Anders in Göbekli Tepe: Hier fanden sich kreisrunde Grundrisse mit Mauerwerk, in das in regelmäßigen Abständen massive Stützpfeiler aus hartem Kalkstein eingelassen waren. Im Zentrum der Gebäude standen in gewissem Abstand und einander genau gegenüber zwei weitere mächtige Stützpfeiler, auf die noch zurückzukommen sein wird. Zunächst aber einmal zu den Gebäuden selbst. Ihr oft aus zwei konzentrischen Mauern bestehender Grundriss ist nicht rechteckig, sondern rund, mit einem gelegentlich massiven, U-förmigen Eingangsbereich, und rief damit automatisch Assoziationen mit den riesigen bronzezeitlichen Kreisgrabenanlagen vom Typ Stonehenge hervor.

Nichts ist so verführerisch wie eine Assoziation, die sich ohne Schwierigkeiten in ein gesichertes Hintergrundwissen einzufügen scheint und den kulturfremden Betrachter damit leicht auf eine irreführende Fährte lockt. So auch hier. Die kreisrunde Anlage, die tonnenschweren, teilweise mit martialisch wirkenden Tierfiguren geschmückten oder übergroße Menschen imitierenden Pfeiler konnten nur eines bedeuten: Hier war man auf frühe Tempel gestoßen. Nur die Macht des Religiösen konnte Menschen zu dieser enormen Arbeitsleistung bringen, und da sich keine Bildnisse fanden, die als Idole, also Götterbildnisse, hätten gedeutet werden können, mussten die mit Tierreliefs verzierten Pfeiler Totempfähle sein.

Visuelle Wahrnehmung

Wahrnehmung erfolgt immer innerhalb von Gewohnheiten, durch die das Wahrgenommene bereits auf eine bestimmte Weise interpretiert wird. An einem einfachen Beispiel zur visuellen Wahrnehmung lässt sich das leicht veranschaulichen: Die meisten Menschen sehen in der Abb. 7.3 ein weißes Dreieck, das sich vor drei schwarzen Quadraten und zwei schwarzen Linien befindet, hinter denen nochmal ein weißer Hintergrund liegt. Tatsächlich entsteht dieses Bild jedoch nur dadurch, dass Form und Anordnung der schwarzen Flächen und Linien den Eindruck eines davor befindlichen weißen Dreiecks hervorrufen. Wir konstruieren das Dreieck, weil Dreiecke in unserer Wahrnehmung (über Geometrie, Bauformen, Verkehrsschilder u. a.) so fest verankert sind, dass bereits die Anzeichen von Konturen eines Dreiecks von uns gedanklich in einer Weise ergänzt werden, dass wir das Dreieck tatsächlich sehen.

Auch in der Wissenschaft existieren „Sehgewohnheiten", die durch das oft ja ausgesprochen reiche Vorwissen zustande kommen. Sie können dazu führen, dass steinzeitliche Gebäudereste, die vermeintliche Ähnlichkeiten zu religiösen Bauwerken aufweisen, vorschnell als Zeugnisse von Religion gedeutet werden – obwohl außer den Sehgewohnheiten eigentlich gar nichts dafür spricht.

Abb. 7.3 Ein Dreieck, das gar nicht da ist. Unsere Wahrnehmungsgewohnheiten lassen uns oft etwas sehen, das bei gründlicher Betrachtung nicht gegeben ist

Trotz der kreisrunden Grundrisse und der massiven Pfeiler, die nach Ansicht des Ausgräbers keinerlei architektonische Funktion hatten, und trotz der sorgfältigen Bearbeitung und aufwendigen Verzierung der Pfeiler, die ein Gewicht von mehreren Tonnen haben und deren Beschaffung einen enormen Arbeitsaufwand bedeutet haben muss, sind die einzelnen Strukturen im Gesamteindruck jedoch bemerkenswert zierlich: Mit einem Durchmesser von etwa 10 m taugen die meisten der kreisförmigen Anlagen kaum dazu, ein großes Festpublikum aufzunehmen, sondern entsprechen in ihren Maßen dem, was man von einem Wohnhaus erwarten würde – und was auch der Größe anderer neolithischer Wohnhäuser entspricht. Und tatsächlich handelt es sich bei genauer Beleuchtung der Fakten bei den Gebäuden auch um Wohnhäuser, deren Mittelpfeiler dazu dienten, die Dachkonstruktion zu tragen (Abb. 7.4 und 7.5).

Ist aber erst einmal der gedankliche Schritt vollzogen, dass es sich bei Göbekli Tepe nicht um einen Kultplatz handelt, der in isolierter Lage weitab von jeder Wohnbevölkerung liegt, entfallen auch die Fragen, warum es so viele Tempel an einem Platz gegeben haben soll, welches der Einzugsbereich einer solchen Tempelanlage gewesen sein könnte und wo die Menschen während der Feierlichkeiten kampiert haben könnten. Göbekli Tepe ist also tatsächlich eine frühe Siedlung, deren älteste Schicht (die hier beschriebene Schicht III aus den Jahren 9600 bis 8800 v. Chr.) eine der ältesten festen Siedlungen der Menschheit dokumentiert. Und die Architektur dieser festen Siedlungen orientierte sich offensichtlich nicht an den leichten zeltähnlichen Hütten umherstreifender Jäger, sondern an den althergebrachten festen, wetterbeständigen Unterkünften in Höhlen und Abris. Und genau an diese Welt der Jäger erinnert auch das Kunstschaffen ihrer Bewohner.

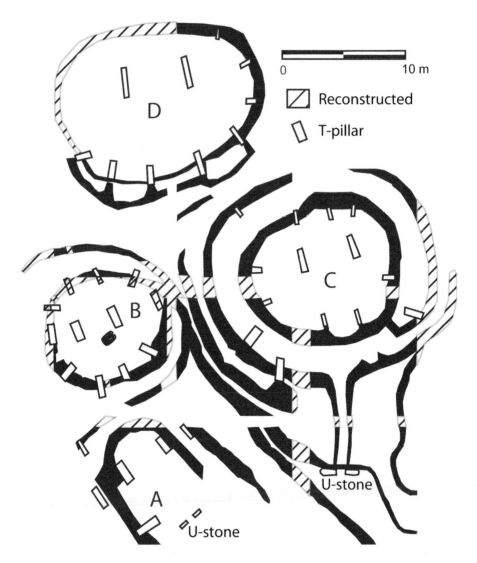

Abb. 7.4 Gebäudegrundrisse des Grabungshorizontes III von Göbekli Tepe. (Mit freundlicher Genehmigung von Prof. Dr. E. B. Banning. Aus: Banning EB (2011) So fair a house. Göbekli Tepe and the identification of temples in the pre-pottery neolithic of the near east. *Curr Anthropol* 52: 619–660)

Schöner wohnen

Wie in den paläolithischen Bilderhöhlen auch haben frühe Künstler nun, in einer Zeit des Übergangs vom Jäger zum Ackerbauern, einen Teil ihrer Arbeitskraft darauf verwandt, einen Mehrwert zu produzieren: einerseits starke und dauerhafte Behausungen, die möglichen Konkurrenten deutlich

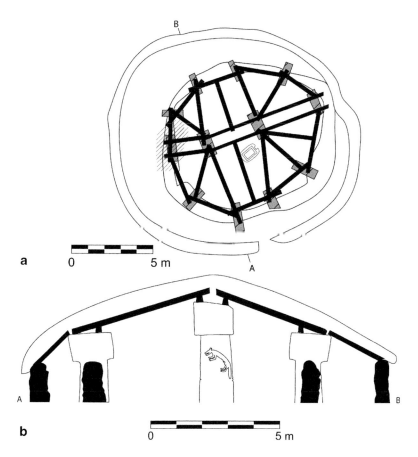

Abb. 7.5 Dachrekonstruktion bei einem Hausgrundriss in Göbekli Tepe. **a** Aufriss und **b** Querschnitt auf Höhe der tragenden Mittelpfeiler. (Mit freundlicher Genehmigung von Prof. Dr. E. B. Banning. Aus: Banning EB (2011) So fair a house. Göbekli Tepe and the identification of temples in the pre-pottery neolithic of the near east. *Curr Anthropol* 52: 619–660)

machten, dass man dieses Gebiet für sich beanspruchte und dauerhaft in Besitz zu nehmen gedachte, die jedoch auch ganz einfach soliden Schutz vor den Unbilden der Witterung boten, andererseits aber diese Wohnungen verschönerten und verzierten. Auch hier galt wieder, genau wie in den Bilderhöhlen, dass die Kunstwerke Gefühle zum Ausdruck bringen und inneres Erleben materialisieren sollten; ein inneres Erleben, das die geistige Auseinandersetzung mit einer Umwelt widerspiegelt, die für den Menschen, der einerseits noch immer auf den Jagderfolg angewiesen war und sich mit gefährlichen Wildtieren auseinandersetzen musste, der sich aber andererseits bereits in einem Prozess der Domestikation befand, zunehmend unheimlicher und furchtein-

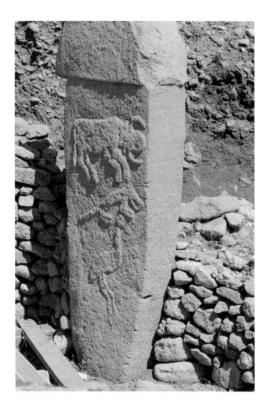

Abb. 7.6 Pfeiler in Göbekli Tepe mit Darstellung eines Rindes, eines Fuchses und eines Vogels. (© Teomancimit; Creative Commons Attribution-Share Alike 3.0 Unported license.)

flößender erschien und den Charakter von gefährlicher Wildnis im Gegensatz zu den vertrauten und sicheren häuslichen Gefilden annahm.

Dementsprechend finden sich auf den Pfeilern der Hauskonstruktionen gerade jene Tiere wieder, die einerseits wichtige Jagdbeute, sei es für die Ernährung, für die Kleidung oder als Trophäe, andererseits auch wegen ihres furchteinflößenden Wesens Ausdruck von Macht und Stärke sind. Dazu gehört sicherlich der Auerochse als wichtige Nahrungsressource und gleichzeitig gefährlicher Gegner, dazu gehört aber auch der Leopard als wehrhaftes Raubtier, der sich immer wieder allein oder in unterschiedlicher Vergesellschaftung auf den Stelen wiederfindet. Auf weitere Tiere muss an dieser Stelle hingewiesen werden, die sich sowohl an den Stelen von Göbekli Tepe als auch auf den Wänden anderer neolithischer Häuser immer wieder findet: Vögel und Füchse (Abb. 7.6). Beide sind auch Aasfresser, die das Fleisch von Kadavern, ob Tier oder Mensch, picken und fressen. Dass diese Tiere im neolithischen Weltbild eine herausragende Rolle spielten, lässt sich in Göbekli Tepe zwar feststellen; über die Art dieser Rolle muss an dieser Stelle jedoch spekuliert

Abb. 7.7 Ithyphallisches Protom von Göbekli Tepe. (Zeichnung: Karolina Rupik nach Klaus Schmidt.)

werden. Es ist letztlich der Umgang mit dem Tod, dieser zweiten großen Säule neolithischer Weltanschauung (vgl. vor allem auch das folgende Kapitel), der diesen Tieren zu ihrer überragenden Bedeutung verhalf, eine Bedeutung im Übrigen, die sich bis in den Götterglauben der Antike hinein erhalten hat. In Ägypten ist es der schakalköpfige Gott Anubis, der Gott der Totenriten, der die Erinnerung an ältere weltanschauliche Vorstellungen spiegelt, in Europa der germanische Gott Wotan, der Herr des Wilden Heeres (ein Heer von Toten!), auf dessen Schultern die Raben Hugin und Munin sitzen.

Als weiteres wichtiges Motiv tauchen immer wieder Keiler auf – Tiere, die als Fleischlieferanten ebenso wichtig waren wie als Gegner gefährlich –, aber auch Raubtiere, Schlangen oder Skorpione spielen als Motive auf den Stelen eine wichtige Rolle.

Um das uns bekannte Szenario an bedrohlichen Zeichen mit Signalfunktion zu vervollständigen, fanden sich auch in Göbekli Tepe der drohende Phallus sowie die gleichfalls drohende, schampräsentierende Frau, die deutlich machen, dass man auf das Repertoire an drohenden und abwehrenden Zeichen noch nicht verzichten konnte (Abb. 7.7 und 7.8).

Abb. 7.8 Ritzzeichnung einer schampräsentierenden Frau, gefunden im sogenann-ten Löwenpfeilergebäude in Göbekli Tepe. (Zeichnung: Karolina Rupik nach Klaus Schmidt.)

Dass es hier in der Tat in erster Linie um Drohen und Abwehren ging, belegen nicht nur die bekannten sexuell drohenden Menschenabbildungen, also die klassischen Wächterfiguren, sondern auch der Vergleich mit einer Hausdekoration, die erheblich jünger und einer ganz anderen Epoche und Kultur zuzuordnen ist – ein Mosaikfußboden aus einem römischen Haus in Antiochia (Abb. 7.9). Hier wird ein Angriff auf den bösen Blick thematisiert. Gedroht wird hier mit einem ithyphallischen Zwerg, einem Hund, einem kat-zenartigen Raubtier, der Schlange und dem Skorpion, also bewährten Wäch-terfiguren, die ihren Weg als kulturelles Erbe aus der Steinzeit über die Antike bis an mittelalterliche Kathedralen gefunden haben.

Dieser hier geschlagene Bogen vom Neolithikum über die römische Antike bis zum Mittelalter Westeuropas und darüber hinaus illustriert eindrucksvoll eine Erkenntnis, die kaum hoch genug einzuschätzen ist: Noch während der Steinzeit, konkret im Verlauf des Neolithikums, entstand aus den Signalen und Zeichen nonverbaler Kommunikation, wie wir sie bereits aus dem Ver-halten von Primaten kennen, ein Repertoire an unheilabwehrenden Bildern und Zeichen. Diese reichhaltige Sammlung entfaltete ihre Wirkmächtigkeit nicht nur in der Zeit ihrer Erschaffung, sondern bewährte sich über Jahr-tausende und wurde von Generation zu Generation weitergegeben. Im Neo-lithikum entfalteten tierische Wächterfiguren mit gebleckten Zähnen, Phal-lus und gefährlichen Hörnern ihre unheimlichen Abwehrkräfte genau wie im vergleichsweise historisch nahen Mittelalter (Abb. 7.10).

Abb. 7.9 Römisches Mosaik aus dem Haus des bösen Blicks in Antiochia. Hier findet sich eine beeindruckende Sammlung bedrohlicher Kreaturen: Rabe, Hund, Katze, Schlange, Skorpion, Tausendfüßer und Zwerg mit groteskem Penis. (Archäologisches Museum Antakya. © Roland und Sabrina Michaud/akg-images.)

Noch ein weiterer Faktor ist jedoch von enormer Wichtigkeit. Nicht nur die Signalwirkung der steinzeitlichen Motive blieb über Generationen erhalten, sondern noch mehr. Die ursprünglich apotropäischen Reliefs und Figurinen wurden im Zuge der kulturellen Evolution zu selbstständigen Bedeutungsträgern, die ein Eigenleben entwickelten. Der Erfolg der obszön schamweisenden Frauengestalt als Abwehrfigur war so durchschlagend, dass die positive Wirkung nicht mehr auf das eigentliche Signal, sondern auf ihre Trägerin, die Figurine, zurückgeführt wurde. Und genau damit begann die Entstehung einer übermächtigen Frauengestalt, der sogenannten Urmutter, die das Wohlergehen derjenigen Menschen, die sie beschützen sollte, beeinflusste und von der im übernächsten Kapitel ausführlicher die Rede sein wird. Als Motiv hat sich die schamweisende Frau kulturgeschichtlich bis in die Mythologie gehalten. Ihre Darstellungen zieren als sogenannte Sheela-na-Gig noch die Außenwände (Abwehrfunktion) mittelalterlicher englischer und irischer Kirchen.

Çayönü Tepesi – vom Jägerlager zum Dorf

Göbekli Tepe ist nicht die einzige Siedlung des präkeramischen Neolithikums, die über die Grenzen eines kleinen Kreises von Archäologen hinaus Furore machte, sondern reiht sich ein in eine Reihe anderer spektakulärer

Abb. 7.10 Gefährliche und wehrhafte Tiere als Wächterfiguren. Bären mit Phallus als Wächter im Rathaus von Appenzell/Schweiz.

Funde in Anatolien, die langsam aber sicher den Fundstätten der Levante den Rang abzulaufen drohen. Unter diesen Fundorten nimmt vor allem das intensiv erforschte und oft auch kontrovers diskutierte Çayönü eine herausragende Stellung ein, weil hier eine ungestörte Schichtfolge die entscheidende Phase des Übergangs von einer Wildbeuter- zu einer Ackerbaugesellschaft deutlich macht und weil die sorgfältige Erforschung dieser Fundstelle zeigt, dass viele der rasch durchgeführten und nur auf eine kleine Fläche beschränkten Rettungsgrabungen anderer neolithischer Siedlungen jeweils nur verkürzte Einblicke zuließen und damit zu vorschnellen Urteilen und unrichtigen Ergebnissen führten.

Çayönü liegt am Rande des Taurusgebirges an einem Nebenfluss des Tigris in der türkischen Provinz Diyarbakır und wurde nach seiner Entdeckung 1963 von 1964 bis 1991 in drei großen Kampagnen von einem internationalen Team ausgegraben. Bis heute werden neue Ergebnisse, angefangen von der

Baugeschichte bis zur Archäozoologie, veröffentlicht und ermöglichen intensive Einblicke in das Leben vor mehr als 10.000 Jahren.

Hinsichtlich der naturräumlichen Umgebung waren die Verhältnisse um Çayönü als Lebensraum für den Menschen geradezu ideal. Wo heute aride Klimabedingungen herrschen, bedeckten im Neolithikum offene Eichenwälder die Landschaft. Weiter im Süden erstreckte sich eine Graslandschaft mit Mandel- und Pistazienbäumen, mit wilden Linsen und anderen Hülsenfrüchten sowie den Wildgetreiden Emmer und Einkorn. Zahlreiche Quellen sorgten für ausreichend Wasser, und Lagerstätten lieferten das Material für die notwendigen Steinwerkzeuge. Neuere Studien zeigen, dass die Gegend überdies reich an Wild war: Wildschwein, Wildrind, Wildschaf und Wildziege sowie Reh, Hirsch, Gazelle, Wildesel und Pferd bevölkerten die Ebenen, während die Raubtiere mit Bär, Leopard, Fuchs, Marder, Wiesel und Dachs vertreten waren. Biber, Igel und zahlreiche Vogelarten runden das Bild eines vorzeitlichen Paradieses ab.

In dieser ressourcenreichen Landschaft ließen sich um 10.200 v. Chr., also etwa während der präkeramischen Phase A (PPNA) von Jericho, Wildbeuter nieder, die über einem leicht in den Untergrund eingetieften (semisubterranen) Grundriss runde Hütten aus Lehmflechtwerk mit einem Durchmesser bis zu 5 m errichteten (eben genau die Art von Hütten, die man auch in Göbekli Tepe erwartet hätte). Die Hütten selbst gruppierten sich um gleichfalls runde Flächen mit Feuerstellen.

Darauf folgte eine weitere Siedlungsschicht, wegen der charakteristischen Fundamente ihrer Häuser als Grillplanphase bezeichnet (PPNA und frühes PPNB; 9400 bis 9100 v. Chr.), bestehend aus einer Reihe von rechteckigen, im Grundriss ca. 5,5 mal 11 m messenden Häusern in nord-südlicher Orientierung mit charakteristischer Aufteilung: drei kleinen Zellen im Süden, einem gepflasterten Raum, vermutlich der Wohnbereich mit der Herdstelle in der Gebäudemitte, und einem nördlichen Teil mit eben jenen charakteristischen parallelen Mauerstreifen, die an einen Grillrost erinnern, der möglicherweise das Fundament für einen hölzernen Fußboden darstellte. In diesem Gebäudeteil fanden handwerkliche Aktivitäten statt, wie Materialreste aus Knochen, Reißzähnen und Stein sowie Werkzeuge für die Bearbeitung feinerer Werkstücke deutlich machen. Schwereres Gerät wie Mörser wurden dagegen vornehmlich im zentralen Raum mit der Feuerstelle gefunden. Obwohl die freien Plätze zwischen den Hütten nun deutlich kleiner geworden waren, fanden hier offensichtlich immer noch Aktivitäten um die Nahrungszubereitung statt, eine Nahrung, die aus Reh und Hirsch, Wildschwein, Wildrind sowie den wilden Formen von Schaf und Ziege bestand. Auch wilde Hülsenfrüchte wurden gesammelt und ergänzten den Speisezettel.

Ein entscheidender Wandel sowohl der Lebensverhältnisse als auch der Bestattungssitten fand in der darauffolgenden Subphase statt, in der die ursprünglich geradlinigen, grillähnlichen Fundamente zunächst die Gestalt von Mäandern annahmen und sich dann zu einer von Kanälen durchzogenen steinernen Plattform entwickelten, der die darauffolgende Schicht den Namen „Kanalplanphase" (9100 bis 9000 v. Chr.) verdankt. Auch das äußere Erscheinungsbild der Gebäude ändert sich von ovalen Hütten hin zu rechteckigen Gebäuden, bei denen nur noch die abgerundeten Ecken auf die ursprüngliche Bauweise hindeuten, während zuletzt auf gemauerten Fundamenten regelrechte Sockel aus Lehmklumpen und Steinen die Dachkonstruktion trugen. In dieser Phase wurden die Gebäude für alle Aktivitäten einschließlich des Zuschlagens von Steinwerkzeug genutzt. Auch zeigen sich Ansätze erster Arbeitsteilung insofern, als nun erstmals spezialisierte Ateliers auftraten, in denen man sich der Herstellung von Perlen, Flintwerkzeugen oder der Bearbeitung von Reißzähnen widmete.

Auch die Siedlungsstruktur erfuhr eine Veränderung insofern, als die Wohn- und Produktionsstätten nun in ost-westlicher Ausrichtung im Westen der Siedlung lagen, während im Osten ein ca. 1000 m² großer Platz für gemeinsame Veranstaltungen zur Verfügung stand. Während der Kanalplanphase stand dort das sogenannte *skull building* (Schädelgebäude), eine gemeinschaftliche Begräbnisstätte in Form eines Totenhauses.

Parallel zu dieser Entwicklung hatte sich die Wirtschaftsweise entscheidend gewandelt – erste Schritte von der aneignenden zur produzierenden Wirtschaftsweise wurden gemacht, wie eindeutige Spuren von Schweinehaltung belegen. Zu den Hülsenfrüchten trat nun auch Wildgetreide mit auf den Speiseplan.

Die nächstjüngere Phase 3, gleichfalls PPNB, ist gekennzeichnet durch das Auftreten von *cobble-paved buildings*. Wie der Name nahelegt, zeichnen sich die dreiteiligen *cobble-paved-buildings* (Kopfsteinpflastergebäude) durch einen mit Steinchen gepflasterten Fußboden aus, der von Wänden begrenzt wurde, die man aus einem vergänglichen Material auf einem steinernen Sockel errichtete. Erst die Zellplangebäude, bei denen das mehrkammerige Untergeschoss einem Netz von Mauern auflag, hatten ein aus Lehmziegeln aufgemauertes Obergeschoss, waren also zweigeschossig. Die hier gefundenen Werkzeuge, darunter Sicheln mit dem typischen, beim Schneiden von Gräsern entstehenden Silikatglanz, machen deutlich, dass nun zunehmend Getreide geerntet wurde. Auch Schaf und Ziege nahmen auf dem Speisezettel einen merklich größeren Raum ein, während Schweineknochen verschwunden waren.

In der Endphase (Phase 4) der akeramischen Kulturstufe, also einer Zeit der Sesshaftigkeit ohne die sonst so charakteristischen Tongefäße (dem PPNC von Jericho), wurden dann letztendlich Großraumgebäude aus geschichteten

Steinen errichtet. Die bis dahin auffälligen Sondergebäude, über die noch zu sprechen sein wird, fehlen gänzlich. Dieses Fehlen sowie eine Reihe anderer Indizien haben die Ausgräber veranlasst, einen Übergang von kommunalem Besitz zu persönlichem Eigentum anzunehmen.

Çayönü und der Tod

Nicht nur der Übergang vom jagenden und sammelnden Wildbeuter zum nutztierzüchtenden und getreideanbauenden Bauern oder die Entwicklung der Baukunst von ersten Rundhütten aus Zweigen mit eingetieftem Grund über ovale Hütten mit gemauerten Sockeln bis zu Lehmziegelbauten auf sorgfältig ausgeführten Fundamenten machten die Entdeckung von Çayönü zu einer Sensation, sondern auch der Umgang seiner Bewohner mit dem Tod, und auch hier lässt sich eine charakteristische Entwicklung nachverfolgen.

Während der Rundbauphase waren die Bestattungen durchweg unauffällig. Die Toten wurden ohne Beigaben in Gruben auf freien Plätzen oder innerhalb der Häuser bestattet; allerdings zeigt die einheitliche nord-südliche Ausrichtung der Toten mit Blick in Richtung Westen einen bewussten Umgang mit dem Tod, dem vermutlich Vorstellungen über eine Welt der Toten zugrunde lagen.

Auch während der folgenden Grillplanphase änderten sich die Begräbnissitten kaum. Die Toten wurden entweder in Gruben außerhalb der Häuser auf Siedlungsgelände in Kauerhaltung mit zum Erdboden weisenden Gesicht beigesetzt, oder aber sie fanden ihre letzte Ruhestätte unter dem Fußboden der Wohnhäuser. Beigaben waren nun kleine Stückchen von Ocker oder aber auch Steinwerkzeuge; gelegentlich fanden sich auch Halsketten, die man den Verstorbenen vor der Beisetzung nicht abgenommen hatte. Allerdings waren die Bestattungssitten wohl nicht verbindlich, denn zur gleichen Zeit finden sich auch Beispiele abweichender Bräuche: So hat man ganz offensichtlich gelegentlich auch die Schädel der Toten zunächst eine Weile im Hause, und zwar im Bereich für die handwerkliche Nutzung, aufgestellt, bevor man sie endgültig auf den Freiflächen zwischen den Häusern beisetzte.

Nicht alle Toten wurden jedoch in oder zwischen den Häusern bestattet, im Gegenteil. Der Tod hatte in Çayönü eine große Bedeutung, die sich in kollektiven Bestattungsaktivitäten niederschlug. Und hier sind wir bei einem besonderen Punkt, der Çayönü so interessant macht: In der ersten dauerhaften Siedlung der Menschheit hatten die Bewohner große Gebäude errichtet, die offensichtlich nicht profanen gemeinschaftlichen Zwecken dienten. Dazu gehört ein Sondergebäude am Rand einer 1000 m^2 großen Freifläche, das *flagstone building* im Osten der Siedlung, das vermutlich gemeinschaftlichen

Abb. 7.11 Das *skull building*, Ort kollektiver Bestattungen. (© Krähenstein; Creative Commons Attribution-Share Alike 3.0 Unported license.)

kultischen Ereignissen diente. Es handelte sich hier um einen großen, mit Kalksteinplatten ausgelegten Raum, in dessen Mitte zwei Kalksteinplatten stelenartig aufgerichtet worden waren.

Genau hier am Rande der Freifläche hatte man auch ein weiteres Sondergebäude, das *skull building* errichtet (Abb. 7.11), in dem unter einem sogfältig ausgelegten Fußboden zwei kellerartige Hohlräume für Bestattungszwecke angelegt worden waren. Hier fanden sich in einem der Kollektivgräber die Reste von Primärbegräbnissen, das heißt, man hat hier die Verstorbenen gleich nach ihrem Tod ohne weitere Behandlung bestattet, während die andere Grube vorwiegend Schädel, also die Überreste von Sekundärbestattungen, enthielt. Die Ausgräber glauben anhand von Indizien sagen zu können, dass die Schädel wohl zunächst in diesem Gebäude in Regalen aufgestellt worden sind. Im Gebäude selbst fand sich noch eine altarähnliche Steinplatte, während menhirartige Steinsetzungen die an das Gebäude angrenzenden Freiflächen einfassten. Am Ende seiner Nutzung wurde das Gebäude nicht einfach aufgegeben, sondern säuberlich verfüllt, also selbst quasi bestattet.

Dieses „Begraben" von Sondergebäuden verlief, wie Ausgrabungen auch an anderen neolithischen Plätzen zeigen, immer nach einem bestimmten Muster. Das Gebäude wurde zunächst gereinigt und so weit wie möglich zerstört, einstmals aufgerichtete Steine umgelegt und ihre Spitze abgeschlagen, die Türen versperrt. Zuletzt wurden die Überreste mit sauberer, gesiebter Erde oder Asche verfüllt. Wurde auf dem so vorbereiteten Grund ein neues Sonder-

gebäude errichtet, so wurde sein Grundriss gegen den des Vorgängers leicht versetzt.

Aber nicht nur hinsichtlich des Abrisses der Gebäude, die regelrechten Bestattungen ähnelten, entwickelten sich Traditionen. Auch die Sondergebäude selbst gleichen sich über die Grenzen einzelner Ortschaften und Regionen hinaus – so in Çayönü, Beidha (Jordanien), Quermez Dere und Nemrik 9 (beide Irak). Charakteristika dieser Gebäude sind ihre sorgfältig angelegten Fußböden über traditionell eingetieftem Grundriss, die von Pilastern gestützten Wände, monumentale menhirartige Steinsetzungen im Inneren und flache Becken. Es wundert daher nicht, dass das oben besprochene Göbekli Tepe zunächst als Kultstätte angesprochen wurde, bevor man den Behausungscharakter der einzelnen Gebäude realisierte.

Aber zurück zu Çayönü. Während der Phase der *cobble-paved buildings* errichtete man im Osten der Siedlung eine Freifläche, die alltäglichen Aktivitäten, vielleicht gelegentlich auch besonderen Zwecken diente, denn sie wurde sorgfältig gepflastert. Umgeben war dieser Platz von den erwähnten Sondergebäuden: im Südosten vom *skull building* und einem angeschlossenen Gebäude mit nur einem Raum, im Südwesten von einem Gebäude mit umlaufenden Bänken. Im Nordosten der Piazza dagegen fand sich in der Nähe von Behausungen einer frühen Elite ein Sondergebäude, das durch seinen kunstvoll angelegten Boden besticht. Hier hatte man rote und weiße Kalksteinchen mit Kalkmörtel fest miteinander verbunden und abgeschliffen, sodass ein fester Estrich entstand, der ganz den Charakter italienischer Terrazzoböden hatte. Weiße Bänder an den Rändern setzten zusätzliche Akzente. In der nordöstlichen Ecke des Gebäudes fand sich ein mondförmiger Herd, während an anderer Stelle auf der Kante einer altarähnlichen Steinplatte ein fast lebensgroßes menschliches Gesicht als Hochrelief zu sehen ist.

Während dieser Phase wurde weiterhin vorwiegend im *skull building* bestattet, das selbst mehrere Bau- und Renovierungsphasen erlebte und am Ende wohl einen recht monumentalen Charakter aufwies, das aber auch selbst unterschiedliche Bestattungssitten widerspiegelt. Während der ersten Bauphase wurden auf der einen Seite einer unterirdischen Kammer Langknochen und auf der anderen Schädel sorgfältig arrangiert, während in einer anderen Kammer das schädellose Skelett einer Frau mit einem Neugeborenen und einem Kleinkind beigesetzt wurde. In einer weiteren Schicht fanden sich Sekundärbestattungen, in einer letzten dann nur noch Schädel. In allen Phasen diente das Gebäude als Totenhaus, in dem die Verstorbenen ihre letzte Ruhestätte fanden. Die altarähnliche Steinplatte gehörte offensichtlich zu den notwendigen Requisiten, um die Toten auf das Sekundärbegräbnis vorzubereiten. Zu erwähnen ist noch ein Auerochsenschädel, den man an die Wand gehängt hatte – wobei die Hörner des Auerochsen wieder primär Zeichen der Stärke

und Wehrhaftigkeit waren; möglicherweise spielte der Auerochse jedoch auch im Kult eine Rolle, wie später am Beispiel Çatal Hüyüks zu zeigen sein wird.

Wie auch immer die Details ausgesehen haben mögen, wenn die Ausgräber vermuten, dass das Schädelgebäude der Ort eindrucksvoller Rituale war, dürften sie damit kaum falsch gelegen haben.

Sesshaftigkeit und die Folgen für das Weltbild

Göbekli Tepe und Çayönü bewegen sich, was Zeichen und Signale, was die Vorformen religiösen Handelns anbelangt, ganz im Rahmen des bislang Bekannten: Wirkmächtige Wächterfiguren wie sexuell drohende menschengestaltige Figurinen und Abbilder, vor allem aber gefährliche Tiere, sollen Eindringlinge, aber auch das Unheil von diesen frühen Dörfern fernhalten. Die Toten, im Haus unter den Fußböden oder kollektiv in einem Totenhaus bestattet, machen deutlich, dass man den Besitz des Territoriums auf Vorfahren zurückführte und damit unterstrich. Gleichzeitig schienen diese Vorfahren in ihrer unterirdischen Welt bereits über eigene Wirkmächtigkeit zu verfügen, denn die aufgerichteten Stelen deuten darauf hin, dass hier Zeremonien zu Ehren eben dieser Toten stattgefunden haben. Soweit ist alles bekannt und ohne Schwierigkeiten auf das Brauchtum altsteinzeitlicher Jäger zurückzuführen. Und doch hat sich etwas entscheidend geändert und seine Spuren hinterlassen: Das Ritual hat seinen Einzug in die neolithische Gesellschaft gehalten!

Fassen wir also noch einmal zusammen: In der Zeit, in der sich in Westeuropa die Parietalkunst zu einer erzählenden Form der Darstellung wandelte, ethologische Signale in Amulettform festgehalten wurden und künstlerischer Wettbewerb Imponierzwecken und Bestattungen der Dokumentation territorialer Ansprüche dienten, fanden auch die Wildbeuter Anatoliens und der Levante Formen, sich mit Gefühlen existenzieller Bedrohung und tatsächlicher Konkurrenz auseinanderzusetzen, denn Signale mit Droh-, aber auch mit bloßem Verweischarakter wie Bestattungen und Schädeldeponierungen sind ja keineswegs auf die bildende Kunst beschränkt, obwohl Göbekli Tepe hier Erstaunliches geleistet hat. Im Gegenteil: Mit ihrem Ursprung im Alltagsleben, wo sie in der Kommunikation eine wichtige Rolle spielen, haben sich ethologische Signale nicht nur in bildkünstlerischen Objekten, sondern auch in performativem Ausdruckshandeln, den Ritualen, niedergeschlagen.

Rituale sind strukturiertes, gleichzeitig ererbtes und kulturell erworbenes Kommunikationsverhalten, das aus Sets von Wort- und Handlungssequenzen besteht. Diese Sequenzen wiederholen auf unterschiedliche Weise identische Inhalte. Sie haben eine bestimmte Struktur und dienen der Kommunikation oder dem Festigen sozialer Bindung. Weit entfernt davon, stabil und unver-

änderlich zu sein, unterliegen Rituale im Lauf der Zeit einem Wandel, der den gleichen Veränderungstendenzen wie die bildkünstlerisch festgehaltenen Signale gehorcht. Das bedeutet, dass möglicherweise Teile einer sogenannten Luxurierung unterzogen, also ausgeschmückt werden und andere verloren gehen, dass rituelle Elemente beibehalten werden, auch wenn sie keine Funktion mehr erfüllen, oder dass neue Funktionen hinzukommen, die dann wieder auf den Ablauf des Rituals zurückwirken.

Kulturelles Verhalten in einem Bereich, den wir heute als religiös oder weltanschaulich bezeichnen würden, ist demnach nicht zufällig oder gar beliebig. Außerdem ist es auch nur in bestimmten Grenzen modifizierbar, denn zu radikale Neuerungen würden von den Rezipienten nicht verstanden, also ihren eigentlichen Zweck einer erfolgreichen Kommunikation verfehlen. Daher ist jede Form dieses Verhaltens, sei es performativ oder bildkünstlerisch, stets an bekanntes, über Generationen tradiertes Verhalten gebunden, an dessen Ursprung ererbte Verhaltensdispositionen stehen. Es wird weiterentwickelt, und verschiedene mögliche Varianten werden durchgespielt, von denen sich die eine oder andere durchsetzen mag, bevor sie in einem Selektionsprozess ausgemustert wird. Aus ursprünglichen, ersten vorreligiösen Vorstellungen im Rahmen der Schädeldeponierungen oder schützenden Frauenfigurinen entstehen auf die beschriebene Weise durch Variabilität und Selektion letztlich unterschiedliche, an ihre jeweilige (soziale, politische, ökonomische, naturräumliche) Umwelt adaptierte Religionen, die sich in einem kontinuierlichen Prozess weiterentwickeln.

Genau diese Prozesse und die Art der Modifikationen im Sinne der von der Kulturethologie herausgearbeiteten Regelmäßigkeiten lassen sich auch in den hier exemplarisch beschriebenen neolithischen Siedlungen beobachten, bei denen es letztlich um die Entstehung von Religion und später dann um die Aufspaltung in unterschiedliche Religionen geht.

Was es nun aber mit dem Tod auf sich hat und welche Rolle hier Rituale spielen, zeigt die Siedlung Çatal Hüyük in Anatolien, die im nächsten Kapitel vorgestellt wird.

8

Çatal Hüyük, das Ritual und der Tod

Was ist ein Ritual?

Zu Beginn des 20. Jahrhunderts entfachte der britische Biologe und Humanist Julian Huxley (1887–1975) einen Sturm der Entrüstung, als er die Entstehung streng regelhafter Bewegungsabläufe in Zusammenhang mit dem Verhalten – vor allem dem Paarungsverhalten bei Vögeln – nicht nur analysierte, sondern in bewusster Analogie zu den gottesdienstlichen Riten der Kirche als Ritualisierung bezeichnete und damit als Enfant terrible und Schreck frommer Bürgersleute in die Fußstapfen seines Großvaters Thomas Henry Huxley trat, der ja bekanntermaßen zwei Generationen zuvor Bischof Wilberforce bloßgestellt hatte, als es um Darwins *On the origin of species* ging.

Es waren die feierlichen, nach strengen Regeln ablaufenden gottesdienstlichen Handlungen und Interaktionen zwischen Priester und Gemeinde, die sich nach festen Gesetzmäßigkeiten wiederholenden Bewegungen und Körperhaltungen, die Gebete und Gesänge, kurzum eine feste Folge von Handlungs- und Wortsequenzen mit hohem Symbolgehalt im Dienste der Kommunikation sowohl der Gemeindeglieder untereinander als auch mit der Gottheit, die Huxley vorschwebten, als er die auf ererbten Verhaltensdispositionen beruhenden formalisierten Interaktionen zwischen Vögeln derselben Spezies – vor allem in Zusammenhang mit der Balz – beschrieb und damit die Grundlage für eine eigenständige biologische Disziplin, die Verhaltensforschung, legte, auf der dann wissenschaftliche Größen wie Nikolaas Tinbergen (1907–1988) oder der durch seine Nähe zum Nationalsozialismus mehr als umstrittene Konrad Lorenz (1903–1989) aufbauen konnten. Vor allem während der 1940er- und 1950er-Jahre konzentrierten sich Lorenz und Tinbergen auf die Untersuchung des tierischen Instinktverhaltens im natürlichen Lebensraum des Tieres und die Bedeutung eben jenes Verhaltens unter einem evolutionistischen Gesichtspunkt sowie seiner physiologischen und genetischen Ursachen. Grundlage dieser Forschungen war die Annahme, dass gleiche Handlungsmuster als soziale Signale bzw. als quasiautomatische Auslöser für angepasstes Verhalten sowohl innerhalb der Tierspezies, aber auch beim Menschen fungierten; Letzteres ist der Grund, weshalb heute ethologische

Methoden zur Erforschung nicht nur biologischer, sondern auch psychologischer, soziologischer und religiöser Phänomene Anwendung finden. Wie bereits erwähnt, widmete sich vor allem der Zoologe Irenäus Eibl-Eibesfeldt intensiv dem Studium expressiven Ausdrucksverhaltens mit Signalfunktion und konnte eine Reihe angeborener Verhaltensmuster ausmachen, die beim Menschen im Allgemeinen in komplexere Handlungsfolgen eingebettet sind – eben die von Huxley angesprochenen Rituale: nach vorgegebenen Regeln ablaufende, formelle und oft feierlich-festliche Handlungen mit Verweischarakter, die sich demnach nicht nur im religiösen, sondern auch im profanen Alltagsgeschehen feststellen lassen, so zum Beispiel bei Staatsempfängen, Abiturfeiern, aber auch bei ganz normalen Begrüßungen.

Solche ritualisierten Verhaltensmuster sind partiell genetisch fixiert, andere Elemente kulturell und wieder andere individuell erworben, wobei das Kriterium der Homologie (also gemeinsamer Abstammung) sowohl auf die genetisch als auch auf die kulturell ererbten Verhaltensmuster anzuwenden ist.

Expressives Ausdrucksverhalten, das zusammen mit sprachlichen sowie kulturellen Symbolen jeweils die kleinste Einheit im Rahmen eines Rituals ist, sowie das Ritual selbst dienen letztlich der Kommunikation. Dabei können sich ursprünglich zielgerichtete Aktionen zu rein symbolischen Akten wandeln, sodass das Ritual dann zuletzt nur noch die Funktion hat, das *social bonding* sic herzustellen, also den sozialen Zusammenhalt der ausführenden Gruppe zu gewährleisten hat.

Rituale haben Strukturen

Rituale wie der berühmte Balztanz der Kraniche sind nicht nur im Tierreich allgegenwärtig, sondern durchziehen auch das menschliche Miteinander wie ein roter Faden. So sind bereits Begegnungen zwischen Menschen ritualisiert: Man nähert sich, stoppt in bestimmtem Abstand, nimmt Blickkontakt auf, lächelt (eine ritualisierte und hinsichtlich ihrer Bedeutung ins Gegenteil verkehrte Beißdrohung – man denke an das Zitat des Kabarettisten Werner Finck: „Lächeln ist die eleganteste Art, seinen Gegnern die Zähne zu zeigen"), reicht die Hand, verbeugt sich leicht (macht sich kleiner als Demutsgeste), spricht eine bekannte Begrüßungsformel und erst dann folgt das eigentliche Gespräch. Das ganze Begrüßungsritual hat den Sinn, dem Gegenüber deutlich zu machen, dass man keinerlei feindliche Absicht hegt, die Begegnung also gefahrlos ist und unkompliziert verlaufen wird. Anders im Fahrstuhl (Abb. 8.1). Hier verzichtet man auf die Begrüßung, nimmt aber auch keinen Blickkontakt auf, das heißt, man tut also so, als sei der andere trotz offensichtlicher physischer Nähe nicht existent!

Abb. 8.1 Menschen im Fahrstuhl vermeiden Blickkontakt; der andere ist sozial nicht existent. (© anonymus; bearbeitet von Karolina Rupik)

Noch bevor diese kleinen alltäglichen Rituale als Mittel der sicheren Kommunikation im Alltag zum Forschungsobjekt der Humanethologie wurden, gerieten die großen, sich oft über Monate hinziehenden Rituale der Völker Afrikas und Südostasiens in den Interessenfokus der Völkerkunde (Abb. 8.2).

Während zunächst das Exotische oder auch das angeblich so Barbarische im Vordergrund des Interesses standen, wandte sich der belgische Völkerkundler Arnold van Gennep (1873–1957) dem Aufbau dieser Rituale zu und entdeckte Erstaunliches: Ein bestimmter Ritualtyp begleitet alle Übergänge im menschlichen Leben, die offensichtlich als gefährlich oder zumindest verunsichernd eingestuft und deshalb von ritualisierten Handlungen begleitet werden. Solche Übergänge können den Lebenszyklus betreffen und sind daher mit Ereignissen wie Geburt (Taufe), Pubertät und Reife (Kommunion und Konfirmation), Hochzeit und Tod (Beerdigungen) verknüpft. Feierlichkeiten begleiten jedoch auch Übergänge im Jahresverlauf, so zum Beispiel die Feiern an den Äquinoktien (Tag- und Nachtgleiche) und an den Solstitien (Sonnwendtagen) – heute Weihnachten, Ostern, Mittsommer und Erntedank. Weitere Übergänge sind Statusveränderungen wie der Eintritt in einen Orden, die Graduierung nach Abschluss der universitären Ausbildung oder der Eintritt ins Rentenalter, die alle von Feierlichkeiten begleitet werden. Aber damit nicht genug: Auch räumliche Übergänge werden zelebriert, wenn sich ein Freund oder Familienmitglied auf eine längere Reise begibt und sowohl

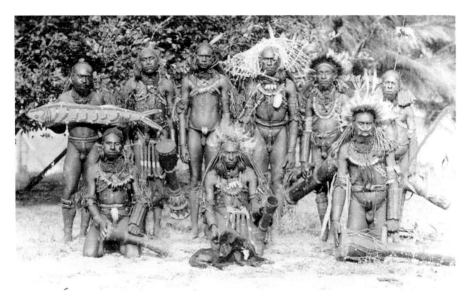

Abb. 8.2 Die von dem Völkerkundler Adolf Ellegard Jensen beschriebenen, für ein Ritual festlich gekleideten Marind-Anim. Südküste des ehemaligen holländischen Neu-Guinea. Postkarte aus den 1920er-Jahren

feierlich verabschiedet als auch nach seiner Rückkehr willkommen geheißen wird.

Van Gennep machte nicht nur auf diese Übergangsrituale (*rites de passage*), aufmerksam, sondern fand auch heraus, dass ihnen allen eine bestimmte Struktur gemeinsam ist. Die rituelle Begleitung von als bedrohlich und verunsichernd empfundenen Brüchen im Leben eines Menschen gliedert sich nach van Gennep in drei Phasen. Die Phase der Separation kennzeichnet die Ablösung vom alten Status. Die liminale Phase (auch *marge*-Phase genannt), die eigentliche Übergangszeit, kennzeichnet den Initianden als tot. Er führt eine Zwischenexistenz außerhalb des üblichen gesellschaftlichen Lebensraums, aber auch außerhalb der gesellschaftlichen Normen. Erst in der letzten, als Wiedergeburt verstandenen Integrationsphase erfährt der Initiand eine Rehabilitation auf höherem Niveau, die ihn auf seinen neuen Platz in der Gesellschaft verweist. Das Ganze ist nicht nur von einem oft üppigen Zeremoniell begleitet, sondern auch Äußerlichkeiten machen den Wandel deutlich. So wird zum Beispiel bei der Initiation eines Mannes oder einer Frau in einen geistlichen Orden das neue Ordensmitglied nicht nur andere Kleidung, nämlich Ordenskleidung, tragen, sondern auch einen neuen Namen führen: Es hat sein altes Ich völlig abgestreift und ist in jeder Hinsicht ein neuer Mensch geworden.

Unyago – ein Initiationsritual bei den Makonde

Wie viele Bantuvölker kennen auch die Makonde, ein Volk von Ackerbauern im Grenzgebiet von Tansania und Mosambik, die Sitte, die Knaben gegen Ende der Pubertät zu initiieren, das heißt, sie offiziell aus der Kindheit und der Umgebung des mütterlichen Haushalts zu entlassen und in die Gemeinschaft der jagd- und kriegstauglichen Jungmänner zu überführen. Hat in einem Dorf eine Anzahl von Knaben das entsprechende Alter erreicht, werden die Vorbereitungen für ein solches Fest getroffen, indem nicht nur Einladungen an die umgebenden Dörfer verschickt, sondern auch ein Festplatz hergerichtet und genügend Lebensmittel sowie reichlich Hirsebier bereitgestellt werden.

 Die eigentlichen Feierlichkeiten beginnen mit einem Festessen und nächtlichen Tänzen vor allem der Frauen, bis am nächsten Morgen die Initianden von ihren Mentoren an eine geheime Stelle des Waldes geführt werden. Von den Müttern wird der Moment der Trennung von lauten Klagen und gelegentlich auch aggressiven Akten gegen die Mentoren begleitet: „Es geht fort, mein geliebtes Kind!"

 Damit beginnt für die Knaben die liminale Phase, der mehrmonatige Aufenthalt im Busch, während sie für die Dorfgemeinschaft offiziell als tot gelten. In dieser Zeit leben die Initianden in strenger Abgeschlossenheit unter Aufsicht ihrer Mentoren und werden in die Sitten, religiösen Überlieferungen, aber auch gesellschaftlichen Aufgaben des erwachsenen männlichen Makonde eingeführt. Nach einer ersten Nacht, die die Knaben ohne Schutz im durchaus nicht ungefährlichen Busch verbringen müssen, gehen sie am kommenden Morgen daran, sich ihre Hütte zu bauen. Hier verbringen sie die ersten Tage nach der schmerzhaften Circumcision. Der Aufenthaltsort der Initianden, die sozial als Nichtlebende gelten, ist geheim und tabu. Niemand, der nicht als Mentor oder Beschneider unmittelbar beteiligt ist, darf die Hütte betreten und Einblick in das geheime Geschehen nehmen. Der Status der Knaben als gesellschaftlich nicht existent und sozial tot wird auch optisch deutlich durch die Ascheschicht, die sie bedeckt und die erst vor ihrem ersten offiziellen Erscheinen abgewaschen wird.

 Erst beim Mapiko, einem Maskentanz (vgl. Abb. 1.4), treten die Tanzkundigen unter den Initianden und ihre Mentoren öffentlich in Erscheinung, indem sie während eines neuerlichen Festaktes im Heimatdorf, durch Masken und entsprechende Bekleidung als frauenraubende Ahnengeister gekennzeichnet, angeblich aus den Gräbern steigen, eigentlich aber hinter Büschen hervorspringen und dann von den Männern des Dorfes im Rahmen ritueller Kampfhandlungen in die Flucht geschlagen werden. Der inhaltliche Hintergrund ist der, dass die Knaben sozial tot sind, sich also in der Toten- und

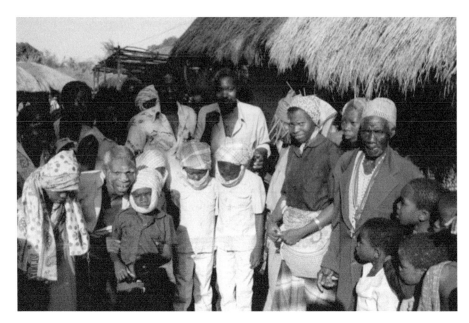

Abb. 8.3 Die Phase der Integration bei einem Unyago der Makonde. Die Initiierten tragen neue weiße Kleidung, sie gelten als Neugeborene. (© Karl Ulrich Petry; mit freundlicher Genehmigung)

Geisterwelt aufhalten, aus der sie nun dem Dorf einen Besuch abstatten, bevor sie einige Wochen später als Männer, das heißt als neu (in einen neuen sozialen Status) geboren in ihr Dorf, nicht aber in den Haushalt ihrer Mütter zurückkehren. Der soziale Grund für den Mapikotanz ist die ökonomische Übermacht der Frauen, in deren Händen der Feldbau liegt und die allein über dessen Erträge verfügen dürfen, was ihnen eine ökonomische Vormachtstellung gegenüber den Männern verleiht, die dann während des Maskentanzes wenigstens ihre Verteidigungsbereitschaft und ihre Macht über die Geisterwelt deutlich machen können.

Die Integrations- und damit letzte Phase des Rituals beginnt für die Initianden mit der Rasur ihres Kopfes und einem gemeinsamen Bad, bei dem die Staub- und Ascheschicht entfernt wird. Dann werden sie völlig neu eingekleidet (Abb. 8.3). Als Neugeborene ziehen die jugendlichen Krieger in ihr Dorf ein, wo sie enthusiastisch empfangen werden. Dieser allgemeine Festtag endet mit Tanz und einem großen Festmahl. Die Initianden, in religiös-gesellschaftlicher Hinsicht vor Monaten während des Separationszeremoniells rituell verstorben und in der Zwischenzeit als Tote in der Geisterwelt lebend, werden nun aus dieser in einem veränderten Zustand wiedergeboren: Das Kind hat die Welt der Lebenden verlassen und ist zu den Ahnengeistern gegangen, der Mann kommt aus der Ahnenwelt in sein Dorf zurück, um dort die Aufgaben eines Mannes zu übernehmen.

Das hier in knappster Form vorgestellte Ritual beeindruckt durch seine subtile Behandlung möglicher gesellschaftlicher Konflikte. Die Männer bilden über die gemeinsame Initiation und die damit verbundene Geheimhaltungspflicht eine enge Ritualgemeinschaft, die einen wirksamen Gegenpol zu der bei den Makonde weiblich dominierten Familienstruktur (die Makonde sind matrilineal und matrilokal) und Wirtschaftsgemeinschaft darstellt und über die Gemeinschaft der Männer die unterschiedlichen matrilinearen Familienverbände zu einem größeren Verband zusammenfasst. In zwischenmenschlich-psychologischer Hinsicht wird im Ritual die Beziehung zwischen Vater und Sohn gestärkt: der Knabe, ursprünglich in einer von Frauen dominierten Welt aufgewachsen, löst sich seelisch von seiner weiblichen Verwandtschaft, verliert durch einen medizinischen Eingriff sinnfällig alles Weibliche und wird Teil einer Männergemeinschaft, in der der Vater als mutiger Jäger und Krieger einen hervorragenden Platz einnimmt.

Ritual und Konflikt

Die kurze Darstellung des Initiationsrituals bei den Makonde hat nicht nur illustriert, wie ein Ritual aufgebaut ist und welche Rolle die von van Gennep so klar erkannten Phasen spielen, sondern auch, dass solch ein Ritual eine klare Aufgabe in der jeweiligen Gesellschaft hat, vor allem dann, wenn eine solche Gesellschaft keine Hierarchien und keine konfliktlösenden Institutionen wie Geistlichkeit oder Gerichte kennt.

Wenn in einer Gruppe von Wildbeutern Konflikte auftreten – wobei die meisten Wildbeuter ausgefeilte Konfliktvermeidungsstrategien verfolgen –, können sie notfalls auseinandergehen. Die Gruppe teilt sich. Anders bei sesshaften Völkern. Die Investitionen in die Urbarmachung der Felder und in den Hausbau sind zu hoch, als dass sie einfach aufgegeben werden könnten. Die Folge ist, dass wirkungsvolle Maßnahmen zur Konfliktlösung ergriffen werden müssen. Dies ist durch die Schaffung geeigneter Hierarchien oder Institutionen, also einer Obrigkeit und Rechtsprechung, möglich. Wenn eine Gesellschaft aber nicht arbeitsteilig ist oder wie viele afrikanische Völker bis heute obrigkeitliche Machtstrukturen ablehnt, bieten Rituale die geeigneten Konfliktlösungsstrategien, indem sie die gesellschaftlichen Rollen potenzieller Konfliktparteien herausarbeiten, ihren jeweiligen Wert betonen und unter Verweis auf höhere und nicht mehr hinterfragbare Mächte einen Konsens herbeiführen. Im Fall der hier erwähnten Makonde ist der potenzielle Konflikt das ökonomische und gesellschaftliche Ungleichgewicht zwischen Männern und Frauen, das im Ritual durch das Schaffen eines Bundes der erwachsenen Männer, aber auch durch Verweis auf den Wert beider Geschlechter nivelliert wird.

Die Erkenntnis des hohen Stellenwertes des Rituals gerade bei Völkern mit egalitären Gesellschaftssystemen, in denen es weder Arbeitsteilung noch Hierarchien gibt, hat die Wissenschaft dem hier bereits erwähnten Victor Witter Turner zu verdanken, der nicht nur van Genneps Erkenntnisse über die Struktur des Rituals um eine subtile Analyse der entscheidenden liminalen Phase bereichert, sondern auch die Elemente, die Bilder, Handlungs- und Wortsequenzen des Rituals minutiös untersucht hat und zu dem Ergebnis kam, dass die kleinste Einheit des Rituals das Symbol ist; ein Symbol, das sowohl ein Bild, ein Gegenstand, eine Geste (expressiver Ausdruck; Signal) oder eine Wortsequenz (z. B. Mantra, Gebetsformel) sein kann und das auf höhere Bedeutungsinhalte verweist. Gerade der Verweischarakter der Symbole, die im Ritual zu sich wiederholenden Sequenzen zusammengefügt werden, ist entscheidend, werden so doch gemeinsame Werte beschworen, die die jeweilige Gesellschaft oder Gruppe über mögliche Interessenkonflikte hinaus zusammenhalten oder, wenn das nicht mehr möglich sein sollte, den vorübergehenden oder endgültigen Bruch sozialverträglich gestalten. Nichts anderes tun im Übrigen auch unsere Gerichte!

Es verwundert demnach nicht, wenn im Zuge der Sesshaftwerdung Rituale aufgetreten sind, die eben jene konfliktlösende Aufgabe hatten und sich in diesem Zusammenhang nicht nur wirkungsvoller Zeichen und Symbole bedienten, sondern auch auf die bekannten höheren und damit nicht mehr hinterfragbaren Mächte und Autoritäten verwiesen. Dabei handelte es sich einerseits um die Verstorbenen, die ja bereits seit Generationen als wirkmächtige Marker bei der Sicherung des Territoriums in Erscheinung getreten waren und damit ihr Machtpotenzial eindrücklich unter Beweis gestellt hatten, andererseits die Urmutter, jene schamweisende Frauengestalt, deren Schutzfunktion sich seit dem Paläolithikum bewährt hatte und die in dieser Funktion ein Eigenleben als übermächtige Figur spielte, wie das Beispiel des neolithischen Çatal Hüyük zeigt.

Çatal Hüyük, die Urmutter und der Tod

Es war gerade eben jenes frühneolithische Çatal Hüyük, eine anatolische Siedlung, die in den Jahren 1961 bis 1963 von dem britisch-niederländischen Archäologen James Mellaart (1925–2012) ausgegraben wurde, welches nicht nur intime Einblicke in die Weltanschauung der ersten Ackerbauern ermöglicht, sondern darüber hinaus den Schlüssel zum Verständnis der Ikonografie sowohl des Neolithikums im Vorderen Orient als dann auch des neolithischen Europas lieferte. Inzwischen sind den bahnbrechenden Entdeckungen Mel-

Abb. 8.4 Rekonstruktion des Hausinneren in der Siedlung von Çatal Hüyük. (© Stipich Béla; Creative Commons Attribution-Share Alike 3.0 Unported license)

laarts weitere Ausgrabungen gefolgt, sodass die ursprünglichen Aussagen und Annahmen Mellaarts inzwischen relativiert und präzisiert werden konnten.

Çatal Hüyük liegt in der Ebene von Konya auf einem auch heute noch fruchtbaren Hochplateau in der südlichen Zentraltürkei und damit an den nordwestlichen Ausläufern des fruchtbaren Halbmondes. Erste Siedlungsspuren lassen sich bis 8000 v. Chr. und darüber hinaus zurückverfolgen, die Blütezeit des Ortes lag jedoch zwischen 7250 und 6150 v. Chr. (kalibrierte Zeitrechnung). Die Grabungen Mellaarts erstreckten sich über 13 aufeinanderfolgende Siedlungsschichten, von denen die Schichten II bis VII systematisch rekonstruiert wurden.

Im neolithischen Çatal Hüyük reihten sich die rechteckigen, türlosen Hauskonstruktionen aus luftgetrockneten Lehmziegeln mit einer zusätzlichen, vor die Wände gesetzten tragenden Holzstruktur puebloähnlich ohne Zwischenräume aneinander und bildeten eine stabile, festungsartige Einheit. Die jeweiligen Wohneinheiten konnten nur über eine Luke im Dach betreten werden, von wo aus eine Leiter ins Hausinnere führte (Abb. 8.4). Dieser Einstieg lag in allen Häusern an der Südwand der Gebäude, an der sich auch der

in die Wand eingelassene Herd sowie eine Nische für Brennstoff befanden. Auffallend an der Ausstattung der Wohnräume waren fest integrierte, mit Matten und ursprünglich wohl auch Polstern bedeckte Plattformen, die nicht nur als Ruhezonen dienten, sondern unter denen auch die Toten bestattet wurden. Über die Funktion als Wohnhäuser und gleichzeitige Grablege hinaus zeichneten sich die Häuser durch ihre teilweise so üppige, liebevolle und abwechslungsreiche künstlerische Ausgestaltung auf, dass sich der Ausgräber zunächst veranlasst sah, wie in Göbekli Tepe die besonders schönen Häuser als Heiligtümer anzusprechen, eine Annahme, die sich jedoch auch hier als nicht haltbar erwies. Es muss also davon ausgegangen werden, dass die Bewohner Çatal Hüyüks genau wie ihre direkten zeitlichen Vorläufer in Göbekli Tepe oder wie ihre längst vergessenen Ahnen in Gönnersdorf großen Wert darauf legten, ihre Umgebung und ihr Heim nicht nur zu verschönern, sondern damit auch ihre geistige Welt abzubilden; eine Welt, deren konstituierende Elemente sich ohne Brüche auf Vorläufer zurückführen lassen und die dem an der Kunst des Paläolithikums, des Mesolithikums und des präkeramischen Neolithikums geschulten Leser inzwischen nur allzu vertraut sein dürfte.

Dazu gehören in erster Linie Darstellungen des Weiblichen, wie wir sie als bewährte apotropäische Zeichen, angefangen von den Bilderhöhlen Frankreichs über die Frauenfigurinen des Gravettien (Venus von Willendorf) bis zu den Ritzungen von Göbekli Tepe, kennengelernt haben. In Çatal Hüyük schmückte regelmäßig eine aus Gips modellierte, schematisierte, weibliche Gestalt mit rechtwinklig vom Körper abgespreizten Armen und Beinen als massives, die Wand dominierendes Relief das Hausinnere – eine Figur, die unschwer als Schamweisende zu identifizieren ist, auch wenn hier auf die obszöne Darstellung der Geschlechtsteile wie bei den Kopfskulpturen in Lepenski Vir verzichtet wurde. Etwas anderes aber ist mit den Skulpturen von Lepenski Vir identisch: die räumliche und damit auch inhaltliche Nähe der Schamweisenden, auch als „heraldisches Weibchen" bezeichnet, zum Tod. Wenn in Lepenski Vir die bekannte Frauenfigur und ähnliche Geröllfiguren am Herd über den Gräbern der Verstorbenen deponiert wurde, ist es in Çatal Hüyük die Wand über den Bestattungsplattformen, auf der das Frauenrelief zu finden ist. Die schamweisende Frauenfigur mit ursprünglich bloßer apotropäischer Funktion hat sich also nun endgültig zu einer wirkmächtigen Gestalt entwickelt, die als Urmutter in Zusammenhang mit dem Tod und damit dem Kreislauf von Leben und Sterben und möglicherweise einer Existenz in der Unterwelt steht, wobei unter Unterwelt hier tatsächlich die untere Welt, also eine Welt unterhalb des Wohnortes der Lebenden, gemeint ist. Wie eng der Zusammenhang zwischen den Attributen des Weiblichen, dem Sterben und dem Tod ist, machen die zahlreichen Halbreliefs weiblicher Brüste im Inneren der Häuser deutlich. Sie wurden über in die Wand eingelassene Schädel

Abb. 8.5 Wandmalereien in Haus VII 8, Çatal Hüyük. (Zeichnung: Karolina Rupik nach einer Rekonstruktion von James Mellaart)

von Geiern, Füchsen und Wieseln modelliert, eben jenen Tieren, die für das Mazerieren der Toten zuständig waren, bevor man deren Gebeine unterhalb der Plattformen beisetzte.

Nicht nur die Bestattungen im Haus – also bei den Lebenden, nur eben in der Unterwelt – machen auf die große gesellschaftliche Bedeutung des Todes aufmerksam, auch die üppige und gekonnte Bemalung der Wände widmete sich mit beeindruckender Häufigkeit diesem Thema. So zeigt ein Wandgemälde (aus der Schicht VI B) eine Anzahl menschlicher Schädel und Knochen in unmittelbarer Nähe der Vorderfront eines Bauwerks, in dem gleichfalls die Überreste menschlicher Körper liegen. Ganz offensichtlich ist hier ein Beinhaus gemeint, in dem die Leichen der Verstorbenen aufgebahrt bzw. zunächst primär bestattet wurden. Wie diese erste Bestattungsphase aussah, zeigen weitere Wandgemälde, deren Inhalt für den Menschen des 21. Jahrhunderts grausig und abstoßend erscheinen, wenn nämlich riesige Geier, in nahezu natürlicher Größe mit einer Flügelspannweite von etwa 150 cm, auf kopflose, winzig kleine Menschenkörper einhacken. Ganz offensichtlich hatten die Bewohner der Stadt Çatal Hüyük keine Scheu, das Ende der physischen Existenz des Menschen mit all seinen Konsequenzen darzustellen. Im Gegenteil, das Ausgeliefertsein des Menschen an den Tod wird durch das Größenverhältnis Mensch und Geier noch betont (Abb. 8.5).

Nicht alle Wandgemälde beschäftigten sich jedoch mit dem Tod. Thema ist auch die Welt der Lebenden, wenn nämlich die Stadt selbst und im Hintergrund der Vulkan Hasan Dag abgebildet werden oder eine Jagdszene na-

turgetreu geschildert wird: In Schurze aus Leopardenfell gekleidete Männer, bewaffnet mit Bogen und Keulen, nähern sich in offenbar ausgelassener Stimmung einer Herde von Hirschen – auch hier erzählen Wandmalereien nun Geschichten!

Aber auch auf die traditionellen Tierdarstellungen wie in Göbekli Tepe, die Darstellung von animalischer Kraft und Wildheit, wollte man noch nicht verzichten, wobei die abgebildeten Raubkatzen – Löwinnen oder Leoparden – bereits in heraldischer Doppelung auftreten und damit die von der Kulturethologie beschriebene Entwicklung eingeschlagen haben (vgl. Kap. 5).

Zu den eindrücklichsten Tierbildnissen gehören die Darstellungen von Rindern, seien es Auerochsen, auf die man Jagd machte, oder sei es das gerade erst domestizierte Rind, das im Leben der Bewohner Çatal Hüyüks offensichtlich einen wichtigen Platz einnahm, denn entsprechende Hinweise sind nicht zu übersehen: Sowohl an den Wänden im Hausinneren als auch am Rande der Plattformen fanden sich Bukranien, die den so ausgestatteten Häusern ein dramatisches Aussehen verliehen.

Bukranien tauchen jedoch auch immer wieder in räumlichem Zusammenhang mit der schamweisenden Frauenfigur auf, also jener Gestalt, die inzwischen über ihre rein apotropäische Funktion hinausgewachsen war und in ganz offensichtlichem Zusammenhang mit dem Tod stand. Bei der Dominanz des Todesthemas darf jedoch nicht vergessen werden, dass Hörnern auch eine Schutz- und Abwehrfunktion zukommt. Dies wird besonders im europäisch-christlichen Kulturraum deutlich, wo sowohl der Teufel als auch Masken, so beim alemannischen Mummenschanz, immer wieder Hörner tragen. Hörner sind Signale im Rahmen des Droh- und Imponierverhaltens, die in den kulturellen Kontext übernommen wurden und der Selbstdarstellung dienen. Auch das Alte Testament kennt einen (falschen) Propheten Zidkija, der sich eiserne Hörner machte, um damit vor dem König Ahab dessen überragenden Erfolg in der Schlacht symbolhaft vorherzusagen. Tatsächlich aber verlor der König in der Schlacht sein Leben.

Das Anfügen von Hörnern führt zu Wirkungssteigerungen anderer Abwehrzeichen und verstärkt die Wirkmächtigkeit von Idolen oder Amuletten. Auch als isoliertes Bild, Zeichen oder Gegenstand entfaltet das Horn seine schutzmächtige Wirksamkeit. Die in Çatal Hüyük allgegenwärtigen Hörner, vor allem aber deren frontale Präsentation im Wandrelief, fügen sich nahtlos in die Abwehr- und Schutzsymbolik und sollen als wirkmächtige Darstellung von kämpferischer Wehrhaftigkeit das drohende Übel von den Häusern und der Ortschaft fernhalten.

Zu diesem Bild passt, dass sich in den Gebäuden immer wieder Menschenschädel fanden. Mal hatte man sie auf Sockel unterhalb des Reliefs der Schamweisenden gestellt, mal lagen sie in einem Korb unterhalb eines modellierten

Stierkopfes, dann hatte man sie bei den Geiergemälden, dann wiederum in unmittelbarer Herdnähe aufgestellt.

Und noch etwas fand sich in unmittelbarer Nähe des Herdes: kleine Figurinen, die meist Frauen und seltener Männer darstellen, von denen die Frauenfiguren gelegentlich das Erscheinungsbild der Schamweisenden nachahmen. Hier ist besonders eine Figurine hervorzuheben, die eine reife Frauengestalt auf einer von Leoparden flankierten Sitzgelegenheit zeigt, wobei die Assoziation der Sitzgelegenheit mit einem Thron nahe liegt. Offensichtlich wurden in dieser Figurine die apotropäischen Funktionen nackter Weiblichkeit zusammen mit den Attributen von Wildheit und Stärke zu einer wirkmächtigen Einheit zusammengeführt, die ab diesem Zeitpunkt charakteristisch für übermächtige Frauengestalten werden sollte – drei bis vier Jahrtausende später ließ sich die kleinasiatische Kybele in ihrem Wagen von Löwen ziehen, und die sumerische Ishtar wurde von Raubkatzen begleitet. Zum hiesigen Zeitpunkt jedoch war mit den weiblichen und deutlich weniger männlichen Figurinen, die in Çatal Hüyük auch meist mit erheblich weniger Sorgfalt ausgeführt worden sind als das hier genannte Beispiel, etwas ganz anderes gemeint: der kulturelle Nachfolger der deponierten und in Jericho übermodellierten Schädel!

Der lange Weg ins Jenseits: Sekundärbestattungen

Übergänge im Lebenszyklus, so stellte Arnold van Gennep fest, werden von Ritualen begleitet, um den durch den Verlust eines wichtigen Menschen entstandenen Bruch im Sozialgefüge aufzufangen, aber auch, um den seelischen Schmerz beim Verlust eines geliebten Menschen zu mildern. Diese Rituale sind darüber hinaus gerade in egalitären Gesellschaften notwendig, um Interessenkonflikte zu bewältigen und im Alltag entstehende Verwerfungen zu glätten. Wie ein solches Ritual ausgesehen haben könnte, zeigt uns hier wiederum ein Beispiel aus der Völkerkunde: Sterben, Tod und Begräbnis bei den Toraja auf Celebes (heute Sulawesi).

Wie für die meisten traditionellen Kulturen gilt auch bei den Toraja der Eintritt des physischen Todes nicht als das Ende der individuellen Existenz. Vielmehr ist der Tod der Übergang in eine neue Existenzform, der einen gewissen Zeitraum in Anspruch nimmt und, wenn er gelingen soll, großer Sorgfalt und der Einhaltung bestimmter Regeln bedarf. Zu diesen Regeln gehört die stufenweise Bestattung, die in physischer Hinsicht durch die Verwesung des Leichnams dokumentiert wird, in weltanschaulicher Hinsicht aber die Reise des Verstorbenen in die Totenwelt dokumentiert.

Ist also ein Toraja verstorben, wird der Tote, begleitet von einer Zeremonie, vorübergehend in einem Sarg im Wohnhaus aufgebahrt bzw. beigesetzt. Sein Zustand gilt jetzt als reduziert, etwa wie bei einem Schlafenden. Während dieser Zeit wird er weiterhin wie ein Familienmitglied behandelt. Kommt ein Gast, wird der Gong geschlagen, um dem Toten den Besuch anzukündigen. Bei den Mahlzeiten stellt man eine Schale Reis und Wasser neben den Sarg. Ein Mitglied der Familie berichtet dem Verstorbenen regelmäßig über die neuesten Ereignisse im Dorf usw. Erst nach Ablauf einer bestimmten Frist, aus ökonomischen Gründen jedoch frühestens nach der nächsten Reisernte, finden die weiteren Bestattungsfeierlichkeiten statt. Dazu gehört, dass man in der Zwischenzeit ein Abbild des Verstorbenen hat schnitzen lassen, eine sogenannte Tau-Tau-Figur, in der dann die Totenseele ihren Platz finden kann. Ein Festplatz einschließlich vorübergehender Unterkünfte für mehrere Hundert Trauergäste wird hergerichtet, und üppige Speisen und enorme Mengen Palmwein stehen für die Bewirtung der Gäste bereit. Ist der große Tag herangekommen, werden im Rahmen der Feierlichkeiten, zu denen auch das Defilee der Trauernden gehört, mehrere Wasserbüffel mit einem einzigen, gewaltigen Hieb mit der Machete geschlachtet. Ihr vergossenes Blut dient dazu, die Lebenskraft des Verstorbenen zu ersetzen. Das Fleisch der geschlachteten Tiere wird dann nach einem genau festgelegten Schlüssel unter den Gästen verteilt.

Der Verstorbene selbst kann, auf diese Weise mit neuer Lebenskraft ausgestattet, in der jenseitigen Welt weiterexistieren, während seine Bildseele, der individuelle Anteil seiner Persönlichkeit, in der Tau-Tau-Figur Platz nimmt. Diese Figur wird nun von den Hinterbliebenen am Begräbnisplatz der Familie aufgestellt, während die nicht verweslichen Überreste des Leichnams in einer verschließbaren Nische ihre letzte Ruhe finden.

An einem festen Tag im Jahr widmet man sich im Dorf den Verstorbenen. Ihre Abbilder werden gebadet, neu eingekleidet, mit Blumen gekränzt und mit Speisen versorgt, denn die Toten sind weiter existent und Teil des Torajakosmos, wenn auch in veränderter Existenzform.

Um die Geschlossenheit und innere Logik eines solchen Weltbildes egalitärer Ackerbauern deutlich zu machen, sei darauf verwiesen, dass das schiffsähnliche, auf Stelzen gebaute Haus der Toraja ein getreues Abbild ihres Kosmos darstellt: Unter dem Haus, zwischen den Stelzen, werden die Büffel gehalten, eben jene Tiere, die während des Begräbnisses ihr Leben lassen müssen. In der Mitte, im eigentlichen Wohnbereich, leben die Menschen, während unter dem hohen, schiffsbugartigen Dach in luftiger Höhe die Geister hausen. Dabei entsprechen das Dach der überirdischen Welt, der Wohnbereich der Menschenwelt und die Region zwischen den Stelzen der Unterwelt.

Das zweistufige Begräbnis dokumentiert demnach sinnfällig den Übergang des Menschen von der Welt der Lebenden in eine andere Welt – die der Verstorbenen, wobei auch diese weiter existent gedacht werden, aber in anderer Form. Als Geister hausen sie mit der Familie im Haus, aber unter dem Dach, mit der nötigen Energie ausgestattet durch die Lebenskraft der Wasserbüffel, jener Angehörigen der Unterwelt. Als Ahnen führen sie weiterhin eine Existenz in den Tau-Taus, die das Objekt fortgesetzter Fürsorge sind. Das zweistufige, sich über einen langen Zeitraum hinstreckende Begräbnis zeigt, dass es sich beim Tod um einen Prozess, um einen regelrechten Übergang im Sinne von van Gennep handelt: Der Tote wird in einem ersten Begräbnis, der Phase der Separation, aus seinem sozialen Umfeld gelöst. Er befindet sich dann in der hoch sensiblen liminalen Phase, seiner eigentlichen Verwandlung von einem Mitglied der Lebendwelt in ein Mitglied der Totenwelt, um zuletzt im Rahmen einer letzten großen Feier in sein neues soziales Umfeld, die Welt der Verstorbenen, aufgenommen zu werden. In sozialer Hinsicht dient ein solch aufwendiges Begräbnisritual der Umverteilung: Im Rahmen großer Festlichkeiten werden angesammelte Güter gemeinschaftlich genossen bzw. als Geschenke verteilt; nur ein geringer Teil verbleibt bei den Hinterbliebenen. Soziale Ungleichgewichte werden so vermieden, eine Voraussetzung für ein gelingendes Miteinander in Gesellschaften ohne Hierarchien. Auch stärken die gemeinsam durchgeführten Riten mit den immer wieder sinnfälligen Verweisen auf höhere Mächte den Zusammenhalt der Gemeinschaft. Die durch den Tod eines Mitgliedes entstandene Lücke wird geschlossen, mögliche Brüche werden geheilt.

Eine solche Sekundärbestattung wie die hier geschilderte ist weder in der Völkerkunde noch im Lauf der Menschheitsgeschichte eine Ausnahme, im Gegenteil. Selbst beim christlichen Begräbnis zeigt die Sitte des Aufbahrens und der Totenwache noch Anklänge an alte Bräuche.

Der große Übergang

Unter dem Blickwinkel der Übergangsrituale fügen sich nun also endlich die einzelnen Elemente des neolithischen Weltbildes, wie es mit dem Beginn der Sesshaftigkeit und des Ackerbaus entstanden ist, zu einem sinnvollen Gesamtbild zusammen.

Durch die Sesshaftigkeit entstand eine noch egalitäre Gesellschaft zunächst von Jägern, bald aber von frühen Ackerbauern, für die Konfliktbewältigungsstrategien von existenzieller Bedeutung waren. In diesem Zusammenhang entwickelten sich aus bewährten Verhaltensweisen zur Sicherung des Territoriums und zur Gefahrenabwehr Rituale, in denen mögliche Konfliktpunk-

Abb. 8.6 Töten eines Rindes in Çatal Hüyük während eines feierlichen Totenrituals. (Zeichnung: Karolina Rupik)

te thematisiert und unter Verweis auf gemeinsame Werte und nicht mehr hinterfragbare Mächte bearbeitet werden konnten. Zu solch einer Macht hatte sich offensichtlich die zunächst nur apotropäischen Zwecken dienende schamweisende Frau entwickelt, die nach und nach die Züge einer Urmutter annahm, die insbesondere mit dem Tod verknüpft war.

Der Tod selbst war in Çatal Hüyük von immenser Bedeutung, drehte sich doch von der Symbolik bis zur Wohnraumgestaltung alles um dieses Ereignis. War in dieser frühen Gemeinschaft von Ackerbauern ein wichtiges Mitglied verstorben, wurde der Leichnam zunächst primär bestattet, das heißt ausgesetzt, vermutlich in einem Beinhaus, wie es sich auf einer der Wandzeichnungen findet. Hier blieb der Verstorbene so lange, bis Geier, Füchse oder Wiesel das Fleisch von den Knochen entfernt, den Toten also mazeriert hatten. Erst dann wurde der Verstorbene endgültig beigesetzt, und zwar möglicherweise im Rahmen eines großen Festes, bei dem zahlreiche Rinder ihr Leben lassen mussten (Abb. 8.6). Ob auch zu diesem frühen Zeitpunkt der menschlichen Kulturgeschichte das Blut der Rinder die Lebenskraft des Verstorbenen ersetzen sollte, sei dahingestellt. Sicher ist aber, dass die bei den Totenfeierlichkeiten geopferten Rinder bei einem gemeinsamen Fest verspeist wurden und ihre Schädel einschließlich der Gehörne im Hause der Trauernden als Wandschmuck oder Einfassung der Schlaf- und Begräbnisplattformen ihren Platz fanden und damit auch dokumentierten, dass die Familie des Verstorbenen in der Lage war, eine große Bestattung auszurichten. Es ging also auch hier um Selbstdarstellung und Hierarchie!

Der Verstorbene selbst wurde nun noch einmal, und zwar jetzt endgültig, bestattet. Seine letzte Ruhestätte fand er genau unter der Plattform, auf der er zu Lebzeiten geschlafen hatte. Er blieb also im Haus, in der Gemeinschaft

seiner Familie, nur eben in der unteren, in der Unterwelt. Sein Schädel allerdings, in dem vielleicht seine Kräfte als Angehöriger der mächtigen tellurischen Welt Platz gefunden hatten, wurde im Haus deponiert, bis man im Lauf der Zeit dazu überging, kleine Figurinen als Ahnenfigürchen anzufertigen und sie in der Nähe des Herdes – wie in Lepenski Vir der Eingang zur Unterwelt(?) – aufzustellen. Die mit Lehm überformten Schädel und die fast lebensgroßen Figuren aus dem neolithischen Jericho zeigen also im Zusammenhang mit den eben geschilderten Bestattungsbräuchen den Übergang zwischen Schädeldeponierung und Ahnenbildnis! Wie in Lepenski Vir nahmen die Figürchen hin und wieder die Züge der Urmutter an, ein Hinweis darauf, dass diese übermächtige Gestalt mit dem Tod verknüpft wurde.

Das Ereignis um die Bestattung wurde anschließend dokumentiert. Man bemalte das Haus, brachte die übermodellierten Stierschädel an, montierte Fuchs- oder Wieselschädel, über die Brüste modelliert wurden usw. Nach einer Zeit wurde das Haus renoviert. Die Wandbemalungen verschwanden unter schmucklosem Putz, bis ein nächstes großes Ereignis erneute Veränderungen notwendig machte.

Das Haus selbst war übrigens zum heiligen Ort geworden und spiegelte möglicherweise wie bei den Toraja den Kosmos wider. Wurde eines der Häuser baufällig und musste aufgegeben werden, so wurde das Relief der Urmutter sorgfältig zerstört und das Gebäude zugeschüttet.

Çatal Hüyük erlaubt jetzt ein vorläufiges Fazit. Nun, zwischen 10.000 und 7000 v. Chr., gibt es eine regelrechte Religion: einen Kosmos aus Menschenwelt und Unterwelt (von einer Himmelswelt wissen wir noch nichts), in dem das Leben der Menschen durch zelebrierte und ritualisierte Übergänge von einem Lebensstadium ins andere Struktur und Maß findet. Wichtigster Übergang ist der von der Welt der Lebenden in die Welt der Toten, ein Prozess, der durch zweistufige Begräbnisse dokumentiert wird und dem auf geistiger Ebene die Reise des Verstorbenen in ein Totenreich entspricht. Räumlich bleibt der Verstorbene bei den Seinen, nur eben in der unteren, der Unterwelt, während sein Schädel bzw. später seine Ahnenfigur zum Sitz seiner Kräfte wird. Aus der Sitte der Schädeldeponierung zur Dokumentation territorialer Ansprüche ist also eine Religion geworden, die den Umgang mit dem Tod in den Mittelpunkt stellt. Genau so hat sich eine apotropäische Geste, das Scham- und Brustweisen über ihre Darstellung in Figurinen zu einer wirkmächtigen Gestalt entwickelt, die in engem Zusammenhang mit dem Tod, möglicherweise auch dem Leben, steht und als Urmutter angesprochen werden kann (siehe dazu ausführlich die Ausführungen im folgenden Kapitel). Ähnlich muss eine erste Religion in der Levante oder in der oberen Tigrisregion ausgesehen haben, denn auch dort finden wir Ansätze von Sekundärbestattungen. Diese fanden im Fall von Nevali Cori (Türkei) im Kollektiv statt, während Çatal

Hüyük den Anfang für einen Hauskult markiert, der dann besonders für das südosteuropäische Neolithikum charakteristisch werden sollte und sich noch in historischer Zeit in der Verehrung der Laren und Penaten im antiken Rom zeigt.

Auch mit der Urmutter erreichen wir nun bekannte Gefilde, denn sie ist uns, wenn auch recht blass, aus der Mythologie bekannt. In Babylon begegnen wir ihr als Tiamat, Mutter der Götter, die nach einem Götterkrieg entmachtet wird, deren Fleisch aber als Materie für die Erde dient, oder als Gaia, die Muttergottheit der Griechen, aus der die Geschlechter der Titanen und Götter hervorgehen. Gerade die Geschichten um ihre Entmachtung machen deutlich, dass wir es hier mit den Resten alter religiöser Vorstellungen zu tun haben, die von neueren Gedanken überlagert und dann in das neuere Weltbild eingefügt wurden – dazu aber später mehr!

Enūma eliš

Der babylonische Schöpfungsmythos Enūma eliš, niedergeschrieben vor dem neunten vorchristlichen Jahrhundert, Tafel 1,1:

Als oben der Himmel noch nicht existierte
und unten die Erde noch nicht entstanden war –
gab es Apsu, den ersten, ihren Erzeuger,
und Schöpferin Tiamat, die sie alle gebar;
Sie hatten ihre Wasser miteinander vermischt,
ehe sich Weideland verband und Röhricht zu finden war –
als noch keiner der Götter geformt
oder entstanden war, die Schicksale nicht bestimmt waren,
da wurden die Götter in ihnen geschaffen:
(http://www.welt-erschafft.de/uploads/media/Originaltext_Enuma_Elish_01.pdf)

9

Ex Oriente Lux oder: Die neolithische Weltsicht wird populär

Das Erfolgsmodell Neolithikum auf dem Vormarsch

Die Frage, was die sogenannte neolithische Revolution zum Erfolgsmodell machte, ist keineswegs überflüssig: War es die Sesshaftigkeit mit festen Behausungen, die ja ganz offensichtlich der produzierenden Wirtschaftsweise und neolithischen Technologien voranging – möglicherweise als eine Folge stärkerer Konkurrenz um attraktive Territorien, die man sich dauerhaft sichern wollte? Und war diese Form der Wirtschaft vielleicht nur die einer daraus resultierenden Notwendigkeit geschuldete Folge? So viel ist immerhin klar: Das Leben des Bauern war keinesfalls sicherer oder gar leichter als das des Jägers. Wo der Jäger und Sammler dem Wild folgt, in schlechten Jahren also gezwungen ist, seinen Aktionsradius zu erweitern oder auch seinen Speisezettel umzustellen, ist der Bauer an seinen Boden gebunden und muss sowohl Dürrejahre als auch Überflutungen oder Hagel überstehen; dabei ist die sorgfältige Beobachtung der Jahreszeiten mit ihrem charakteristischen Wettergeschehen eine logische und notwendige Folge. Aber auch hinsichtlich des Arbeitsaufwandes bedeutet das Leben als Ackerbauer keine Erleichterung, im Gegenteil. Beobachtungen haben gezeigt, dass Wildbeuter im Vergleich zu Bauern nur einen Bruchteil der Zeit für ihren Lebensunterhalt aufwenden müssen (drei Arbeitsstunden pro Tag genügen einem Yanomami im südamerikanischen Regenwald).

Tatsächlich rätselt die Wissenschaft bis heute über die Gründe für den durchschlagenden Erfolg der neolithischen Revolution und über die Frage des „Warum" und „Wie" ihres Vordringens vom fruchtbaren Halbmond über Westanatolien bis Europa. Waren es Einwanderer, die die neuen Techniken mitbrachten, oder wurden die Kenntnisse von den ursprünglichen Bewohnern übernommen, fand also ein Wissenstransfer statt? Manches spricht für die erste Variante, denn die domestizierten Getreidesorten und Tiere hatten bis auf das Schwein in Europa keine wild lebenden Vorläufer. Und uneingeschränkt überzeugend kann die neue Lebensweise auch nicht gewesen sein, denn sie wurde von den einheimischen Gruppen nur nach und nach im Lauf

der folgenden Jahrtausende übernommen. Klar ist allerdings, dass sich der Lebensraum für Wildbeuter signifikant verkleinerte, als er ihnen von Bauern mit ihrer konkurrierenden Wirtschaftsweise streitig gemacht wurde, sodass sie sich letztlich dem Druck beugen und der neuen Überlebensstrategie anschließen mussten.

Was letztlich die Ursachen für die Neolithisierung zunächst Westanatoliens, dann Südosteuropas gewesen sein mögen, Tatsache ist, dass neolithische Technologien einschließlich der Töpferei, dass Viehzucht und Ackerbau sich durchsetzten und in einem Siegeszug ohnegleichen den Weg nach Westen antraten. In ihrem Gefolge entstanden nicht nur feste Dörfer und eine erste Hausarchitektur und damit auch eine neue Form von sozialer Gemeinschaft, sondern auch die Weltanschauung und das Lebensgefühl wurden neolithisch.

Konkret bedeutet das, dass das neolithische Weltbild mit dem heraldischen Weibchen, seinen Ritualen und seiner Totenverehrung den Kosmos dieser frühen Ackerbauern bildete und entsprechend den lokalen Erfordernissen abgewandelt wurde. In biologischer Sprache ausgedrückt: Das neolithische Weltbild, das sich in der Levante und in Ostanatolien aus Vorläufern (biologischen Dispositionen) entwickelt hatte, passte sich in einem Adaptationsprozess an verschiedene Lebensräume an und erfuhr so regional unterschiedliche Ausprägung.

Die Urmutter – eine Deutung aus Sicht der Analytischen Psychologie

Zu den dominierenden Gestalten des neolithischen Weltbildes gehört zweifelsohne jenes heraldische Weibchen – ursprünglich entstanden aus einem Idol –, das wirkmächtige Abwehrsignale in sich vereinigte, wiederholt mit dem Tod in Verbindung gebracht und hier mehrfach als Urmutter bezeichnet wurde. Ihr Erscheinungsbild ist eindeutig. Es handelt sich um die Darstellung einer üppigen und betont weiblichen Frau, überwiegend in Frontalansicht dargestellt. Die ursprünglichen Drohgebärden, so die obszöne Spreizung der Beine und damit Zurschaustellung der Vagina, sind meist deutlich. Verstärkt wird der Eindruck durch das Beigesellen gefährlicher Tiere, die die Figur heraldisch flankieren. Das Motiv dieses heraldischen Weibchens tritt zwar nirgendwo mehr so dominierend in Erscheinung wie in den Wandreliefs von Çatal Hüyük, bleibt aber ein fester Bestandteil weltanschaulich motivierten Kunstschaffens und deutet auf die ungebrochen große Bedeutung dieser Urmutterfigur, die ja, wie das vorherige Kapitel zeigte, auch die Verbindung zu den ersten schriftlich überlieferten Religionen darstellt.

Der Zusammenhang zwischen dem Weiblichen und dem Tod, der schon in Lepenski Vir, vor allem aber in Çatal Hüyük deutlich zu erkennen ist, mag dabei zunächst irritieren, assoziieren wir heute mit dem Weiblichen doch viel stärker den Vorgang der Geburt als Beginn des Lebens statt den Tod. Dass Frauengestalten mythologisch aber immer wieder mit dem Tod in Verbindung gebracht worden sind, hat insbesondere der Begründer der Analytischen Psychologie, Carl Gustav Jung (1875–1961), in seinen Arbeiten über den Mutterarchetyp beobachtet. Archetypen sind nach Jung grundlegende Vorstellungsmuster, die als Bestandteile eines kollektiven Unbewussten allen Menschen als Prägung mitgegeben werden und in Form archetypischer Ereignisse (z. B. Geburt, Initiation, Heirat, Tod), archetypischer Motive (z. B. Weltschöpfung oder Weltuntergang) und archetypischer Figuren (z. B. Mutter, Vater, Kind, Held, Schatten oder weiser Alter und weise Alte) unsere Lebenserfahrungen strukturieren. Dabei ist wichtig darauf hinzuweisen, dass nach Jungs Ansicht lediglich die Formen der Archetypen zur vorgegebenen psychischen Ausstattung des Menschen gehören. Ihre konkrete inhaltliche Ausgestaltung erfolgt abhängig vom jeweiligen kulturellen Kontext, und nur in bereits kulturell verfestigter Form sind sie uns auch in Mythen, Sagen und Märchen oder in der Kunst zugänglich.

Der Archetyp der Mutter begegnet uns Jung zufolge in den unmittelbaren Erfahrungen von Muttergestalten wie Mutter, Großmutter oder Amme, daneben aber auch in Form mysteriöser Frauengestalten, so als weise alte Frau oder als Hexe, als göttliche Mutterfigur wie Isis, Kybele, Demeter oder Maria, oder als mythische Stammmutter Tiamat oder Eva. Aber auch in Personifizierungen wie „Mutter Erde", „Mutter Natur" oder „Mutter Kirche" begegnet uns der Mutterarchetyp und ähnlich auch als „allesnährende Mutter" (Alma Mater = Universität) sowie als Heimatstadt oder -land („Mütterchen Russland"). Auch Landschaften, Höhlen (Gebärmutter), stehende Gewässer, Brunnen und Meere (Fruchtbarkeit, Fruchtwasser) können die Mutter versinnbildlichen. Allerdings klingen bei etlichen Beispielen neben den fürsorglichen, nahrungs- und lebensspendenden Facetten des Mütterlichen auch die bedrohlichen Seiten des Mutterarchetyps an, der auch durch ein zerstörerisches, verschlingendes Moment gekennzeichnet ist. Bei Jung ist dies einerseits die Bedrohung angesichts des Inzesttabus, aber auch schlicht überbordende, eifersüchtige, erdrückende und „verschlingende" Mutterliebe. Unter diesem Aspekt können auch Ungeheuer und Drachen ein Sinnbild der Mutter sein. Viele Schöpfungsmythen kennen das Motiv, dass ein urtümliches Ungeheuer von einem Helden getötet werden muss, um den Mutterboden für die werdende oder neu zu schaffende Welt zu bereiten. Eindrückliches Beispiel ist die hier bereits erwähnte babylonische Tiamat, die als Urdrache vom Gott Marduk bezwungen und aus deren Leib anschließend die Welt geformt wird. Hier

zeigt sich also ein deutlicher Zusammenhang zwischen dem Mutterarchetyp und dem Tod.

Neben dem zerstörerischen Element des Mutterarchetyps spielt für die Beziehung zwischen Mutter und Tod jedoch auch der Gedanke einer Symmetrie von Leben und Tod eine Rolle, der sich vor allem am Aspekt der Fruchtbarkeit festmacht. Im Sinne der Symmetrie steht die Mutter dann nicht nur für das Werden (Geburt), sondern auch für das Vergehen (Sterben), das notwendig ist, um neues Leben zu ermöglichen. Geburt und Sterben werden damit beide durch den Mutterarchetyp repräsentiert: Der Tote kehrt in den Schoß der Mutter Erde zurück – „Staub bist Du, zum Staub kehrst Du zurück". Angesichts dieser Assoziationen zwischen Mutter und Tod überrascht es nicht, dass in historischen Religionen auch das Totenreich selbst durch eine Göttin verkörpert werden konnte. Das ist beispielsweise beim germanischen Totenreich Hel der Fall, das von einer gleichnamigen Göttin beherrscht wurde. In späterer Zeit wurde aus Hel dann die Hölle als Bezeichnung der christlichen Unterwelt.

Jungs Theorie der Archetypen im kollektiven Unbewussten ist – nicht nur in der Psychologie – teilweise heftig als zu spekulativ kritisiert worden. Man muss allerdings kein Anhänger der Archetypenlehre sein, um anzuerkennen, dass es über verschiedene Kulturen und Religionen hinweg immer wiederkehrende Motive gibt, weil sie grundlegende Erfahrungen widerspiegeln, die Menschen zu allen Zeiten gemacht haben. Der hier skizzierte Zusammenhang zwischen mütterlichem Prinzip und Tod gehört sicherlich dazu, und Lepenski Vir sowie Çatal Hüyük stellen die ersten historischen Beispiele dar, in denen sich dieser Zusammenhang kulturell in Gestalt der Urmutter manifestiert hat. Dabei dürfte es kaum ein Zufall sein, dass die Urmutter als Symbolgestalt von Leben und Tod genau in dem Zeitfenster erstmalig auftritt, in dem sich der Wechsel zur agrarischen Wirtschaftsform und damit zu einer gesteigerten Bedeutung des natürlichen Wechselspiels von Werden und Vergehen vollzieht.

Die Urmutter im Neolithikum: von Ritual und Mythos

Zwar verweisen die uns bekannten ältesten Kosmogonien des Enūma eliš, des pelasgischen oder des homerischen Schöpfungsmythos, in denen eine Überwindung der Urmutter erkennbar ist, eindeutig auf uralte und, wie wir gezeigt haben, neolithische Religionsschichten, sie wurden aber erst in einer Zeit niedergeschrieben, in der neue Göttergeschlechter schon längst die urzeitlichen heiligen Figuren abgelöst hatten und eine neue, nunmehr stratifizierte Gesell-

schaft ganz andere Anforderungen an ihr Weltbild stellte – der kriegerische Held war erst in einer Welt gefragt, in der sich frühe Stadtstaaten mit Königen an der Spitze bekriegten und um die Vorherrschaft kämpften. Von diesen Zeiten früher Heroen von der Art eines Marduk oder auch eines Dionysos, eines Gilgamesch oder eines Herakles trennten die ersten Bauern jedoch noch mindestens 3000 Jahre historischer Entwicklung, bis aus der egalitären Gemeinschaft gerade erst sesshaft gewordener Bauern eine stratifizierte Gesellschaft entstand, in der eine Elite schicksalhaft mit den Göttern verbunden war und daraus Vorrechte ableitete.

Zunächst einmal lag aber diese stratifizierte Gesellschaft mit ihren Heroen in weiter Zukunft, und an Göttergestalten hatte das Neolithikum noch keinen Bedarf. Die Rolle der Urmutter bleibt also über die von Jung anhand des späteren religionsgeschichtlichen Materials gezeichneten Grundlinien hinaus genauer zu klären. Es war der herausragende Völkerkundler Adolf Ellegard Jensen (1899–1965) – eigentlich studierter Physiker –, der als Ergebnis intensiver Forschungen in der Südsee den Begriff der Dema in die Völkerkunde einführte. Demnach ist die Dema ein übermächtiges Wesen, das zu Beginn der (für die jeweilige Gruppe sozial relevanten) Zeit die Welt betritt, in seiner Umgebung wunderbare Dinge geschehen lässt, daraufhin ermordet und zerstückelt wird, dann aber als Totengottheit die Welt der Toten beherrscht. Aus den vergrabenen Leichenteilen entstehen die wichtigsten Feldfrüchte. Geschehnisse in Verbindung mit diesem Urmord sind die Grundlage der Sozialordnung, weshalb sie in regelmäßigen Abständen im Ritual wiederholt werden müssen, um eben jene Ordnung aufrechtzuerhalten. Berühmt wurde der von Jensen im Rahmen einer Expedition (1937) auf die Molukkeninsel Ceram (heute Seram) aufgezeichnete Hainuwele-Mythos, an dessen Beispiel er *Das religiöse Weltbild einer frühen Kultur* (1948) prototypisch deutlich machte (vgl. auch Abb. 8.2).

Der Mythos erzählt, dass am Anfang der Zeiten, als Urwesen auf der Welt lebten, die weder den Tod noch die körperliche Liebe kannten, ein Mann namens Ameta mit seinem Hund auf die Jagd ging und ein Schwein aufstöberte, das sich in einen Teich flüchtete und darin ertrank. Ameta fischte das Schwein aus dem Wasser, das auf einem seiner Hauer eine Kokosnuss aufgespießt hatte. Kokosnüsse waren aber zur damaligen Zeit unbekannt. Ameta ging mit der Kokosnuss nach Hause und legte sie zunächst auf ein Gestell. Während der Nacht träumte er, dass ihn ein Mann anweise, die Kokosnuss einzupflanzen. Er folgte dieser Stimme, und bereits nach drei Tagen war aus der Nuss eine hohe Palme gewachsen, die nach weiteren drei Tagen bereits Blütenstände trug. Ameta wollte die Blütenstände schneiden, um Palmwein zu gewinnen, als er sich in den Finger schnitt und Blut aus der Wunde auf den Blütenstand tropfte. Aus der Mischung von Blut und Palmsaft entstand

auf dem Palmblatt ein kleines Mädchen, das er in einen Sarong patola (Sarong mit Schlangenmuster) wickelte, mit nach Hause nahm und Hainuwele, das heißt Kokospalmzweig, nannte. Bereits nach drei Tagen war aus dem Kind eine heiratsfähige junge Frau, eine Mulua, geworden, die über wunderbare Eigenschaften verfügte, denn wann immer sie ihre Notdurft verrichtete, so waren das wertvolle Gegenstände, sodass ihr Vater sehr reich wurde. Dies jedoch erregte den Neid der anderen Menschen. Als daher nach einiger Zeit ein großer Marotanz stattfand, bei dem die Frauen in der Mitte der Tanzenden zu sitzen und ihnen Bethel zu reichen pflegen, Hainuwele dagegen an die Tanzenden große Kostbarkeiten verschenkte, wurde sie ermordet, indem man sie während des Tanzes in Richtung einer Grube drängte, sie hineinstürzte und die Grube mit Erde zuschüttete. Nachdem Ameta vergeblich auf seine Tochter gewartet hatte, wusste er, dass sie ermordet worden war. Mithilfe der Blattrippen der Kokospalme fand er die Leiche seiner Tochter, grub sie aus, zerstückelte sie und begrub die einzelnen Stücke am Rande des Tanzplatzes. Aus den Leichenstücken jedoch entstanden die Knollenfrüchte, die seitdem die Hauptnahrung der Menschen darstellen. Die Arme vergrub Ameta jedoch nicht, sondern ging mit ihnen zu Mulua Satene, die selbst aus einer unreifen Banane entstanden war und seitdem über die Menschen herrschte. Satene wurde daraufhin auf die Menschen böse, weil sie gemordet hatten. Sie ließ sie bei einem großen Tor antreten und teilte sie in die Lebewesen ein, die auch heute die Erde bevölkern. Sie selbst verließ die Erde und wohnt seit dieser Zeit auf dem Totenberg. Erst nach ihrem eigenen Tod und einer beschwerlichen Reise können die Menschen wieder zu Mulua Satene gelangen. Seit dieser Zeit aber gibt es den Tod und die körperliche Liebe auf der Welt.

Wie Jensen weiter ausführt, handelt es sich hier um eine charakteristische Erzählform, die es zur Zeit seiner Expedition ganz ähnlich bei allen benachbarten Völkern gab: Durch ein dramatisches Ereignis fand die Urzeit des Menschen (die Welt der Wildbeuter?) ein Ende, und das Leben der Menschen erfuhr eine charakteristische Umgestaltung. Die wichtigsten Nutzpflanzen der frühen Ackerbauern erschienen im Rahmen dieses Urzeitereignisses, aber auch die Liebe und der Tod, Sozialstrukturen und Grundformen des Rituals – hier der Marotanz – wurden eingeführt. Der Mythos, also eine sinnstiftende Ursprungserzählung, deutet demnach die Welt in metaphysischer Hinsicht. Der Mythos will die Welt keineswegs naturwissenschaftlich erklären, sondern greift tiefer, dahin, wo naturwissenschaftliche Erklärung versagen muss. Es geht um die Grundfragen des Menschen, um das Wesen von Liebe und Tod, die Bedingungen des Menschseins und die soziale Ordnung.

Die Ordnung, die der Mythos begründet und die als gut und richtig empfunden wird, bleibt aber fragil. So wie Mulua Hainuwele und Mulua Satene die Welt geordnet haben, muss sie von Zeit zu Zeit wieder geordnet werden,

damit sie nicht im Chaos versinkt. Die Tat von Hainuwele muss also in regelmäßigen Abständen wiederholt werden – im Ritual! Unabhängig von seiner sozialen Bedeutung im Dienste der Konfliktlösung dient das Ritual also aus theologischer Sicht der Herstellung oder Wiederherstellung einer als gut und sinnvoll empfundenen Ordnung und bindet dabei existenzielle Fragen nach Tod und Liebe ein.

Mit seiner sensiblen Analyse führte Jensen zu seiner Zeit nicht nur die Theorien in der Nachfolge eines Condorcet oder Comte *ad absurdum*, die in den Riten und Handlungen traditionell lebender Völker nichts als Aberglauben und hoffnungslose Zurückgebliebenheit sehen wollten, sondern lieferte auch die Erklärung für bis dahin unverständliche Elemente in den Kulthandlungen und Mythen des klassischen Altertums. Auch hier ließ sich ein zeitlicher Horizont rekonstruieren, der auf weitaus älteren Vorstellungen als das antike Pantheon fußt und das geistig-seelische Erleben einer frühen Kultur, nämlich des Neolithikums, widerspiegelt.

Welche Bedeutung hat in diesem Zusammenhang demnach die Urmutter? Es handelt sich offensichtlich um eine übermächtige Frauengestalt im Sinne der Mulua Hainuwele oder der Mulua Satene. Diese ist zwar übermächtig, aber nicht unsterblich, und verlässt im Rahmen eines dramatischen Ereignisses die diesseitige Welt, um Herrscherin über das Totenreich zu werden. Da im Rahmen dieses Ereignisses nicht nur der Tod, sondern auch die körperliche Liebe und damit Geburten Teil der menschlichen Existenz wurden und gleichzeitig die Feldfrüchte entstanden, wird die Urmutter oder weibliche Dema sowohl mit Geburt und Tod als auch mit der Fruchtbarkeit der Felder verknüpft. Es ist in diesem Fall also das Wechselspiel von Werden und Vergehen, das aus dem heraldischen Weibchen die Urmutter mit ihrer Verbindung zum Tod begründet. Wenn auch der ursprüngliche Mythos um die schamweisende Frauengestalt, die anatolische Urmutter, nicht mehr zu rekonstruieren ist, dürfte das Grundmuster einer übermächtigen Frauengestalt mit Schutzfunktion und mit deutlichen Bezügen zum Tod wie auch zur sozialen Ordnung der Wirklichkeit doch recht nahekommen. Gleiches gilt für das Ritual, welches Urzeitgeschehen wiederholt, um vom metaphysischen Standpunkt aus gesehen die soziale Ordnung aufrechtzuerhalten und von sozialer Warte auf gemeinsame Werte zu verweisen.

Hacılar

Welchen durchschlagenden Erfolg das Denkmodell der Urmutter hatte, zeigt sich nicht nur an den bereits beschriebenen neolithischen Ausgrabungsstätten, bei denen die Schamweisende immer wieder dominierend in Erscheinung

trat – besonders eindrücklich in Lepenski Vir und natürlich in Çatal Hüyük –, sondern auch während der folgenden Jahrtausende, in denen diese frühe übermächtige Gestalt oder Dema immer wieder auftauchte, um dann langsam sowohl hinsichtlich ihrer Bedeutung als auch ihrer Erscheinungsform verschiedenste Abwandlungen(!) zu erfahren. Wie wenig das Bild der Urmutter festlag, wie stark es auch in künstlerischer Hinsicht variiert wurde und wie schwierig es oft zu erkennen ist, zeigt das Beispiel der Siedlung Hacılar.

Hacılar oder auch Hacılar Höyük, eine in den Jahren 1957 bis 1960 ebenfalls von James Mellaart ausgegrabene neolithische Siedlung, liegt in unmittelbarer Nähe der Stadt Burdur im Südwesten des anatolischen Plateaus. Hier, in einem fruchtbaren Tal mit mildem Klima und guter Wasserversorgung, ließen sich um 6700 v. Chr. (nicht kalibriert) zum ersten Mal neolithische Bauern nieder, die Ziegen und vielleicht auch schon Rinder züchteten und erste Getreidesorten wie Emmer und Einkorn anbauten. Nach verschiedenen frühen Phasen der Blüte und des Niedergangs entstand etwa 1000 Jahre später ein Dorf, das einer Brandkatastrophe zum Opfer fiel. Was für die damaligen Bewohner ein furchtbares Ereignis gewesen sein muss, entpuppte sich für die Archäologie als Glücksfall, denn organisches Material ist, wenn es angekohlt ist, erheblich resistenter gegen Fäulnis! Man weiß daher, dass dieses Dorf, das Hacılar der Ausgrabungsschicht VI, aus einer Reihe zweigeschossiger, rechteckiger Häuser mit etwa 30 bis 50 m² Grundfläche bestand, die sich um Höfe mit überdachten Kochstellen gruppierten. Betreten wurden diese Häuser durch ein breites Portal mit zweiflügeligen Türen. Das Hausinnere war wenig aufregend: Es gab Feuerstellen und regalartige Vertiefungen in den Wänden zur Aufbewahrung von Gegenständen.

Hinsichtlich des Siedlungsbefundes blieb Hacılar VI also unspektakulär, und Gleiches gilt auch für die folgenden jüngeren Schichten dieses Ortes. Berühmt geworden ist Hacılar dagegen sowohl durch seine herausragende Keramik als auch durch seine faszinierenden Frauenfigurinen. Es handelt sich bei Letzteren um 7 bis 24 cm große, oft rot und cremeweiß bemalte Tonfigürchen, die vorwiegend in der Nähe der häuslichen Herde gefunden wurden (Abb. 9.1). Trotz einiger charakteristischer stilistischer Elemente wie runde Arme und Schenkel, kleine Hände und Füße und betonte Brüste zeigen die Figürchen doch individuelle Züge besonders hinsichtlich Alter und Haartracht – es wurden demnach Individuen und nicht ein Typus dargestellt. Hinzu kommen einige Attribute, die bereits aus Çatal Hüyük bekannt sind, so der Leopard, hier in den Armen einer offensichtlich noch jungen Frau. Auch die beschwichtigenden und bedrohenden Gesten des heraldischen Weibchens mit gespreizten Schenkeln und Brustweisegestus tauchen wieder auf.

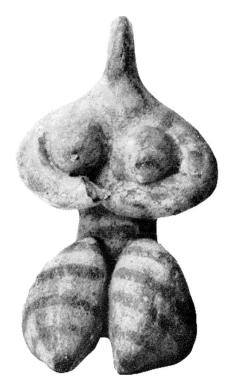

Abb. 9.1 Frauenfigurinen aus Hacılar (Türkei) mit apotropäischem Brustweisegestus

Über die Verwendung der Figürchen sagt der Siedlungsbefund allein wenig. Zwar wurden sie meist, wie bereits erwähnt, am häuslichen Herd, aber niemals mit Küchengerät vergesellschaftet gefunden, und Parallelen zu Çatal Hüyük und Lepenski Vir legen den Gedanken nahe, dass es sich hier um Ahnenfigürchen mit inhaltlichem Zusammenhang mit einem Totenritual handeln könnte. Klare Bezüge zum Tod und zum Bestattungsbrauch fehlen allerdings. Wir wissen nicht, wo und wie die Bewohner von Hacılar ihre Toten beisetzten.

Und auch andere Motive – die Urmutter und der Stier –, die in Çatal Hüyük ständige Begleiter des Todes waren, sind in Hacılar durchaus präsent, wenn auch nicht als lebensgroßes Relief oder Bukranium, aber doch als eindrucksvolles Motiv auf der Keramik: Auf Bechern und Schalen fanden sich ihre Abbilder in den unterschiedlichsten Abwandlungen (Abb. 9.2).

Auch wenn die Motive vielfach eine Wandlung hin zu den von der Kulturethologie festgestellten Regelmäßigkeiten durchlaufen haben (vgl. Kap. 5), sind doch die ursprünglichen Motive zumindest bei Kenntnis der Entwicklungslinie noch deutlich zu erkennen, so das heraldische Weibchen (Urmut-

Abb. 9.2 Keramik aus der Grabungsschicht II B von Hacılar. (Zeichnung: Karolina Rupik nach Mellaart)

ter; Abb. 9.3), das drohstarrende Auge oder das zum Muster mutierte Bukranium (Abb. 9.4).

Hier findet man sowohl die thronende Frauenfigur Çatal Hüyüks in heraldischer Frontalansicht als auch in Seitenansicht. Man findet das Motiv vereinfacht als Stufenpyramide oder Treppe, beides häufig flankiert von Schnörkeln, die sich – allerdings nur bei Kenntnis der Ausgangsformen – als Rinderhörner identifizieren lassen.

Das heraldische Weibchen, die Urmutter, ist also zusammen mit dem Bukranium auch in Hacılar allgegenwärtig und die Tatsache, dass beides skelettiert, in Einzelelemente zerlegt, neu zusammengesetzt, den Regeln von Vereinfachung, Dopplung, Luxurierung usw. unterworfen wurde, macht deutlich, dass diese Figur inzwischen selbstverständliches Element des anatolischen Kosmos geworden war.

Ahnenkult – Hausschreine entstehen

Aber zurück zu den Figurinen, die uns in Lepenski Vir, Çatal Hüyük und Hacılar zum ersten Mal begegneten und zumindest in den beiden erstgenannten Orten in eindeutigem Zusammenhang mit Begräbnissen standen. Diese

Abb. 9.3 Keramikmotiv des heraldischen Weibchens. (Zeichnung: Karolina Rupik nach Mellaart)

meist nur handtellergroßen Kunstwerke tauchen nun im Zuge der Neolithisierung auch in Südost- und Ostmitteleuropa auf, und zwar in einer solchen Fülle und Vollendung, dass sie geradezu als Charakteristikum dieser Epoche gelten können.

Eine solche Siedlung ist das der sogenannten Sesklokultur zugehörige, frühneolithische Achilleion (6400 bis 5600 vor Chr.) in Thessalien, in dem Frauenfigurinen mit den nun schon bekannten ethologischen Signalen des Schampräsentierens und Brustweisens vorwiegend in Herdnähe gefunden wurden. Eine Ausnahme ist ein Amulett aus schwarzem Gesteinsmaterial, das das heraldische Weibchen darstellt und in einer Vorratsgrube entdeckt wurde (Abb. 9.5). Hier hatte es offensichtlich seine Schutzfunktion zu erfüllen, nämlich die Vorräte vor Plünderung und Schädlingsbefall, möglicherweise auch vor Diebstahl, zu bewahren.

Im selben Ort, aber in den nächstjüngeren Siedlungsschichten, tauchten in unmittelbarer Nähe von Herden, überdachten Backöfen oder Feuerstellen immer wieder Figurinen auf, charakteristischerweise oft mit besonders schönen Gefäßen vergesellschaftet.

Abb. 9.4 Keramikmotiv Bukranium. (Zeichnung: Karolina Rupik nach Mellaart)

Ganz unverstellt nehmen die Figürchen ethologische Signale auf. Scham-präsentieren und Brustweisen sind mehr die Regel denn die Ausnahme und belegen, dass man auch hier, im gerade erst neolithisierten Südosteuropa, auf die apotropäischen Eigenschaften der kleinen Idole noch nicht verzichten konnte. Interessanter aber ist hier das Auftreten einer Neuerung. Bei den Figurinen handelt es sich häufig um Sitzfiguren (Abb. 9.6), die entweder auf Stühlchen sitzend oder der Einfachheit halber gleich vierfüßig modelliert wurden, um sie besser in Herdnähe aufstellen zu können. Dies erlaubt Rückschlüsse hinsichtlich ihrer Verwendung: Sie wurden nun nicht mehr nur im Rahmen eines zeitlich begrenzten Ereignisses genutzt, sondern hatten einen dauerhaften Platz am Herd gefunden, wo man sie ganz offensichtlich verehrte und mit Gaben von Speisen versorgte.

Abb. 9.5 Achilleion: heraldisches Weibchen als Amulett. (Zeichnung: Karolina Rupik nach Gimbutas)

Abb. 9.6 Figurinen aus Achilleion. (Zeichnung: Karolina Rupik nach Gimbutas)

Dass aus Figurinen, die ursprünglich der Vergegenwärtigung der Toten während des Bestattungsrituals und der unmittelbar folgenden Zeit gedient hatten, nun im Lauf der Zeit etwas anderes entstand, belegen eben diese und weitere Funde aus dem Neolithikum des südöstlichen und östlichen Europas. Im Hausinneren waren regelrechte Kultecken mit kleinen Idolen und besonders schönen Gefäßen – gelegentlich auch Miniaturgefäßen – eingerichtet worden, die bei Kenntnis ihrer Ursprünge im fruchtbaren Halbmond nur eines bedeuten können: Es handelt sich um Ahnenfigurinen, die hier im Rahmen eines Hauskultes verehrt wurden (Abb. 9.7).

Abb. 9.7 „Tempel" von Sabatinovka (Ukraine) im Gebiet Moldau. (erste Hälfte 5000 v. Chr.) (Zeichnung: Karolina Rupik nach Gimbutas)

Abb. 9.8 Hausmodell aus Platia Magoula in Zarkos. (Spätneolithikum: 5300 bis 4800 v. Chr.) (Zeichnung: Karolina Rupik)

Aber nicht nur Kultecken oder altarähnliche Plattformen wurden errichtet, sondern regelrechte kleine Hausaltare wie das aus dem mittelneolithischen Platia Magoula in Zarkos (Abb. 9.8). Hier entdeckten die Ausgräber unter dem Fußboden des Wohnhauses in Herdnähe ein tönernes Hausmodell ohne Dach, aber mit Einrichtungsdetails wie Schlafplattform, Türöffnung und einen Ofen, in dem acht Figurinen lagen. Offensichtlich war das Modell in einem Ritual als Bauopfer unter dem Fußboden begraben worden und er-

Abb. 9.9 Hausmodell bzw. Hausaltärchen aus dem neolithischen Makedonien (um 5500 v. Chr.) (Zeichnung: Karolina Rupik)

setzte die alten Hausbestattungen und Schädeldeponierungen. Wo seit dem Paläolithikum Schädel deponiert wurden, um die Rechtmäßigkeit eines Territorialanspruches zu belegen, hatten nun Ahnenfigürchen diese Aufgabe zu erfüllen. In einem Hauseinweihungsritual wurden die tönernen Abbilder der Ahnen in Herdnähe unter dem Fußboden „bestattet" und verweisen so auf Kontinuität einerseits, zeigen andererseits aber auch, dass das Haus als heilig und Teil des neolithischen Kosmos angesehen wurde.

Nicht immer waren die kleinen Architekturmodelle jedoch Bauopfer, sondern wurden auch oft am Herd, der alten häuslichen Kultstätte, gefunden und nahmen Motive auf, die die alles dominierende Urmutter von Çatal Hüyük anklingen lassen. Das Hausmodell wurde dominiert von einer weiblichen Figur, die gleichermaßen das Haus selbst ist und offensichtlich als dessen Beschützerin galt (Abb. 9.9). Die Urmutter entwickelte also bereits individuelle Züge, besondere Eigenschaften und Zuständigkeiten, was auf eine Aufspaltung in mehrere Gottheiten hinweist: Hier wurde Hestia (römisch Vesta), die Göttin des Heimes und des Herdes, geboren!

Noch im Rom der Antike verehrte man im Haus die Laren und Penaten (Abb. 9.10), die häuslichen Schutzgeister, die der römische Dichter Plautus

Abb. 9.10 Opferaltar und Nische für Figürchen (Lararium) in Pompeji (79 n. Chr.). (Bibelfreilichtmuseum in Nimwegen; © Wolfgang Sauber; Creative Commons Attribution-Share Alike 3.0 Unported license)

wie folgt sprechen lässt:

> Ich bin der *Lar familiaris* des Hauses, aus dem ihr mich habt treten sehen. Dieses Haus besitze und hege ich schon viele Jahre, schon für den Vater und Großvater dessen, der es jetzt bewohnt. (Plautus, Aulularia, Prolog 1–5)

Und über die Penaten sagt Meyers Konversationslexikon von 1888:

> Die guten Hausgeister, […] welche die Einheit und den Bestand der Familie schützten und namentlich für den täglichen Bedarf an Lebensmitteln sorgten. Ihr Heiligtum war der Herd als Mittelpunkt des Hauses, auf dem ihnen und der Vesta zu Ehren ein immerwährendes Feuer unterhalten wurde, und in dessen unmittelbarer Nähe auch die Bilder der Penaten (meist puppenartig klein und oft roh aus Holz geschnitzt) aufgestellt waren.

Der römische Hauskult hat demnach seine Wurzeln im häuslichen Ahnenkult des Neolithikums, der selbst wieder aus den frühneolithischen, zweistufigen

Bestattungsritualen mit der Vergegenwärtigung des Toten in einer Ahnen-
figur hervorgegangen ist. Die römische Hausgöttin Vesta dagegen hat ihren
Ursprung in der neolithischen Urmuttervorstellung Anatoliens, die auf noch
ältere Wurzeln, nämlich die apotropäische Wirkung des heraldischen Weib-
chens und damit direkt auf Schutz- und Abwehrsignale zurückblicken kann.

Felsbildnisse am Latmos – ein Initiationsritual

Nicht nur für das Überleben und den Wandel alter Bräuche im Zusammen-
hang mit Bestattungen gibt es Hinweise, auch das Ritual wurde zum festen
Bestandteil der neolithischen Gesellschaft. Rituale sind in unstratifizierten
Gesellschaften ein unverzichtbares Mittel der Konfliktbewältigung, auch, in-
dem sie auf höchste Werte verweisen, höchste Werte, die im Mythos als geis-
tigem Abbild der Weltsicht formuliert werden. Dass Rituale vor allem im Zu-
sammenhang mit dem Tod im Neolithikum der Levante und Anatoliens eine
große, wenn nicht die entscheidende Rolle gespielt haben, konnte anhand
der Ausgrabungen verifiziert werden, aber auch andere Übergänge im Leben,
so der vom Jugendlichen zum Erwachsenen, wurden festlich begangen. Da-
bei wiederholt das Ritual performativ den Mythos, hält auf diese Weise die
kosmische Ordnung aufrecht und löst durch Verweis auf gemeinsame Werte
mögliche oder konkrete Konflikte. Hinweise auf Rituale gibt es in neolithi-
schen Siedlungen immer wieder. So glaubte man auch in Achilleion einen
Ritualplatz gefunden zu haben, der sich durch zentrale Feuerstellen und eine
große Plattform auszeichnete. Näheres ließ sich aber nicht mehr festmachen.

Ganz anders im Latmosgebirge, dem heutigen Batı Menteşe Dağları in der
türkischen Provinz Muğla, wo Felsmalereien von einzigartiger thematischer
und stilistischer Geschlossenheit einen vertieften Einblick in das religiöse
Handeln der kleinasiatischen Neolithiker erlauben. Hier, im Hinterland der
alten griechischen Stadt Milet, fanden sich in höhlen- und grottenartigen Ni-
schen und Kammern des zerklüfteten Gebirges Felsmalereien, die stark sti-
lisierte Menschen in charakteristischen Gruppierungen zeigen: häufig Paare
von Mann und Frau (Abb. 9.11), die einander zugewandt sind oder sich um-
armen, aber auch Gruppen, deren Zusammengehörigkeit durch einen Balken
gekennzeichnet wird. Auch Darstellungen von Frauen mit Kindern, meist
Mädchen, kommen vor. Daneben finden sich Ornamente, Zeichen und Sym-
bole, die sich meist einer Deutung entziehen.

Besonders schön und gleichzeitig repräsentativ für eine Reihe vergleich-
barer Plätze ist die Felskammer von Balıktaş, idyllisch gelegen in einem stillen
und grünen Tal mit Bachlauf, altem Baumbestand und Farnen. Hier entstan-
den in einer feuchten, aus drei großen Felsblöcken gebildeten Nische durch
die Lösungsverwitterung kassettenähnliche Vertiefungen, die als natürliche

Abb. 9.11 Das Paarmotiv in den Felszeichnungen am Latmos. (Zeichnung: Karolina Rupik nach Peschlow-Bindokat)

Kartuschen für jeweils eine Bildgruppe dienen. Hier fallen nicht nur die bereits bekannten Handpositive auf, sondern auch Menschendarstellungen in charakteristischen Gruppierungen, bei denen vor allem die Darstellung von Paaren, aber auch von Mutter und Kind wie auch Mutter und Tochter von großer Bedeutung sind (Abb. 9.12).

Auch in weiteren grottenähnlichen Nischen oder unter Felsvorsprüngen tauchen immer wieder Darstellungen von Liebespaaren oder Eltern bzw. Mutter mit Kind auf, sodass ohne viel Fantasie konstatiert werden kann, dass in den Malereien das Verhältnis zwischen Mann und Frau und hier möglicherweise konkret Ehe, Liebe und Zeugung thematisiert wird (Abb. 9.13).

Dabei waren die Malereien nun nicht mehr, wie noch im Paläolithikum, Ausdruck einer lustbetonten, reflexionsfreien Tätigkeit, bei der höchstens Prestigedenken eine Rolle spielte, sondern die schematisierten Menschenbilder und Zeichen dienten einem konkreten Zweck, über den ein Blick in die Völkerkunde und die Überlieferungen der Antike Auskunft geben.

Auch die Ureinwohner Australiens, deren gesellschaftliche Organisation ohne Hierarchien und Arbeitsteilung den Verhältnissen des Neolithikums entspricht, haben ein Weltbild, in dem Dema und übermächtige Ahnengestalten die entscheidenden Figuren sind. Hier spielen Felsmalereien eine wichtige Rolle im Rahmen von Initiationsritualen: Auf regelrechten Prozessionswegen, die durch lange Reihen von gemeißelten oder gemalten Men-

Abb. 9.12 Eltern-und-Kind-, meist Mutter-und-Tochter-Darstellungen in den Felsmalereien des Latmosgebirges. (Zeichnung: Karolina Rupik nach Peschlow-Bindokat)

Abb. 9.13 Eine Liebesszene und eine Mutter mit Tochter. Malereien in Lösungskartuschen der Felskammer von Balıktaş. (Zeichnung: Karolina Rupik nach Peschlow-Bindokat)

schen, Geistwesen und Tieren gekennzeichnet sind, ziehen die Ureinwohner von einer Bildergruppe zur anderen und wiederholten vor den einzelnen Bildstellen dramatische Szenen ihrer alten Mythen.

Auch die griechische Religionsgeschichte stößt immer wieder auf Spuren uralten Brauchtums im Verein mit einem ebenso alten Mythos, die sich bis in die Antike erhalten konnten, auch wenn die genauen Zusammenhänge und Bedeutungen schon lange nicht mehr verstanden wurden. Wie noch der römische Dichter Ovid berichtet, wurden im Athen des klassischen Zeitalters im Zuge der Arrhephoria, einem kultischen Fest, jeweils im Herbst zwei sehr junge Mädchen aus den Reihen der Töchter der vornehmen Familien ausgewählt. Diese Mädchen lebten nun auf dem Tempelgelände der Akropolis, erfüllten sakrale Pflichten und erlernten das Weben. Nach Ablauf eines Jahres hatten die Jungfrauen einen geschlossenen Korb, den ihnen die Priesterin der Athene überreichte, auf einem vorgeschriebenen Pfad in den heiligen Bezirk der Aphrodite in den Gärten zu tragen, ihn dort in einer natürlichen, feuchten Grotte zu deponieren und eine andere, ebenfalls verdeckte Last zurückzubringen. Weltanschaulicher Hintergrund dieser Ritualhandlung ist der Mythos von den Töchtern des Kekrops, des ersten mythischen Königs, die in sagenhafter Urzeit im Haus ihres Vaters auf der Akropolis lebten und den Menschen die Herstellung von Kleidung aus Wolle beibrachten. Damals übergab die Göttin Athene den Schwestern einen Korb, in dem der gerade geborene schlangengestaltige Erichthonios, der zweite mythische König Athens und Kind des Hephaistos und der Mutter Erde, lag. Trotz des ausdrücklichen Verbotes blickten zwei der Kekropstöchter in den Korb und stürzten sich, vom Anblick der Schlange zu Tode erschreckt, von der Akropolis.

Sowohl der Mythos als auch die aus klassischer Zeit überlieferten Kulthandlungen weisen auf einen frühen Initiationsritus, in dessen Verlauf junge Mädchen vom Elternhaus getrennt und auf die Burg verbracht wurden, um dort ihre Rolle als Frau und die damit verbundene Tätigkeit des Spinnens und Webens zu erlernen. In ritueller Hinsicht wiederholten sie damit die Taten der Kekropstöchter, die die Menschen das Weben lehrten.

Am Ende ihres Aufenthaltes werden die Mädchen zum ersten Mal mit der Liebe, Empfängnis und Mutterschaft vertraut gemacht: Der Tau und die Feuchtigkeit in der Grotte im Garten der Aphrodite steht für Empfängnis, der schlangengestaltige Erichthonios steht für das männliche Glied und die Zeugung, das Neugeborene im verdeckten Korb für Mutterschaft. Mit ihrem Abstieg von der Akropolis wiederholten die Initiandinnen rituell den Todessturz der Kekropstöchter: Auch sie erleiden als Kinder einen sozialen Tod und steigen aus den Tiefen der Gärten der Aphrodite als junge Frauen wieder hinauf in die Welt der Lebenden. Tatsächlich konnte die Archäologie inzwischen Belege dafür finden, dass die bei Ovid und Pausanias beschriebenen

Kulthandlungen tatsächlich so stattgefunden haben: Bei der Akropolis führt ein steiler, verborgener Pfad hinunter in ein kleines Heiligtum der Aphrodite und des Eros und in eine feuchte Grotte.

Letztlich erlauben also religionstypologische Überlegungen, der ethnografische Vergleich und ein Blick in die Religionsgeschichte, die Felsbildnisse des Latmos zu deuten. Zu einem bestimmten Zeitpunkt im Jahr begaben sich junge Mädchen zum Latmos, um dort heilige Plätze aufzusuchen, die als Wohnort bzw. ehemaliger Aufenthaltsort einer bekannten mythischen Gestalt von der Art einer Mulua Hainuwele galten. Das Schicksal dieser mythischen Gestalt – möglicherweise die Begegnung mit dem männlichen Prinzip oder dem Eros – wurde im Ritual nachvollzogen und bedeutete nach dessen Abschluss eine neue Form der Existenz für die initiierten und damit erwachsenen Mädchen. Die Begegnung mit dem Eros weist jedoch über den persönlichen Bereich hinaus: Die zukünftige Mutterschaft der Frau steht in engster Beziehung zur Fruchtbarkeit überhaupt. Wasser in Form der unmittelbar benachbarten Quellen und die Feuchtigkeit der grottenähnlichen Höhlungen dürfte ähnlich dem Tau des Hephaistos ein befruchtendes Element dargestellt haben, dem die Mädchen begegneten und damit zur Frau wurden. Auf diese Weise wiederholten sie den Weg der mythischen Urzeitgestalt und ermöglichten damit sowohl der Natur wie der Kultur, sich zu erneuern und zu verjüngen. Ein Urzeitgeschehen wurde im Ritual wiederholt, um die gegenwärtige Seinsordnung zu erneuern und zu sichern.

10
Von Göttern und Helden

Religion im Neolithikum? – eine Rückblende

Im Neolithikum entstanden die Grundlagen eines Weltbildes, das wir heute als religiös bezeichnen würden. Man glaubte an übermächtige Wesen, die auf die Geschicke derjenigen Menschen Einfluss nehmen, für die (im Fall der Totenverehrung) Sorge zu tragen ist oder die im Ritual vergegenwärtigt werden. So unterschiedlich die Vorstellungen und Praktiken in den verschiedenen Kulturen, ja selbst in den einzelnen Ortschaften auch gewesen sein mögen, so lassen sich doch einige Merkmale dieser frühesten Religion, ihre Verankerung in der Biologie des Menschen und charakteristische Entwicklungstendenzen (Stichwort „kulturelle Evolution") herausarbeiten.

Zu den Merkmalen dieser frühen Religion gehört sicherlich die Tatsache, dass alte Verhaltensweisen, gerade wenn sie religiös konnotiert sind, ein großes Beharrungsvermögen zeigen, eine Beobachtung, die im Übrigen bereits der Begründer der britischen Anthropologie, Edward Burnet Tylor (1832–1917), gemacht hat. Ein alter Brauch wird beinahe unverändert beibehalten, die unterlegte Begründung wird jedoch dem entsprechenden Zeithorizont angepasst, wie auch die hier diskutierte Sitte der Schädeldeponierungen zeigt: Ursprünglich gedacht zur sinnfälligen Legitimierung von Territorialbesitz, werden die Schädel im Lauf der Jahrtausende zum Sitz der Kräfte des Verstorbenen und sind damit ein Äquivalent zu den sich langsam entwickelnden Ahnenfiguren, die letztlich die Schädeldeponierungen ablösen.

Eine weitere charakteristische Entwicklung betrifft die schamweisende Frauenfigur, die zunächst nur Trägerin ethologischer Signale war und apotropäischen Zwecken diente und die dann zur schützenden Urmutter wurde. Aus dieser mythischen Figur entwickelten sich in den folgenden Jahrhunderten durch Hypostasierung offensichtlich voneinander unabhängige übermächtige Gestalten, von denen eine sicherlich der Unterwelt, eine andere ebenso sicher Heim und Herd zuzuordnen ist, die also langsam verschiedene Zuständigkeitsbereiche übernahmen und denen vermutlich auch nach und nach spezifische Eigenschaften zugeordnet wurden.

Damit spiegelte das Weltbild die Bedürfnisse einer inzwischen sesshaft geworden Bevölkerung, die der Rituale bedurfte, um potenzielle oder auch tatsächliche Konflikte in den jeweiligen Gesellschaften zu lösen. Man bezog sich dabei auf gemeinsame höchste Werte; das waren neben den Dema die gemeinsamen Ahnen, deren Schicksale in mythischen Erzählungen sinnstiftend miteinander verknüpft waren und damit unverständliche Bedingungen des Menschseins – Liebe, Geburt und Tod – in einen deutenden Zusammenhang brachten.

Dies heißt, es existierten nun religiöse Vorstellungen und Praktiken. Es gab also ein Repertoire an Symbolen, die auf eine jenseitige Welt und höhere Mächte einerseits, auf gemeinsame Werte andererseits verwiesen und die im Ritual vergegenwärtigt wurden – vor allem zu Zeiten, in denen Brüche im Lebenszyklus Einzelner (Pubertät, Tod) die kleine Gesellschaft besonders störanfällig machten.

Wichtig festzuhalten ist allerdings Folgendes. Es gab zu diesem Zeitpunkt noch keine regelrechten Götter mit klaren Zuständigkeitsbereichen und Charakteristika, die diese als eigene, fest umrissene Personen mit individuellen Eigenschaften charakterisierten, sondern vielmehr Dema, jene übermächtigen Figuren aus mythischer Vorzeit, die durch ein bestimmtes Schicksal gekennzeichnet werden und einmal in dieser, ein andermal in jener Gestalt und unter verschiedenen Namen auftreten können, genau wie im Hainuwele-Mythos Serams die Persönlichkeiten der Mulua Hainuwele mit der der Mulua Satene verschwimmen und nur unterschiedliche Seiten ein und derselben Figur zeigen. Eine solche Unschärfe ist beabsichtigt, denn die genannten Gestalten werden noch heute bei traditionellen Völkern und wurden auch damals im Neolithikum im Ritual vergegenwärtigt: Jedes kleine Mädchen bei den Alune und Wemale wird bei seiner Geburt in einen Sarong patola gewickelt und damit zur Mulua Hainuwele, jeder kleine Makondeknabe wird zum Mitglied der Ahnenwelt und damit zum Träger der alten Stammestraditionen. Die Welt der Übermächtigen und die Menschenwelt sind noch nicht absolut getrennt, und es sind eher qualitative Unterschiede, die die Übermächtigen von den Menschen abgrenzen.

Erst in späterer, historischer Zeit entstanden – auch aus den Dema, wie zum Beispiel die Geschichten von Dionysos oder Persephone zeigen – regelrechte Götter, die dann aber nicht mehr im Ritual vergegenwärtigt, sondern im Kult verehrt wurden. Dass sich die älteren Sitten auch in klassischer Zeit lange hielten, zeigt unter anderem das oben exemplarisch erwähnte Beispiel der Arrhephoria: Es handelt sich um ein Ritual, das noch zu einer Zeit praktiziert wurde, in der die Religion bereits ein völlig anderes Gepräge trug. Bis zu den Göttergestalten der Antike, die nun nicht mehr nur chthonischen Charakter hatten (also der Unterwelt angehörten), wie es noch bei den Ahnen der

Fall war, sondern in der luftigen Höhe des Himmels angesiedelt waren, und die vor allem nicht mehr im Ritual vergegenwärtigt, sondern kultisch verehrt wurden, war noch ein weiter Weg zurückzulegen, dessen erste Schritte sich allerdings im Jungneolithikum zeigen.

Zeittafel

Protoneolithikum (auch Natufien):
* 11.500 bis 9500 v. Chr
* zumindest saisonal sesshafte Wildbeuterkulturen in der Levante und am mittleren Euphrat; Figurinen (sexuelles Drohen) mit apotropäischer Funktion; Beispiel: Ain Sakhri

präkeramisches Neolithikum A (engl. *pre-pottery neolithic A*, PPNA):
* 9500 bis 8200 v. Chr.
* feste Siedlungen mit Rundhäusern; erster Getreideanbau; Reliefs (meist gefährliche Tiere, aber auch sexuelles Drohen) mit apotropäischer Funktion; Beispiel: Göbekli Tepe III

präkeramisches Neolithikum B (engl. *pre-pottery neolithic B*, PPNB):
* 8200 bis 6800/6500 v. Chr.
* rechteckige Häuser, Getreideanbau, Domestikation von ersten Nutztieren; meist weibliche Idole mit apotropäischer Funktion; intramurale Bestattungen mit Schädeldeponierungen, übermodellierten Schädeln und ersten Totenfiguren im Rahmen zweistufiger Bestattungen; Beispiele: 'Ain Ghazal, Tell es-Sultan

keramisches Neolithikum in Anatolien und im Vorderen Orient (engl. *pottery neolithic*, PN):
* 6500 bis 5500 v. Chr., ab ca. 6200 v. Chr. auch in Südosteuropa
* elaborierte Bestattungsrituale mit zweistufigen Bestattungen, zunächst Schädeldeponierungen und später Ahnenfiguren, die am Herd verehrt wurden; erste Bestattungen außerhalb der Siedlungen; Urmuttervorstellungen und Dema, aus denen durch Hypostasierung übermächtige weibliche Gestalten mit besonderem Zuständigkeitsbereich entstanden; Beispiele: Çatal Hüyük, Hacılar, Achilleion

Neolithikum in Mitteleuropa (Unterstufen Früh-, Mittel-, Jung-, Spät-, Endneolithikum; letztere auch Kupfersteinzeit oder Äneolithikum):
* 5500 bis 2200 v. Chr.
* weiterhin Schädeldeponierungen und Ahnenverehrung; zweistufige Bestattungen auf Gräberfeldern, in Höhlen oder auf Siedlungsgelände; später in der Trichterbecherkultur entstehen megalithische Grabstätten mit Hinweisen auf eine übermächtige Gestalt, die als Herrscherin der Unterwelt gelten kann; mithilfe der Rondellanlagen lassen sich wichtige kalendarische

Eckdaten für eine bäuerliche Wirtschaft und gemeinsame Kulthandlungen bestimmen; im Jungneolithikum entstehen aus der Kombination von Heldentum und Ahnenkult zusammen mit Mythenbildung erste männliche übermächtige Gestalten; Beispiel: Szegvár-Tüzköves

Kupfersteinzeit (auch Kupferzeit, Chalkolithikum oder Äneolithikum) im Vorderen Orient:

- 5500 bis 3300 v. Chr.; Kupfersteinzeit in Mitteleuropa: 4500/4000 bis 2200 v. Chr.
- stärkere gesellschaftliche Differenzierung und sukzessive Herausbildung einer Oberschicht; aus den Dema werden regelrechte Götter, die im Kult verehrt werden

Helden sind gefragt

Dass sich etwas veränderte, zeigte sich zuerst im häuslichen Ahnenkult, der im Jungneolithikum langsam ein neues Gepräge bekam. Hatten bisher die weiblichen Ahnenfigurinen allein schon zahlenmäßig im Vordergrund gestanden, trat nun langsam, aber dafür umso deutlicher, das männliche Geschlecht in den Vordergrund. Bei Ausgrabungen in Szegvár-Tüzköves (Theißkultur; eine Nachfolgekultur der östlichen [oder Alföld-]Linearbandkeramik im Spätneolithikum in Ostungarn) fand sich in einem der typischen Figurinenensembles in Herdnähe eine männliche, thronende Gestalt mit angewinkelten Armen und im vorderen Brustbereich aufliegenden Händen (Abb. 10.1), die sich hinsichtlich ihrer Größe deutlich von den übrigen Ahnenfigürchen abhebt. Am linken Arm trägt sie einen doppelten, am rechten einen sechsfachen Armreif und hält gleichzeitig in der rechten Hand eine sichelartige Waffe, die über der rechten Schulter liegt. Das Gesicht dieser Figur ist maskenhaft flach und schematisch dargestellt. Ähnliche Figurinen sind auch aus dem Neolithikum Rumäniens und Griechenlands bekannt geworden. Rätselhaft erschien zunächst die Sichel, die in gleicher Form sowohl als Beigabe in neolithischen Gräbern in Portugal, als Zeichnung in der spanischen Cueva de los Letreros in Almeria und zuletzt als konkreter, nun allerdings schon bronzezeitlicher Fund in Zaerzentmihály (Ungarn) auftauchte. Bei der angeblichen Sichel, die das Idol von Tüzköves geschultert hat, handelt es sich allerdings um ein Krummschwert, eine offensichtlich im neolithischen Europa verbreitete, gefährliche und effektive Waffe.

Nicht nur Krummschwerter traten ab dem Spätneolithikum einen aus heutiger Sicht unrühmlichen Siegeszug durch Europa an, sondern auch die

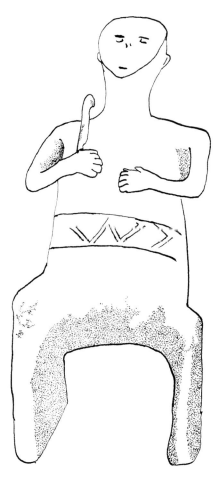

Abb. 10.1 Idol von Szegvár-Tüzköves (Ostungarn). (Zeichnung: Karolina Rupik)

Streitaxt war weit verbreitet und zierte sowohl als isoliertes Objekt als auch als Waffe in der Hand des Kriegers manches megalithische Bauwerk.

Mit dem Aufkommen eines aggressiven männlichen Elementes und der damit einhergehenden Heldenverehrung reagierten die frühen bäuerlichen Gemeinschaften auf das Auftreten offensichtlicher Gewaltakte, die das eigentlich idyllische Leben in den Dörfern unsicher machten. Im heutigen Talheim bei Heilbronn hatten zur Zeit der Bandkeramik Angreifer ein Dorf überfallen (um 5100 bis 5000 v. Chr.) und seine Bewohner einschließlich der Kinder teils mit Pfeilen erschossen, teils mit der charakteristischen, quer geschäfteten Axt, dem Schuhleistenkeil, hinterrücks erschlagen und in einem Massengrab verscharrt. Ob Spekulationen über möglichen Frauenraub den Motiven für die bestialische Tat nahe kommen oder ob es um geeigneten Siedlungsgrund

und fruchtbare Böden, also territoriale Ansprüche ging, lässt sich heute nicht mehr mit letzter Genauigkeit sagen. Tatsache ist jedoch, dass die neolithischen Siedlungen sowohl in Südost- als auch in Mitteleuropa ab einem gewissen Zeitpunkt mit Palisaden gesichert wurden, und offensichtlich hatte man gewichtige Gründe für diese Vorsichtsmaßnahme.

Im Zuge der Ausbreitung der neolithischen Lebensweise veränderte sich also das Zusammenleben der verschiedenen Gruppen, und das Erscheinen von befestigten Dörfern ab etwa 5000 v. Chr. ist eine Neuerung, die auf eine Zunahme gewalttätiger Auseinandersetzungen hinweist. Damit veränderte sich jedoch auch der Charakter der jeweiligen Gesellschaft: Der kriegerische Held trat auf und spielte nun eine wichtige Rolle.

Diese Verschiebungen innerhalb der neolithischen Gemeinschaften spiegelten sich ganz selbstverständlich in der Gestaltung der häuslichen Kultecken wider, wo nun ab dem Jungneolithikum männliche Idole auftraten, die hinsichtlich ihrer Größe und der Sorgfalt der Darstellung aus der Masse der Figurinen hervorstechen. Bei den Portraitierten handelt es sich um die Ahnenfiguren herausragender Persönlichkeiten, eben jener kriegerischen Heroen, die zunächst im Rahmen des häuslichen Ahnenkultes verehrt wurden. Soweit die archäologischen Tatsachen, die im überlieferten Mythos ihre Entsprechung finden.

Der Held im Mythos

Von den meisten der alten Mythen wissen wir nichts mehr – sie lassen sich höchstens anhand von Ritualen und Überlieferungen aus historischer Zeit rekonstruieren wie im Fall der oben geschilderten Arrhephoria. Auch hier wird wieder deutlich, wie zuverlässig und ausdauernd alte Sitten und Vorstellungen tradiert werden, die, zwar vielfach abgewandelt und den jeweiligen Kulturnachfolgern angepasst, dennoch die alten Vorstellungen in Grundzügen bewahrt haben. Wie wir im vorigen Kapitel gesehen haben, ist genau dieser Umstand die Grundlage für Carl Gustav Jungs Archetypenlehre. Und genauso ist es auch mit den frühen Helden, die nach einem Leben voller großer Taten zuletzt den Heldentod starben und, so wollen es die mythischen Erzählungen aus der Antike, zuletzt unter die Götter versetzt wurden. Nach der Ausbildung der Gestalt der Urmutter erleben wir also nun im späteren Neolithikum die „Geburt" eines weiteren von Jung beschriebenen Archetyps, dem des Helden (vgl. Kap. 9), der von nun an zu einer kulturellen Konstante wird.

Der Monomythos des Helden

Auf der Grundlage von Carl Gustav Jungs Archetypenlehre hat der amerikanische Mythenforscher Joseph Campbell (1904–1987) die grundlegenden Elemente der in allen Kulturen der Welt zu findenden Heldenerzählungen herausgearbeitet und in seinem Buch *The hero with a thousand faces* (1949; dt: *Der Heros in tausend Gestalten*) als Monomythos des Helden beschrieben.

Der Monomythos ist gekennzeichnet durch eine charakteristische Abfolge von Ereignissen und Handlungen des Helden. Der Held wird zu einer besonderen Aufgabe berufen, begibt sich, unterstützt von einem Mentor (bei Carl Gustav Jung der weise Alte) und eventuell weiteren Helfern, auf eine gefahrvolle Reise voller Widernisse in eine fremdartige Welt. Dort warten Prüfungen auf ihn, die ihn auf bevorstehende, noch größere Aufgaben vorbereiten. Er erlangt schließlich eine besondere Gabe oder Einsicht oder er raubt ein Artefakt, die ihn zu noch größeren Taten befähigen und symbolisch für seine durch die Prüfungen (Initiation) erlangte Selbsterkenntnis (Individuation) stehen. Teils führt dies dazu, dass der Held dadurch zum Gott aufsteigt oder aber seine schon vorhandene Göttlichkeit erweist, zum Beispiel im Fall der griechischen Heroen, die zumeist von Geburt an Halbgötter sind. Der so transformierte Held begibt sich sodann auf den Rückweg in seine eigene Welt, wo er vor der Herausforderung steht, seine neuen Gaben und Einsichten in den Alltag zu integrieren, um so die Gesellschaft an seinen Errungenschaften teilhaben zu lassen.

Ähnlich wie Jungs Archetypenlehre ist auch Campbells Monomythos wissenschaftlich keineswegs unumstritten. Dennoch ist sein Konzept der Heldenreise – wohl nicht zuletzt aufgrund des gemeinsamen kulturellen Erbes – kulturübergreifend ungemein anschlussfähig. So bediente sich unter anderem der Regisseur George Lucas für seine Star-Wars-Filme des Monomythoskonzepts und produzierte anschließend eine TV-Dokumentation über Leben und Werk Campbells. Und der Drehbuchautor Christopher Vogler entwarf auf der Grundlage des Monomythos eine Anleitung für Autoren (*The writer's journey: mythic structure for writers*), die für zahlreiche Hollywoodproduktionen verwendet wurde.

Der Heldenmythos dokumentiert ein Geschehen, dessen realhistorische Grundlagen in der zweiten Hälfte des Neolithikums zu suchen sind. Ein jugendlicher Held sammelt bei der Verteidigung seines Dorfes und bei Überfällen auf andere Dörfer (auf die fremde Welt) Schätze und Erfahrungen, von denen die eigene Dorfgemeinschaft profitiert, und erntet auf diese Weise Ruhm und Ehre, bis er eines Tages nach einem ruhmreichen Leben den Heldentod stirbt. Man wird sein Begräbnis rituell gestaltet und begleitet haben. Er dürfte im Rahmen einer komplexen, zweistufigen Bestattung beigesetzt und anschließend, in einer Ahnenfigurine vergegenwärtigt, verehrt worden sein, während sein *alter ego* seinen Wohnsitz im Reich einer Dema von der Art einer Mulua Satene aufgeschlagen hatte – ein Reich, das charakteristischerweise auf oder in einem Berg gedacht wurde. Noch heute versetzen alte Sagen Götter oder Heroen in Berge. So wartet Kaiser Friedrich Rotbart im

Kyffhäuser auf die Zeit, wo er seinem in Bedrängnis geratenen Volk zur Hilfe eilen soll, während Frau Venus im Hörselberg bei Eisenach über ein Reich der Lüste und Leidenschaften herrscht.

Vorstellungen und Erzählungen um so einen archetypischen mythischen Helden haben bis in die Antike überlebt. Spätestens dann wurde aus dem Helden ein Gott, dessen Schicksal, ganz wie in neolithischen Zeiten, immer noch im Ritual vergegenwärtigt wurde. Mehr noch: Das Ritual und der begleitende Mythos waren von solch geistiger Kraft, dass sich aus ihnen noch Jahrhunderte später einer der anhängerstärksten Mysterienkulte zur Zeit des römischen Imperiums entwickelte: Die Rede ist von Dionysos, der hier als Beispiel für einen im Lauf der Jahrhunderte vergöttlichten Helden dienen soll.

Wie der Mythos berichtet, war Dionysos der Sohn des Zeus und seiner sterblichen Geliebten, der Königstochter Semele (Mond). Wie bei vielen griechischen Heroen ist der Topos der Berufung zum Helden damit für Dionysos bereits durch seine göttliche Herkunft gegeben. Aufgestachelt von der eifersüchtigen Hera, erzwang Semele von Zeus, sich ihr in seiner göttlichen Gestalt zu zeigen. Zeus erschien ihr als flammender Blitz, der sie verbrannte. Hermes jedoch rettete ihr ungeborenes Kind, indem er es in den Schenkel des Zeus nähte, der es dann nach entsprechender Frist aus seinem Schenkel gebar. Das Neugeborene wurde jedoch auf Heras Befehl von den Titanen zerrissen, dann aber von seiner Großmutter Rhea (eine andere Erscheinungsform der Gaia, der griechischen Variante der Urmutter), die die Stücke zusammenfügte und wiederbelebte, gerettet (Abb. 10.2).

In ein Böckchen verwandelt, wuchs Dionysos bei den Nymphen auf, zog dann mit seinem Mentor Silenos, begleitet von Satyrn und Mänaden, um die Welt (Motiv des Weges) und gelangte auch nach Ägypten, wo er auf Amazonen stieß und mit ihnen zusammen die Titanen besiegte (Motiv des heldenhaften Sieges). Anschließend eroberte er Indien, zog nun gegen die Amazonen, gegen die Thraker, feierte Triumphe als Gott in Böotien, segelte dann nach Naxos, wo er die liebliche Ariadne freite, und zog zuletzt nach Argos (Rückkehr in die bekannte griechische Welt). Nachdem alle eroberten Landstriche seine Göttlichkeit anerkannt hatten, stieg Dionysos zum Himmel auf, um sich dort im Kreise der großen Götter auf ewig niederzulassen.

In der mythischen Figur des Dionysos mischen sich Elemente einer Dema – sein gewaltsamer Tod, der mit der Entstehung wichtiger Kulturpflanzen wie Granatapfel und Wein verbunden war (die Gaben des Helden an die Gesellschaft), und seine Nähe zu Rhea, einer Göttin mit den Zügen der Urmutter – mit denen eines Helden, wie er im Epos besungen wurde. Der realhistorische Hintergrund des Dionysos-Mythos ist wahrscheinlich das Leben eines Helden, der nach seinem Tod zunächst im Zuge des Ahnenkultes verehrt und dessen Schicksal dann entsprechend den geläufigen Vorstellungen von einer

Abb. 10.2 Die griechische Göttin Rhea. Man beachte die Ikonografie, die genau der in Çatal Hüyük gefundenen Urmutterstatuette gleicht!

Dema ausgestaltet worden war. An seine Herkunft aus der Welt der Toten erinnert im antiken Griechenland seine Zuordnung zu den chthonischen, das heißt unterweltlichen Göttern, die – und auch das ist charakteristisch für übermächtige Gestalten, die ihren Ursprung in der Totenwelt haben – mit der Fruchtbarkeit assoziiert wurden.

Wie ein Mythos entsteht

Unser Wissen von den Mythen der Antike verdanken wir der literarischen Überlieferung, von der allerdings nur Bruchstücke erhalten sind. Der antike Mythos gibt Einblick in das Denken und die Weltanschauung einer längst versunkenen Zeit, er ermöglicht Einsichten in überzeitliche Wahrheiten und er liefert nicht zuletzt einen Fundus von Symbolen, aus denen bis heute geschöpft wird. Nur eines tut er nicht: Er sagt nicht, wie und wodurch er zustande gekommen ist. In dieser Hinsicht müssen wir – auch, um möglicherweise Regeln und Gesetzmäßigkeiten feststellen zu können – die Gegenwart bemühen. Auch die Gegenwart kennt Mythen im eigentlichen Sinne, nämlich als sinnstiftende Ursprungserzählung. Drei solcher modernen Mythen

mit dem ihnen typischen Heilscharakter sollen hier exemplarisch als Beispiele für die aktuelle Mythenentstehung herangezogen werden.

1844 wurde Bernadette Soubirous als Tochter eines verarmten Müllers in Lourdes geboren. Das Kind war nicht nur schwach und kränklich, sondern überdies minderbegabt, sodass sowohl ihre kirchliche als auch ihre schulische Bildung scheiterte. Für ihre am Rande des Existenzminimums lebende Familie war die Tochter eine enorme Belastung. Unter dem Eindruck ihres Versagens und ihrer Untüchtigkeit hatte Bernadette am 11. Februar 1858 eine Vision bei der Grotte Massabielle (*massa vièlha* für „alter Fels") in Occitan, bei der ihr eine weiße Frauengestalt erschien. Die Visionen wiederholten sich mehrfach, wenn Bernadette diesen Ort aufsuchte. Die Kunde von den Ereignissen verbreitete sich und kam auch dem Ortspfarrer zu Ohren, der das Kind einbestellte, um es zur Ordnung zu rufen. Bernadettes Schilderungen der Begegnung und ihre Aussage, die Frauengestalt habe sich ihr mit den Worten „*Que soy era immaculada concepcion*" vorgestellt, obwohl das noch neue Dogma von der unbefleckten Empfängnis Mariens in der abgelegenen Gegend nicht bekannt war, machten dem Pfarrer sofort klar, dass sich das Kind nicht wichtig machen wollte, sondern ihm die heilige Jungfrau tatsächlich erschienen war. Für Bernadette, die trotz des Aufhebens, das nun plötzlich um sie gemacht wurde, immer bescheiden blieb, bedeutete dieser Kontakt mit der göttlichen Sphäre einen völligen Wandel ihrer bis dahin so prekären Lebensverhältnisse: Im Jahre 1866 trat sie, die man ursprünglich nicht einmal zur Kommunion zugelassen hatte, in das Kloster Saint-Gildard der Barmherzigen Schwestern in Nevers ein und konnte dort zum ersten Mal ein Leben in gesicherten und für sie fast luxuriösen Verhältnissen führen. Allerdings forderte die überharte Kindheit ihren Tribut: Mit 35 Jahren starb Bernadette, die inzwischen im Rufe einer Heiligen stand, an Knochentuberkulose. Nachdem 1909 ihr nicht verwester Leichnam exhumiert und in einem gläsernen Sarg beigesetzt worden war, wurde sie 1925 selig- und acht Jahre später heiliggesprochen. Pilger suchen bis heute Heilung am Ort der Jungfrauenerscheinung.

Ganz anders der Mythos von der Schlacht bei Tannenberg. Hier hatten am 15. Juli 1410 die Ritter des Deutschen Ritterordens die entscheidende Schlacht gegen die Heere des Polenkönigs Władysław II. Jagiełło und des Großfürsten Vytautas von Litauen verloren. 1914 schienen sich die Ereignisse zu wiederholen. Wieder sah sich in Ostpreußen ein deutsches Heer einer feindlichen Übermacht aus dem Osten gegenüber, und wieder schien es aus deutscher Sicht nicht nur um eine Schlacht, sondern um das Überleben Deutschlands, ja der gesamten westlichen Zivilisation zu gehen. In dieser schier ausweglosen Situation gelang es Paul von Hindenburg und Erich Ludendorff, die beiden gegnerischen Heere durch einen genialen taktischen Schachzug zu schlagen und damit die schon sicher geglaubte Niederlage im Osten in einen Sieg zu

verwandeln. Aus rein propagandistischen Gründen wurde die Schlacht, die eigentlich in der Nähe von Allenstein stattgefunden hatte, als Schlacht von Tannenberg bezeichnet – diesmal mit einem Sieg der Deutschen, die damit die Schmach von 1410 getilgt hatten. Vor allem Hindenburg, der sich gut in Szene zu setzen wusste und sich beispielsweise in der Haltung des mittelalterlichen Roland porträtieren oder als getreuer Eckart charakterisieren ließ, galt damit als Retter des Vaterlandes und genoss einen geradezu messianischen Ruf – mit den allseits bekannten fatalen Spätfolgen.

Noch ein letzter moderner Mythos sei genannt. Vor allem in den 1980er-Jahren häuften sich Ufosichtungen und Kontakte zu außerirdischen Wesen. Den Ufos pflegten dann leuchtende Wesen zu entsteigen, die den Zustand der Welt anprangerten, klare Anweisungen zur Rettung der Welt gaben und ihre Kontaktperson mit der Verkündigung der Botschaft beauftragten. Die Idee des Besuchs durch Außerirdische war für viele Jahre ungemein populär und zog zahlreiche Anhänger in ihren Bann.

So unterschiedlich diese Ereignisse und die daraus entstandenen Mythen auch sind, haben sie doch wesentliche Merkmale gemeinsam: Am Anfang steht stets eine als ausweglos empfundene Situation – im Fall der Bernadette Soubirous für sie selbst, bei der Schlacht bei Tannenberg für das Volk, im Fall der Ufosichtung gar für die ganze Welt. Dann erscheint unversehens ein Retter, entweder ein Tatmensch wie im Fall Hindenburgs oder Gestalten aus der Sphäre der Übermächtigen, die von einer visionären Persönlichkeit (Bernadette, Ufoseher) wahrgenommen werden. Die Deutung der Erlebnisse und Visionen erfolgt häufig durch Dritte und stets auf der Basis des bekannten Weltbildes und vorheriger Erfahrungen. Im Fall der Bernadette Soubirous konnte die weiße Frau nur die Jungfrau Maria sein (tatsächlich hatte Bernadette sie eher als eine feenartige Märchengestalt beschrieben), die Schlacht bei Tannenberg war die Wiederholung eines mittelalterlichen Ereignisses, und die Deutung leuchtender Himmelsobjekte erfolgte auf der Basis eines technisch-naturwissenschaftlichen Weltbildes, in dem der Retter nun eben nicht mehr aus der überlieferten Welt traditioneller Religion oder alter Heldenepen stammt, sondern seinen Sitz im Leben ganz in der heutigen technisierten Welt der Raumfahrt findet. Immer aber geht es um die erhoffte Rettung und Erlösung von existenzbedrohenden Übeln, seien es Krankheit, ein übermächtiger Feind oder die drohende ökologische Katastrophe.

Übertragen wir diese Erkenntnisse auf die Verhältnisse um 5000 v. Chr. Auch hier sahen sich die bäuerlichen Gemeinschaften unversehens existenziellen Bedrohungen ausgeliefert, mit denen sie in Form feindlicher Übergriffe oder Landmangels konfrontiert wurden. Hier waren es junge Kämpfer, die einerseits ihre Dörfer verteidigten, andererseits vielleicht selbst zu Eroberungszügen aufbrachen, die ihren Zeitgenossen als Helden und Retter erschienen und deren Leben die Grundlage für einen Mythos bildete.

Heldengeschichten ziehen sich im Übrigen nicht nur durch Epen, sondern durch die gesamte Religionsgeschichte. Der indische Gott Krishna ist so ein Held mit wahrscheinlich realhistorischem Hintergrund, der zum Gott avanciert ist, und Moses, der mythische Erretter eines fiktiven bronzezeitlichen Volkes Israel, steht im Mittelpunkt eines Mythos, der bis heute sowohl für eine konkrete Religion als auch für eine ethnisch heterogene Nation identitätsstiftend ist.

Kulturelles Umfeld – das Neolithikum in Mitteleuropa

Die oben geschilderten Entwicklungen haben sich so oder ähnlich im Neolithikum des östlichen Mittelmeerraums bis nach Mittel- und dann Westeuropa abgespielt. Der Grund für die gleichgerichtete Entwicklung dürfte vor allem in der Tatsache zu suchen sein, dass es Auswanderer aus Anatolien nach Südosteuropa und dann von Südost- nach Mitteleuropa waren, die sowohl die neolithische Lebensweise als auch die dazugehörige Weltanschauung mitbrachten und an das jeweilige Umfeld anpassten. Nicht zu vergessen ist jedoch, dass die grundlegenden religiösen Symbole, von Warburg als „Psychologie des menschlichen Ausdrucks" bezeichnet, tief in der Biologie des Menschen verankert sind: in der Territorialität des Menschen, im Ranking und in gemeinsamen Symbolen, die der Kommunikation dienen und die im Umgang mit existenziellen Ängsten eine wichtige Rolle spielen.

Der kulturelle Hintergrund dieser Entwicklung stellt sich wie folgt dar. Um 5600 v. Chr. waren Techniken, Lebensweise und Weltanschauung des Neolithikums nach ihrem Zug durch Südosteuropa in Mitteleuropa angekommen, hatten aber auf dem Vormarsch nach Westen ihr Erscheinungsbild stark verändert. Statt kleiner Häuser aus luftgetrockneten Lehmziegeln bauten die Bandkeramiker groß und massiv mit riesigen Baumstämmen aus den dichten Urwäldern, die sich von der ungarischen Tiefebene bis ins Pariser Becken erstreckten. Ihre charakteristischen Bauwerke waren riesige, rechteckige Langhäuser von bis zu 45 m Länge und einer Breite von 5,5 bis 7 m, deren tragende Konstruktion aus fünf Längsreihen senkrechter, im Boden verankerter Balken bestand, während die inneren Pfosten das schwere Dach stützten. Die Außenwände bestanden – ganz wie bei heutigen Fachwerkhäusern – aus lehmverputztem Flechtwerk, das auf der Wetterseite der Gebäude durch eine Spaltholzverkleidung zusätzlich gegen Starkregen gesichert wurde. Das Innere der Gebäude wies eine charakteristische Dreiteilung in einen nordwestlichen Schlaftrakt, einen Aufenthalts- und Arbeitstrakt, vergleichbar der Küche in alten Bauernhäusern, und einen Lagerraum auf. Die tiefen Gruben, die stets in unmittel-

barer Nachbarschaft der Häuser gefunden wurden, hatten ursprünglich den Lehm für den Wandverputz geliefert und dienten später als Abfallgruben.

Zunächst waren einige dieser Gruben, in denen man auch menschliche Überreste gefunden hatte, als Opfergruben gedeutet worden. Inzwischen werfen jedoch die Bestattungssitten der Bandkeramiker ein neues Licht auf diese Knochenfunde. Im Allgemeinen begrub man seine Toten auf Gräberfeldern außerhalb der Siedlungen, also regelrechten Friedhöfen. Beigaben in Form von Gefäßen, die Speisen enthielten, machen deutlich, dass man den Toten für eine Reise ins Jenseits ausrüstete. Nach dieser Phase des Übergangs, die wir ja bereits exemplarisch in Çatal Hüyük kennengelernt haben, wurde der Tote exhumiert und ein zweites Mal und diesmal endgültig beigesetzt. Diese zweite Beisetzung konnte auf dem Siedlungsgelände erfolgen, gelegentlich wurde der Schädel aber auch hier im Haus aufbewahrt. Bei der Umbettung des Toten gingen nicht selten Teile des Skelettes verloren oder fanden sich nicht mehr im anatomischen Verbund, was zunächst als Spuren von Kannibalismus oder Menschenopfern gedeutet wurde, heute aber korrekt in Zusammenhang mit Sekundärbestattungen interpretiert wird. Menschenreste in den Abfallgruben sind das Resultat von unfreiwillig geöffneten, älteren Begräbnissen – sei es im Zuge der Anlage eines Gartens, sei es nach der Störung einer Bestattung durch wühlende Füchse oder Wildschweine (Letzteres wurde durch mikroskopische Untersuchungen offensichtlich angeknabberter menschlicher Gebeine bestätigt).

Wildschweine wühlen neben Gräbern

Eberswalde. So viele Wildschweine wie seit April hätten seine Kollegen in vergangenen Jahren nicht erlegt, sagt Stadtförster Wolfram Simon [...] Nun haben sie sich auch auf dem Waldfriedhof zu schaffen gemacht. Die Rotten [...] kommen nicht zur Gräberpflege, sondern sind auf Nahrungssuche [...] Vereinzelt sind auch Grabstellen betroffen [...] An der Spitze im alten Friedhofsteil hätten die Wildschweine ebenfalls zugeschlagen. (*Märkische Oderzeitung* vom 21. Juni 2013)

Gelegentlich haben diese Sekundärbestattungen auch ganz charakteristisches Züge angenommen und können auf diese Weise etwas über die Jenseitsvorstellungen der Bandkeramiker verraten. Einer der in dieser Hinsicht spektakulärsten Begräbnisplätze ist die Jungfernhöhle bei Tiefenellern (Fränkische Alb; Abb. 10.4), eine recht kleine Höhle mit einem unregelmäßigen, unterirdischen Raum, zu dem ein steiler Schacht hinabführt. Hier fanden sich bei Ausgrabungen in den 1950er-Jahren die Überreste menschlicher Gebeine fast ausschließlich weiblicher Personen zusammen mit Resten von Tongefäßen, Tierknochen, Holzkohle und anderen Kulturabfällen. Während die damali-

gen Ausgräber auch hier wieder an Kannibalismus oder Menschenopfer dachten, wird das Geschehen um die Jungfernhöhle heute auf der Basis rechtsmedizinischer und anthropologischer Untersuchungen anders gedeutet. Die starke Streuung der Knochenfragmente und das weitgehende Fehlen kleiner Knochen wie Rippen, Hand oder Fußknochen sind ein untrügliches Indiz für die Tatsache, dass die Verstorbenen zunächst im Rahmen eines primären Begräbnisses beigesetzt wurden, um sodann exhumiert und an ihre endgültige Ruhestätte in der Höhle überführt zu werden.

Während zunächst die Weichteile des Verstorbenen in einem Erdgrab verwesten, trat der nichtmaterielle Teil seiner Persönlichkeit, ausgerüstet mit Beigaben von Speisen, die Reise in die jenseitige Welt an, die mit seiner rituellen und endgültigen Beisetzung in der Höhle beendet war. Mit der Höhle hatten die Toten ihre letzte Ruhestätte erreicht, und zwar in der Unterwelt, zu der Höhlen und Spalten (wie auch heute noch im Volksglauben) einen Zugang darstellten. Auch Spuren der mit der letzten Beisetzung einhergehenden Feierlichkeiten wurden gefunden. Topfscherben und Tierknochen belegen, dass man zu Ehren der Toten ein Festmahl abgehalten und/oder ihnen Beigaben mit in ihr letztes Grab gegeben hatte.

Das differenzierte Erscheinungsbild des bandkeramischen Totenbrauchtums fügt sich damit letztendlich bei allen Unterschieden im Detail in den Kontext neolithischer Religionsausübung, wobei die für traditionell lebende und prähistorische Ackerbaukulturen typischen Elemente nachgewiesen werden können. Wie schon in den frühneolithischen Dörfern Anatoliens wurde der Tod auch im neolithischen Mitteleuropa nicht als sofortiges Ende der individuellen Existenz angesehen, sondern galt als Einschnitt im Lebenszyklus, als Übergang von einer Existenzform in die andere, wobei der Mensch die soziale Gemeinschaft der Lebenden verlässt, um in die Gemeinschaft der Toten aufgenommen zu werden. Für die jeweilige Gesellschaft war eine solche Veränderung ein markanter Einschnitt, in dessen Folge auch das Kräftegleichgewicht ein Stadium der Instabilität durchlief, das nur durch Rituale wieder in ein Gleichgewicht gebracht werden konnte. Traditionelle, nichtstratifizierte Ackerbaugesellschaften mit ihren sorgfältig austarierten Besitzverhältnissen an Grund und Boden, Vieh oder anderen Wirtschaftsgütern reagieren sensibel auf Kräfteverschiebungen, wie sie durch den Tod eines ihrer Mitglieder auftreten. Gleichzeitig beginnt im Hinblick auf weltanschauliche Vorstellungen mit dem Tod eines Menschen der Wandlungsprozess, in dessen Verlauf der Verstorbene zum Mitglied der Totenwelt wird. Die verschiedenen Phasen des Übergangs von einem in den anderen Zustand – das Scheiden aus dem bisherigen Leben, der Aufenthalt in einem quasi embryonalen Zustand (Turners *betwixt and between*) und der Eintritt in die neue Existenzform – werden von den Mitgliedern der Gemeinschaft durch Rituale begleitet, die

völkerkundlich gut dokumentiert sind. Auch bei den Bandkeramikern lassen sich solche mit dem Tod verbundenen Übergangsrituale nachweisen. Die erste Phase der Trennung wird durch das primäre Begräbnis auf einem Gräberfeld oder auf Siedlungsgrund dokumentiert. Die Reste zerschlagener Gefäße und die Spuren von Feuer zeugen von einer letzten Mahlzeit, die man mit dem Verstorbenen zusammen einzunehmen pflegte. Der Tote wurde nun in einem Stadium des Übergangs von der Welt der Lebenden in die jenseitige Welt befindlich gedacht, während dessen ihm die Beigaben als Wegzehrung dienten. Dieser Übergang wurde augenfällig dokumentiert durch den Verwesungsprozess oder aber auch durch die ebenfalls gebräuchliche Kremation, in deren Verlauf die organischen Bestandteile des Körpers zersetzt wurden. Anschließend konnten die Gebeine exhumiert und endgültig beigesetzt werden. Damit verbunden war sehr wahrscheinlich ein weiterer ritueller Akt wie in der Jungfernhöhle, in dessen Verlauf man den Verstorbenen offiziell in die Welt der Toten eingliederte. Gleichzeitig pflegte man den unsterblichen Persönlichkeitsanteilen des Toten einen endgültigen Platz zuzuweisen, der bei den Linienbandkeramikern, einer uralten Tradition folgend, der Schädel oder möglicherweise auch eine Figurine war, während andere Anteile – wir würden heute von Seele sprechen – in die Unterwelt, die Welt der Toten eingingen.

Ein Punkt ist bei der Diskussion des Totenbrauchtums noch anzusprechen: jenes schampräsentierende Weibchen, das in den vorausgegangenen Kapiteln mithilfe des historischen und völkerkundlichen Vergleichs als eine Dema, die Urmutter, bezeichnet wurde, die sich offensichtlich durch Hypostasierung zu einer Dema des Totenreiches einerseits und zu einer Dema von Heim und Herd andererseits entwickelt hatte. Zwar taucht diese Figur nicht mehr, wie noch in Anatolien, als wandbeherrschendes Relief oder Figurine auf, ist aber nichtsdestoweniger im Zusammenhang mit dem Tod die beherrschende Figur. Es handelt sich um Gefäße mit den bekannten anthropomorphen Darstellungen einer stilisierten schamweisenden Frauenfigur, wie sie sich beispielsweise in Gneiding (Bayern), Derenburg (Kreis Magdeburg), Monsheim (Kreis Worms), Stuttgart-Bad Cannstatt oder Assenheim (Hessen) fanden (Abb. 10.3). Der gute Erhaltungszustand der Gefäße und die Fundvergesellschaftung mit Gräbern macht deutlich, dass die Urmutter – hier als Herrscherin über die Totenwelt – ihren Weg aus Anatolien über Südosteuropa bis nach Mitteleuropa gefunden hat.

Abb. 10.3 Die sogenannte Krötendarstellung auf einer Tonscherbe vom Fundort Assenheim ist ein stilisiertes Abbild der Urmutter

Hengeanlagen und Rondelle

Die Bandkeramiker waren weiterhin traditionellen Vorstellungen verbunden, die sie als Einwanderer aus Südosteuropa mitgebracht hatten und die sich wiederum auf anatolische Vorläufer zurückführen lassen. Doch mit den Jahrhunderten entstand in den verstreuten Weilern und Gehöften inmitten der dichten Wälder zusätzlich etwas Neues: der Kultplatz.

Der Ausdruck „Woodhenge" ist sicherlich nur Fachleuten bekannt, „Stonehenge" dagegen ist jedermann ein Begriff. Inmitten einer heute baumlosen Ebene im südenglischen Wiltshire erheben sich eindrucksvoll megalithische, konzentrische Steinkreise (Abb. 10.4), deren Nutzung als Kultzentrum außer Frage steht, wenn auch die Einzelheiten dieses Kultes bis heute Gegenstand von teilweise abenteuerlichen Spekulationen sind.

Von Seiten der Wissenschaft ist klar, dass es sich sowohl bei dem ins Spätneolithikum bis in die Bronzezeit zu datierenden Stonehenge, als auch bei anderen Hengemonumenten, Steinkreisen und Rondellen um archäoastronomische Objekte handelt, die dazu dienten, den Himmel und die Bewegungen der Himmelskörper zu beobachten. Vor allem kalendarische Eckpunkte im Jahresverlauf wie die Wintersonnenwende und die Äquinoktien und damit wichtige Termine im bäuerlichen Kalender ließen sich mithilfe der Steinsetzungen sicher bestimmen, denn die Orientierung in Raum und Zeit anhand der Positionen von Sonne, Mond und Sternen waren für ackerbauende Kulturen von immenser Bedeutung, wenn es zum Beispiel um den Beginn des Pflügens oder die Aussaat ging.

Abb. 10.4 Das berühmte Stonehenge in der Nähe von Amesbury in Wiltshire, England. (© Maiva Petry; mit freundlicher Genehmigung)

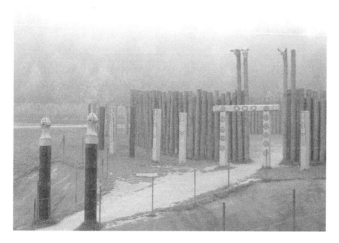

Abb. 10.5 Rekonstruktion einer Kreisgrabenanlage für die niederösterreichische Landesausstellung 2005 in Heldenberg. (© Wolfgang Glock)

Das südenglische Stonehenge ist allerdings keine Einzelerscheinung, sondern hatte Vorläufer in den sogenannten Kreisgrabenanlagen, die sich in einem breiten Gürtel vom Rheinland über Bayern bis nach Ungarn ziehen (Abb. 10.5).

Eine der ältesten bekannten Hengeanlagen, die Schalkenburg, liegt im Mittelelbe-Saale-Gebiet und datiert in die stichbandkeramische Kultur (4900 bis 4500 v. Chr.). Sie bestand aus fünf konzentrischen, ovalen Ringen aus hölzernen Palisaden, die an drei Stellen von Erdbrücken unterbrochen wur-

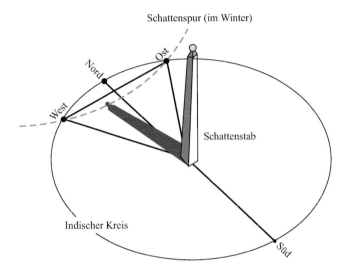

Abb. 10.6 Der indische Kreis. Der Kreis dient der Bestimmung der Haupthimmelsrichtung. Im Laufe eines sonnigen Tages wird der Verlauf des Schattens, den ein senkrecht in den Boden gesteckter Stab wirft, aufgezeichnet. Abends wird ein großer Kreis um den Fußpunkt des Stabs gezogen, der somit die gezeichnete Schattenverlaufslinie zweimal schneidet. Die Schnittstellen zeigen gleiche Schattenlängen des Morgens und des Abends. Beide Punkte ergeben, miteinander verbunden, die Ost-West-Linie. Die senkrecht dazu stehende Linie ergibt die Nord-Süd-Linie

den. Mit dieser simplen Anlage, die der Methodik des aus der Völkerkunde bekannten indischen Kreises (Abb. 10.6) entspricht, konnten die für eine frühe bäuerliche Gesellschaft lebensnotwendigen kalendarischen Eckdaten bestimmt werden.

Über ihre Aufgabe als frühes Kalendarium hinaus erfüllten diese Bauwerke jedoch noch einen weiteren Zweck: Sie waren Orte früher kollektiver Kulthandlungen, wie neben anderen, vergleichbaren Objekten vor allem eine Rondellanlage bei Těšetice-Kyjovice in Mähren exemplarisch verdeutlicht. Das von einem Graben und zwei Innenpalisaden eingefasste Rondell mit vier Eingängen in den Haupthimmelsrichtungen barg in seiner Mitte eine Grube, in der sich Keramik, die Bruchstücke einer großen Menschenfigur und ein menschlicher Schädel fanden. Im Rondell selbst fanden sich ein weiteres Skelett und die bereits aus den häuslichen Kulten bekannten Frauenfigurinen. Auch das deutlich jüngere Stonehenge weist im Übrigen die Überreste von Bestattungen auf: In den sogenannten Aubrey-Holes, das sind 56 den inneren Rand der Anlage säumende Löcher, fand man die Überreste von Brandbestattungen.

Rondell- oder Hengeanlagen, die immer inmitten eines Siedlungsareals lagen, dienten demnach nicht nur als frühe Kalendarien, sondern auch als Begräbnisstätte und Ort der kollektiven Totenverehrung und fügen sich da-

mit in den zeittypischen weltanschaulichen Hintergrund. Totenkult und die Beobachtung der Haupthimmelskörper hingen demnach eng miteinander zusammen und spielten in den Glaubens- und Jenseitsvorstellungen eine wichtige Rolle. Im Glauben heutiger traditionell lebender Völker – hier wurde exemplarisch der Hainuwelemythos erzählt – sind Himmelsrichtungen häufig wichtige Ortsangaben im Mythos, wenn von einem Kulturheros oder einer Dema berichtet wird, die aus einer bestimmten Himmelsrichtung kam, um dem Menschen wichtige Kulturgüter zu bringen, dann aber nach ihrem gewaltsamen Tod in ein in bestimmter Himmelsrichtung liegendes Totenreich verschwand und gleichzeitig als Gestirn am Himmel erschien. In einem solchen Weltbild sind die Ahnen nicht nur gleichzeitig die mythischen Begründer der Sippen, sondern werden zum ersten Male nachweislich in einen engen Zusammenhang mit den Bewegungen der Himmelskörper gebracht und gleichzeitig kollektiv verehrt.

Vom kollektiven Kult zur kollektiven Bestattung: die Megalithgräber der Trichterbecherkultur

Die Trichterbecherkultur (4200 bis 2800 v. Chr.), die sich von Tschechien über Mitteldeutschland bis zur Weser in Nordwestdeutschland zieht, ist unter anderem gekennzeichnet durch ihre auffälligen Bestattungssitten, die bei allen regionalen Unterschieden der verschiedenen archäologischen Gruppen doch eines gemeinsam haben: den Grabhügel, eine Erdaufschüttung, die gelegentlich geradezu gigantische Dimensionen erreichen konnte. Vor allem die niedersächsische und mecklenburgische Trichterbecherkultur beeindruckt mit ihren Großsteingräbern, die bis heute der Landschaft ein einzigartiges Gepräge verleihen. Die ersten Megalithgräber, auch als Dolmen bekannt, waren noch kleine, aus vier Wandsteinen und einem einzelnen Deckstein bestehende Grabkammern für einen einzigen Toten. Als im Laufe der Zeit die Bestattung mehrerer Verstorbener in einem Grab üblich wurde, erweiterte man die ursprüngliche Grabarchitektur durch Hinzufügen weiterer Joche aus jeweils zwei aufgerichteten eiszeitlichen Findlingen und einem Deckstein. Die so entstandenen Grabkammern wurden sorgfältig hergerichtet. Ihre Böden bestanden aus gestampftem Lehm, aus plattenförmigen Steinen mit darüberliegendem Granitgrus, gebranntem Feuerstein oder weißem Sand. Der Zugang erfolgte meist über einen an der Schmalseite des Grabes errichteten Gang aus Holz oder Steinen. Über dem Bauwerk erhob sich zuletzt ein Erdhügel, umgeben von einer rechteckigen oder trapezförmigen Einfassung aus Findlingen (Abb. 10.7).

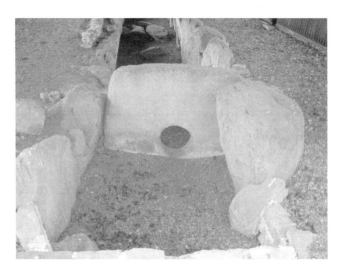

Abb. 10.7 Das Steinkammergrab von Züschen. Das Grab ist bekannt durch seine Ritzzeichnungen von stilisierten Rindern mit vorgespanntem Pflug. Durch den Lochstein, der die eigentliche Grabkammer von einer Vorkammer trennt, konnte Kontakt zu den Toten aufgenommen werden. (© Armin Schönewolf)

Nicht immer bestanden die großen Kollektivgräber jedoch aus Findlingen. In Odagsen bei Einbeck wurde ein jungsteinzeitliches Kollektivgrab ausgegraben und rekonstruiert, dass die Grabstätte aus einer zeltartigen Holzkonstruktion über einer in den anstehenden Löss eingetieften Grube bestanden hat, sodass die Bestattungsebene etwa 1 m unter Bodenniveau lag. In der etwa 30 m² großen, gepflasterten Grabkammer waren über einen längeren Zeitraum mindestens 100 Tote in drei Schichten beigesetzt worden, und zwar, indem man den Toten primär in gestreckter Rückenlage parallel zur Längsachse der Grabkammer niederlegte, die Skelettreste aber an den Rand des Totenhauses schob, wenn eine neue Bestattung den Platz in der Mitte beanspruchte. Das „Haus für die Toten" von Odagsen verrät jedoch noch mehr über die Bestattungssitten und Todesvorstellungen zur Zeit der Trichterbecherkultur. Der Verstorbene wurde an seinem neuen Wohnort mit allem Lebensnotwendigen versorgt. So behielt er nicht nur seine Kleidung und seinen Schmuck (beliebt waren die Reißzähne von Wolf, Fuchs und Hund), sondern erhielt auch Nahrungsmittel in Keramikgefäßen, Fleischstücke, Werkzeuge und Waffen.

Mit den hier aufgeführten Beispielen sind natürlich weder die Bandbreite der Bestattungssitten (auch Siedlungsbestattungen kamen weiterhin vor) noch die Formenvielfalt der großen Kollektivgräber erschöpfend behandelt, aber es wurde deutlich, dass sowohl in der Trichterbecherkultur als auch im westeuropäischen Neolithikum Kollektivbestattungen in eigens für die Toten errichteten Häusern üblich wurden. Diese Totenhäuser waren von Grabhügeln bedeckt und so als zur Unterwelt gehörig gekennzeichnet. Funde von

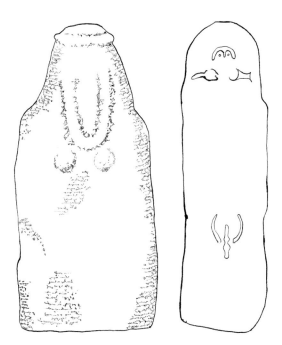

Abb. 10.8 Dolmengöttinnen. Links: Göttin aus einem megalithischen Galeriegrab auf Guernsey (Kanalinseln, Großbritannien). Rechts: Göttin auf einem Dolmen in Trigueros (Spanien). (Zeichnungen: Karolina Rupik)

Tongefäßen und Überresten von Mahlzeiten im Eingangsbereich der Kollektivgräber belegen, dass die Hinterbliebenen den Kontakt zu den Verstorbenen weiterhin aufrechthielten, indem sie zu bestimmten Zeiten mit den Toten zusammen speisten und ihnen Gaben darbrachten. Grundlage dieser Form der Erinnerungskultur war die Vorstellung, dass die Verstorbenen nun in eine Unterwelt eingingen, die als der Herrschaftsbereich einer regelrechten Unterweltsgöttin, auch Dolmengöttin genannt, galt. Auf die Anwesenheit dieser übermächtigen weiblichen Gestalt weisen nun nicht mehr nur die Scherben von Tongefäßen mit den typischen „Krötendarstellungen" hin, sondern kleine und stark vereinfachte Idole der Dolmengöttin mit drohstarrenden Augen und vor allem Augendarstellungen, Brüste oder auch Halsketten (Abb. 10.8), die als Wandverzierungen in den Gräbern oder auf Menhiren auftauchen.

Die Verstorbenen führten in dieser Unterwelt eine dem diesseitigen Leben vergleichbare Existenz, die allerdings einerseits durch die regelmäßige Fürsorge der Hinterbliebenen gesichert werden musste. Als Angehörige der tellurischen Welt waren die Toten jedoch andererseits besonders mächtig; vor allem auf die Fruchtbarkeit hatten sie großen Einfluss, denn sie „bewohnten" ja nun auch den Boden, auf dessen Fruchtbarkeit die Nachfahren angewiesen waren. Noch bis vor wenigen Jahrzehnten gab es in niedersächsischen Dörfern den

Brauch, dass sich eine junge Frau, die schwanger werden wollte, nackt auf einen Dolmen setzte, um auf diese Weise ihre Fruchtbarkeit zu steigern.

Warum megalithische Grabstätten?

Es hatte sich also in den Jahren zwischen 5000 und 3000 v. Chr. – hier dargestellt am Beispiel des Neolithikums in Mitteleuropa – Entscheidendes geändert, und diese Veränderung lässt sich sowohl am kultischen Handeln als auch am Totenbrauchtum deutlich ablesen.

Der Wandel betraf zunächst die Gesellschaft. Zu Beginn des Neolithikums in Mitteleuropa, zur Zeit der Bandkeramik, ließen sich erste Bauern nieder, bauten ihre Dörfer und betrieben Landwirtschaft. Die Gesellschaften waren egalitär und nicht arbeitsteilig. Jeder hatte die gleichen Rechte und Pflichten, es gab höchstens eine geschlechts- und altersspezifische Arbeitsteilung. Konflikte innerhalb dieser frühen bäuerlichen Gesellschaften wurden mithilfe des Rituals unter Berufung auf gemeinsame Werte gelöst. Diese gemeinsamen Werte wurden von den tatsächlichen und mythischen Ahnen verkörpert, den ersten Bauern, auf die sowohl die Sitten als auch die Besitzverhältnisse zurückgeführt wurden. Sinnfälliger Beleg war ein deponierter Schädel oder eine Figurine. Zum Ahnen konnte jedes bedeutende Mitglied der Gesellschaft werden, wenn es nach seinem Tod im Zuge einer komplizierten zweistufigen Bestattung in die Ahnenwelt überführt wurde.

Die produzierende Wirtschaftsweise und die zunehmende Abhängigkeit vom Getreideanbau stellten die bäuerlichen Gemeinschaften vor neue Herausforderungen: Besonders die sensiblen Eckdaten im Jahr mussten für die Aussaat bestimmt werden. Dazu bediente man sich gemeinsamer Großanlagen zur Bestimmung der kalendarischen Daten mithilfe des Sonnenstandes und verknüpfte auch diese wieder mit den mythischen Ahnen. Kollektive Kulte entstanden, während derer möglicherweise nun auch Konflikte zwischen konkurrierenden Siedlungen gelöst wurden. Dass diese Siedlungen miteinander konkurrierten, machen die Palisadenanlagen deutlich, mit denen die Dörfer gesichert waren.

Überhaupt scheint das aggressive Element zugenommen zu haben. Es zeigen sich Spuren gewalttätiger Auseinandersetzungen bis hin zum Massenmord nach einem feindlichen Überfall, und als Reaktion darauf entstand eine erste gesellschaftliche Differenzierung – vielleicht auch diese noch altersspezifisch, indem junge Männer in einen kriegerischen Männerbund initiiert wurden, bevor sie ins heiratsfähige Alter kamen. Dies sind jedoch Spekulationen. Lediglich sehr viel jüngere Sitten aus der Eisenzeit mit ihrem kriegerischen Männerbund im Gefolge des Gottes Wotan könnten nahelegen, dass eine solche Sitte aufkam. Sicher ist jedoch, dass mit dieser Veränderung in der Gesellschaft

das Bild des kriegerischen Helden aufkam, der bald den Ahnenkult beherrschte und sich zu einer mythischen Heldenfigur entwickelte. Bei etlichen der antiken Götter lassen sich ihre Ursprünge im Heroenkult noch nachweisen.

Die verstärkte Konkurrenz unter den Siedlungen bei offensichtlich knapper werdenden, geeigneten Siedlungsarealen führte jedoch auch hinsichtlich des Totenbrauchtums zu Veränderungen. Die Ahnen dienten nun nicht mehr nur als Garanten gemeinsamer Werte, sondern, genau wie zur Zeit des Paläolithikums, als sinnfällige Belege territorialer Ansprüche. Um diese Ansprüche geltend zu machen, genügte nun nicht mehr das Deponieren eines Schädels oder eine Figurine mit Abwehrsignalen, sondern gleichzeitig mit der Legitimität des Anspruchs musste auch die ökonomische und physische Potenz der Gemeinschaft betont werden. Dies tat man, indem man gewaltige Gräber auftürmte, um einem eventuell aggressiven Nachbarn die eigene Stärke und damit das Risiko einer Auseinandersetzung deutlich zu machen. Auch hier fanden also wieder ein Wettbewerb und ein Ranking statt, diesmal aber zwischen Dörfern und nicht nur zwischen Individuen. Die Toten bekamen damit neue Aufgaben. Sie waren nun nicht mehr nur die Garanten für einen Wertekonsens, sondern als Angehörige der übermächtigen tellurischen Welt für das Wohlergehen ihrer Nachfahren zuständig. Diese wiederum bemühten sich, die Ahnen durch Gaben sowohl bei Laune als auch bei Kräften zu halten.

Wie sehr diese Form des Konkurrierens um Lebensraum eine Kultur prägen und zu kulturellen Höchstleistungen führen kann, zeigt das Beispiel der Mittelmeerinsel Malta, von der im nächsten Kapitel die Rede sein wird.

11

Gabentausch und Totenreich: Malta

Die Macht der Unterirdischen

Die neolithische Vorstellung von einer Unterwelt, in der die Toten unter einer Herrscherin weiter existierten, hat sich nicht nur im eigentlichen Mythos, also in der für die entsprechende Gesellschaft weltbildbestimmenden Ursprungs-erzählung, niedergeschlagen, sondern ebenso in zahlreichen Vorstellungen und Bräuchen des Volksglaubens, in Sagen und Märchen.

Im griechischen Mythos ist es Persephone, die Tochter der Muttergottheit Demeter, die vom Herrscher des Totenreiches, Hades, zur Frau begehrt und entführt wird. Aus Kummer über den Verlust ihrer Tochter lässt Demeter, die Göttin der Fruchtbarkeit der Erde, des Getreides, der Saat und der Jahres-zeiten, die Vegetation absterben, sodass Zeus seinen Bruder Hades bedrängt, die Geliebte wieder in die Oberwelt zu entlassen. Persephone hatte jedoch in der Unterwelt bereits vom Granatapfel, dem Todesapfel, gekostet und war damit der Unterwelt verfallen. Daher verbringt sie seitdem ein halbes Jahr mit ihrem Gatten Hades als Herrscherin der unterirdischen Totenwelt. In dieser Zeit ist auf der Erde jegliche Vegetation abgestorben. Die andere Jahreshälfte verbringt sie mit ihrer Mutter, die daraufhin die Vegetation einschließlich des Getreides wachsen und gedeihen lässt. Der Demetermythos verbindet so auf sinnfällige Weise Leben und Tod mit Vorstellungen von Aussaat und Ernte. Die Saat, die in die Erde, die Unterwelt, gegeben wird, keimt und wird im nächsten Sommer reiche Frucht tragen. Ähnlich dem Dionysos-Mythos hatte auch der Demetermythos eine solche Kraft, dass er zu einem der bedeutends-ten Mysterienkulte des Altertums avancierte. Aus der Unterwelt, so eine der Aussagen des Mythos, kommt letztlich die Fruchtbarkeit; es sind die Unterir-dischen und ihre Herrscherin, die über die Fruchtbarkeit der Äcker, des Viehs und der Menschen entscheiden.

Im deutschen Sprachraum hat sich die Vorstellung von einer Herrscherin der Toten, die das Schicksal der Lebenden beeinflusst und über ungeheure Reichtümer gebietet, bis heute im Volksmärchen erhalten. Hier ist es Frau Holle, also letztlich die germanische Göttin Hel, Hulda, Holle oder auch Perchta, die über das unterirdische Totenreich herrscht, in das man durch

Höhlen, Brunnen und Erdspalten gelangt (vgl. Kap. 9). Im Märchen der Ge-
brüder Grimm wird ein junges Mädchen von einer böswilligen Stiefmutter
so gequält, dass sie sich in einen Brunnen stürzt und so in die Unterwelt ge-
langt. In dieser Unterwelt, einem Abbild der oberirdischen Welt mit Wiesen,
Obstbäumen und Brotbackofen, trifft sie auf Frau Holle, in deren Diensten
sie sich in der darauffolgenden Zeit bewährt. Unter anderem ist sie zuständig
für das Wetter – wenn sie die Betten aufschüttelt, schneit es auf der Welt!
Als das Mädchen nach einer gewissen Zeit wieder nach Hause zurückkehren
möchte, wird sie beim Verlassen der Unterwelt mit Gold überschüttet. Ihrer
faulen Stiefschwester, die nun ebenfalls ihr Glück in der Unterwelt suchen
will, ist ein anderer Lohn zugedacht: Als Strafe für ihre Faulheit wird sie mit
Pech übergossen. Die Toten oder ihre Herrscherin sind also im Volksglauben
wie im Märchen diejenigen Wesen, die Hilfsbereitschaft und Fleiß großzügig
belohnen. Gleichzeitig ist in der alten Sagenwelt Frau Holle auch das Urbild
der Fruchtbarkeit, die den Segen des Frühlings spendet. Um diesen Segen zu
fördern, kennt der Volksbrauch allerlei Praktiken, darunter das Bereitstellen
von Mahlzeiten oder das Hinterlegen einer Münze als Gabe an die mächtige
Unterirdische.

Im Gefolge der Herrscherin der Unterwelt finden sich die Zwerge, die in
Höhlen, aber auch in den steinzeitlichen Grabhügeln wohnen sollen. Dort
hüten sie unermessliche Schätze, vor allem Gold. Aber auch Gegenstände des
alltäglichen Bedarfs einer bäuerlichen Gesellschaft nennen sie ihr eigen, wobei
diese Gegenstände die wunderbare Eigenschaft haben, Teilhabe an materieller
Unerschöpflichkeit zu gewähren – sagenhaftes Beispiel ist die von Zwergen
geschenkte Spindel, auf der der gesponnene Flachs niemals zur Neige geht,
und auch das goldspinnende Rumpelstilzchen ist eine solche Figur.

Diese Vorstellung von wirkmächtigen Toten, die sich, wie in den vorange-
gangenen Kapiteln nachgezeichnet wurde, im Neolithikum aus älteren Vor-
stellungen entwickelt hat, hat vor allem die Kultur im neolithischen Malta
entscheidend geprägt.

Malta und seine Megalithkultur

Malta ist die größte und namengebende Insel einer kleinen Inselgruppe im
zentralen Mittelmeer, zu der außer Gozo noch drei weitere kleine, unbewohn-
te Inseln gehören. Trotz der geringen Entfernung zum europäischen Festland
waren die Inseln bis Ende 6000 v. Chr. nicht besiedelt. Erst dann gelang es
frühen Siedlern, die damals paradiesischen Inseln mit ihrer üppigen Flora und
Fauna von Sizilien aus zu erreichen. Die zunächst unerschöpflich scheinenden
natürlichen Ressourcen, ergänzt durch mitgebrachte Haustiere, ermöglichten

Abb. 11.1 Der Tempel von Ħaġar Qim (3600 und 2500 v. Chr.) im Süden Maltas. (© Christine Wunn; mit freundlicher Genehmigung)

den ersten Generationen ein mehr als sorgenfreies Leben, in dessen Folge die Bevölkerungsdichte stark zunahm. Nach etwa 2000 Jahren ununterbrochener Nutzung der natürlichen Ressourcen zeigten sich erste negative Folgen, die sich in den folgenden Jahrhunderten dramatisch verstärkten. Diese langsame, aber kontinuierliche ökonomisch-ökologische Fehlentwicklung mit dramatischen Konsequenzen für die Inselbewohner spiegelte sich im Weltbild der maltesischen Kultur wider und fand ihren eindrucksvollen Niederschlag im Bau von beeindruckenden Tempel- und Grabanlagen.

Hier sind, auch aus religionsökologischer Sicht, mehrere Phasen zu unterscheiden, in denen sich die Grab- und die Tempelarchitektur abhängig von den knapper werdenden Ressourcen von einfachen Anfängen bis zu den beeindruckenden Tempelanlagen entwickelte.

Nach der Besiedlungsphase mit ihren frühen, aber leider kaum erhaltenen Kultplätzen (Għar-Dalam- und Skorbaphase) setzte mit der Żebbugphase (4100 bis 3800 v. Chr.) die Zeit der eigentlichen Tempelkultur ein, für die Malta heute berühmt ist und die das Landschaftsbild dieser kleinen Insel so eindrucksvoll prägt. Gefolgt wurde diese Periode von der Mġarrphase, in der die megalithisch inspirierte Tempelkultur einen ersten Höhepunkt erreichte. Mit dem Tempelbau von Ġgantija auf Gozo war in der gleichnamigen Ġgantijaphase (3600 bis 3000 v. Chr.) das Niveau einer frühen Hochkultur erreicht, das während der anschließenden Tarxienphase (3000 bis 2500 v. Chr.; Abb. 11.1) einer Klimax zustrebte.

Abb. 11.2 Grundriss eines Hauses bei Għajnsielem. (Zeichnung: Karolina Rupik)

In den folgenden Jahrhunderten führte die Erschöpfung der Ressourcen der Insel zusammen mit ihrer durch Übernutzung entstandenen Verkarstung zu einem Bevölkerungsrückgang und letztlich zum Untergang der maltesischen Tempelkultur.

Im Unterschied zur Sakralarchitektur, die unser eigentliches Thema ist, sind die archäologisch gesicherten Spuren einer frühen Wohnbebauung spärlich und beschränken sich auf wenige und häufig schlecht erhaltene Fundplätze, zu denen Għar Dalam, eine Höhlenunterkunft, Skorba mit seiner Lehmziegelarchitektur über ovalem Grundriss und Għajnsielem mit ebenfalls ovalen Hauskonstruktionen (Abb. 11.2) gehören.

Vom Aussehen der Wohngebäude hat man inzwischen vor allem deshalb recht konkrete Vorstellungen, weil Funde von Hausmodellen, so bei Ta' Ħaġrat, die Ausgrabungsergebnisse ergänzen. Entscheidend bei diesen Entdeckungen ist, dass es offensichtlich eine architektonische Formenverwandtschaft zwischen Wohn-, Sakral- und Sepulchralarchitektur gab, die keinesfalls zufällig ist, sondern bedachtsam gewählt wurde.

Die ovale bzw. Höhlenform der maltesischen Wohnbebauung lässt sich nämlich schon früh sowohl in der Architektur der Tempel als auch der Begräbnisstätten wiederfinden. Nach einer schlecht dokumentierten frühen Phase von Einzelbestattungen in kleinen untertassen- oder nierenförmigen Gräbern begannen die Malteser mit Beginn der Żebbuġphase, ihre Toten kollektiv in Felsgräbern beizusetzen. Die weitere Entwicklung lässt sich dank

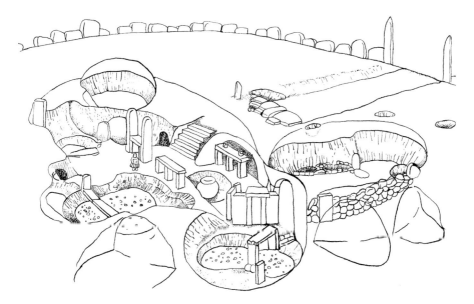

Abb. 11.3 Der Brochtorff-Circle auf Gozo. (Zeichnung: Karolina Rupik)

glücklicher Umstände am besten am sogenannten Brochtorff-Circle auf der kleineren Insel Gozo verfolgen (Abb. 11.3), der kontinuierlich als Begräbnis- und Kultplatz genutzt wurde und daher den Wandel der Begräbnissitten von der Żebbuġ- bis zur Tarxienphase in idealtypischer Weise wiedergibt.

Am Anfang der Entwicklung auf Gozo standen zwei einfache Grabkammern aus der Żebbuġphase, die nach und nach mit mehr als 50 Verstorbenen belegt wurden. In der anschließenden Ġgantijaphase ging man dazu über, ein unmittelbar benachbartes natürliches Höhlensystem in die unterirdische Anlage mit einzubeziehen, bis die Anlage in der Tarxienphase schließlich zu einem regelrechten unterirdischen Monument erweitert wurde, bei dem sich zahlreiche kollektive Begräbnisstätten um einen zentralen, kathedralenähnlichen Kultraum gruppierten. Zuletzt wurde das gesamte Areal mit seinen verschiedenen Kollektivgräbern von einem megalithischen Steinkreis eingefasst. Die unterirdische Haupthöhle erhielt zu diesem Zeitpunkt eine Ausgestaltung, die genau den megalithischen, oberirdischen Tempeln entsprach, während die Eingänge zu weiteren seitlichen Grabnischen durch megalithische Blöcke optisch von der Haupthöhle separiert wurden.

Die genaue architektonische Übereinstimmung von unterirdischer Begräbnisstätte und überirdischer Tempelanlage wird besonders bei dem berühmten Hypogäum von Ħal Saflieni deutlich (Abb. 11.4), das nur etwa 500 m von der oberirdischen Kultanlage von Tarxien entfernt liegt und zu dieser in einer konkreten Sinnbeziehung stand. Auch diese Kult- und Begräbnisstätte – ein Gewirr neben- und untereinanderliegender Felskammern und Hallen, die

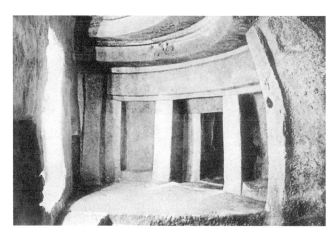

Abb. 11.4 Eine tempelartig gestaltete Halle des Hypogäums von Ħal Saflieni. (© Richard Ellis 1924)

durch Schächte, Treppen und Gänge miteinander in Verbindung stehen – wurde von der Żebbuġ- bis in die Tarxienphase kontinuierlich genutzt. Jede dieser Kammern und Hallen ist von rundovalem Grundriss und ähnelt so in der Form den ältesten Grabammern vom Żebbuġtyp, die auch hier am Anfang der Baugeschichte standen. Die folgenden Generationen erweiterten diese höhlenartigen Kammern, um Platz für neue Bestattungen und die damit verbundenen Kulthandlungen zu finden. Zuletzt stellte das Hypogäum einen Komplex von Hallen und Kammern dar, die sich über drei Hauptstockwerke erstreckten. Der Eingang zum eigentlichen Hypogäum führt durch einen Trilithen, durch den man direkt die oberste Ebene mit einigen nur grob in den Fels gehauenen Kammern betritt. Auf der nächsttieferen Ebene fallen sorgfältig gestaltete Hallen mit einer Reihe von rein dekorativen Elementen auf, die in den älteren Teilen noch gefehlt haben. Darunter befinden sich sakrale Einrichtungsgegenstände aus sorgfältig behauenen, megalithischen Blöcken, wie sie von den Tempelanlagen der Ġgantija- und Tarxienphase bekannt sind. Eine als Fassade gestaltete Außenwand eines hallenartigen Zentralraums nimmt die Tempelarchitektur genau auf, indem die Wandflächen wie in den Tempeln durch flache Raumnischen gegliedert, die Fassade konkav gewölbt und die Decke scheinbar ein aus megalithischen Blöcken konstruiertes Kraggewölbe mit zentraler Öffnung zu sein scheint – nur ist hier alles aus dem anstehenden Fels herausgeschlagen, während die oberirdischen, formidentischen Tempel aus Megalithblöcken gefügt sind.

Neben diesem und weiteren sorgfältig gestalteten, teilweise auch bemalten Räumen und Hallen der zweiten Ebene gibt es eine Treppe, die zur untersten Ebene mit ihren Grabkammern führt.

Trotz der delikaten Ausstattung einiger Räume, vor allem der zweiten Ebe-
ne, sind wohl weder das Hypogäum von Ḥal Saflieni noch der Brochtorff-
Circle Orte für die eigentlichen Kulthandlungen gewesen, sondern dienten
als Orte für Beisetzungen, während Kulthandlungen im eigentlichen Sinne in
den assoziierten Tempelanlagen vorgenommen wurden, die ja auch äußerlich
ganz den Begräbnisstätten ähnelten.

Tempel und der Totenkult auf Malta

Charakteristisch für alle Tempelanlagen auf Malta und Gozo – es waren ur-
sprünglich wohl mehr als 30 – ist die monumentale, konkav zum Tempel-
inneren gebogene Außenfassade sowie die Anordnung runder oder halbkreis-
förmiger Räume entlang einer Reihe von Höfen und Durchgängen. Diese
Grundrisse sind nach Auffassung des britischen Archäologen und Maltaex-
perten John Davies Evans (1925–2011) so merkwürdig und bautechnisch
unpraktisch, dass sie ein Vorbild jenseits des Bereichs der üblichen Gebäude-
architektur haben müssten. Ein Vergleich der ursprünglichen Tempelgrund-
risse mit dem Plan früher Begräbnishöhlen wie bei Xemxija belegt folgerichtig
deren verblüffende und bis ins Detail gehende Übereinstimmung, sodass der
Schluss naheliegt, dass die Bewohner Maltas ihren frühen Tempeln genau das
Aussehen von unterirdischen Grabstätten geben wollten. Aus diesen höhlen-
imitierenden Raumensembles entwickelte sich anschließend die Tempel-
architektur hin zu stärker schematisierten Grundrissen, ohne die organischen
Rundformen der Ursprungszeit aufzugeben.

Ein Beispiel ist der aus der Ġgantijaphase stammende Tempel auf der Insel
Gozo, der aus zwei ursprünglich unabhängigen Bauwerken besteht, die dann
mit einem kurzen Gang verbunden und von einem gemeinsamen Außenwall
umgrenzt wurden. Der ältere Gebäudeteil zeigt den für maltesische Tempel-
anlagen charakteristischen, nun aber stark vergrößerten, kleeblattförmigen
Grundriss, über dem sich ein Hofareal und drei weitere hufeisenförmige Räu-
me erstrecken. Später wurde vor diesen Gebäudekomplex ein weiteres Oval
gesetzt und durch einen Gang mit dem älteren Teil verbunden. Ein kleineres,
weniger massives Nachbargebäude wiederholt dieses Bauschema im Wesent-
lichen. Hier treten nun zum ersten Mal altarähnliche Konstruktionen aus
senkrecht stehenden Blöcken mit einer horizontal aufliegenden Platte auf, die
den Durchgang zu den hinteren Kammern einrahmen.

Die Aufgabe dieser altarähnlichen Konstruktionen (Abb. 11.5) wird be-
sonders in den großen Tempelanlagen, so zum Beispiel von Tarxien, deutlich.
Letztere besteht aus drei zu unterschiedlichen Zeiten entstandenen und später
zu einer Einheit zusammengeschlossenen Anlagen. Gleich im Eingangsbereich

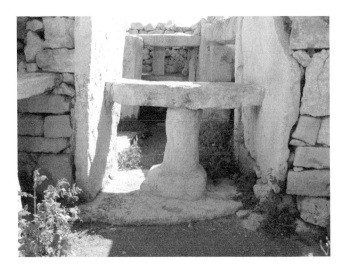

Abb. 11.5 Altarähnliche Konstruktion; hier aus Ħaġar Qim. (© Christine Wunn; mit freundlicher Genehmigung)

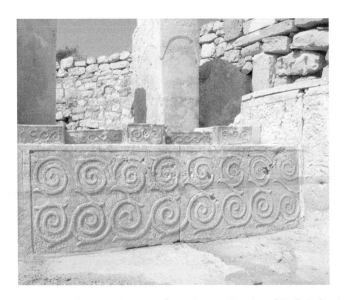

Abb. 11.6 Der mit Ranken verzierte Opferstein von Tarxien. (© Christine Wunn; mit freundlicher Genehmigung)

der westlichen Tempelanlage findet sich eine Nische mit einem Lochstein für Libationsopfer. Im selben Tempelbereich stehen zwei mit eindrucksvollem Rankenrelief verzierte Altäre (Abb. 11.6), von denen der eine so ausgehöhlt wurde, dass er Tierknochen aufnehmen konnte. Gleichzeitig fand sich hier in einer verschließbaren Öffnung ein scharfes Opfermesser aus Flint, welches deutlich macht, dass Tieropfer vom Schaf, der Ziege, von Schwein und Rind zu den in den Tempeln vollzogenen Kulthandlungen gehörten.

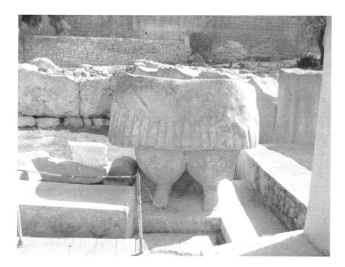

Abb. 11.7 Kolossalstatue von Tarxien. (© Christine Wunn; mit freundlicher Genehmigung)

Derselbe Tempelbereich wird von einer ursprünglich 2 bis 3 m hohen Kolossalstatue dominiert, von der leider nur der untere Bereich mit den feisten Unterschenkeln und einem Faltenrock erhalten ist (Abb. 11.7).

Jene fettleibigen Kolossalstatuen und daneben auch kleinere Statuetten wurden ab der Mġarrphase immer wieder in Zusammenhang mit Tempeln und Bestattungen gefunden, haben also offensichtlich bei entsprechenden kultischen Handlungen eine wesentliche Rolle gespielt. Der Bestattungskult ist damit der Schlüssel zum Verständnis nicht nur der Tempel selbst, sondern auch der anthropomorphen Statuetten und Figurinen!

Damit stellt sich die Entwicklung der neolithischen Religion auf Malta wie folgt dar. Die Malteser brachten vom europäischen Festland die uns schon bekannte Sitte der Totenverehrung mit, die dann in der kulturellen Isolation der Insel langsam immer komplexere Formen bis zum regelrechten Ahnenkult annahm. Die ersten Heiligtümer und Tempelanlagen auf Malta dienten der Verehrung der Verstorbenen und sämtliche weiteren Kultstätten mit ihren komplizierten Grundrissen, Altären und Schreinen waren letztlich nichts anderes als Weiterentwicklungen dieser ersten Ahnentempel, in denen man den Verstorbenen Opfer darbrachte. Zahlreiche Lochsteine mit Vertiefungen und Näpfchen in den Tempeln dienten der Aufnahme von Libations- und Speiseopfern für die Ahnen, während die Nischen in den späteren Tempeln mit den Gebeinen geopferter Tiere angefüllt waren. Opfertiere waren Schweine, Schafe, Rinder und Ziegen, wie eine paläobiologische Analyse des Knochenmaterials und ein Blick auf die Tempelfriese gleichermaßen bestätigen.

In diesen Kontext fügen sich sowohl die Kolossalstatuen als auch die Statuetten mühelos ein. Es handelt sich um Ahnenfiguren, die sowohl im

Bestattungskult als auch während der späteren kultischen Handlungen in den Tempelarealen eine wesentliche Rolle spielten.

Am Anfang der Religionsentwicklung auf Malta stand ein noch relativ schlichtes Totenbrauchtum. Man bestattete die Verstorbenen zunächst einzeln, dann kollektiv in Höhlen oder in künstlich eingetieften, höhlenförmigen Gräbern. Die Form dieser Grabstätten wurde in den ersten Tempelanlagen wiederholt; die Tempel waren also Abbilder der Gräber, die jedoch im Gegensatz zu ihren architektonischen Vorbildern für die Gemeinschaft auch außerhalb der Beisetzungsfeierlichkeiten zugänglich blieben. Hier konnte man den Kontakt zu den an unterirdischer Stätte existierenden Toten aufnehmen und ihnen über Opferhandlungen Gaben zukommen lassen. Die Verstorbenen wurden, in Statuetten vergegenwärtigt, in den Tempeln aufgestellt und waren dort Objekt der Verehrung. Die üppige Körperlichkeit der Idole sollte auf die paradiesischen Verhältnisse anspielen, die in der tellurischen Welt der Verstorbenen herrschten. Dort existierten die Ahnen frei von jedem Mangel inmitten unbegrenzter Fülle. Solche idealen Zustände wurden durch die Versorgungsleistungen der lebenden Nachkommen sichergestellt: Durch Libationen und Opfertiere wurden die Toten mit allem Notwendigen versorgt. Während Flüssigkeiten über Vertiefungen sofort dem Bereich der Unterwelt zugeführt wurden, hinterlegte man die Knochen der Opfertiere in den Tabernakeln und Altären der Tempel und ließ sie so symbolisch den Verstorbenen in ihren Gräbern zukommen.

Die Fettleibigkeit der Ahnenstatuen war ein Beleg dafür, wie gut man die Vorfahren, die mächtigen Angehörigen der tellurischen Welt und Herren über Fruchtbarkeit und unterirdische Reichtümer, versorgte. Entsprechend dem *do ut des*-Prinzip erwartete man, dass die Ahnen ihrerseits nun als Gegengaben die dringend notwendige Fruchtbarkeit der Felder und des Viehs gewährten. Es kann daher nicht verwundern, dass die kultischen Bemühungen gegen Ende der Tempelbauerzeit, als die Ressourcen der Insel deutlich knapper wurden, einem fiebrigen Höhepunkt zustrebten.

Gabentausch

Auf der maltesischen Inselgruppe hat sich eine Form des Kulthandelns entwickelt, die das Verhältnis von Lebenden zu Toten völlig neu definierte. Kommen wir zunächst auf die uns bislang bekannte Form der Bestattung zurück, die sich als Ritual abspielte. Das Ritual ist die performative Wiederholung des im Mythos geschilderten Urzeitgeschehens; der Mythos wiederum ist eine sinnstiftende Ursprungserzählung, die das Leben der jeweiligen Gemeinschaft und die existenziellen Grundlagen menschlichen Daseins einschließlich ihrer

sozialen Bezüge deutet und in einen wertenden, in der konkreten Existenz umzusetzenden Zusammenhang bringt. In einem solchen Weltbild ist jedes Individuum das Abbild „seines" konkreten und mythischen Ahnen, in seinem Leben wiederholt sich gesetzmäßig das Erleben des Sippengründers. Eine solche Weltsicht hat exemplarisch der herausragende französische Anthropologe Marcel Mauss dargelegt, der im Rückgriff auf die Vokabel *persona* in der ursprünglichen Bedeutung von „Maske" deutlich machen konnte, dass *persona* etwas anderes ist als nur das biologische Individuum. Eine „Person" ist vielmehr derjenige, der innerhalb einer Verwandtschaftsgruppe eine ganz bestimmte Stellung innehat, also eine vorgegebene Rolle ausfüllt. Das kann so weit gehen, dass der Sieger in einem Zweikampf dem Besiegten nicht nur die Waffen abnimmt, sondern auch seine Güter, seinen Namen und die Stellung innerhalb seiner Familie, sich also nun auch auf den mythischen Ahnen des Besiegten zurückführt.

Ganz anders war jedoch das Verhältnis der Lebenden zu den Verstorbenen auf Malta. Hier war es offensichtlich der Austausch von Gütern, der die Beziehungen zwischen der Welt der Lebenden und der Welt der Toten regelte. Die Lebenden versorgten die Verstorbenen mit allem, was sie für ihre Existenz benötigten, und das waren vor allem Speise und Trank. Die Verstorbenen als Angehörige der tellurischen Welt hatten zwar keinerlei Zugriff auf Speise und Trank, galten aber als übermächtig und konnten das irdische Glück hemmen oder fördern. Vor allem die Fruchtbarkeit der Felder und des Viehs lag in ihren Händen und ihrem Belieben. Um sich dieser Dienste der Ahnen zu vergewissern, bedienten sich die neolithischen Malteser des Gabentausches, einer archaischen Sitte, deren Kenntnis wir gleichfalls Marcel Mauss zu verdanken haben.

Wie Mauss anhand der anthropologischen Literatur seiner Zeit herausgearbeitet hat, sind einige traditionell lebende Völker einer „Institution der totalen Leistung" verpflichtet, also der moralischen Verpflichtung, Geschenke zu machen, Geschenke anzunehmen und zu erwidern. Diese Sitte des Gabentausches ist tief in der Biologie nicht nur der Primaten, sondern auch in manch anderem Tierstamm bzw. anderer Tierklasse verwurzelt, in der Geschenke dazu dienen, mögliche Aggressionen beim Gegenüber – meist einem Sexualpartner – abzubauen. So beschwichtigt das Spinnenmännchen die Mordlust eines von ihm zur Paarung auserkorenen Weibchens, indem es ihm eine Fliege als Speise vorsetzt, während es sich dem Paarungsakt widmet. Auch Vögel betören ihre Liebste mit Geschenken und die Weibchen gehen nicht nur gern auf dieses Spiel ein, sondern verstärken die Gebefreudigkeit des Männchens noch, indem sie durch rasches Flügelschlagen das Bettelverhalten von Jungvögeln nachahmen. Parallelen zum *Homo sapiens*, bei dem gelegentlich ein ähnliches infantiles Verhalten zu beobachten ist, drängen sich auch auf der nichtwissenschaftlichen Ebene auf.

Der Austausch von Geschenken, wie ihn die Anthropologie als eine frühe Form der Ökonomie in archaischen Gesellschaften beschreibt, ist eingebunden in eine ganze Reihe von Rechten und Pflichten, die das Verbrauchen der Gaben, die notwendige Erwiderung, das Anbieten und Empfangen regeln. In den betreffenden archaischen Gesellschaften sind sämtliche Güter, angefangen von Nahrungsmitteln über handwerkliche Produkte, Talismane, Grund und Boden, Arbeit und Dienstleistungen bis zu Priesterämtern, der sozialen Stellung und Lebenspartnern Gegenstand der Übergabe und Rückgabe. Jedes Mitglied einer solchen Gesellschaft ist entsprechend seinem Rang verpflichtet, berechtigten Persönlichkeiten zu festgesetzten Anlässen Geschenke zu machen, die von den Beschenkten sowohl angenommen als auch, und das ist von entscheidender Wichtigkeit, nach einer angemessenen Frist durch ein zumindest gleichwertiges Geschenk erwidert werden müssen. Durch diesen über die Konvention geregelten Gabentausch ergibt sich zwischen Geber und Empfänger eine juristische Beziehung, aber zusätzlich auch eine darüber hinausgehende feinstoffliche Bindung (wir würden heute von seelischer Beziehung sprechen), die über die dem Geschenk eigene feinstoffliche oder geistige Potenz geknüpft wird. Diese Potenz wird als eine Art Wirkungskraft verstanden, die dem Geschenk selbst anhaftet, aber auch Anteile der Potenz des Schenkenden enthält. Durch diese feinstofflichen oder geistigen Anteile an der Gabe kann der Geber eine gewisse Macht über den neuen Eigentümer erlangen, sodass eine enge Beziehung zwischen Gebendem und Empfangendem entsteht. Dieses System des kontinuierlichen Austausches von Gaben umfasst jedoch nicht nur die Gemeinschaft der Lebenden, sondern kann die Verstorbenen bzw. die Ahnen und die Götter durchaus einschließen. So werden beim nordwestamerikanischen Potlatch regelmäßig enorme Mengen von Gütern nicht nur verschenkt und konsumiert, sondern auch vernichtet.

An dieser Orgie der Verschwendung beteiligen sich, so die allgemein akzeptierte Fiktion, eben nicht nur die lebenden Mitglieder der Gemeinschaft, sondern auch die mythischen und tatsächlichen Vorfahren, die durch diejenigen Menschen vertreten werden, die aktuell ihre Namen tragen und damit als ihre Personifizierungen (*persona*) gelten. Der Gabentausch mit den Vorfahren, Geistern und Göttern ist auch deshalb notwendig, da sie als die wahren Eigentümer des Landes und der darauf produzierten Güter gelten. Das Motiv der Zerstörung ist also letztlich darauf zurückzuführen, dass die vernichteten Güter als Gabe an höhere Mächte verstanden werden. Im Gegenzug zwingt die unbedingte Verpflichtung, eine empfangene Gabe zu erwidern, den Beschenkten, im Falle Maltas also die Ahnen, zu reichlichen Gegengeschenken.

Werden den Ahnen also wie im Fall des neolithischen Maltas wertvolle Opfergaben dargebracht, so müssen die Ahnen diese annehmen. Damit gehen sie eine enge Beziehung zu den Lebenden ein, die eine entsprechende

Abb. 11.8 Auch auf Malta herrschte die Göttin der Unterwelt über das Totenreich. Sie wurde jedoch nicht mehr im Idol vergegenwärtigt, sondern nur ein Augenpaar zeigt, dass sich der Besucher im Herrschaftsbereich der sogenannten Dolmengöttin bewegt. (© Christine Wunn; mit freundlicher Genehmigung)

Gegengabe erwarten und sogar einfordern können. Der Verstorbene und mit ihm eine möglicherweise gleichzeitig angesprochene Unterweltsgottheit sind verpflichtet, ein Gegengeschenk von möglichst größerem, zumindest aber gleichem Wert zu machen, also für das Prosperieren der Geber zu sorgen. Die Gebenden waren hier im Falle Maltas nicht Individuen, sondern Dorfgemeinschaften, die ihre Ahnen kollektiv im Kult verehrten. Damit hat die Beziehung zu den übermenschlichen Mächten auf Malta eine neue Qualität erreicht. Wenn bislang im Umgang mit Ahnen und Dema Identifikation und Teilhabe zählten, die Mächte also im Ritual vergegenwärtigt wurden, um die kosmische Ordnung zu gewährleisten, ist nun das *do ut des*-Prinzip an diese Stelle getreten. Ahnen und Gottheiten sind zu Objekten der Verehrung und des Kultes geworden, um auf diesem Wege von ihnen Schutz und Leistungen zu erlangen (Abb. 11.8).

Malta: Religion und Ökosystem

Mit dem Gabentauschsystem – aus säkularer, ökonomischer Sicht eine Vernichtung von Gütern – reagierten die Bewohner im neolithischen Malta auf die Verschlechterung ihrer Lebensverhältnisse. Diese war Folge einer Überbevölkerung und überstrapazierter natürlicher Ressourcen, ein Zusammenhang, der rasch deutlich wird, wenn man die Verteilung der Tempelkomplexe über die Inseln Malta und Gozo betrachtet. Die Tempelanlagen sind an Einhei-

ten fruchtbarer und damit landwirtschaftlich nutzbarer Böden gebunden und sind damit die sichtbaren Zeichen autarker Wirtschafts- und Kultgemeinschaften. Die recht gleichförmige Verteilung der Tempel über die Inseln verdeutlicht, dass das nutzbare Kulturland zur Zeit der Tempelbauer weitgehend erschlossen war, wobei die landschaftlichen Besonderheiten mit ihrer kleinräumigen Verbreitung fruchtbarer Terrarossaböden die Größe der einzelnen Siedlungseinheiten diktierten.

Die Tempel stellten die Kultplätze jeweils einer Siedlungsgemeinschaft mit (wahrscheinlich) verwandten Individuen dar. Somit dürfte der in der jeweiligen Idolfigur vergegenwärtigte Ahne der mythische und gleichzeitig tatsächliche Begründer der Sippe gewesen sein, auf den sich die Nachfahren zurückführten, wobei dessen *persona* und die sich darauf zurückführende Abstammungslinie aber auch der Legitimation von Besitzansprüchen an Grund und Boden diente. Deutlich werden diese Zusammenhänge vor allem bei den Grabfunden des Brochtorff-Circles, in dem unterhalb einer Gemengelage von isolierten menschlichen Knochen zusammenhängende Skelette auftraten, die von den Ausgräbern als Beleg für eine genealogische Weltanschauung angesehen wurden. Die für die neolithischen Tempelanlagen Maltas so charakteristischen, zwischen 25 und 40 cm hohen Figurinen, die fettleibige, meist sitzende, nackte oder bekleidete, geschlechtslose Menschen darstellen, sind demnach als Kultfiguren aufzufassen, deren Geschlechtslosigkeit die Identifikation sowohl mit den männlichen als auch den weiblichen Verstorbenen erlaubte. Auch die in späterer Zeit auftretenden Kolossalstatuen sind Ahnenfiguren, die dann allerdings im Sinne eines Wettbewerbs zwischen den verschiedenen Tempelgemeinschaften immer gewaltigere Formen annahmen.

Auch die riesenhafte Größe der megalithischen Tempelanlagen findet so eine Erklärung. Wie Parallelen aus der Religionsgeschichte und der Völkerkunde zeigen, dienen megalithische Bauwerke der Betonung territorialer Ansprüche. In Madagaskar zum Beispiel baut das Volk der Merina unter geografisch beschränkten räumlichen Bedingungen Reis an und ist dabei zu sorgfältigstem Umgang mit den geringen vorhandenen Ressourcen gezwungen. Die Notwendigkeit, eine begrenzte Anbaufläche für die eigene Gruppe zu sichern, führt in sozialer Hinsicht zur Betonung von Verwandtschaftsgruppen (*lineages*), die sich auf gemeinsame Ahnen zurückführen. Diese Ahnen gelten als die eigentlichen Eigentümer des Landes, die dieses bereits in mythischer Vorzeit in Besitz genommen hatten und daher legitime Ansprüche geltend machen können. Megalithische Grabstätten als Wohnungen der Ahnen und weithin sichtbare Zeichen in der Landschaft sind nachweislich die Symbole sowohl von Kontinuität als auch von Territorialität. Knappe Ressourcen und eine noch weitgehend segmentäre Gesellschaft scheinen damit die Entstehung bestimmter Bestattungssitten und Grabformen geradezu zu provozieren, so dass

ein Bedürfnis nach markanten Grabstätten vor allem dann entsteht, wenn die verfügbaren Ressourcen knapp werden. In einer Gesellschaft, der übergeordnete politische Regulative zur Klärung territorialer Besitzansprüche fehlen, dienen megalithische Bauwerke mit Bezug zu den Ahnen dazu, Ansprüche auf Landbesitz in einer Weise geltend zu machen, die Legitimität und Kontinuität in gleicher Weise einschließt und sich demnach auf die Ahnen beruft. Die Ahnen als legitime Eigentümer des Landes seit mythischen Vorzeiten sind Mittel und Argument, um eine aktuelle territoriale Forderung religiös zu fundieren und zu verankern.

Das weltanschaulich fixierte Verhältnis zwischen Lebenden und Toten erhält dann zusätzliches Gewicht, wenn die natürlichen Ressourcen, wie im Fall der vorgeschichtlichen Entwicklung Maltas, bei traditionellen technischen Möglichkeiten knapp werden. Einerseits setzt zwischen den Lebenden ein Wettbewerb um die verfügbaren Ressourcen ein, in dessen Zuge der legitime Besitz eines Territoriums über den Verweis auf Ahnen besonders betont wird, andererseits werden die Verstorbenen als die Bewohner der Unterwelt in die komplexen ökonomischen Verhältnisse mit einbezogen. Sie sind Empfänger von Opfergaben und damit im Sinne des Gabentausches zur Versorgung ihrer Nachfahren verpflichtet. Große Tempelanlagen, schwindende Ressourcen, eine möglicherweise scharfe Konkurrenz und ein aufwendiger Ahnenkult stehen also in direkter Beziehung zueinander.

12
Doppelaxt und Stier – ein Götterpantheon entsteht

Am Ende des Neolithikums

Bis zum Ende des Neolithikums hatte sich das Weltbild also noch einmal entscheidend gewandelt. Aus dem Deponieren von Schädeln im Paläolithikum, dann kleinen Ahnenfigurinen im Zuge von Bestattungsritualen hatte sich vor allem auf Malta ein regelrechter Ahnenkult entwickelt. Als mächtige Bewohner der Unterwelt, in die sie nach ihrem Tode rituell überführt wurden, waren die Ahnen der sichtbare Verweis auf die Legitimität von Landbesitz, aber auch als mächtige Angehörige der tellurischen Welt für das Wohlergehen ihrer Nachfahren verantwortlich. Während das Verhältnis zu den Ahnen zu Beginn des Neolithikums noch das von Identifikation und Teilhabe im Ritual war – man wurde als Darsteller im Ritual eins mit der vergegenwärtigten Gestalt – wandelte sich die Beziehung der Lebenden zu den Toten im Laufe von drei bis vier Jahrtausenden zu einem Gabentauschverhältnis. Das heißt, an die Stelle der Vergegenwärtigung trat die Verehrung. Zur selben Zeit machte die in der zweiten Hälfte des Neolithikums beginnende Differenzierung der Gesellschaft auch vor den Toten nicht halt. Vor allem herausragende Persönlichkeiten, in erster Linie Helden, nahmen in Zusammenhang mit der Verehrung der Mächtigen der tellurischen Welt eine zunehmend bedeutende Stellung ein, die im Mythos reflektiert wurde, und so entstanden die ersten tellurischen Göttergestalten. Gleichzeitig spielte im Kreis der Übermächtigen immer noch eine weibliche Figur eine wichtige Rolle, die sich aus der paläolithischen apotropäischen (schamweisenden) Frauenfigur zu einer Dema (Urmutter) und anschließend durch Hypostasierung zu regelrechten weiblichen Gottheiten entwickelt hatte. Archäologisch nachweisbar wurde sie immer wieder als Herrscherin der Unterwelt (Dolmengöttin), deren Bildnis zunächst als Schamweisende in Zusammenhang mit Hausbestattungen in Anatolien, dann in Zusammenhang mit Bestattungen der Bandkeramik in Mitteleuropa und zuletzt als Dolmengöttin in den megalithischen Kulturen Europas auftrat. Im Mythos, der allerdings erst in historischer Zeit für uns greifbar wird, erscheint diese Figur (Gäa und Rhea) noch als große weibliche Gottheit einer

inzwischen entmachteten Göttergeneration und spiegelt so in der kollektiven Erinnerungskultur ein Stück Religionsgeschichte.

Zu diesem religiösen Substrat traten in Zusammenhang mit dem Ackerbau und der Notwendigkeit der sicheren Bestimmung kalendarischer Eckdaten die Beobachtungen der Jahreszeiten und des Wettergeschehens, wie die ersten Kreisgrabenanlagen (Henges) zur Zeit der Bandkeramik zeigen. Archäologisch machen Begräbnisse in den Kreisgrabenanlagen deutlich, dass die Himmelsbeobachtungen und damit auch das Wettergeschehen – siehe das Märchen von Frau Holle – in Beziehung zur Unterwelt und den Ahnen gebracht wurden.

In den megalithischen Grabstätten Mittel- und Westeuropas taucht immer wieder ein männliches Idol auf, das deutlich phallische Bezüge zeigt und durch eine Axt gekennzeichnet ist. Ein Blick in die Religionsgeschichte (Bronze- bis Eisenzeit) und der Vergleich entsprechender Ikonografien legt nahe, diese Bilder als Hinweis auf die Existenz einer frühen Wettergottheit zu sehen, deren Waffe für Blitz und Donner stand und der die Schlange als Blitzsymbol zugeordnet wurde. Weitere archäologische Hinweise auf die Existenz einer solchen Gottheit fanden sich in Form von Bauopfern in den Fundamenten der Wohnhäuser vor allem der Trichterbecherkultur, wo aufrecht stehende Axtschneiden vor Blitzschlag schützen sollten. Auch die gelegentlichen Abbilder von Äxten und die seltenen Schlangenabbilder, die sich in megalithischen Grabmalen fanden, sind als Zeichen dieses Gottes zu lesen und dürften mit seinem befruchtenden und lebensspendenden Aspekt in Beziehung stehen. Hier kommt nun endlich die Theorie der HADD (*hyperactive agency detection device*) (vgl. Kap. 1) zum Zuge. Wie bereits in Zusammenhang mit kognitionswissenschaftlichen Erklärungsansätzen zur Religionsentstehung diskutiert (und als Erklärung für den Ursprung von Religion begründet abgelehnt!), vermuten Menschen hinter allen Ereignissen zunächst einmal automatisch und vorsichtshalber einen bewusst handelnden Akteur – also theoretisch auch hinter natürlichen Ereignissen wie Gewitter und Regen. Ist die Religionsentwicklung bereits so weit fortgeschritten, dass Dema und wirkmächtige Ahnen im religiösen Kosmos gegenwärtig sind, ist es nur noch ein kleiner Schritt, auch Wetterphänomenen, die für die Ernte ja von essenzieller Bedeutung sind, im Sinne der HADD übermenschliche Akteure als Urheber zuzuschreiben. Die Gabentauschbeziehung mit den in der Unterwelt hausenden Ahnen, auf deren Wirken der Ertrag der Felder zurückgeführt wurde, war also der erste Schritt auf dem Weg hin zur Vorstellung übermächtiger, spezialisierter Akteure, die dann um einen weiteren wichtigen Spezialisten für das Wettergeschehen erweitert wurde. Die Theorie der HADD ist demnach zwar ungeeignet, das eigentliche Entstehen von Religion zu erklären, aber sie hilft zu verstehen, wie auf der Grundlage bereits vorhandener Vorstellungen von

der Existenz übermächtiger Gestalten sukzessive ein ganzes Götterpantheon entstehen konnte, in dem jeder Gottheit ihr eigener Zuständigkeitsbereich zugewiesen wurde.

Dass solche, später himmlischen übermächtigen Gestalten allerdings durchaus noch lange als irdisch gesehen wurden, belegt die Tatsache, dass sie noch in historischer Zeit auf Höhen und noch später auf unerreichbar hohe Berge versetzt wurden – noch die Griechen glaubten ihre Götter auf dem Berg Olymp –, aber sie waren unzweifelhaft Bestandteil der realen und höchst irdischen Welt.

Mit dieser Deutung aus religionsgeschichtlicher Perspektive wurde die Ebene der Entstehung der Religion aus verhaltensbiologischer Sicht streng genommen verlassen: Es waren nicht mehr nur Territorialverhalten, Dominanzstreben und existenzielle Ängste, die auf der Basis angeborener neuronaler Sollmuster im Dienste der Kommunikation zur Herausbildung erster Symbole bzw. symbolischer Akte führten, die dann letztlich in die Vorstellung einer jenseitigen Welt mündeten. Vielmehr hatte diese Anderswelt inzwischen eine solche Realität gewonnen, dass sie zu einem bedeutenden Teil der geistigen Kultur der ausgehenden neolithischen Gesellschaft geworden war und sich mit und in Abhängigkeit von dieser Kultur wandelte – ein Prozess, der mit Fug und Recht als Evolution von nun jeweils spezifischen Religionen bezeichnet werden kann (vgl. Kap. 5). Die ganz auf einen Ahnenkult fokussierende Religion des neolithischen Maltas war ein Beispiel für die Adaptation einer Inselregion an eine ganz spezielle Nische. Wie diese Evolution in Griechenland ausgesehen hat, sollen die folgenden Abschnitte zeigen.

Gesellschaftlicher Wandel

Bereits während des Neolithikums hatte sich ein gesellschaftlicher Wandel angebahnt, der im Lauf der Jahrtausende zu einer Differenzierung und letztlich auch zur Stratifizierung der Gesellschaft führte. In Griechenland und auf dem Balkan lassen sich diese Veränderungen recht gut anhand der Siedlungsstrukturen nachweisen. Die ersten, seltenen neolithischen Siedlungen aus dem achten bis sechsten vorchristlichen Jahrtausend wie Nea Nikomedeia in Makedonien bestanden noch aus kleinen, rechteckigen Häusern. Von ihnen gruppierten sich im genannten Beispiel jeweils sechs um ein größeres Zentralgebäude und markierten damit zwar soziale Einheiten innerhalb des Dorfes, lassen aber keine Schlüsse auf eine soziale Differenzierung zu. Im Lauf der Jahrhunderte wurden nicht nur die Häuser, sondern auch die Siedlungen immer größer, und auch hinsichtlich der Sozialstruktur traten Veränderungen ein. Im thessalischen Dimini aus dem fünften vorchristlichen Jahrtausend

fand sich ein zentraler, befestigter und von einem Steinwall umgebener Bereich mit einem großen öffentlichen Platz und einem megaronartigen Zentralgebäude. Hinsichtlich des Handwerks, vor allem der Töpferei, fällt auf, dass sich einerseits bestimmte, voneinander abgrenzbare Stile entfalteten, die Dörfer also eindeutige Identitäten entwickelten, durch die sie sich von Siedlungen benachbarter Regionen unterschieden, andererseits aber über einen intensiven Handelsaustausch auch mit weiter entfernten Regionen in Kontakt standen. Die (in den vorangegangenen Kapiteln beschriebene) Entwicklung religiöser Vorstellungen spiegelt diesen Wandel, in dem nun der individuelle häusliche Kult in der Familie mehr und mehr durch kollektives und damit ortstypisches Kulthandeln ergänzt und ersetzt wurde, das innerhalb der örtlichen Gemeinschaft die Rolle der Gesellschaft in den Vordergrund stellte und nach außen ihrer Selbstdarstellung diente.

Hinsichtlich des Handwerks führten die hohe Kunstfertigkeit im Bereich der Töpferei und die damit verbundene Erfahrung im Umgang mit Mineralien und Feuer um die Mitte des fünften Jahrtausends zu einer umwälzenden Neuerung: der Metallverarbeitung. Zunächst waren es Kupfer und Gold, die, zu einfachen Formen gehämmert oder gegossen, als Statussymbole dienten, über weite Entfernungen gehandelt wurden und zuletzt auch als Beigaben in die Grabstätten gelangten. Berühmt wurde in dieser Hinsicht ein Gräberfeld der Karanovokultur bei Varna (Bulgarien; 4600 bis 4200 v. Chr.; Abb. 12.1). Als Prestigeobjekte fanden auch Gefäßformen großen Anklang, die ihren Ursprung in Anatolien (z. B. Troja) hatten und aus denen man alkoholische Getränke genoss. In wirtschaftlicher Hinsicht waren die Einführung des Pfluges, der von Rindern gezogene Wagen oder neue Haustierrassen wie das wollliefernde Schaf von großer Bedeutung. Gesellschaftlich fanden diese Entwicklungen ihren Niederschlag in der Herausbildung klarer Verhaltensnormen, die an die neuen Herausforderungen infolge eines inzwischen auch aggressiven Wettbewerbs angepasst waren; also Verhandlungsgeschick und Tapferkeit, aber auch verlässliche Gastfreundschaft; Eigenschaften, die in Zusammenhang mit der Möglichkeit der Ansammlung materieller Güter die Entstehung einer Elite und letztlich Führungsschicht ermöglichte.

Im Zuge dieses Wandels und beeinflusst von einer Entwicklung, die im Osten bereits sehr viel früher eingesetzt hatte, wurden vor allem auf dem Peloponnes und den Inseln der Ägäis große Zentralbauten errichtet, eine Entwicklung, die sich besonders gut auf Kreta nachverfolgen lässt.

Kreta mit seinem Zentrum Knossos war noch im Neolithikum relativ isoliert, sodass sich dort die alten Vorstellungen um übermächtige weibliche Gestalten ungestört entfalten konnten und länger erhalten blieben als auf dem Festland, wo ein zunehmend aggressiver Wettbewerb das ideelle Kräftegleichgewicht in Richtung auf das männliche Element und männliche „Tugenden"

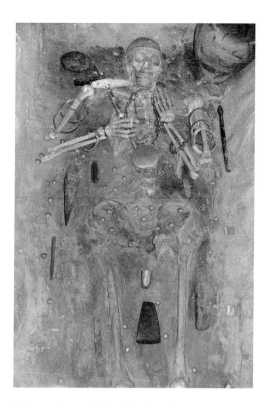

Abb. 12.1 Gräberfeld von Varna. (© Yelkrokoyade; Creative Commons Attribution-Share Alike 3.0 Unported license)

wie Kraft und Tapferkeit verschoben hatte. Erst mit der Erfindung seetüchtiger, mit Segeln ausgerüsteter Schiffe sollte Kreta im Fernhandel eine bedeutende Rolle spielen, die sich in der gesellschaftlichen Entwicklung niederschlug: Knossos und andere Siedlungen der Insel wuchsen zu Palastzentren heran.

Kreta in der Bronzezeit

Während der sogenannten Vorpalastzeit (3300 bis 2000/1900 v. Chr.) erlaubten technische Neuerungen und landwirtschaftliche Innovationen (unter anderem der Anbau von Wein und Oliven) ein starkes Bevölkerungswachstum und stabile gesellschaftliche Verhältnisse. Dies wiederum führte zum Anwachsen der Dörfer zu Siedlungen mit fast städtischem Charakter. Zwischen 2000 und 1600 v. Chr., der älteren Palastzeit, entstanden hier palastartige Baukomplexe, die in erster Linie zur Nahrungsmittelvorratswirtschaft (vermutlich zur Überbrückung von Zeiten der Nahrungsmittelknappheit nach

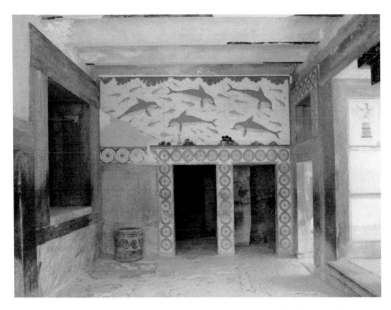

Abb. 12.2 Im Palast von Knossos. (© Nikater; GNU-Lizenz für freie Dokumentation)

schlechten Ernten) dienten, wie nicht nur die Gebäudegrundrisse deutlich machten, sondern auch die hier gefundenen, mit dem sogenannten Linear B beschrifteten Tontafeln, bei denen es sich um Verwaltungsaufzeichnungen handelte – übrigens in einer frühen Form der griechischen Sprache. Daneben dienten die Paläste zur Koordination der Produktion von Luxusgütern wie Waffen, Trinkgefäßen aus kostbaren Materialien oder Schmuckstücken und als Warenumschlagplatz für den immer wichtiger werdenden Handel. Über die wirtschaftlichen Aufgaben hinaus dienten die Paläste von Knossos (Abb. 12.2), Mallia oder Phaistos, jeweils im Zentrum einer Region gelegen, auch der Repräsentation, wie kostbar ausgestattete und aus edlen Materialien errichtete Räume zeigen. Die zentrale Bedeutung der Paläste und ihre dominierende Stellung im Wirtschaftssystem einer noch vormonetären Gesellschaft führte nach und nach zu handwerklicher Spezialisierung und damit zu einer gesellschaftlichen Differenzierung: Bauern, die zunächst ihr Handwerk nur nebenbei ausgeübt und ihre Produkte an den Palast weitergereicht hatten, arbeiteten nun zunehmend für den Palast und wurden dafür mit Lebensmitteln versorgt, und genau diese Verpflichtungen und Transaktionen wurden schriftlich auf den Tontafeln festgehalten.

Während der jüngeren Palastzeit (1600 bis 1425 v. Chr.) entwickelten sich die Paläste über ihre Aufgabe als wirtschaftliche Zentren hinaus zu Mittelpunkten des gesellschaftlichen Lebens mit allen Zeichen der Prachtentfaltung und des Luxus, mit denen eine Elite sich das Leben einerseits angenehm machte, sich andererseits aber auch darstellte. Die palastartigen Anlagen aus

dieser Zeit – im Übrigen relativ gut erhalten, weil nicht von späteren Generationen überbaut – waren wie ihre zeitlichen Vorläufer um einen zentralen Hof angeordnet. Ein Teil des Erdgeschosses diente der Lagerung landwirtschaftlicher Produkte, während anderen Räumen säulengestützte Vorhallen vorgelagert waren und Treppen zu großen Räumen im Obergeschoss führten. Der Ausgräber Sir Arthur John Evans (1851–1941) glaubte, in Knossos ein „Megaron des Königs" und ein „Megaron der Königin" mit Badezimmer wie auch eine elegante Suite im Oberstock identifizieren zu können, während andere Räume möglicherweise kultische Funktionen hatten. Neben der ausgefeilten und hoch entwickelten Bautechnik beeindruckt die Anlage vor allem durch ihre Pracht und wundervolle Wandbemalung, die einen Einblick in ein Leben gestattet, das mit Fug und Recht als höfisch bezeichnet werden kann. In der unmittelbaren Umgebung der Paläste konnten kleinere, aber ebenso elegante Gebäude ausgegraben werden, die man Würdenträgern oder bedeutenden Privatleuten zuschreibt. Auch auf dem Land entstanden in dieser Zeit Villen, die möglicherweise das Heim und der Verwaltungssitz eines vom Palast ernannten Gouverneurs oder lokalen Herrschers waren.

So faszinierend die Palastanlagen, die minoische Gesellschaft und ihre künstlerischen Spuren auch gewesen sein mögen, stehen sie allerdings nicht im Vordergrund unserer Erörterungen, sondern können nur als Hintergrund für die eigentliche Fragestellung, nämlich die nach der Religionsentwicklung, dienen. Hier ist von entscheidender Bedeutung festzuhalten, dass wir es nun, spätestens mit Beginn der Bronzezeit und keineswegs auf Kreta beschränkt, mit einer arbeitsteiligen und stratifizierten Gesellschaft zu tun haben, an deren Spitze eine Elite die Wirtschaftsleistungen der Gemeinschaft koordiniert und den Kontakt zu und den Schutz vor Mitbewerbern und möglichen Aggressoren übernommen hat. Für eine solche Gesellschaft ist charakteristisch, dass sie mit den übermächtigen Gestalten der Anderswelt eben nicht mehr in dem alten Verhältnis von Identifikation und Teilhabe, sondern vielmehr in einem Gabentauschverhältnis steht, dessen Entwicklung sich bereits auf Malta oder in den Bestattungen der Megalithkultur andeutete, das aber unter anderem auf Kreta ein charakteristisches Gepräge erhalten sollte.

Die Weltanschauung einer sich differenzierenden Gesellschaft auf Kreta

Zunächst aber finden sich auf Kreta in der Vorpalastzeit (nach Evans: Frühminoisch I bis Mittelminoisch IA) noch alle Elemente des altüberlieferten neolithischen Brauchtums einschließlich gemeinsamer Feierlichkeiten an den Gräbern der Verstorbenen. Auch die Unterwelt, zu der vor allem Höhlen

einen Zugang darstellten, war von Bedeutung. Die Höhlen von Psychro, von Kamares und die Höhle der Eileithyia in Amnissos galten als heilige Orte und Zugang zur Anderswelt, wo man den Unterirdischen nun im Sinn des Gabentausches Opfer darbrachte.

Das Höhlenheiligtum der Eileithya

Die intensive Nutzung der Höhle der griechischen Geburtsgöttin Eileithyia bei Knossos als Heiligtum ist seit der minoischen Periode SMIII bezeugt. Zu den Besonderheiten dieser Höhle gehörte ein Stalakmit, dessen Umriss entfernt an eine Frauengestalt erinnert. Dieser Tropfstein war von einer Mauer eingefasst, davor diente ein massiver Steinblock als Altar. Im Hintergrund der Höhle sammelt sich mineralhaltiges Wasser, das geschöpft wurde. Eine in Knossos gefundene Tontafel mit der folgenden Inschrift belegt, dass Eileithyia bereits hier verehrt wurde: „Amnisos, für Eleuthia, eine Amphore Honig." Ganz in der Tradition des Gabentausches mit den mächtigen Unterirdischen suchte man deren Hilfe, wenn es um Fruchtbarkeit ging.

Zu den Opfergaben gehörten männliche und weibliche Figuren, Tierfiguren und Miniaturen von Körperteilen, um von den Übermächtigen im Gegenzug Heilung (Körperteile) oder materielle Wohlfahrt erwarten zu können. All dies bewegt sich im Rahmen eines Brauchtums, das für Malta und das mitteleuropäische Neolithikum (Jungfernhöhle von Tiefenellern und Gräber der Trichterbecherkultur) exemplarisch dargestellt wurde, das wesentlich für das neolithische Weltbild war und sich bis in die Bronzezeit erhalten hat. Im Unterschied zu den Vorläufern ging es jetzt jedoch nicht mehr um Zugänge zur Unterwelt, in der man sich die mächtigen Toten und eine Dolmengöttin mit unscharfen Eigenschaften und Zuständigkeiten dachte, sondern um Heiligtümer für ganz spezifische Gottheiten mit streng umrissenen Zuständigkeitsbereichen.

Ein weiteres Element neolithischer Religiosität hatte sich offensichtlich nicht nur erhalten, sondern sich auf Kreta, das durch seine abgeschiedene Lage lange Zeit vor feindlichen Übergriffen geschützt war, auch ungestört entwickeln können: die Urmutter. Während ihre Differenzierung in eine übermächtige Gestalt und Herrscherin der Unterwelt einerseits, in eine Hüterin von Heim und Herd andererseits sowohl in Anatolien als auch Europa sichtbar wurde, scheint hier auf Kreta noch mindestens eine übermächtige weibliche Gestalt, oft heraldisch in Begleitung zweier Tiere dargestellt, hinzugekommen zu sein, die in Höhenheiligtümern (Abb. 12.3) kultisch verehrt wurde, also regelrechten Göttinnenstatus hatte. Diese Höhenheiligtümer standen in Beziehung zu den zugehörigen Gemeinschaften (die wie die Totentempel Maltas den Siedlungen eindeutig zugeordnet waren) und dienten zu ihrem Schutz und zur Sicherung ihres Wohlstands.

Abb. 12.3 Rekonstruktion eines Höhenheiligtums. (Zeichnung: Karolina Rupik)

Wie ein solches Höhenheiligtum ausgesehen hat, zeigt ein Reliefrhyton (Gefäß für die Libation) aus dem Palast von Katos Zakros. Über einem Steinsockel erhob sich eine dreiteilig-symmetrische, von Stierhörnern gekrönte Tempelfassade mit der Tür im Zentrum, während verschiedene, zum Teil ebenfalls mit Hörnern verzierte Altäre im Vordergrund zu sehen sind. Die abgebildeten Ziegen waren vermutlich zum Opfer bestimmt. Auch den Ablauf der Opferfeierlichkeiten kennt man von Abbildungen. Demnach wurde zur Nachtzeit ein großes Feuer entfacht, tönerne Votivfiguren ins Feuer geworfen und Tiere geopfert. Walter Burkert (*1931), Philologe und exzellenter Kenner der griechischen Religion, sieht hier den Ursprung der späteren griechischen Feuerfeste wie der Daidala bei Plataiai. Nicht eindeutig zu klären ist die Frage, an welche Gottheit sich die Opfer richteten, denn Kultbilder wurden nicht gefunden. Lediglich ein Siegel aus Knossos, das eine weibliche Figur zwischen zwei Löwen auf der Spitze eines Berges zeigt – auf der anderen Seite des Siegels ist ein hörnergekrönter Kultbau zu sehen – legt nahe, dass in den Höhenheiligtümern weibliche Gottheiten verehrt wurden.

So viel wurde allerdings deutlich: Die Zuordnung der Höhenheiligtümer zu den Palästen und ihren Städten belegt, dass eine jede Ansiedlung ihre ei-

gene Schutzgottheit mit ihrem entsprechenden Heiligtum hatte, in der ihr Opfergaben dargebracht wurden, sei es, um eine Bitte zu unterstreichen, oder auch, um für eine erwiesene Wohltat Dank abzustatten.

Während es sich bei den Opfergaben meist um typische, auch von archaischen griechischen Tempeln bekannte Votivgaben in Form menschlicher und tierischer Miniaturen handelte, legt der archäologische Befund von Anemospelia an den Hängen des Berges Iouktas südlich von Knossos die Existenz weiterer und weitaus drastischerer Opferbräuche nahe. Dort lag ein abgeschiedenes, bei einem Erdbeben zerstörtes und ausgebranntes Gebäude, in dessen zentralem Saal ein paar tönerne Füße als Überrest eines ursprünglichen Idols, umgeben von Tongefäßen als Behältnisse für die Opfer landwirtschaftlicher Produkte, gefunden wurden. Ein anschließender Raum war mit einem Podest ausgestattet, auf dem das Skelett eines jungen Mannes mit einem Dolch über der Brust lag; zwei weitere Skelette fanden sich in demselben Raum. Ob es sich hierbei um Menschenopfer handelt, konnte nicht mit Sicherheit geklärt werden.

Die kretische Religion ist über einen Kreis von Fachleuten bekannt, ja berühmt geworden. Frühere Archäologen wollten hier eine Religion sehen, in der eine große Muttergottheit verehrt wurde, an ihrer Seite ihr Sohn und Geliebter, dargestellt als Stier. Den Ursprung dieser Religion wollte man bereits im neolithischen Çatal Hüyük ausgemacht haben, indem man die Wandreliefs des schampräsentierenden Weibchens mit den allgegenwärtigen Bukranien nicht nur in einen unzulässigen inhaltlichen Zusammenhang brachte, sondern auch das soziale Umfeld – nämlich eine noch unstratifizierte, egalitäre Gesellschaft – vollkommen vernachlässigte. Um es kurz zu machen: Von einer stiergestaltigen Gottheit oder einem Gefährten der in den verschiedenen Heiligtümern verehrten weiblichen Gottheiten kann auch in Kreta keine Rede sein. Allerdings ist der Stier geopfert worden, darauf deutet ein Gebäude mit Steinaltar, Blutrinne und Kultgerät hin – darunter ein Ständer für die berühmte Doppelaxt. Den Ablauf eines solchen Stieropfers schildert eine Sargbemalung von Ayia Triada, die neben einem Baumheiligtum einen Altar mit Priesterin zeigt, darüber eine Libationskanne und einen Korb mit Broten als Voropfer. Auf einem Opfertisch im Hintergrund liegt der geschlachtete Stier, aus dessen durchschnittener Kehle Blut in ein Gefäß rinnt. Ein Flötenspieler begleitet die Szene. Damit zeigt das Bild dieses bronzezeitlichen Stieropfers alle Elemente, die auch das spätere griechische Opferritual kennzeichnen: Pompé, Altar, Voropfer und Flötenbegleitung. Die inhaltliche Verknüpfung dieses Opfers mit einer Bestattung weist auf alte Traditionen hin: Auch im neolithischen Anatolien hatten die Rinderopfer und das anschließende Anbringen der Schädel im Haus in Zusammenhang mit Bestattungsritualen gestanden.

In Zusammenhang mit den älteren, hier kurz erwähnten Fehldeutungen ist auf zwei Motive zurückzukommen, die geradezu als Kennzeichen der minoi-

schen Religion gelten können: Stierhörner und Doppelaxt. Die Doppelaxt, die möglicherweise tatsächlich beim Rinderopfer Verwendung fand, konnte bereits für das dritte Jahrtausend in Sumer (als rituelle Waffe der Priesterinnen!), Elam und dann Troja nachgewiesen werden, bevor sie Kreta in frühminoischer Zeit erreichte und dann zunächst als Weihegabe auftauchte, bis sie zuletzt Heiligtümer markierte bzw. geradezu als ihr Kennzeichen gelten konnte, aber auch als rein dekoratives Element Verwendung fand. Das Stieropfer mit vorausgegangenen Stierspielen (das berühmte Stierspringen) und die Doppelaxt – Labryx, das Labyrinth, heißt übersetzt nichts anderes als Doppelaxt – haben letztlich ihren erzählerischen Niederschlag in der griechischen Mythologie gefunden, in der Zeus Europa nach Kreta entführte, wo sie den späteren kretischen König Minos gebar. Dessen Frau Pasiphae wird wiederum Mutter des Ungeheuers Minotauros, das, gefangen im Labyrinth, dem Haus der Doppelaxt, letztlich von dem Helden Theseus getötet wird. Der realhistorische Hintergrund der Erzählung könnte die Eroberung Kretas durch kriegerische Bewohner des griechischen Festlandes gewesen sein, denn das Ende der blühenden Kultur der Insel kam plötzlich und gewaltsam: Um 1400 ging die minoische Kultur in einer Katastrophe unter und der Aufstieg Mykenes begann.

Sumer, die Heimat der Doppelaxt

Aus einer Hymne für Inanna

> Ich sage, Gepriesen seist Du (Hail), zu Inanna, Erste Tochter des Mondes!
> Die jungen Männer, die Reifen tragen, singen zu Dir.
> Die jungen Frauen und die frisierten Priesterinnen treten vor Dich hin.
> Sie tragen das Schwert und die Doppelaxt.
> Die heraufkommenden *kurgarra*-Priester erheben Ihre Schwerter vor Dir.
> Der Priester, der sein Schwert mit Blut bedeckt, versprengt Blut,
> Er versprengt Blut über den Thron des fürstlichen Gemachs.
> Die *tigi*-Trommel, die *sem*-Trommel und die *ala*-Tamburine erschallen!

Mykene

Während Kreta mit seinen offenen Palästen, unbefestigten Ortschaften, jugendlichen Stierspringern, Göttinnen und Priesterinnen den Eindruck einer heiteren, unbeschwerten Kultur machte, trug das bronzezeitliche Mykene (1600 bis 1400 v. Chr.) ein ganz anderes, ein kriegerisches Gepräge. Vor allem die aufwendigen Schachtgräber mit ihren reichen Beigaben, darunter nicht nur wertvoller Goldschmuck und Gefäße, sondern vor allem auch Waffen sowie bildliche Darstellungen von Streitwagen machen die Bedeutung des kriegerischen Elementes dieser Kultur deutlich. In einer weiteren Hinsicht

sind diese Schachtgräber aufschlussreich. Im Gegensatz zu Kreta mit seinem Seehandel und einer blühenden Landschaft verfügte Mykene weder über einen Hafen noch über ein fruchtbares Hinterland, das als Grundlage für den angehäuften, in den Gräbern zutage tretenden Reichtum hätte dienen können. Das Vermögen Mykenes dürfte demnach seinen Ursprung am ehesten in kriegerischen Auseinandersetzungen gehabt haben.

Rund 200 Jahre später hatten sich aus den ersten Siedlungen Machtzentren mit regelrechten Festungen entwickelt: Burgen in Mykene selbst, in Tiryns oder Athen, mit zyklopischen Mauern, deren Errichtung so unverhältnismäßig aufwendig gewesen sein muss, dass ihre Aufgabe nicht nur die der effektiven Verteidigung, sondern auch der selbstbewussten Darstellung von Macht gewesen sein muss (man erinnere sich an die *costly signaling*-Theorie). Die mächtigen Herrscher in diesen Burgen ließen sich mit unvorstellbarem Pomp bestatten, wie die reichen Tholosgräber mit mehreren Kammern für die Bestattung selbst und für begleitende Kulthandlungen belegen; ein Beispiel ist das sogenannte Schatzhaus des Atreus in Mykene.

Während der folgenden Jahrhunderte wurden diese Machtzentren weiter ausgebaut, die wie auf Kreta als Verwaltungszentren und der Vorratshaltung dienten (so die Paläste von Tiryns und Pylos, die jeweils eine Region beherrschten). Viele Machtzentren lassen sich im Übrigen mit den in der homerischen *Ilias* genannten Orten identifizieren. Obwohl die Palastanlagen deutlich kleiner als ihre kretischen Vorbilder waren, zeigte ihre Innendekoration mit Fresken und bemalten Stuckfußböden deutliche Anklänge an kretische Vorbilder; darunter befinden sich Damen mit sorgfältig frisiertem Haar und gestuften Röcken.

Auch der Kultus hatte in unmittelbarer Nähe der Paläste seinen Platz: In Mykene fand sich bei Gräbern ein Kultgebäude mit einem Raum, der als „Raum mit dem Fresko" bekannt wurde. Hier waren in der Mitte des Raumes eine Herdstelle, eine altarähnliche Bank unterhalb des Freskos sowie der Elfenbeinkopf eines jungen Mannes, der ursprünglich auf einem Holzkörper befestigt gewesen sein dürfte. Der Hauptraum der Kultstätte barg eine grob modellierte weibliche Tonfigur. Dahinterliegende Vorratsräume enthielten Figurinen beiderlei Geschlechts mit erhobenen Armen, bei denen es sich wahrscheinlich um Votivfiguren handelt. Opfer in Form von Schmuck und anderen Gaben, die man auf die Bänke und Altäre legte, gehörten nachweislich zu den Kulthandlungen.

Wie der Kultus in Mykene im Einzelnen ausgesehen haben könnte, entzieht sich letztlich unserer Kenntnis. Allerdings geben die in Linear B beschrifteten Tontäfelchen Auskunft, die bei der Zerstörung der mykenischen Kultur, in deren Zuge auch die Burgen in Flammen aufgingen, gebrannt wurden. So werden in Pylos neben anderen Göttern auch Zeus und Poseidon erwähnt, von denen vor allem der letztere große Bedeutung hatte. Sein Heiligtum in der Stadt war Emp-

fänger regelmäßiger Abgaben und eine Zeremonie, das „Bereiten des Betts", deutet auf eine heilige Hochzeit hin: In historischer Zeit spielte die Heilige Hochzeit (*hieros gamos*) von Poseidon mit Demeter Erinys (der zürnenden Demeter) eine wichtige Rolle im Kult. Möglich wäre jedoch auch die Hochzeit des Gottes mit einer Sterblichen, der Gattin des Herrschers, zur Legitimierung der Herrschaft.

Weitere Gottheiten, so die Göttinnen Diwija und Posidaeja, haben jeweils eigene Kulte und Kultorte, während die Göttin des Hauptheiligtums in Pylos lediglich als Potnia (Herrin) bekannt ist. Als die Burgen der mykenischen Zeit um 1200 v. Chr. – durch das gewaltsame Eindringen von Seevölkern – untergingen, existierten im griechischen Weltbild zahlreiche Götter, die in verschiedenen, ihnen gewidmeten Heiligtümern verehrt wurden: Ein Polytheismus im wahrsten Sinne des Wortes war mittlerweile zur allseits verbreiteten Religionsform geworden.

Zeittafel

um 3000 v. Chr.:
* älteste Burgen von Troja entstehen; Troja I mit Megaronhäusern, Troja II, das in einer gewaltigen Feuersbrunst untergeht

um 2500 v. Chr.:
* Anfänge der kretisch-minoischen Kultur auf Kreta
* Palastanlagen in Knossos und Phaistos
* Sage vom Labyrinth des Stiergottes Minotaurus
* Linear A (bis heute nicht entziffert)

um 1700 v. Chr.:
* Zerstörung der kretischen Paläste durch Erdbeben
* Neubau und naturalistisches Kunsthandwerk
* Prozessionen und Stierspiele
* Verehrung lokaler, überwiegend weiblicher Gottheiten

um 1600 v. Chr.:
* Schachtgräber von Mykene mit Goldbeigaben im minoischen Stil
* Übernahme der kretischen Schrift (Linear B)

um 1400 v. Chr.:
* Zerstörung der Palaststädte Kretas, Ende der minoischen Kultur
* Hochblüte der mykenischen Kultur

um 1300 v. Chr.:
* Burganlagen (Mykene, Löwentor und Tyrins), Monumentalbauten, Kuppelgräber (Schatzhaus des Atreus in Mykene) als Totenkult für Herrscher

um 1200 v. Chr.:
* Seevölkersturm, Untergang der mykenischen Kultur
* um 1150 v. Chr.
* Untergang von Troja VIIa (historisches Vorbild des trojanischen Krieges?)

um 900 v. Chr.:
- Vorrang des kriegerischen Adels
- Religion der olympischen Götter
- Orakel von Dodona und Delphi
- Heldenepen Homers mit *Ilias* und *Odyssee*
- Entstehung der Stadtstaaten (Poleis)

um 800 v. Chr.:
- Niedergang
- Fehden, Willkürherrschaft des Adels, Ruf nach Gerechtigkeit und Ordnung
- Dichtung des Hesiod (Götterlehre, Lob der Landarbeit)

um 776 v. Chr.:
- Beginn der olympischen Spiele beim Heiligtum des Zeus in Olympia
- Gesetzgebung Lykurgs im dorischen Sparta; die Vollbürger Spartas tragen das neugestaltete Kriegswesen
- Geburt der Idee des Staates auf der Basis gleichberechtigter Bürger
- Heldenepen Homers mit *Ilias* und *Odyssee*

ab 740 v. Chr.:
- erste deutliche Hinwendung der Kunst zur Persönlichkeit

seit 650 v. Chr.:
- ehrgeizige Adlige erheben sich an der Spitze der Unzufriedenen zu Tyrannen

um 530 v. Chr.:
- Gegenbewegung: Forderung nach einem Rechtsstaat freier Bürger
- Entstehung der griechische Mysterienreligionen
- Kult des Apollo von Delphi (Forderung nach Reinheit und Maßhalten)

594 v. Chr.: Gesetzgebung des Solon

um 570 bis ca. 470 v. Chr.:
- Xenophanes kritisiert anthropomorphe und unethische Göttervorstellungen

508/507 v. Chr.:
- in Athen erhalten Lohnarbeiter (Theten) Zutritt zur Volksversammlung (Ekklesia) und zum Geschworenengericht (Helasia)
- Beginn der Blütezeit Griechenlands

500 bis 338 v. Chr.:
- Zusammenstöße mit dem persischen Weltreich
- Athen tritt unter Perikles an die Spitze Griechenlands; Folge: Auseinandersetzungen mit Sparta und Korinth im Peloponnesischen Krieg; am Ende geht das makedonische Königshauses als Gewinner aus den innergriechischen Streitigkeiten hervor

428/427 bis 348/347 v. Chr.:
- Platon stellt die Vernunft als göttlichen Teil der menschlichen Seele heraus
- 384 bis 322 v. Chr.:
- Aristoteles, der Erzieher Alexanders des Großen, fasst die Gottheit als reine Form (Geist), frei von jeder Materie auf

Abb. 12.4 Heinrich Schliemann, der Ausgräber Trojas. (© Library of Congress)

Heinrich Schliemann und das homerische Zeitalter

Als Heinrich Schliemann (1822–1890; Abb. 12.4) in den Jahren 1870 bis 1873 Troja ausgrub, war er der festen Überzeugung, das Troja Homers gefunden zu haben, und belegte seine Fundplätze und Fundstücke mit den Namen aus dem berühmten Epos. Schliemann, Sohn eines mecklenburgischen Pfarrers, war bereits als Kind fasziniert von den Helden der *Ilias*. Schicksalsschläge und die Notwendigkeit, sich schon früh seinen Lebensunterhalt verdienen zu müssen, machten jedoch zunächst jede Vorstellung von einem Leben als Wissenschaftler zunichte. Erst nachdem es Schliemann gelungen war, ein großes Vermögen zu erwerben, ging er an die Verwirklichung seines Kindheitstraumes. 1864 begann er in Paris mit dem Studium der Altertumswissenschaft und unternahm bereits vier Jahre später eine erste Studienreise nach Griechenland, um nach den legendären, in der *Ilias* beschriebenen Stätten zu suchen (der Bericht über diese Reise trug ihm einen Doktortitel ein). Im Frühjahr 1870 begann Schliemann mit ersten Grabungen am Hügel Hisarlık, unter dem zeitgenössische Wissenschaftler das antike Troja vermuteten, die nach einigen bürokratischen Hindernissen von Seiten der türkischen Behörden im Herbst des folgenden Jahres erfolgreich fortgesetzt wurden. Während der zweiten Grabungskampagne 1872 machte Schliemann einen geradezu fantastischen Fund, der allerdings in eine sehr viel spätere Zeit datierte: die

berühmte Heliosmetope vom Triglyphenfries des hellenistischen Athenatempels. Den Höhepunkt der Grabung stellte jedoch im folgenden Jahr die Entdeckung eines bronzezeitlichen Stadttores dar. Es war über eine breite Straße mit einem Haus verbunden, in dessen unmittelbarer Umgebung dann noch ein großer Goldschatz gefunden wurde. Schliemann, der der Überzeugung war, das homerische Troja gefunden zu haben, identifizierte das Tor als das skäische Tor der *Ilias*, das Haus als Palast des Priamos und den Goldfund als Schatz dieses legendären trojanischen Herrschers.

Schliemann, besessen von den Geschichten um den trojanischen Krieg, setzte im Sommer 1876 seine Forschungen in Mykene fort, wo er im selben Jahr auf prunkvolle Gräber stieß, die er als das Grab des Agamemnon und seiner Familie identifizieren zu können glaubte.

Schliemann irrte, was die Details anbelangt. Zwar hatte er der Wissenschaft unschätzbare Dienste erwiesen, indem er zum ersten Mal außerhalb Ägyptens bronzezeitliche Siedlungen ausgegraben hatte, ob es sich aber wirklich um das in Homers Epos besungene Troja handelt, wird heute stark bezweifelt, denn von der sogenannten geometrischen Zeit des Dichters Homer trennen Schliemanns Funde rund 1700 Jahre! Tatsächlich besteht der Hisarlıkhügel aus neun Schichten, die die Besiedlung Trojas über 3000 Jahre und in 40 Bauphasen widerspiegeln. Schliemanns spektakulärer Schatzfund datiert aus der Siedlungsschicht Troja II (ca. 2600 bis 2450 v. Chr.). Aus kretischer und mykenischer Zeit stammt hingegen Troja VI (ca. 1700 bis 1250 v. Chr.), das 1893 bis 1894 von Schliemanns Mitarbeiter und Nachfolger Wilhelm Dörpfeld (1853–1940) ausgegraben wurde. Zeitlich kommt Troja VI damit eher als Troja des Priamos infrage, jedoch wurde diese Siedlung nicht durch Krieg oder Brand, sondern durch ein Erdbeben schwer beschädigt, während die wiederaufgebaute Siedlung (Troja VIIa; ca. 1250 bis 1150 v. Chr.) tatsächlich durch einen Brand zerstört wurde. Etwa um das Jahr 1000 v. Chr. verfiel jedoch auch Troja VII und es kam zu einer Siedlungsunterbrechung von rund 250 Jahren. Erst in der zweiten Hälfte des achten Jahrhunderts vor Christus – zu Lebzeiten Homers – erfolgte eine Neubesiedlung durch kleinasiatische Griechen, die die imposanten, zweifellos die Vorstellungskraft anregenden Ruinen des älteren Troja in die neu errichteten Haus- und Festungsmauern einbezogen.

Aber zurück zu dem Dichter, der Schliemann so sehr beeindruckt hatte, dass er sein ganzes Leben der Erforschung des griechischen Altertums widmete: Homer. Der Dichter der Epen *Ilias* und *Odyssee* wurde als Sohn einer gewissen Kreitheïs in Smyrna geboren und zog möglicherweise als Wandersänger von Hof zu Hof. Der von ihm bearbeitete literarische Stoff bestand aus Erzählungen über Ereignisse der kretisch-mykenischen Epoche, die offensichtlich über mehrere Jahrhunderte mündlich tradiert worden waren und

nun das Material für eine eigenständige Dichtung lieferten – eine Dichtung, die bereits auf ein Repertoire an festen Formeln zurückgreifen konnte. Die Epen Homers sind daher als die Neugestaltung und Zusammenfassung verschiedener Stoffe aufzufassen, die selbst wiederum auf eine lange eigenständige Tradition zurückblicken konnten. Inhaltlich geht es in der *Ilias* um einen Streit zwischen Achilleus und Agamemnon, Heerführer der Griechen im Krieg gegen das kleinasiatische Troja, in den die Götter eingreifen – einmal auf Kosten der einen, dann der anderen Seite. Damit werden die Auseinandersetzungen der Helden um Ehre, Ruhm, Reichtum und nicht zuletzt auch um schöne Frauen in einen höheren Sinnzusammenhang gestellt: Es sind letztlich die Götter und ihr oft genug von einer willkürlichen Emotion hervorgerufener Ratschluss, von denen das Schicksal des Menschen abhängt.

In der Geschichte, die Homer vor seinen Zuhörern entwickelt, ist es die Meeresgöttin Thetis, die von Zeus Gerechtigkeit für ihren Sohn Achilleus fordert und damit den vorläufigen Sieg der Troer herbeiführt. Aber auch die anderen Götter greifen immer wieder auf verschiedenen Seiten in das Kampfgeschehen ein, das in der Schilderung des Zweikampfes zwischen Hektor und Achilleus einem Höhepunkt zustrebt. Während Hektor von dem Gott Apollon unterstützt und gestärkt wird, eilt Athena Achilleus zur Hilfe und bewirkt seinen Sieg, muss sich aber Apollon beugen, wenn es um die Herausgabe des Leichnams von Hektor an seinen Vater Priamos geht.

Neben Homer war es der vermutlich aus Böotien stammende Dichter Hesiod, dem die Griechen ihren Götterhimmel verdankten. In seiner Dichtung, vor allem in seinem Epos *Theogonie*, entwarf er ein Bild von der Entstehung der Welt und des Göttergeschlechts, in der die Anderswelt nun von einem polytheistischen Pantheon großer Göttergestalten beherrscht wurde, die ihre Existenz wiederum Vorgängen in mythischer Urzeit zu verdanken hatten, in denen eine große Göttinnengestalt, Gaia, die entscheidende Rolle spielte.

Homers und Hesiods übermächtige Gestalten eines regelrechten Götterhimmels wurden in Griechenland auf den Olymp und in die kleinasiatische Landschaft Troas in das Gebirge Ida versetzt, jene hohen Berge, deren wolkenverhangene und damit den Blicken der Menschen entzogene Gipfel als Wohnort von Göttern nur zu gut vorstellbar sind. Religionsgeschichtlich knüpft der Aufenthalt von Göttern auf einem Berg nahtlos an ältere Vorstellungen an, bei denen Wesen mit übermenschlichen Fähigkeiten – letztlich Verstorbene – in oder auf Bergen (Hügelgräbern) oder Höhen lokalisiert wurden; Wesen, die zu einer bestimmten Person in einem Schutzverhältnis standen, das sich in Homers *Ilias* in der Parteinahme der einzelnen Göttinnen und Götter für bestimmte Personen noch deutlich niederschlägt. Die Götter blieben also weiterhin Teil der irdischen Sphäre, und das nicht nur bezüglich ihrer Wohnstätte, sondern vor allem auch hinsichtlich ihres Verhaltens. Immer wieder

interagieren sie im Epos mit den Menschen, sei es, dass ein Sterblicher wie Paris ein Urteil von besonderer Bedeutung fällt, dass es die doch eigentlich überlegenen Götter entzweit, sei es, dass sie direkt in das Kriegsgeschehen eingreifen oder sich dem Menschen in menschlicher Gestalt nähern. Letzteres geht so weit, dass Götter und Menschen miteinander Kinder zeugen, die sowohl der göttlichen als auch der menschlichen Sphäre angehören können: Die göttliche Thetis ist Mutter des menschlichen Achilleus, die menschliche, von Zeus geschwängerte Semele Mutter des göttlichen Dionysos, während die ebenfalls von Zeus schwangere Europa dem späteren menschlichen König Minos das Leben schenkt.

Homers große Epen und die Dichtungen des Hesiod entstanden zu Beginn einer Zeit, die auf das sogenannte Dunkle Zeitalter, die Zeit nach dem Untergang der mykenischen Kultur, folgte. In dieser Zeit entwickelte sich nach und nach ein sehr spezifisches System der politischen und gesellschaftlichen Organisation. Gekennzeichnet durch den Wettbewerb adeliger Familien um Macht auf der einen Seite und die prekäre Lage der Bauern auf der anderen entstand in den Stadtstaaten mit Unterstützung des Volkes entweder eine Tyrannis, die jedoch immer von der Unterstützung der Bevölkerung abhängig blieb, oder ein Gemeinwesen mit schriftlich niedergelegtem Recht und institutionalisierter Herrschaft, das die Grundzüge einer frühen Demokratie zeigte. Die Stadtstaaten – Poleis – dieser Epoche blieben nicht nur selbstständig, sondern standen in regem und aggressivem Wettbewerb, wovon die zahlreichen Kriege dieser Zeit beredtes Zeugnis ablegen. Die gegensätzlichen Interessen der konkurrierenden Poleis wurden zumindest in weltanschaulicher Hinsicht durch die großen Dichtungen von Homer und Hesiod überbrückt und schufen damit ein Gefühl kultureller Zusammengehörigkeit. Anders ausgedrückt: Trotz aller politischen Gegensätze, die sich in den häufigen kriegerischen Auseinandersetzungen zwischen den Stadtstaaten Griechenlands deutlich zeigten, gab es einen gemeinsamen weltanschaulichen Hintergrund, der sich in der Dichtung der archaischen Zeit niederschlug und den Griechen bei allen Unterschieden der einzelnen lokalen Kulte eine gemeinsame Religion bescherte (wobei manche der Kulte so berühmt waren, dass sie eine weit über die regionalen Grenzen herausreichende Bedeutung entfalteten; siehe das Apolloheiligtum zu Delphi).

Die Philosophie

Neben ihrem literarischen und historischen Wert war es das Verdienst der großen Epen, dass sie trotz des Persistierens einer unübersehbaren Vielzahl von Göttern, unterschiedlicher Kulte und Kultpraxen den Griechen einen

einheitlichen Götterhimmel, den eigentlichen Polytheismus beschert hatten. Das, was noch zur Bronzezeit, also jenem Zeitalter, dessen materielle Hinterlassenschaften Schliemann ausgraben konnte, ursprünglich Schutzgottheiten einer Stadt und ihres Herrschaftsbereiches waren (auch Delphi, ursprünglich ein Heiligtum der Gäa – griech. *delphys* gleich Gebärmutter – war zunächst das Heiligtum der Stadt Kirrha) wurde nun zusammengefasst, in einen inhaltlichen Zusammenhang gebracht und hierarchisiert. Gerade dies macht deutlich, dass sich bereits zu Homers und Hesiods Zeiten in der Religion ein rationales Element zeigte – eben die Suche nach Zusammenhängen zwischen den einzelnen Kulten und der Wille zur Systematisierung –, das in den nachfolgenden Jahrhunderten immer mehr an Raum gewann und letztlich den mythischen Teil der Religion zugunsten rationaler Überlegungen verdrängte.

Gerade weil die griechische Form der Religion so viele Optionen hinsichtlich der zu verehrenden Gottheit und des Kultes einschließlich der sogenannten Mysterienkulte bot und unterschiedlichste Vorstellungen über die Herkunft von Göttern und Menschen pflegte, stellte sich die Religion selbst in den Mittelpunkt weltanschaulicher Spekulationen, und dies führte im Gefolge auch zur Kritik an einem Götterhimmel, wie Homer und Hesiod ihn entworfen hatten. So kritisierte als erster Xenophanes (ca. 570 bis ca. 470 v. Chr.) das Verhalten der Götter von einem ethischen Standpunkt aus und bemängelte den Anthropomorphismus der Göttervorstellungen:

> Wenn Kühe, Pferde oder Löwen Hände hätten und damit malen und Werke wie die Menschen schaffen könnten, dann würden die Pferde pferde-, die Kühe kuhähnliche Götterbilder malen und solche Gestalten schaffen, wie sie selber haben. (Heitsch 1994)

Die ethische Kritik an den landläufigen Göttervorstellungen wurde vor allem von Platon (428/427 bis 348/347 v. Chr.) aufgenommen. In einem seiner frühen Dialoge, *Euthyphron*, legt er dem jungen Mann, der seinen Vater verfolgt, als Entschuldigung das Verhalten des Gottes Zeus in den Mund, der ja seinen Vater Chronos in Ketten gelegt habe. In seinem Spätwerk *Politeia* kritisiert er dann generell die von Hesiod entworfene Geschichte der Götter einschließlich der Kriege, die sie gegeneinander führen. Diese Geschichten seien unwahr und nicht geeignet als weltanschaulicher Hintergrund für die Wohlfahrt von Staat und Familie. Entscheidend sei vielmehr die Orientierung an der Tugend der Vernunft, die zu kultivieren Aufgabe der Herrschenden im Staat sei – diese Herrschenden sind nach Platon idealerweise die Philosophen. Dabei markiert die Vernunft für Platon den göttlichen Teil der unsterblichen menschlichen Seele, und ihr Streben nach Einsicht ist damit auf die Idee des Guten ausgerichtet (die in den Gleichnissen Platons, z. B. im berühmten

Höhlengleichnis, mehrfach durch die Sonne symbolisiert wird). Platon hielt also an der Vorstellung eines Weiterlebens der Seele nach dem Tod fest, die er der Sphäre des Göttlichen (*nous*) zurechnete, ebenso wie er im Dialog *Timaios* auch von einer Weltschöpfung durch einen Demiurgen (wörtl. Handwerker) ausging, der die Welt gemäß der Vernunft nach dem Vorbild ewiger Ideen planvoll gestaltet habe.

Aristoteles (384 bis 322 v. Chr.) dagegen nahm an, dass man ursprünglich die Himmelskörper als Gottheiten angesehen habe und der Auffassung gewesen sei, die gesamte Natur sei von Göttlichem durchdrungen. Alle weiteren Geschichten und Mythen seien dann gesponnen worden, um die Menschen zu beeindrucken und zu beeinflussen. Allerdings war Aristoteles' Kritik an der Religion oder vielmehr an einer allzu anthropomorphen Auffassung vom Göttlichen – er verstand Gottheit als reine Form, frei von aller Materie, bzw. reinen Geist – für ihn selbst mit den altüberlieferten Formen von Verehrung durchaus vereinbar, denn noch in seinem Testament verfügte er, dass zu Ehren der Götter Zeus und Athene zwei Statuen als Dank für die glückliche Heimkehr seines Adoptivsohnes errichtet werden sollten.

Die Kritik der Philosophen an den homerischen und hesiodschen Göttervorstellungen war also in jener Zeit auch für die Philosophen selbst noch kompatibel mit dem altüberlieferten Kult (eine Ausnahme stellten die Cyniker dar, eine philosophische Schule in der Nachfolge des Diogenes von Sinope, [ca. 400 bis 325 v. Chr.], die niemals an kultischen Handlungen teilnahmen). Für Aristoteles allerdings verdankte das Universum selbst seine Existenz einem einzigen höchsten Wesen, das, obwohl selbst unbewegt, für jede Bewegung im Universum verantwortlich war und damit den Urgrund allen Seins darstellte.

Als sich in den ersten Jahrhunderten unserer Zeitrechnung das Christentum im Mittelmeerraum ausbreitete und dabei in Kontakt mit den antiken philosophischen Lehren geriet, verschmolzen christliches und antikes Gedankengut, ein Prozess, der in der Forschung als „Hellenisierung des Christentums" beschrieben wird. Dabei konnten die Kirchenväter durchaus an platonisches und aristotelisches Gedankengut anschließen, fanden sich doch im Werk beider Philosophen Lehren, die sich mit dem christlichen Monotheismus verbinden ließen. So wurde der christliche Gott als Weltenschöpfer sowohl mit dem Demiurgen Platons als auch mit dem unbewegten Beweger des Aristoteles assoziiert, ebenso wie sich auch die platonische Idee des absolut Guten und die immaterielle Seinsform der Gottheit im aristotelischen Werk als Wesensbestimmungen des christlichen Gottes eigneten.

Mit den beschriebenen Grundlinien der christlichen Rezeption der antiken Philosophie haben wir bereits Vorstellungen erreicht, die bis heute unser Bild von Religion nachhaltig prägen. Um die Entwicklung bis hierher aber

zumindest in den Grundzügen nachvollziehen zu können, ist es notwendig, auch den Ursprüngen des Christentums und der übrigen abrahamitischen Religionen im Vorderen Orient nachzugehen. Dies soll der Gegenstand des abschließenden Kapitels auf unserer Zeitreise von den ersten Ursprüngen bis zu den heutigen Religionen sein.

13
Der Gott Israels

Und was war im Orient?

Die hier (vgl. Kap. 12) beispielhaft für das neolithische Griechenland skizzierte Entwicklung, angefangen von einer egalitären Gesellschaft von Jägern und Sammlern über frühe Ackerbauern bis zur stratifizierten Gesellschaft der Bronze- und Eisenzeit, einschließlich der massiven Veränderungen des Weltbildes, hat ganz ähnlich, aber deutlich früher im Vorderen Orient stattgefunden. Während sich die Bewohner von Göbekli Tepe noch mithilfe des charakteristischen Repertoires an apotropäischen Bildern vor Übergriffen möglicherweise feindlicher Nachbarn schützten, fanden nur unwesentlich später sowohl im südöstlichen Anatolien als auch in der Levante Hausbestattungen einschließlich der Deponierung teilweise dekorierter Schädel statt, um auf diese Weise auf die Legitimität ererbten Territorialbesitzes hinzuweisen. Im ersten Fall fanden die Bestattungen und Deponierungen in einem Sondergebäude statt, erfolgten also von Beginn an kollektiv (in Çayönü Tepesi). Schon früh galten die Orte kollektiver Begräbnisse als heilig, denn bei ihrer Aufgabe wurden auch sie regelrecht bestattet, also einer profanen Nutzung entzogen. Im ausgehenden Chalkolithikum kann dann ein Gemeinschaftsgebäude möglicherweise schon als regelrechter Tempel angesprochen werden. In Tepe Gaura (3500 bis 2900 v. Chr.), in unmittelbarer Nachbarschaft des heutigen Mossul im Nordirak gelegen, standen drei große Sondergebäude, die bereits die für spätere mesopotamische Tempel typische Nischen-Pfeiler-Dekoration zeigten, allerdings noch keinen Altar hatten, um einen offenen Platz.

In sumerischer Zeit haben sich dann erste Stadtstaaten gebildet – naturräumliche Voraussetzung war ein Klimawandel und damit das Trockenfallen fruchtbaren Schwemmlandes –, in deren Zentrum sowohl in politischer als auch religiöser Hinsicht der Tempel eines Stadtgottes stand. Die weltanschaulichen Vorstellungen der Bewohner dieser Städte waren von der Stadt als solche insofern geprägt, als die zeittypischen Kosmogonien davon sprechen, dass Vater- und Muttergötter in einer Urstadt auf dem heiligen Hügel lebten, wo sie dann den Himmelsgott und den Stadtgott hervorbrachten. Im Detail aber waren sowohl die Götter als auch ihre Mythologien noch von Stadt zu Stadt

völlig unterschiedlich. Jede Stadt hatte ihre eigene Stadtgottheit und ihren eigenen Mythos. Erst in der frühdynastischen Periode der sumerischen Geschichte (um 2750 bis 2276 v. Chr.), als es dem nordbabylonischen Stadtstaat von Kiš gelang, die Vorherrschaft zu erlangen, wurden die unterschiedlichen konkurrierenden Mythen uminterpretiert und zu einem Reichsmythos verwoben. Dadurch ließ allerdings die bis dahin noch sehr persönliche Beziehung der Stadtbewohner zu ihrer Gottheit, von der man annahm, sie wohne innerhalb der Stadt in ihrem Tempel, immer mehr nach, bis die Bevölkerung letztlich nur während der großen Kultfeste mit ihrer Gottheit in Kontakt trat.

Obwohl natürlich im Detail von den jeweiligen naturräumlichen, ökonomischen und politischen Faktoren geprägt, verlief die Entwicklung der Religionsgeschichte Mesopotamiens grundsätzlich ähnlich wie die in Westanatolien und auf dem Balkan. Nur die ausgeprägten häuslichen Kulte um die Toten, wie sie für das Neolithikum Mittel- und Westanatoliens, Südosteuropas und Griechenlands typisch waren, fehlen hier. Stattdessen wurde bereits in frühester Zeit kollektiv in Sondergebäuden bestattet, und weitere Sondergebäude dienten gemeinsamem Ritualhandeln und Kult. Daraus entwickelte sich dann in religionsgeschichtlicher Hinsicht der Tempel, der, immer und immer wieder überbaut, zuletzt zum Kennzeichen mesopotamischer Religion wurde: die Zikkurat (Himmelshügel).

Aber nicht die Religionsgeschichte Mesopotamiens oder des Vorderen Orients ist hier von Interesse, darum zurück zur eigentlichen Fragestellung, wie nämlich aus biologischen Dispositionen des Menschen im Lauf der Jahrtausende zunächst die Vorstellung von übermächtigen Toten, dann von Göttern entstand, die zuletzt zumindest lokal in einen Monotheismus mündete. Für diesen letzten Schritt wenden wir uns dem Gebiet zu, das bis heute als wichtigster Ort der drei monotheistischen Weltreligionen gilt: Jerusalem und seine Umgebung.

Die Entstehung Judas und Israels

Gegen Ende der Bronzezeit hatten sich im östlichen Mittelmeerraum und im Vorderen Orient territoriale Einheiten etablieren können, darunter die Stadtstaaten der Philister an der südlichen Küste Palästinas, die eine vorübergehende Schwächeperiode des ägyptischen Reiches nutzten, um ihren Einflussbereich zu vergrößern. Aber auch einige alte kanaanäische Städte wie Meggiddo erlebten eine kurze Nachblüte. Zu dieser Zeit, vom 14. bis zum 10. vorchristlichen Jahrhundert, war das unter ägyptischer Oberhoheit stehende Bergland von Juda nur dünn besiedelt. Es gab einige wenige Dörfer, zu denen auch Jerusalem gehörte, und keiner dieser Orte war befestigt. Bei der loka-

len Bevölkerung handelte es sich um eine dimorphe Mischbevölkerung aus Bauern und Hirten, die in Stammesgemeinschaften organisiert war und nur zu oft unter lokalen Potentaten oder hohen Steuern litt. Aus dieser Schicht rekrutierte sich dann nach und nach ein Sozialbanditentum, das außerhalb des offiziellen Machtapparates operierte – die Apiru (Hebräer?). Der biblische König David, der in Erzählungen mythisch überhöhte Begründer eines Königgeschlechtes und Ideal des guten Königs, war möglicherweise der Anführer einer solchen Räuberbande, die sich auch als Söldner verdingten – der biblische Bericht von David, der Dörfer rettete oder bei den Philistern Schutz vor Verfolgung suchte, passt in dieses Bild. Um 900 v. Chr. muss ein solcher erfolgreicher Hasardeur (namens David?) die Herrschaft in Jerusalem an sich gerissen und Jerusalem zum Mittelpunkt seines Stammesverbandes gemacht haben. Der Ausbau zu einer großen Festung und die Entwicklung Jerusalems zu einem kulturellen Zentrum mit überregionaler Ausstrahlung erfolgten jedoch erst im Lauf der kommenden Jahrhunderte.

Während Juda im zehnten Jahrhundert ein entlegenes und unwirtliches Bergland war, blühten die nördlichen, fruchtbaren Gebiete Kanaans auf. Zunächst wurde die Stadt Gibeon im nördlichen Bergland zum Herrschaftssitz eines weiteren mächtigen Stammesverbandes. Zu Beginn des neunten Jahrhunderts betrat zum ersten Mal ein Potentat die Bühne, der auch aufgrund nichtbiblischer Quellen historisch fassbar ist: 874 ergriff Omri die Macht, errichtete seine Hauptstadt im Bergland von Samaria und gründete die Dynastie der Omriden. Inschriften auf Stelen der Assyrer und Moabiter bezeugen, dass zu dieser Zeit, also im neunten vorchristlichen Jahrhundert, ein Reich Israel unter den Omriden existiert haben muss (Abb. 13.1), das über befestigte Städte und eine immerhin so große Streitmacht verfügte, dass es sowohl nach Aram-Damaskus als auch nach Moab expandieren konnte und sich zumindest für eine gewisse Zeit, nach biblischen Quellen zur Zeit des Davididen Josaphat (868 bis 847 v. Chr.), Juda als Vasallenstaat unterwerfen und anschließend durch Heirat an sich binden konnte.

Während der Herrschaft Israels blühte Juda auf, und auch für Jerusalem finden sich Spuren einer ersten bemerkenswerten Bautätigkeit. Funde aus Grabungen in der sogenannten „David's City" unterhalb des heutigen Tempelberges lassen vermuten, dass hier ein großer, herrschaftlicher Verwaltungskomplex im Stile Samarias errichtet worden war. Im weiteren Verlauf der Geschichte sank der Stern Israels, während Juda zunächst von den veränderten Kräfteverhältnissen profitieren konnte. Es war das assyrische Großreich, das Israel zunächst zum Vasallen machte (ab 738 v. Chr.), dann aber nach einem Aufstand zunächst seiner nördlichen Landstriche (Galiläa) beraubte (ab 733 v. Chr.) und zuletzt auch das Kernland Samaria unterwarf und seine Bevölkerung verschleppte (722 v. Chr.).

Abb. 13.1 Die Königreiche Israel und Juda 900 v. Chr

Die Geschichte Judas und seiner Religion

Durch die Zerschlagung des nördlichen Konkurrenten gewann Juda, das sich rechtzeitig dem Schutz der Assyrer unterstellt hatte, als politisches Zentrum einerseits, als Teil im großen Wirtschaftsgefüge Assurs andererseits, eine nie gekannte Bedeutung. Mit dem wirtschaftlichen Aufschwung und Fernhandel hielt auch die Schrift Einzug in die einst abgelegene Hauptstadt einer öden Bergregion, und die bis dahin mündlich weitergegebenen Hofgeschichten einschließlich ihrer mythischen und historischen Könige und ihrer menschlichen Verstrickungen wurden nun zum ersten Mal schriftlich fixiert. Ein Strom von Flüchtlingen – die Bevölkerung Judas verdoppelte sich in der fraglichen Zeit – aus den von den Assyrern eroberten Gebieten siedelte sich nun in Juda an und brachte sein Traditionsgut in das allgemeine Geschichtswerk ein. Um diese heterogene Bevölkerung auch in ideologischer Hinsicht zu einen, stärkte man die Zentralautorität auf Kosten der ländlichen clanorientierten Führungsstrukturen und verbot alle lokalen Kulte: Archäologische Re-

likte belegen die Existenz der üblichen Stadtheiligtümer und Kultplätze noch im achten vorchristlichen Jahrhundert in Städten wie Arad im Beerschebatal, in Tell Beerscheba, in Lachisch oder Bethel (letzteres auf assyrischem Gebiet), die dann aber nicht etwa brutal zerstört, sondern sorgfältig zurückgebaut und eingeebnet wurden. Jerusalem war nun also nicht mehr nur die politische Hauptstadt Judas, sondern mit seinem Tempel gleichzeitig (einziger) Kultmittelpunkt dieses kleinen Staates.

Der salomonische Tempel, wie er laut biblischer Überlieferung ausgesehen haben soll

Der salomonische Tempel ist dreiteilig aufgebaut und besteht aus Vorhalle (*ulam*), Langhaus (*hekal*) und einem darin eingelassenen Schrein (*debir*) für das Allerheiligste. Das Langhaus ist von einem dreistöckigen Umgang umgeben. Vor der Vorhalle befinden sich die beiden freistehenden Säulen *Jachin* und *Boas*.

Informationen über den salomonischen Tempel finden sich allerdings ausschließlich in der hebräischen Bibel in 1. Könige 5,15–6,38 und 2. Chronik 1,18–5,1, bei Jeremia 52 und in 2. Könige 25. Archäologische Befunde oder historische Quellen, die belegen, dass der von den Babyloniern zerstörte erste Tempel Jerusalems tatsächlich in dieser Form vom mythischen König Salomo gebaut wurde, gibt es nicht.

In dieser Zeit, wahrscheinlich unter dem zunächst politisch klug agierenden König Hiskia (725 bis 697 v. Chr.), wurden die überlieferten Geschichten aus den beiden Traditionssträngen Israels und Judas miteinander verwoben, um auf diese Weise über eine gemeinsame Geschichte das Zusammengehörigkeitsgefühl der verschiedenen Bevölkerungsgruppen zu stärken und eine gemeinsame Identität auf der Basis der Vorstellung eines geeinten Israel zu schaffen. Das Ende der Regierungszeit Hiskias wurde überschattet von den dramatischen Folgen seines späteren unglücklichen politischen Taktierens –

er hatte einen kurzfristigen politischen Druck auf Assyrien für einen Aufstand genutzt – und erst unter seinem geschickt agierenden Nachfolger Manasse (696/695 bis 642/641 v. Chr.) konnte sich das verwüstete Land langsam erholen.

Manasse setzte, um das nach dem missglückten Krieg gegen Assyrien völlig darniederliegende Land wieder aufzubauen, ganz auf Internationalisierung vor allem hinsichtlich der Handelsbeziehungen bis nach Ägypten und zur arabischen Halbinsel. Die Konsequenz dieser weiten Kontakte war ein Aufweichen der Doktrin von der alleinigen kultischen Verehrung des Nationalgottes im Tempel zu Jerusalem, eine Entwicklung, die von Verlierern der Wirtschaftspolitik Manasses kritisch gesehen wurde und zuletzt in eine erfolgreiche Verschwörung gegen seinen Sohn und Nachfolger Amon mündeten.

Es war vielleicht die alte ländliche Elite, die die Gunst der Stunde nutzte und den achtjährigen Joschija (639 bis 609 v. Chr.) auf den Thron hob – in einer Zeit, in der das assyrische Großreich zerfiel und im Süden ein neu erstarktes Ägypten aufstieg. Dies bedeutete kurzfristig eine Lockerung der Kontrolle Judas durch mächtige Fremdherrscher, die diesem kleinen Staat und seinem Regenten plötzlich eine unerwartete Handlungsfreiheit ermöglichte, die so weit ging, dass Joschija Vorstöße Richtung Norden und Westen wagte und sich das alte Bethel wieder einverleiben konnte. Auch hier fand die Politik wieder ihren Niederschlag in der religiösen Überlieferung: Die vermutlich unter seinem Urgroßvater zum ersten Male als Gesamtwerk schriftlich fixierte und im Dienste einer Staatsideologie stehende Geschichte eines mythischen Gesamtisraels wurde nun noch einmal ergänzt und überarbeitet, wobei man vor allem die fatalen Folgen des Abfalls vom Gott Gesamtisraels, der ja tatsächlich ursprünglich nur der Jerusalemer Stadtgott gewesen war, hervorhob; Geschichten, die in der neuen, nun ergänzten Charakterisierung des legendären Salomo einschließlich der göttlichen Strafe für seine Hinwendung zu fremden Göttern ihren Niederschlag fanden, aber auch einen legitimen Anspruch der davidischen Dynastie auf das Territorium Gesamtisraels untermauerten. In diesem Zusammenhang ist auch die angebliche Entdeckung eines Gesetzbuches, des *Deuteronomiums*(?), durch den Priester Hilkija 622 v. Chr. zu verstehen, das noch einmal die alleinige Verehrung des Jerusalemer Gottes forderte, jede Anbetung fremder Gottheiten aggressiv verbot und den Kult ausdrücklich auf den Tempel in Jerusalem beschränkte. Dieser angebliche Fund und in seiner Folge die Radikalisierung der Staatsideologie Joschijas können als Untermauerung von Gebietsansprüchen gelesen werden, die in den folgenden Jahren zu einer Expansion Judas vor allem in Richtung auf die alten Philisterstädte führten. Gerade dieser Teil der historischen Ereignisse fand seinen Niederschlag in der Überarbeitung der biblischen Darstellung insofern, als sie für Joschija die Möglichkeit bot, sich als den neuen König

Abb. 13.2 David und Goliath. In der Überarbeitung der biblischen Geschichte von David und Goliath zur Zeit von König Joschija stellt sich Joschija als der neue David und Befreier Israels von der Fremdherrschaft dar. (Zeichnung: Gustave Doré [1832–1883])

David darzustellen, der das heilige Land von der Fremdherrschaft befreit. Das Motiv des zunächst noch kindlichen Königs, der die vermeintlich stärkeren Feinde bezwingt, findet sich etwa in der prominenten Erzählung von Davids Kampf mit dem hünenhaften Philister Goliath (Abb. 13.2). Diese Geschichte stellt eine in sich geschlossene Erzählung dar, die nach Ansicht vieler Bibelwissenschaftler erst in späterer Zeit als Aufweis jugendlichen Heldentums auf den idealtypischen König David übertragen wurde. Dass diese Geschichte in ihrer in der Bibel vorliegenden Form jüngeren Datums ist als in den Schriften suggeriert, illustriert zum Beispiel die Beschreibung Goliaths und der Philister: Während ersterer ganz wie Achilleus in Homers *Ilias* erscheint, sind die Soldaten der Philister wie griechische Hopliten gekleidet und ausgerüstet!

Joschijas Träume von der Errichtung eines gesamtisraelitischen Großreiches gingen nicht in Erfüllung. Als 609 v. Chr. Pharao Necho einen Feldzug zur Unterstützung des wankenden assyrischen Reiches gegen einen neuen Feind,

das junge babylonische Reich, unternahm, geriet Joschija, der strahlende König und neue David, zwischen die Fronten und wurde in Megiddo ermordet. Sein Tod führte zu einem nationalen Trauma. Der Ort seines Todes, Megiddo (in der griechischen Übersetzung Armageddon), gilt seither als der Ort, an dem die Mächte des Guten und des Bösen eines Tages in einer schicksalhaften Endschlacht aufeinandertreffen werden. Als sein Nachfolger wurde sein Sohn Joahas zum König gesalbt. Die Bezeichnung „der Gesalbte" (Messiach) erhielt jedoch seit diesem tragischen Ereignis eine neue Bedeutung: Eines Tages würde wieder ein König, ein Gesalbter, aus davidischer Linie erscheinen und dann eine dauerhafte, glückliche Herrschaft errichten.

Monotheismus und die Herrschaft Babylons

Die Eckpunkte des Monotheismus israelitischer Prägung waren damit geschaffen. Eine zunächst heterogene Bevölkerung aus Bauern und Hirten hatte um die Stadt Jerusalem einen Staat gegründet, der unter dem Schutz der lokalen Gottheit stand. Diese Gottheit trug die charakteristischen Züge eines Gottes von Viehzüchtern: Sie war unsichtbar, zeigte sich möglicherweise in Blitz und Feuer und verlangte bei Verstößen gegen ihre Gebote Opfer. Genau wie den Schutzgottheiten der umliegenden Stadtstaaten wurde auch dieser unsichtbaren Gottheit ein Tempel gebaut, in dem sie wohnte, und genau so war diese Gottheit für den Schutz nur ihrer Stadt und der dazugehörigen ländlichen Gebiete verantwortlich. Erst im Zuge der Ausdehnung der politischen Macht Judas erweiterte sich der Zuständigkeitsbereich des Jerusalemer Allgottes auf das gesamte Reich. Anders als in Mesopotamien wurden jedoch konkurrierende Schutzgottheiten der unterworfenen oder einverleibten Städte nicht in ein polytheistisches Pantheon integriert. Ursache für diesen Sonderweg war das starke Bedürfnis der Könige Judas nach einer einigenden und staatstragenden Religion, die das Integrieren anderer Gottheiten in ein Pantheon nicht zuließ, sondern stattdessen Assimilation betrieb: Die alten Kultstätten wurden als frühe Kultstätten des Jerusalemer Allgottes umgedeutet und nach der Gründung eines Staates Juda für überflüssig erklärt. Von Monotheismus konnte zunächst keine Rede sein, vielmehr befand sich der Gott Judas durchaus im Wettbewerb mit anderen Gottheiten. Der Bericht über den Propheten Elijja, der es unter dem omridischen König Ahab zu einer Machtprobe zwischen seinem, dem Gott Jerusalems, und den kanaanitischen Baalen kommen ließ, ist beredtes Beispiel. JHWH – so der Name dieses Gottes laut einer entsprechenden Selbstoffenbarung (Exodus 3,14) – will lediglich von dem von ihm erwähnten Volk allein verehrt werden und verspricht im Gegenzug diesem Volk, seinem Bündnispartner, Unterstützung gegen des-

sen Feinde einschließlich der Götter. Erst im Zuge der geschichtlichen Entwicklung Judas, der Gebiete des Nordreiches und vor allem der Jerusalemer Gottesidee wurde aus dem Staatsgott ein einziger Universalgott und aus dem den übrigen Göttern überlegenen Gott (Henotheismus) der einzig existierende Gott (Monotheismus).

Zunächst einmal aber hatten sich alle Hoffnungen auf ein erfolgreiches und glückbringendes davidisches Königtum zerschlagen. Nur wenige Jahre nach dem gewaltsamen Tod Joschijas löste eine neue Weltmacht das assyrische Reich ab. Der Babylonier Nabopolassar, ein Feldherr des assyrischen Königs, ging ein Bündnis mit den Medern gegen die Assyrer ein, eroberte 612 v. Chr. die assyrische Hauptstadt Ninive und in den folgenden fünf Jahren die übrigen wichtigen Städte des assyrischen Reiches, für dessen Konsolidierung dann sein Sohn Nebukadnezar II. (605 bis 562 v. Chr.) verantwortlich zeichnet. Im Zuge seiner Eroberung der Levante wurde auch Juda mit Jerusalem erobert, der Tempel zerstört und ein Teil seiner Bevölkerung in andere Städte des babylonischen Reiches umgesiedelt. Abgesehen von diesem aus heutiger Sicht brutalen, zur damaligen Zeit allerdings üblichen Akt erwies sich Nebukadnezar als kluger Staatsmann, der den Ackerbau und die Wirtschaft förderte, sodass sich die unterworfenen Länder rasch erholten. Nur am Rande sei erwähnt, dass die Welt Nebukadnezar die berühmte Prozessionsstraße mit dem Ištartor verdankt. Auch wurden die Exilierten in Babylon keineswegs unterdrückt oder diskriminiert: Babylonische Urkunden und der biblische Bericht belegen gleichermaßen den Aufstieg von Judäern in höchste Staatsämter.

Für die Religion der Judäer bedeuteten die Zerschlagung Judas, die Zerstörung des für uneinnehmbar gehaltenen Tempels und das Exil (von der Eroberung Jerusalems 597 v. Chr. bis zur Eroberung Babylons 539 v. Chr. durch die Perser) eine intellektuelle Herausforderung ersten Ranges, der sie mit einer Umdeutung der historischen Ereignisse begegneten. Demnach war der Verlust der Heimat und des Tempels die kollektive Strafe für den Abfall des Königs Manasse von der Religion der Väter, und folgerichtig lag in eben dieser Religion auch die Hoffnung für eine glückliche Zukunft. Passagen in den Büchern der Propheten, die in Auseinandersetzung mit den politischen Entwicklungen des sechsten Jahrhunderts entstanden, thematisieren diese Hoffnung, die inzwischen über die reine Wiederherstellung des Staates Juda hinausging und die Züge eines allgemeinen Erlösungsgedankens angenommen hatte:

Und es wird eine Rute aufgehen von dem Stamm Isais und ein Zweig aus seiner Wurzel Frucht bringen, auf welchem wird ruhen der Geist des HERRN, der Geist der Weisheit und des Verstandes, der Geist des Rates und der Stärke, der Geist der Erkenntnis und der Furcht des HERRN. Jesaja 11, 1–3

Siehe, es kommt die Zeit, spricht der HERR, daß ich dem David ein gerechtes Gewächs erwecken will, und soll ein König sein, der wohl regieren wird und Recht und Gerechtigkeit auf Erden anrichten. Zu seiner Zeit soll Juda geholfen werden und Israel sicher wohnen. Und dies wird sein Name sein, daß man ihn nennen wird: Der HERR unsre Gerechtigkeit. Darum siehe, es wird die Zeit kommen, spricht der HERR, daß man nicht mehr sagen wird: So wahr der HERR lebt, der die Kinder Israel aus Ägyptenland geführt hat! sondern: So wahr der HERR lebt, der den Samen des Hauses Israel hat herausgeführt aus dem Lande der Mitternacht und aus allen Landen, dahin ich sie verstoßen hatte, daß sie in ihrem Lande wohnen sollen! Jeremia 23, 5–8

Und ich will ihnen einen einigen Hirten erwecken, der sie weiden soll, nämlich meinen Knecht David. Der wird sie weiden und soll ihr Hirte sein, und ich, der HERR, will ihr Gott sein; aber mein Knecht David soll der Fürst unter ihnen sein, das sage ich, der HERR. Und ich will einen Bund des Friedens mit ihnen machen und alle bösen Tiere aus dem Land ausrotten, daß sie in der Wüste sicher wohnen und in den Wäldern schlafen sollen. Ich will sie und alles, was um meinen Hügel her ist, segnen und auf sie regnen lassen zu rechter Zeit; das sollen gnädige Regen sein, daß die Bäume auf dem Felde ihre Früchte bringen und das Land sein Gewächs geben wird; und sie sollen sicher auf dem Lande wohnen und sollen erfahren, daß ich der HERR bin, wenn ich ihr Joch zerbrochen und sie errettet habe von der Hand derer, denen sie dienen mußten. (Hesekiel 34, 23–27)

Aber nicht nur in den Schriften der Propheten fand die politische Situation ihren Niederschlag. Die Konfrontation mit einem mächtigen Großreich und seiner Religion führte vor allem bei der exilierten Elite zum Kontakt mit der uralten babylonischen religiösen Tradition und ihren Überlieferungen, mit denen man sich auseinandersetzte, indem man manchen Mythos in veränderter Form übernahm – so die Sintflutgeschichte oder die wunderbare Bewahrung eines Helden vor Verfolgung wie im Falle des Mose –, und gab ihnen einen Platz in der eigenen Überlieferung. Andererseits schürte die rasche Assimilation der Judäer in Babylon jedoch auch Ängste hinsichtlich der nationalen und religiösen Identität; als Folge betonten Schriftkundige und Angehörige der Priesterkaste gerade die Besonderheit der jüdischen Überlieferung, die in den gesammelten Schriften aus der Zeit des Königreiches Juda ihren Niederschlag gefunden hatte. Aus theologischer Sicht stellte sich für die Exilierten gleichzeitig die Frage nach der Wirkmächtigkeit ihres Gottes, die nun explizit von der Bindung an die Heimat Juda gelöst wurde, indem JHWH nun als ein universaler und vor allem als der einzige Gott gedeutet wurde (vgl. Jesaja 44,6). In dieser Zeit, so glaubt die historisch-kritische Bibelwissenschaft, entstand mit der Priesterschrift die letzte Fassung des Pentateuch. Gerade die Fünf Bücher Moses bzw. die Tora wurden nun, da der Tempel

als Kultzentrum in Jerusalem nicht mehr existierte, zum Zentrum religiösen Lebens. Das Judentum hatte den entscheidenden Schritt von der Kultreligion zur Schriftreligion vollzogen.

Dies änderte sich auch nicht, als nach dem Tod Nebukadnezars 562 v. Chr. interne Streitigkeiten das neubabylonische Reich so sehr schwächten, dass es 539 v. Chr. dem Perserkönig Kyros in die Hände fiel. Die Perser verfolgten jedoch eine andere Bevölkerungs- und Religionspolitik. Unter ihrer Herrschaft wurde es den unterworfenen Völkern erlaubt, in ihre Heimat zurückzukehren, darunter auch den Exilierten aus Juda, wie das Kyrosedikt von 538 v. Chr. bestätigt. Diese begannen 520 v. Chr. mit dem Wiederaufbau des Tempels – offensichtlich gegen den Widerstand eines Großteils der ansässigen Bevölkerung – und konnten bereits fünf Jahre später ihre Kulthandlungen wieder aufnehmen.

Zeittafel

1400 bis 1000 v. Chr.:
* aus einer dimorphen Mischbevölkerung rekrutieren sich die Apiru (Hebräer?)

874 v. Chr.:
* Omri gründet die Dynastie der Omriden im nördlichen Bergland mit einer Hauptstadt in Samaria (Israel/Nordreich)

868 bis 847 v. Chr.:
* unter dem Davididen Josaphat wird Juda als Vasall des Nordreiches historisch greifbar

ab 738 v. Chr.:
* Israel wird zunächst zum Vasallen des assyrischen Großreiches, dann wird es unterworfen und seine Bevölkerung verschleppt (722 v. Chr.)

ab 725 v. Chr.:
* König Hiskia (725 bis 697 v. Chr.) kann das Südreich (Juda) konsolidieren
* Kultmonopol in Jerusalem

586 v. Chr.:
* Eroberung Judäas durch die Babylonier
* Zerstörung Jerusalems und des ersten Tempels
* Beginn des babylonischen Exils mit redaktioneller Überarbeitung des Pentateuch
* aus Henotheismus wird Monotheismus (Jerusalemer Allgott)

538 bis 515 v. Chr.:
* Rückkehr eines Teils der jüdischen Bevölkerung und Wiederaufbau des Tempels
* die Jehudim verstehen sich erstmals als Angehörige einer Religion mit messianischen Hoffnungen

332 v. Chr.:
- Eroberung des Perserreiches einschließlich Judas durch Alexander den Großen
- Beginn der hellenistischen Zeit

166 bis 160 v. Chr.:
- Aufstand der Makabäer (Hasmonäer) im Zuge politischer Auseinandersetzungen

142 bis 63 v. Chr.:
- jüdische Autonomie unter den Hasmonäern

63 v. Chr.:
- Eroberung Jerusalems durch Pompeius
- Beginn der Herrschaft Roms

39 v. Chr. bis 4 n. Chr.:
- Herodes der Große (Klientelkönig der Römer)
- prächtiger Ausbau des zweiten Tempels

ca. 6 bis ca. 33 n. Chr.:
- Jesus von Nazareth

um 50 bis 60 n. Chr.:
- die Briefe des Paulus von Tarsus entstehen

66 bis 70 n. Chr.:
- jüdisch-römischer Krieg
- Zerstörung des Tempels
- jüdische Religionsgelehrte machen sich an die Kodifizierung der mündlichen Überlieferung (Mischna)

70 bis 100 n. Chr. (unterschiedliche Auffassungen):
- die Evangelien entstehen

313 bis 636 n. Chr.:
- Herrschaft Ostroms
- Christentum wird Staatsreligion

um 390 n. Chr.:
- Jerusalemer Talmud

600 n. Chr.:
- der babylonische Talmud wird abgeschlossen

um 570 n. Chr.:
- der Prophet Muhammad wird in Mekka geboren

614 bis 636 n. Chr.:
- Sassanidenherrschaft

636 n. Chr.:
- Eroberung Jerusalems durch muslimische Truppen
- Herrschaft des Kalifats

691 n. Chr.:
- Kalif Abd el-Malik erbaut am Standort des zerstörten jüdischen Tempels in Jerusalem den Felsendom

Unter persischer Herrschaft – das Judentum entsteht

Nicht alle Exilierten machten jedoch von der Möglichkeit der Rückkehr Gebrauch, sondern blieben in einem Land, dessen materieller und wissenschaftlicher Aufschwung in den kommenden Jahrhunderten beispiellos war. Aus dieser intellektuellen Elite ging letztlich im sechsten nachchristlichen Jahrhundert der babylonische Talmud, die Grundlage des heutigen Judentums, hervor. Auch sollte diese Elite in den Jahrhunderten nach der Eroberung durch die Muslime als intellektuelle Führungsschicht für die Bewahrung und Weiterentwicklung der antiken Wissenschaftstradition noch eine bedeutende Rolle spielen.

Die Provinz Jehud, das alte Königreich Juda, blieb allerdings unbedeutend. Lediglich der Davidide Serubbabel, offizieller Stadthalter Jehuds, versuchte noch einmal, die messianischen Hoffnungen auf sich zu vereinigen (Haggai 2, 21–23), verschwand aber spurlos von der Bildfläche und mit ihm das davidische Geschlecht. Politisch wurde die Stadt nun von einem persischen Statthalter regiert, während in religiöser Hinsicht eine etablierte Priesterschaft die Kulthandlungen sowie die Bewahrung der schriftlichen Überlieferungen in ihre Obhut nahm. In dieser Zeit entstanden nach Auffassung der Bibelwissenschaft die Bücher der Chronik, die trotz der Rückgriffe auf die ältere Geschichte (David und Salomo) vor allem die zeitgenössische Situation mit ihren Hoffnungen abbildeten und nun, nachdem es kein unabhängiges Königreich Juda mehr gab, den Tempel mit seinen Ritualen in den Mittelpunkt einer Gemeinschaft stellten, deren Mitglieder sich mehr und mehr als Juden in religiöser Hinsicht begriffen. Ohne einen eigenen Staat und ohne die Aussicht auf eine Wiederherstellung des alten Königtums dienten die Geschichten um David und Salomo nun der Legitimierung des Tempelkultes und seiner Bedeutung für diejenigen inmitten einer ansonsten heterogenen Bevölkerung, die sich als Jehudim und damit als Anhänger einer monotheistischen Religion verstanden. Damit verschob sich die erhoffte Erlösung von der Wiedererrichtung des davidischen Königtums auf das Kommen eines Gottesreiches, das von der Erfüllung der Religionsgesetze abhängig sein sollte (1. Chronik 15–16).

Jenseits der Grenzen Jehuds erstreckte sich das Kernland des alten Nordreiches, die persische Provinz Samaria. Auch hier wurde unter den Persern ein Tempel auf dem Berge Garizim erbaut, der dem Kult des Gottes Israels geweiht war und so in Konkurrenz zum Jerusalemer Heiligtum stand. Da der Anspruch der Kultgemeinde Jerusalems jedoch war, sich an alle Jehudim unabhängig von ihrer politischen Zugehörigkeit zu richten, bildete das Kult-

zentrum auf dem Garizim eine unwillkommene Konkurrenz, und die Samaritaner wurden fortan als religiös Abtrünnige diskreditiert.

Messianische Hoffnungen

Auch die Tage des achaimenidischen Perserreiches waren gezählt. 332 vor Chr. eroberte der Makedonier Alexander der Große das persische Reich und verleibte es seinem Reich ein, das wiederum nach seinem Tod in die sogenannten Diadochenreiche zerfiel. Diese Reichsgründung hatte vor allem in kultureller Hinsicht insofern weit reichende Folgen, als ein riesiger hellenistischer, später griechisch-römisch geprägter Kulturraum entstand, in dem die Juden nun in erster Linie die Anhänger einer bestimmten, und zwar der einzigen, monotheistischen Religion waren. Der Text der heiligen Schriften wurde in dieser Zeit ins Griechische übersetzt und bildete, bekannt unter dem Namen Septuaginta, die Grundlage der gemeinsamen Identität derjenigen Juden, die inzwischen überall im einstigen hellenistischen Weltreich ansässig waren. Kultmittelpunkt blieb jedoch der Tempel in Jerusalem, dessen Priesterschaft über den Kult wachte und auch die Tempelsteuern eintrieb. Die Erinnerungen an ein ehemaliges real existierendes Königreich sowohl im Norden (Israel) als auch in den südlichen Bergen (Juda) waren inzwischen verblasst. Umso mehr gewann der Mythos vom Auszug der Kinder Israels aus Ägypten an Bedeutung, der die Sehnsucht nach einer gemeinsamen Heimat in Worte fasste und zur sinnstiftenden Ursprungserzählung des Judentums wurde. Noch heute ist die Feier des Jahrestages dieses Auszuges eines der wichtigsten jüdischen Feste (Pessach).

Im zweiten vorchristlichen Jahrhundert schienen sich dann die Träume von einem gemeinsamen Staat der Juden zu erfüllen. Wieder, wie schon zu Joschijas Zeiten, bildeten die Auseinandersetzungen zwischen zwei großen Machtblöcken, dem ägyptischen Ptolemäerreich und dem syrischen Seleukidenreich, den politischen Rahmen für Ereignisse, die letztlich die Bildung eines unabhängigen jüdischen Territorialstaates möglich machten. Die Plünderung des Tempelschatzes durch den Seleukiden Antiochos IV., seine Einflussnahme auf die Wahl des Hohepriesters im Tempel und nicht zuletzt sein Versuch, den Zeuskult im Jerusalemer Tempel einzuführen, führte zum Aufstand des jüdischen Priesters Mattatias und seiner Söhne in Modi'in (Makkabäeraufstand, 166 bis 164 v. Chr.). Nach einem Guerillakrieg mit wechselndem Erfolg gelang es seinem Sohn Judas endlich, Jerusalem mit dem Tempel zu erobern und den Tempelkult nach der rituellen Reinigung des Gebäudes wieder aufzunehmen. Das Chanukkafest erinnert noch heute an dieses historische Ereignis. Letztlich konnte jedoch erst der letzte der Mattatiassöhne, Simon,

Abb. 13.3 Modell des zweiten Tempels, der von Herodes noch einmal glanzvoll um-
gebaut und erweitert wurde. (© Israelmuseum)

die Seleukidenherrschaft endgültig abschütteln und eine regelrechte Dynastie
gründen. Diese Dynastie, die Hasmonäer, nahm den Königstitel an und ver-
band diesen mit dem Amt des Hohepriesters – in den Augen der Frommen,
der Chassidim, die sich aus religiösen Gründen am Aufstand beteiligt hatten,
ein Sakrileg, das dazu führte, dass sich gerade die Religiösen von dieser Dy-
nastie abwandten und die Heilszeit nicht im Hier und Jetzt sahen, sondern
für die Zukunft erwarteten. Die Hasmonäer regierten im Stil orientalischer
Potentaten und verfolgten eine aggressive Eroberungspolitik, in deren Verlauf
es ihnen gelang, die umliegenden Gebiete bis zu den Grenzen des mythi-
schen davidischen Reiches zu erobern und seine Bevölkerung durch Zwangs-
konversion zu Juden zu machen. Erst der römische Feldherr Pompejus, im
Rahmen von Thronstreitigkeiten als Schlichter zur Hilfe gerufen, setzte mit
der Eroberung Jerusalems 63 v. Chr. der Unabhängigkeit des Hasmonäer-
reiches ein Ende. Zwar konnte der Idumäerfürst Herodes (39 bis 4 v. Chr.)
noch einmal ein glanzvolles Reich errichten und dabei auch den Jerusalemer
Tempel prachtvoll ausbauen (Abb. 13.3), doch er war jetzt nicht mehr un-
abhängig, sondern Klientelfürst der Römer. Dass Israel nun nicht mehr war
als ein Teil des römischen Weltreiches, wurde spätestens nach dem Tod von
Herodes deutlich, als Rom seine Söhne zwar für die nördlichen Provinzen des

einstigen herodianischen Reiches als Nachfolger akzeptierte, Judäa mit seiner alten Hauptstadt Jerusalem aber der direkten Verwaltung eines Statthalters unterstellte.

Der Verstoß gegen biblische Gebote wie das Einsetzen eines Hohepriesters aus einem nicht hohepriesterlichen Geschlecht, Konflikte zwischen Tempelaristokratie und der neuen religiösen Elite der Pharisäer, dann ein nichtjüdisches Herrscherhaus (die Idumäer, biblisch Edomiter, waren Proselyten und erst unter den Hasmonäern zwangsjudaisiert worden) und zuletzt römische Herrschaft und die Anwesenheit einer römischen Garnison in der heiligen Stadt Jerusalem führten zu steigender Unzufriedenheit innerhalb der jüdischen Bevölkerung, die sich auch in einer starken Hinwendung zu den Lehren der Religion, vor allem den Propheten einer apokalyptischen Endzeit, niederschlug. Zusammen mit der inzwischen prekären Lage der Landbevölkerung entwickelte sich daraus eine religiös wie sozial höchst angespannte Atmosphäre, die kaum noch zu beherrschen war. Immer wieder flammten im Land Aufstände auf, die blutig niedergeschlagen wurden – sowohl Rom als auch die Herodessöhne hielten daher ein Auge auf mögliche Aufwiegler, um mögliche Erhebungen im Keim ersticken zu können.

In dieser religiös und sozial aufgeheizten Situation trat in Galiläa im Norden Israels in den späten Zwanzigerjahren des ersten Jahrhunderts ein charismatischer Wanderprediger auf, der die unmittelbare Nähe des kommenden Gottesreiches verkündigte. Seine Predigten waren in religiöser Hinsicht von enormer Überzeugungskraft, enthielten aber sozialen Sprengstoff: Was er verkündigte, war nicht weniger als die Umkehrung der gesamten Sozialordnung. Wenn das Gottesreich erst einmal verwirklicht sein würde, wären es die bislang Unterdrückten, die Armen, die Ungebildeten, also all jene, die während der letzten Generationen politische und soziale Verlierer der gesamtpolitischen Entwicklung gewesen waren, die dann von der neuen Situation profitieren würden. Der Wanderprediger, Jesus aus Nazareth, dem auch spektakuläre Krankenheilungen gelangen, hatte bereits innerhalb kürzester Zeit enormen Zulauf, und es dauerte nicht lange, bis erste Stimmen laut wurden, die in ihm den angekündigten Messiach sahen. Auch er hat sich möglicherweise zuletzt als Erneuerer einer göttlich legitimierten Herrschaft gesehen: Für seinen Einzug in Jerusalem zum Pessachfest im Jahre 30 n. Chr. stattete er sich mit allen königlichen Insignien aus – und der Ritt auf einem Esel gehörte dazu –, die laut alttestamentlicher Prophezeiung den neuen König kennzeichnen sollten. Die Bevölkerung verstand die Signale sofort und riss Palmwedel, Insignien der Königsherrschaft, von den Bäumen, um dem ersehnten Gesalbten des Herrn den Weg zu bereiten. Auch die weiteren Ereignisse sprechen dafür, dass Jesus zuletzt daran geglaubt hat, er könne in diesem Augenblick die Gottesherrschaft errichten: Er zog als jener ersehnte König nach Jerusalem und dort

direkt in den Tempel ein, den er in einem überraschenden Gewaltakt von allen nichtreligiösen Elementen reinigte. Was dann geschah, wird wohl im Dunkel der Geschichte bleiben. Immerhin führte der martialische Auftritt im Tempel nicht zu einem großen Volksaufstand, der die Besatzer hinwegfegte, sodass sich die Anhänger von Jesus zunächst einmal wieder in ein kleines Dorf außerhalb der Stadtmauern Jerusalems zurückzogen. Dass sein Schicksal nach dem Auftritt im Tempel besiegelt war, scheint Jesus durchaus bewusst gewesen zu sein. In einem letzten Abendmahl nahm er von seinen Anhängern mit bewegenden Worten Abschied, bevor er dann von den Römern gefangengenommen und als Aufwiegler hingerichtet wurde. Man verurteilte ihn wegen Landfriedensbruchs und Landesverrats, ein Verbrechen, das nach römischem Recht mit Kreuzigung bestraft wurde.

Seine verängstigten und in ihren Hoffnungen getäuschten Anhänger zerstreuten sich zunächst. Dann aber führte eine Reihe unerklärlicher Ereignisse, so das leere Grab und eine Reihe von visionären Erscheinungen dazu, dass seine Anhänger begannen, das schreckliche Ende ihres Messiach umzudeuten und als notwendige Voraussetzung für das endgültige Kommen des Gottesreiches zu sehen. Die Jesusbewegung hatte sich also als so stabil und tragend erwiesen, dass sie auch durch den Tod ihres Protagonisten nicht gestoppt werden konnte, sondern innerhalb kürzester Zeit zu einer ernstzunehmenden Strömung innerhalb des Judentums wurde. Der endgültige Durchbruch gelang dieser Bewegung allerdings erst, nachdem ein Rabbiner mit Namen Paulus auf die Seite der Jesusanhänger gewechselt war und deren Botschaft in eine für Nichtjuden verständliche religiöse Begrifflichkeit fasste. Er deutete den Tod und die Wiederauferstehung jenes Jesus aus Nazareth nach einem Muster analog der zu seiner Zeit florierenden Mysterienreligionen, in deren Zentrum ein sterbender und wiederauferstehender Gott stand. Mit der Initiation in die Mysterien dieses Gottes hatte der Myste (der Initiand) Anteil am Tod, aber vor allem auch an der Auferstehung seines Gottes, und dies bedeutete Erlösung bereits im Diesseits und ewiges Leben im Jenseits. Verbunden mit dem Monotheismus des Judentums ergab sich daraus eine Lehre von solcher Überzeugungskraft, dass die alten polytheistischen Kulte dem schon bald nichts mehr entgegenzusetzen hatten und im Lauf der folgenden Jahrhunderte ausstarben.

Judentum, Christentum, Islam – die Entwicklung der Religion(en) geht weiter

Dieses Buch hat sich zum Ziel gesetzt, die Entwicklung der Religion unter evolutionsbiologischen, kognitionspsychologischen, kulturgeschichtlichen, ethnologischen und archäologischen Gesichtspunkten zu entschlüsseln, wo-

bei die Entstehung der großen monotheistischen Religionen den Schluss-
punkt bildet. Deren weitere Geschichte und Ausdifferenzierung darzustellen,
würde den Rahmen dieses Buches bei weitem sprengen; zudem sind diese
Themen in zahlreichen anderen Werken ausführlich abgehandelt. An dieser
Stelle sei lediglich ein letzter, knapper Blick auf die weitere Entwicklung der
abrahamitischen Religionen und die Entstehung des Islam geworfen.

Auch als im Jahre 66 n. Chr. der große römisch-jüdische Krieg ausbrach,
der 70 n. Chr. mit der völligen Zerstörung des Jerusalemer Tempels endete,
existierte das Judentum weiter. Zwar endete damit der Tempelkult, aber das
Judentum nahm die in Babylon begonnene und seitdem fortgesetzte Tradi-
tion der Schriftreligion nun verstärkt auf und legte in Tiberias die Grundlagen
für seine weitere Entwicklung – ohne die Sekte der Christusanhänger, von der
man sich jetzt massiv absetzte. Während das Christentum missionierte und
sich in den folgenden Jahrhunderten überall im römischen Weltreich aus-
breiten konnte, hatte auch das Judentum große Erfolge zu verzeichnen. Als
alte monotheistische Religion mit vor allem hohem ethischen Anspruch er-
füllte es perfekt die Sehnsüchte der Menschen und hatte zunächst einen gro-
ßen Vorteil gegenüber dem Christentum: Es war eine im Römischen Reich
erlaubte Religion, deren Anhänger manche Privilegien genossen. Und als es
dem Christentum endlich gelang, ebenfalls den Status einer *religio licita* zu er-
langen (313 n. Chr. unter Kaiser Konstantin), geriet es gleich in Abhängigkeit
vom Pontifex Maximus und damit vom Kaiser, der nicht nur in Kult- sondern
auch in Glaubensfragen das letzte Wort für sich reklamierte und abweichende
Auffassungen zu verbotenen Häresien erklären ließ.

In diese spätantike Welt wurde um 570 n. Chr. in der arabischen Han-
delsmetropole Mekka der kleine Muhammad bin Abdallah geboren. Mu-
hammad, ein religiöser und grüblerischer Mensch, litt offensichtlich unter
dem harten Materialismus der Menschen seiner Heimatstadt. Ausgebildet als
Karawanenhändler, lernte er auf seinen Reisen sowohl das Christentum als
auch das Judentum seiner Zeit kennen und setzte sich mit diesen Religionen
auseinander. Überzeugt vom Monotheismus, hegte er doch starke Zweifel an
der Rechtmäßigkeit der jüngeren Entwicklungen beider Religionen. Sowohl
die Vergottung des Jesus aus Nazareth, der in seinen Augen einer der Pro-
pheten war, als auch die Flut der rabbinischen Regeln und Gesetze waren
seiner Ansicht nach nicht konform mit den Überlieferungen der Tora. Seine
Verkündigungen, die als eine Wiederherstellung der alttestamentlichen Reli-
gion gedacht waren, konnten allerdings weder Juden noch Christen überzeu-
gen, sondern mündeten stattdessen in die dritte der drei großen abrahamit-
ischen Religionen: den Islam.

Soweit die Entstehungsgeschichte des Monotheismus, der heute von den
drei großen abrahamitischen Religionen repräsentiert wird. Allerdings ist da-

mit noch kein Ende der Entwicklung dieser westlichen Religionen erreicht. Auch heute noch verändern sich sowohl Christentum als auch Judentum und Islam entsprechend der jeweiligen Bedürfnisse ihrer Anhänger, und auch neue Religionen wie die Religion der Bahai entstehen, ganz im Sinne einer Evolution der Religionen.

Glossar

abrahamitische Religionen
die drei Hochreligionen Judentum, Christentum und Islam, die sich gleichermaßen auf Abraham als ihren geistigen Religionsstifter zurückführen, also ihre Verwandtschaft und grundsätzliche Ähnlichkeit anerkennen

Adaptation (evolutionsbiologisch)
phylogenetische Entwicklung eines Organismus bis zur optimalen Angepasstheit an seine Umwelt

altruistisches Verhalten, Altruismus
uneigennütziges Verhalten zum Wohl eines andern Individuums

Apotropäisch
Fachbegriff für Unheil abwehrend. Die apotrópaioi theoí der Antike waren solche Götter, die man für Unheil verantwortlich machte und vor denen man sich zu schützen hatte

archäologische Kultur
ein räumlich und zeitlich begrenzter Ausschnitt der materiellen und damit archäologisch nachweisbaren Kultur, deren Grenzen daher durch die Verbreitungsgrenzen der materiellen Hinterlassenschaften definiert sind; eine archäologische Kultur ist demnach nicht deckungsgleich mit einer Ethnie oder einer soziopolitischen Einheit

Bauopfer
Gaben an Gottheiten, Geister oder Ahnen, die im Rahmen der Errichtung eines Bauwerkes dargebracht wurden und dessen Bestand sichern sollen

biologische Fitness
auch Adaptionswert; Angepasstheit eines Individuums oder einer Population an die Umwelt, heißt, Durchsetzungsfähigkeit des Genotyps in weitere Generationen

Bukranium
ursprünglich Rinderschädel; in der klassischen Archäologie auch dessen Nachbildung, vor allem als Schmuckmotiv

Ethologie
auch Verhaltensforschung oder Verhaltensbiologie; Teilgebiet der Zoologie, bei der das Verhaltensmuster von Organismen experimentell untersucht wird; kann innerhalb der Zoologie ergänzend zu Morphologie, Physiologie und Anatomie im Dienste phylogenetischer Forschung gesehen werden

Evolution
in erster Linie die Veränderung einer Population im Lauf der Zeit; Evolution ist ein zweistufiger Prozess, wobei der erste Schritt in der Herstellung von Variation in jeder Generation besteht, das heißt von zahllosen genetischen oder phänotypischen Varianten, die als Ausgangsmaterial der Selektion dienen können; diese variable Population wird dann in einem zweiten Schritt dem Prozess der Auslese ausgesetzt

Evolutionstheorie
beschreibt und erklärt die Entstehung und Veränderung der Arten als Ergebnis der natürlichen Veränderung der Organismen im Lauf der Naturgeschichte, indem sie die Evolutionsfaktoren benennt und ihr Zusammenwirken erklärt.

Figurine
eine kleine (10 bis 20 cm große) Statue bzw. Plastik, die eine Person oder ein Tier darstellt und die der symbolhaften Repräsentation dient

Flintwerkzeug
Feuerstein, auch Silex genannt; während der Steinzeit war dieser besonders harte Silizit das bevorzugte Material für die Herstellung von Schneidewerkzeugen, den sogenannten Flintwerkzeugen

Graffiti (ital.; Sing. Graffito)
Sammelbegriff für thematisch und gestalterisch unterschiedliche Bilder oder Schriftzüge auf verschiedenen Oberflächen im privaten und öffentlichen Raum

Hochreligion
aus religionswissenschaftlicher oder theologischer Perspektive die großen, weltweit verbreiteten, also nicht mehr an eine bestimmte Ethnie gebundenen Religionen Judentum, Christentum, Islam, Buddhismus und Hinduismus; oft werden auch Konfuzianismus, Taoismus und die Religion der Bahai zu den Hochreligionen gezählt

Jäger- und Sammlerkultur
auch Wildbeuterkultur; eine Kultur, deren Mitglieder ihren Lebensunterhalt ausschließlich durch das Sammeln von Wildfrüchten und die Jagd auf Wildtiere bestreiten; ihre Ökonomie als aneignende Wirtschaftsweise

JHWH (vokalisiert: Jahve)
der Eigenname des Gottes des Volkes Israel im Tanach bzw. im Alten Testament

klassisches Konditionieren
siehe Konditionierung

Kleinkunst

generell ein Genre der darstellenden Künste, das seinen Namen aufgrund seines begrenzten personellen, räumlichen und materiellen Aufwands erhalten hat; im hiesigen Zusammenhang jedoch die Bezeichnung für die kleinen, transportablen Kunstwerke (franz. charakteristischerweise *art mobilier* genannt) des Jungpaläolithikums bis Neolithikums im Gegensatz zur Parietalkunst

Kognitionswissenschaft

interdisziplinäre Wissenschaftsdisziplin, die sich mithilfe von Ansätzen und Ergebnissen aus der Psychologie, der Neurowissenschaft, der Informatik einschließlich künstlicher Intelligenz, der Linguistik, der Philosophie und der Anthropologie der Erforschung geistiger Prozesse widmet

Konditionierung

das Erlernen von Reizreaktionsmustern (Stimulus-Response); während die klassische Konditionierung das durch einen bestimmten Reiz automatisch ausgelöste Verhalten meint, handelt es sich beim operanten Konditionieren um ein Verhalten, das durch Belohnung und Bestrafung bewusst herbeigeführt wird.

Kremation

Feuerbestattung

Krötendarstellung

schematische Darstellung einer hockenden menschlichen Gestalt; fälschlich als Kröte identifiziert

Levante (Region; ital. für Sonnenaufgang)

bezeichnet die Länder des östlichen Mittelmeeres, im hiesigen archäologischen Zusammenhang vor allem die Regionen des heutigen Libanon, Palästinas, Syriens und des Iraks

Neolithisierung (von altgriech. *νεος, neos* für neu, jung und *λίθος lithos* für Stein)

Ausbreitung des Ackerbaus, der Viehhaltung und die Einführung besonderer Werkzeugtechniken zu Beginn des Neolithikums.

operantes Konditionieren

siehe Konditionierung

Paläoanthropologie

Wissenschaft von fossilen Vertretern der Menschen oder Menschenähnlichen und deren Evolution

Parietalkunst

der Fachbegriff für künstlerische Darstellungen auf gewachsenem Felsen; der Begriff Parietalkunst wird für die Felsmalerei vor allem des Paläolithikums verwendet und grenzt diese Kunstform damit gegenüber der beweglichen Kleinkunst (Statuetten) ab

Polytheismus
eine Religionsform, in der im Gegensatz zum Monotheismus von einer Vielzahl existenter Gottheiten ausgegangen wird

PPNA und PPNB
s. präkeramisches Neolithikum (engl. *pre-pottery neolithic*, PPN)

präkeramisches Neolithikum (engl. *pre-pottery neolithic,* PPN)
eine frühjungsteinzeitliche Epoche zwischen 9500 und 8800 bzw. 6400 v. Chr. in der Levante und im nördlichen Teil des fruchtbaren Halbmonds, in der eines der maßgeblichen Charakteristika des Neolithikums, die Tongefäße, noch nicht existierten; die Epoche, deren Name von der britischen Archäologin Kathleen Kenyon in Zusammenhang mit der Ausgrabung bei Jericho eingeführt wurde, lässt sich weiter in das PPNA (9500 bis 8800 v. Chr.), PPNB 8800 bis 7000 v. Chr.) und in der Levante auch in PPNC (7000 bis 6400 v. Chr.) unterteilen

Radiation (biol. adaptive Radiation)
Auffächerung einer generalisierten Art in mehrere spezialisierte Arten unter Anpassung der Merkmale an die Umwelt

Rondellanlage
auch Kreisgrabenanlage oder Henge; Bauwerk (Erdwerk) einer neolithischen Kultur; besteht aus Palisade und Graben, die ein meist rundes Areal umfrieden und sowohl der Ermittlung kalendarischer Eckdaten für die Landwirtschaft als auch der Durchführung kollektiver Kulthandlungen dienten

Selektionsdruck
Einwirken eines Selektionsfaktors (z. B. Klimaveränderung, Prädatoren usw.) auf eine Population einer Art von Lebewesen; eine weitere Anpassung der Individuen ist infolgedessen nötig

Silexklinge
Feuersteinklinge

Tellurisch
von der Erde kommend, auf die Erde bezogen. Tellurische Mächte sind in diesem Zusammenhang unterirdische Mächte, tellurische Gottheiten sind unterirdische Gottheiten im Gegensatz zu den Himmelsgottheiten

Territorialität
alle Verhaltensweisen, die sowohl dem Erwerb und der Kontrolle eines Reviers als auch der Abgrenzung zu Konkurrenten dienen

Wildbeuter
siehe Jäger- und Sammlerkultur

Literatur

Adami NR (1991) Religion und Schamanismus der Ainu auf Sachalin. Iudicium, München

Ainsworth M, Blehar M, Waters E, Wall S (1978) Patterns of attachment. A psychological study of the strange situation. Erlbaum, Hillsdale

Alcock J (2005) Animal behavior: an evolutionary approach. Sinauer Associates, Sunderland

Anderson JR (2011) A primatological perspective on death. Am J Primatol 73:410–414

Anderson JR, Gillies A, Lock LC (2011) Pan thanatology. Curr Biol 20, R349–351

Astington JW, Hughes C (2013) Theory of mind: self-reflection and social understanding. In: Zelazo PD (Hrsg) Oxford handbook of developmental psychology. Oxford University Press, New York, S 398–424

Astington JW, Harris PL, Olson DR (Hrsg) (1988) Developing theories of mind. New York: Cambridge University Press

Atran S (2002) In Gods we trust. The evolutionary landscape of religion. Oxford University Press, Oxford

Atran S, Norenzayan A (2004) Religion's evolutionary landscape: counterintuition, commitment, compassion, communion. Behav Brain Sci 27:713–770

Auffermann B, Orschiedt J (2002) Die Neandertaler. Eine Spurensuche. Sonderheft Archäologie in Deutschland

Auffermann B, Weniger GC (Hrsg) (1998) Frauen – Zeiten – Spuren. Ausstellungskatalog des Neanderthalmuseums. Mettmann: Neanderthal-Museum

Babylonischer Schöpfungsmythos. http://www.welt-erschafft.de/uploads/media/Originaltext_Enuma_Elish_01.pdf. Zugegriffen am: 23.07.2014

Bächler E (1921) Das Drachenloch ob Vättis im Taminatale, 2445 m. ü. M. und seine Bedeutung als paläontologische Fundstätte und prähistorische Niederlassung aus der Altsteinzeit (Paläolithikum) im Schweizerlande. Zollikofer, Cie, St. Gallen

Bächler E (1923) Die Forschungsergebnisse im Drachenloch ob Vättis im Taminatale (2445 m ü. M.) Nachtrag und Zusammenfassung. Jahrbuch der St. Gallischen naturwissenschaftlichen Geschichte, 59, 79–118

Bächler E (1940) Das alpine Paläolithikum der Schweiz im Wildkirchli, Drachenloch und Wildenmannlisloch. Birkhäuser, Basel

Bächthold-Stäubli H, Hoffmann-Krayer E (Hrsg) (2000) Handwörterbuch des deutschen Aberglaubens. de Gruyter, Berlin, (Spalte 1760)

Banning EB (2011) So fair a house. Göbekli Tepe and the identification of temples in the pre-pottery Neolithic of the near East. Curr Anthropol 52:619–660

Baron-Cohen S (1991) Precursors to a theory of mind: understanding attention in others. In: Whiten A (Hrsg) Natural theories of mind: evolution, development and simulation of everyday mindreading. Blackwell, Oxford, S 233–251

Barrett JL (2004) Why would anyone believe in God. Alta Mira Press, Lanham

Barrett JL (2007) Cognitive science of religion: What is it and why is it? Religion Compass 1:768–786

Barrett JL (2012) Cognitive science, religion, and theology: from human minds to divine minds. Templeton Press, West Conshohocken

Becker E (1973) The denial of death. Free Press, New York

Bellah RN (1973) Religiöse Evolution. In: Seyfarth C, Sprondel WM (Hrsg) Seminar Religion und gesellschaftliche Entwicklung. Studien zur Protestantismus-Kapitalismus-These Max Webers. Suhrkamp, Frankfurt a. M., S 267–302

Bering JM (2002) Intuitive conceptions of dead agents' minds: the natural foundations of afterlife beliefs as phenomenological boundary. J Cognit Cult 2:263–308

Bering JM (2006) The cognitive psychology of belief in the supernatural. Am Sci 94:142–149

Bering JM (2011) The belief instinct: the psychology of souls, destiny, and the meaning of life. W. W. Norton & Company, New York

Bering JM, Bjorklund DF (2004) The natural emergence of reasoning about the afterlife as a developmental regularity. Developmental Psychology, 40, 217–233

Bering JM, Hernández-Blasi C, Bjorklund DF (2005) The development of „Afterlife" beliefs in secularly and religiously schooled children. Br J Dev Psychol 23:587–607

Biro D, Humle T, Koops K, Sousa C, Hayashi M, Matsuzawa T (2010) Chimpanzee mothers at Bossou, Guinea carry the mummified remains of their dead infants. Curr Biol 20:R351–352

Bischof HJ (1989) Neuroethologie. Einführung in die neurophysiologischen Grundlagen des Verhaltens. Ulmer, Stuttgart

Blanc, AC (1942) I Paleantropi di Saccopastore e del Circeo. Quartär. Jahrbuch für Erforschung des Eiszeitalters und seiner Kulturen 4:1–37

Bloch M (1975) Property and the end of affinity. In: Bloch M (Hrsg) Marxist analyses and social anthropology. Wiley, New York, S 203–228

Blume M (2009) Neurotheologie. Hirnforscher erkunden den Glauben. Tectum, Marburg

Böhme H (1997) Aby M. Warburg. In: Michaels A (Hrsg) Klassiker der Religionswissenschaft. von Friedrich Schleiermacher bis Mircea Eliade. Beck, München, S 133–156

Bower B (2002) Cave finds revive Neanderthal Cannibalism. http.//www.sciencenews.org/sn_arc99/10_2_99/fob4.htm. Zugegriffen: 22. Juli 2002

Bowlby J (1969) Attachment. Attachment and loss, Bd 1. Hogarth Press, London

Bowlby J (1973) Separation: anxiety and anger. Attachment and loss, Bd. 2. Hogarth Press, London

Bowlby J (1980) Loss: sadness and depression. Attachment and loss, Bd. 3. Hogarth Press, London

Bowlby J, Fry M, Ainsworth M (1965) Child care and the growth of love. Penguin Books, London

Boyer P (1994) The naturalness of religious ideas: a cognitive theory of religion. University of California Press, Berkeley

Boyer P (2001) Religion explained: the evolutionary origins of religious thought. Basic Books, New York

Boyer P (2008) Religion: bound to believe? Nature 455:1038–1039

Bremmer JN (1996) Götter, Mythen und Heiligtümer im antiken Griechenland. Wissenschaftliche Buchgesellschaft, Darmstadt

Bruit Zaidmann L, Schmitt Pantel P (1994) Die Religion der Griechen. Kult und Mythos. Beck, München

Burkert W (1990) Griechische Religion der archaischen und klassischen Epoche. Kohlhammer, Stuttgart

Burridge RA (1994) Four Gospels, One Jesus? Eerdmans, Grand Rapids

Burridge RA (2004) What are the Gospels? A comparison with Graeco-Roman biography. Eerdmans, Grand Rapids

Buschan G (Hrsg) (1922) Das deutsche Volk in Sitte und Brauch. Geburt, Liebe, Hochzeit, Familienleben, Tod, Tracht, Wohnweise, Volkskunst, Lied, Tanz und Spiel, Handwerk und Zünfte, Aberglaube. Die Sitten der Völker, Bd 4. Union-Verlag, Stuttgart

Call J, Tomasello M (1998) Distinguishing intentional from accidental actions in Orang-Utans (Pongo pygmaeus), Chimpanzees (Pan troglodytes), and Human Children (Homo sapiens). J Comp Psychol 112:192–206

Campbell J (1995) Der Heros in tausend Gestalten. Suhrkamp, Frankfurt a. M.

Cavalli-Sforza LL (1999) Gene, Völker und Sprachen. Die biologischen Grundlagen unserer Zivilisation. Hanser, München

Cicirelli VG (2002) Fear of death in older adults: predictions from terror management theory. J Gerontol B Psychol Sci Soc Sci 57:358–366

Condorcet A de (1976) Entwurf einer historischen Darstellung der Fortschritte des menschlichen Geistes. (Hrsg und kommentiert von Wilhelm Alff). Suhrkamp, Frankfurt a. M.

Corsi P (1988) The age of Lamarck. Evolutionary theories in France 1790–1830. University of California Press, Berkeley

Dalén L, Orlando L, Shapiro B, Brandström Durling M, Quam R, Gilbert MTP, Díez Fernández-Lomana JC, Willerslev E, Arsuaga JL, Götherström A (2012) Partial genetic turnover in Neandertals: continuity in the east and population replacement in the west. Mol Biol Evol. doi:10.1093/molbev/mss074

D'Aquili EG, Newberg AB (1993) Religious and mystical states: a neuropsychological model. Zygon 28:177–200

D'Aquili EG, Newberg AB (1998) The neuropsychological basis of religions: or why God won't go away. Zygon 33:187–201

Darwin C (1985) The origin of species by means of natural selection. Penguin, Harmondsworth

Dawkins R (2000) Das egoistische Gen. Rowohlt, Reinbek

Dawkins R (2006) Der Gotteswahn. Ullstein, Hamburg

De Waal F (2009) The age of empathy: nature's lessons for a kinder society. Crown Publishing, New York

Defleur A, White T, Valensi P, Slimak L, Crégut-Bonnoure E (1999) Neandertal Cannibalism at Moula-Guercy, Ardèche, France. Science 286:128–131

Donner H (2000) Geschichte des Volkes Israel und seiner Nachbarn in Grundzügen. Teil 1. Von den Anfängen bis zur Staatenbildungszeit. Vandenhoeck & Ruprecht, Göttingen

Donner H (2001) Geschichte des Volkes Israel und seiner Nachbarn in Grundzügen. Teil 2. Von der Königszeit bis zu Alexander dem Großen. Mit einem Ausblick auf die Geschichte des Judentums bis Bar Kochba. Vandenhoeck & Ruprecht, Göttingen

Eck, Werner (2007) Rom und Judaea. Fünf Vorträge zur römischen Herrschaft in Palästina. Mohr Siebeck, Tübingen

Edmondson J, Mason S, Rives J (Hrsg) (2005) Flavius Josephus and Flavian Rome. Oxford University Press, Oxford

Eibl-Eibesfeldt I (2004) Die Biologie des menschlichen Verhaltens. Grundriß der Humanethologie. Blank-Media, Vierkirchen-Pasenbach

Eibl-Eibesfeldt I, Sütterlin C (1992) Im Banne der Angst. Zur Natur- und Kunstgeschichte menschlicher Abwehrsymbolik. Piper, München

Eliade M (1978) Geschichte der religiösen Ideen, Bd 1. Von der Steinzeit bis zu den Mysterien von Eleusis. Herder, Freiburg im Breisgau

Eliade M, Couliano IP (1991) Handbuch der Religionen. Artemis und Winkler, Zürich

Evans JD (1959) Malta. Ancient peoples and places, Bd. 11. Thames and Hudson, London

Evans JD (1971) The prehistoric antiquities of the Maltese Islands: a survey. Athlone Press, London

Fink, W. http://www.gutzitiert.de/zitat_autor_werner_finck_thema_Lachen_zitat_13077.html

Feifel H (1990) Psychology and death: meaningful rediscovery. Am Psychol 45:537–543

Finkelstein I, Silberman NA (2006) David und Salomo. Archäologen entschlüsseln einen Mythos. Beck, München

Finkelstein I, Silberman NA (2002) Keine Posaunen vor Jericho. Die archäologische Wahrheit über die Bibel. Beck, München

Fischer P, Greitemeyer T, Kastenmüller A, Jonas E, Frey D (2006) Coping with terrorism: the impact of increased salience of terrorism on mood and self-efficacy of intrinsically religious and non-religious people. Personal Soc Psychol Bull 32:365–377

Fitton JL (2004) Die Minoer. Darmstadt: Wissenschaftliche Buchgesellschaft

Flanelly KJ, Koenig HG, Ellison CG, Galek K, Krause N (2006) Belief in life after death and mental health: findings from a national survey. J Nerv Ment Dis 194:524–529

Fossey D (1991) Gorillas im Nebel. Mein Leben mit den sanften Riesen. Droemer Knaur, München

Freeden J von (1993) Malta und die Baukunst seiner Megalithtempel. Wissenschaftliche Buchgesellschaft, Darmstadt

Freud S (2000) Neue Folge der Vorlesungen zur Einführung in die Psychoanalyse (uspr. 1933) In: Mitscherlich A, Richards A, Strachey J (Hrsg) Sigmund Freud – Studien-

ausgabe. Bd 1. Vorlesungen zur Einführung in die Psychoanalyse. Und Neue Folge. Fischer, Frankfurt a. M., S 447–608

Fuisz-Szammer N, Saminig H (2011) Die Bedeutung des nonverbalen Ausdrucks für den Spracherwerb. Deutsches Jugendinstitut e. V, München

Gamble C (1996) Die Besiedlung Europas: 700000–40000 Jahre vor heute. In: Cunliffe B (Hrsg) Illustrierte Vor- und Frühgeschichte Europas. Campus, Frankfurt a. M., S 13–54

Gennep A van (1988) Manuel de folklore français contemporain. Editions A. et J. Picard et Cie, Paris

Gennep A van (2005) Übergangsriten. Campus, Frankfurt a. M.

Gerand: Herd (2000) In: Bächthold-Stäubli H, Hoffmann-Krayer E (Hrsg) Handwörterbuch des deutschen Aberglaubens, Bd 3. de Gruyter, Berlin (Spalte 1760)

Gerlitz P (2001) Art. Symbol II, Religionsgeschichtlich. Theologische Realenzyklopädie. Bd XXXII. Spurgeon – Taylor, Jeremy. de Gruyter, Berlin, S 481–487

Giacobini G, Piperno M (1991) Taphonomic Considerations on the Circeo 1 Neandertal cranium. Comparison of the surface characteristics of the human cranium with faunal remains from the paleosurface. In: Piperno M, Scichilone G (Hrsg), Il Cranio Neandertaliano Circeo 1. Studi e Documenti, Rom, S 457–485

Goodall J (1991) Wilde Schimpansen. Verhaltensforschung am Gombe-Strom. Rowohlt, Reinbek

Goodall J (1996) Ein Herz für Schimpansen. Meine 30 Jahre am Gombe-Strom. Rowohlt, Reinbek

Golzio KH (1983) Der Tempel im alten Mesopotamien und seine Parallelen in Indien. Eine religionshistorische Studie. Brill, Leiden

Graf FW (2004) Die Wiederkehr der Götter. Religion in der modernen Kultur. Beck, München

Greenberg J, Simon L, Pyszczynski T, Solomon S (1991) A Terror Management Theory of Social Behavior: The Psychological Functions of Self-Esteem and Cultural Worldviews. In: Zanna MP (Hrsg) Advances in experimental social psychology, Bd. 24. Academic Press, San Diego, S 93–160

Grimm J, Grimm W (1812/1815) Kinder- und Hausmärchen. Reimer, Berlin

Grimm J, Grimm W (1977) Kinder- und Hausmärchen. Winkler, München, S 51–63

Grzimek B (1993) Grzimeks Tierleben. Enzyklopädie des Tierreiches, 13 Bd. Deutscher Taschenbuch-Verlag, München

Guthrie SG (1980) A cognitive theory of religion. Curr Anthropol 21:181–203

Guthrie SG (1993) Faces in the clouds: a new theory of religion. Oxford University Press, Oxford

Haeckel E (1898) Natürliche Schöpfungsgeschichte. 2 Bde. Erster Theil: Allgemeine Entwickelungs-Lehre (Transformismus und Darwinismus). de Gruyter, Berlin

Haeckel E (1902) Natürliche Schöpfungsgeschichte, 2 Bde. Erster Theil: Allgemeine Entwickelungs-Lehre (Transformismus und Darwinismus), 10. Aufl. Reimer, Berlin, S 106

Hardy AC (1979) Der Mensch, das betende Tier. Religiosität als Faktor der Evolution. Klett-Cotta, Stuttgart

Heiler F (1979) Erscheinungsformen und Wesen der Religion. Kohlhammer, Stuttgart

Heitsch E (Hrsg) (1994) Xenophanes: Die Fragmente. Akademie der Wissenschaften und der Literatur, Mainz

Henke W, Rothe H (1994) Paläoanthropologie. Springer, Berlin

Humphrey N (1998) Cave art, autism, and the evolution of the human mind. Camb Archaeol J 8/2:165–191

Irons W (1996) Morality, religion, and human nature. In: Richardson WM, Wildman M (Hrsg) Religion and science. History, method, dialogue. Routledge, New York, S 375–400

Irons W (2001) Religion as hard-to-fake sign of commitment. In: Nesse R (Hrsg) Evolution and the capacity for commitment. Sage, New York, S 292–309

Irons W (2008) Why people believe (what other people see as) crazy ideals. In: Bulbulia J, Sosis R, Harris E, Genet G, Genet C, Wyman K (Hrsg) The evolution of religion. Studies, theories, and critiques. Collins Foundation Press, Santa Margarita, S 51–57

Jensen AE (1948) Das religiöse Weltbild einer frühen Kultur. Schröder, Stuttgart

Jenson RW (1983) The praying animal. Zygon 18:311–325

Johnson DDP (2005) God's punishment and public goods. A test of the supernatural punishment hypothesis in 186 world cultures. Hum Nat 16:410–466

Johnson DDP, Bering JM (2006) Hand of God, mind of man. Punishment and cognition in the evolution of cooperation. Evolut Psychol 4:219–233

Johnson DDP, Krüger O (2004) The good of wrath: supernatural punishment and the evolution of cooperation. Political Theol 5:159–176

Jonas E, Fischer P (2006) Terror management and religion: evidence that intrinsic religiousness mitigates worldview defense following mortality salience. J Personal Soc Psychol 91:553–567

Jöris O, Street M (2008) At the end of the 14C time scale – the Middle to Upper Paleolithic record of Western Eurasia. In: Adler DS, Jöris O (Hrsg) Setting the record straight: toward a systematic chronological understanding of the middle to upper Paleolithic boundary in Eurasia. J Hum Evolut 55:782–802

Jung CG (1987) Heros und Mutterarchetyp. Grundwerk CG Jung. Bd 8. Walter, Olten

Kadenbach J (1970) Das Religionsverständnis von Karl Marx. Schöningh, München

Kastenbaum R, Aisenberg R (1972) The psychology of death. Springer, New York

Kaufman GD (1981) The theological imagination: constructing the concept of God. Westminster, Philadelphia

Kirkpatrick LA (1999) Toward an evolutionary psychology of religion. J Personal 67:921–952

Kirkpatrick LA (2005) Attachment, evolution, and the psychology of religion. Guilford, New York

Koenig O (1970) Kultur und Verhaltensforschung. DTV, München, S 17

Koenig O (1975) Urmotiv Auge. Neuentdeckte Grundzüge menschlichen Verhaltens. Piper, München

Kölbl S (2005) Im Tode gleich? In: Conard NJ, Kölbl S, Schürle W (Hrsg) Vom Neandertaler zum modernen Menschen. Jan Thorbecke, Ostfildern, S 169–182

Korfmann M, Mannsperger D (1998) Troia. Ein historischer Überblick und Rundgang. Thesis, Stuttgart

Lascu C, Baciu F, Gligan M, Sarbu S (1996) A Mousterian cave bear worship site in Transylvania, Roumania. J Prehist Religion 10:17–30

Lawrence TE (1979) Die sieben Säulen der Weisheit. Deutscher Taschenbuch-Verlag, München

Leroi-Gourhan A (1981) Die Religionen der Vorgeschichte. Suhrkamp, Frankfurt a. M.

Lewin R (1987) Bones of contention. Controversies in the search for human origins. Simon & Schuster Inc, Touchstone, New York

Lewkowicz D (2000) The development of intersensory temporal perception: an Epigenetic systems/limitations view. Psychol Bull 126:281–308

Lonetto R, Templer DI (1986) Death anxiety. Hemisphere, Washington

Luckmann T (1991) Die unsichtbare Religion. Suhrkamp, Frankfurt a. M.

Malinowski B (1925) Magic, science, and religion. In: Needham J (Hrsg) Science, religion and reality. MacMillan, New York, S 18–94

Malinowski B (1973) Magie, Wissenschaft und Religion und andere Schriften. Fischer, Frankfurt a. M., S 32

Malone C, Stoddart S, Bonanno A, Gouder T, Pace A (Hrsg) (2009) Mortuary customs in prehistoric malta. Excavations at the Brochtorff Circle at Xaghra (1987–1994). McDonald Institute Monographs, Cambridge

Mann T, Kerényi K (1960) Gespräch in Briefen. Rhein-Verlag, Zürich

Maringer J (1956) Vorgeschichtliche Religion. Religionen im steinzeitlichen Europa. Benziger, Köln

Mauss M (1989) Die Gabe. Form und Funktion des Austauschs in archaischen Gesellschaften. In: Mauss M, Soziologie und Anthropologie, Bd 2. Gabentausch; Soziologie und Psychologie; Todesvorstellungen; Körpertechniken; Begriff der Person. Fischer, Frankfurt a. M., S 9–144

May F (1986) Les Sépultures Préhistoriques. Editions du Centre national de la recherche scientifique, Paris

Mayr E (1991) Eine neue Philosophie der Biologie. Piper, München, S 125

Menghin O (1931) Weltgeschichte der Steinzeit. Schroll, Wien

Meyers Konversationslexikon (1888) Stichwort Penaten, Bd 12. S 824

Mithen S (1996) The prehistory of mind: a search for the origins of art, religion, and science. Thames & Hudson, London

Morgenthaler C (1997) Carl Gustav Jung (1875–1961) In: Michaels A (Hrsg) Klassiker der Religionswissenschaft. von Friedrich Schleiermacher bis Mircea Eliade. Beck, München, S 234–245

Mowat F (1989) Das Ende der Fährte. Die Geschichte der Dian Fossey und der Berggorillas in Afrika. Bastei Lübbe, Bergisch Gladbach

Müller-Karpe H (1998) Grundzüge früher Menschheitsgeschichte, Bd 1. Von den Anfängen bis zum 3. Jahrtausend v. Chr. Thesis, Stuttgart

Mynarek H (2006) Denkverbot. Fundamentalismus in Christentum und Islam. ASKU-Presse, Bad Nauheim

Narr K (1965) Ursprung und Frühkulturen. In: Bayer E (Hrsg) Saeculum Weltgeschichte, Bd 1. Ursprung und Frühkulturen. Primäre Zentren der Hochkultur. Weltgeschichtliche Berührungszonen. Herder, Freiburg im Breisgau, S 21–235

Neimeyer RA, Wittkowski J, Moser RP (2004) Psychological Research on Death Attitudes: An Overview and Evaluation. Death Stud 28:309–340

Newberg AB, Alavi A, Baime M, Pourdehnad M, Santanna J, D'Aquili EG (2001) The measurement of regional cerebral blood flow during the complex cognitive task of meditation: a preliminary SPECT study. Psychiatry Res Neuroimaging 106:113–122

Newberg AB, D'Aquili EG, Rause V (2001) Why God won't go away. Brain science and the biology of belief. Ballatine Books, New York

Newberg AB, Pourdehnad M, Alavi A, D'Aquili EG (2003) Cerebral blood flow during meditative prayer: preliminary findings and methodological issues. Percept Mot Skills 97:625–630

Newberg AB, Waldman MR (2010) How God changes your brain. Breakthrough findings from a leading neuroscientist. Ballantine Books, New York

Newberg AB, Wintering NA, Morgan D, Waldman MR (2006) The measurement of regional cerebral blood flow during glossolalia: a preliminary SPECT study. Psychiatry Res Neuroimaging 148:67–71

Nilsson MP (1992) Geschichte der griechischen Religion, Bd 1. Die Religion Griechenlands bis auf die griechische Weltherrschaft. Beck, München

Nissen HJ (1990) Grundzüge einer Geschichte der Frühzeit des Vorderen Orients. Wissenschaftliche Buchgesellschaft, Darmstadt

Ochsmann R (1993) Angst vor Tod und Sterben. Beiträge zur Thanato-Psychologie. Hogrefe, Göttingen

Orschiedt J (1997a) Beispiele für Sekundärbestattungen vom Jungpaläolithikum bis zum Neolithikum. Ethnographisch-archäologische Z 38:325–345

Orschiedt J (1997b) Manipulationen an menschlichen Skelettresten. Taphonomische Prozesse, Sekundärbestattungen oder Kannibalismus? Archäologische Inf 20:195–197

Otto WF (1933) Dionysos. Mythos und Kultus. Klostermann, Frankfurt a. M.

Özdogan M, Basgelen N, Kuniholm P (Hrsg) (2011–2013) The Neolithic in Turkey. New excavations and new research, 5 Bde. Archaeology and Art Publications, Istanbul

Pacher M (1997) Der Höhlenbärenkult aus ethnologischer Sicht. Wiss Mitt Niederösterr Landesmus 10:251–375

Peschlow-Bimdokat A (2003) Frühe Menschenbilder. Die prähistorischen Felsmalereien des Latmos-Gebirges (Westtürkei). Philipp von Zabern, Mainz

Peter-Röcher H (1994) Kannibalismus in der prähistorischen Forschung. Studien zu einer paradigmatischen Deutung und ihren Grundlagen. Habelt, Bonn

Peter-Röcher H (1998) Mythos Menschenfresser. Ein Blick in die Kochtöpfe der Kannibalen. Beck, München

Pettitt PB (2002) The Neanderthal dead: exploring mortuary variability in Middle Palaeolithic Eurasia. Before Farming 1:1–19

Piaget J (1978) Das Weltbild des Kindes. Klett, Stuttgart

Pinhasi R, Higham TFG, Golovanova LV, Doronichev VB (2011) Revised age of late Neanderthal occupation and the end of the Middle Paleolithic in the Northern Caucasus. Proc Nat Acad Sci U S A 108:8611–8616

Pinker S (2006) The evolutionary psychology of religion. In: McNamara P (Hrsg) Where God and science meet: how brain and evolutionary studies alter our understanding of religion Bd 1. Evolution, genes, and the religious brain. Praeger, Westport, S 1–9

Piperno M, Giacobini G (1992) A taphonomic study of the paleosurface of Guattari cave. In: Bietti A, Manzi G (Hrsg), Proceedings of the international symposium „The fossil man of Monte Circeo". Fifty years of studies on the Neandertals in Latium: Sabaudia (Latina, Italy), 19–21 October 1989. Istituto Italiano di Paleontologia Umana, Roma, S 143–161

Pötscher W (1990) Aspekte und Probleme der minoischen Religion. Ein Versuch. Georg Olms Verlag, Hildesheim

Premack DG, Woodruff G (1978) Does the Chimpanzee have a theory of mind? Behav Brain Sci 1:515–526

Price S (1999) Religions of the ancient Greeks. Cambridge University Press, Cambridge

Ramachandran VS, Hubbard EM (2001) Synaesthesia – a window into perception, thought and language. J Conscious Stud 8:3–34

Rheinberg F, Manig Y (2003) Was macht Spaß am Graffiti-Sprayen? Eine induktive Anreizanalyse. Rep Psychol 4:222–234

Rust R (1991) Der primitive Mensch. In: Mann G, Heuss A (Hrsg) Propyläen Weltgeschichte, Bd 1. Propyläen-Verlag, Berlin

Rutkowski B (1987) Die Topographie des Höhenheiligtums auf Juktas, Kreta. Archaeol Polona 25–26:85–96

Sagona A, Zimansky P (2009) Ancient Turkey. Routledge, New York

Schachermeyr F (1979) Die minoische Kultur des alten Kreta. Kohlhammer, Stuttgart

Schloss JP (2008) He who laughs best. In: Bulbulia J, Sosis R, Harris E, Genet G, Genet C, Wyman K (Hrsg) The evolution of religion. Studies, theories, and critiques. Collins Foundation Press, Santa Margarita, S 197–207

Schlosser W, Cierny J (1996) Sterne und Steine. Eine praktische Astronomie der Vorzeit. Wissenschaftliche Buchgesellschaft, Darmstadt

Schmidt K (2000) Zuerst kam der Tempel, dann die Stadt. Bericht zu den Grabungen am Gürcütepe und am Göbekli Tepe 1996–1999. Istanbuler Mitteilungen 50:5–40

Schmidt RR (1910) Die spätpaläolithischen Bestattungen der Ofnet. Mannus 1:56–63 (Ergänzungsband)

Schmitz RW, Pieper P (1992) Schnittspuren und Kratzer. Anthropogene Veränderungen am Skelett des Urmenschenfundes aus dem Neandertal. Das Rheinische Landesmuseum Bonn: Berichte aus der Arbeit des Museums 2:17–19

Schmitz RW, Thissen J (2000) Neandertal. Die Geschichte geht weiter. Spektrum, Heidelberg

Schrenk F (2008) Die Frühzeit des Menschen. Der Weg zum Homo sapiens. Beck, München

Schüler S (2012) Religion, Kognition, Evolution. Eine religionswissenschaftliche Auseinandersetzung mit der Cognitive Science of Religion. Kohlhammer, Stuttgart

Sievers J, Lembi G (Hrsg) (2005) Josephus and Jewish history in Flavian Rome and beyond. Brill, Leiden

Solomon S, Greenberg J, Pyszczynski T (2004) The cultural animal: twenty years of terror management theory and research. In: Greenberg J, Koole SL, Pyszczynski T (Hrsg) Handbook of experimental existential psychology. Guilford, New York, S 13–34.

Sosis R (2004) The adaptive value of religious ritual. Am Sci 92:166–172

Sosis R, Alcorta C (2003) Signaling, solidarity, and the sacred. The evolution of religious behavior. Evolut Anthropol 12:264–274

Sosis R, Bressler E (2003) Cooperation and commune longevity. A test of the costly Signaling Theory of religion. Cross-Cultural Res 37:211–239

Sosis R, Ruffle BJ (2003) Religious ritual and cooperation: testing for a relationship on Israeli religious and secular kibbutzim. Curr Anthropol 44:713–722

Sosis R, Ruffle BJ (2004) Ideology, religion, and the evolution of cooperation: field tests on Israeli kibbutzim. Res Econ Anthropol 23:89–117

Srejović D (1973) Lepenski Vir. Eine vorgeschichtliche Geburtsstätte europäischer Kultur. Lübbe, Bergisch Gladbach, S 107

Srejović D (1987) Lepenski Vir. Prähistorische Plastik vom Eisernen Tor. Ausstellung des Nationalmuseums Belgrad in den Staatlichen Museen zu Berlin. Museum für Ur- und Frühgeschichte, Berlin

Stiner M (1992) The Guattari faunas then and now. In: Bietti A, Manzi G (Hrsg), Proceedings of the international symposium „The Fossil Man of Monte Circeo". Fifty years of studies on the Neandertals in Latium: Sabaudia (Latina, Italy), 19–21 October 1989. Istituto Italiano di Paleontologia Umana, Roma, S 163–192

Stoddart S, Bonanno A, Gouder T, Malone C, Trump D (1993) Cult in an island society: prehistoric malta in the Tarxien period. Camb Archaeol J 3:3–19

Streri A (2003) Cross-modal recognition of shape from hand to eyes in human newborns. Somatosens Motor Res 20:13–18

Tattersall I (1999) Becoming human. Evolution and human uniqueness. Harcourt Brace, Orlando

Tattersall I (1999) Neandertaler. Der Streit um unsere Ahnen. Birkhäuser, Basel

Togan AZT (1994) Ibn-Faá̦lān's Reisebericht. Institute for the History of Arabic-Islamic Science, Frankfurt a. M.

Tomasello M (2003) Die kulturelle Entwicklung des menschlichen Denkens. Zur Evolution der Kognition. Wissenschaftliche Buchgesellschaft, Darmstadt

Tomasello M, Call J, Hare B (2003) Chimpanzees understand psychological states – the question is which ones and to what extent. Trends Cognitive Sci 7:153–156

Toth N, White T (1992) Assessing the Ritual Cannibalism Hypothesis at Grotta Guattari. In: Bietti A, Manzi G (Hrsg), Proceedings of the international symposium „The fossil man of Monte Circeo". Fifty years of studies on the Neandertals in Latium: Sabaudia (Latina, Italy), 19–21 October 1989. Istituto Italiano di Paleontologia Umana, Roma, S 213–222

Trinkaus E (1985) Cannibalism and burial at Krapina. J Hum Evol 14:203–216

Trinkaus E, Shipman P (1993) The Neandertals. Changing the image of mankind. Knopf, New York

Turner VW (1967) A forest of symbols: aspects of Ndembu ritual. Cornell University Press, Ithaca

Ungerer F, Schmid HJ (1996) An introduction to cognitive linguistics. Longman, New York

Vaas R, Blume M (2009) Gott, Gene und Gehirn. Warum Glaube nützt. Die Evolution der Religiosität. Hirzel, Stuttgart

Vail KE, Rothschild ZK, Weise DR, Solomon S, Pyszczynski T, Greenberg J (2010) A terror management analysis of the psychological functions of religion. Personal Soc Psychol Rev 14:84–94

Vieweger D (2003) Archäologie der biblischen Welt. Vandenhoeck und Ruprecht, Göttingen

Vlćek E (1993) Fossile Menschenfunde von Weimar-Ehringsdorf. Theiss, Stuttgart

Vogler C (2010) Die Odyssee des Drehbuchschreibers. Über die mythologischen Grundmuster des amerikanischen Erfolgskinos. Zweitausendeins, Frankfurt a. M.

Warburg AM (1996) Schlangenritual. Ein Reisebericht. Wagenbach, Berlin

Wittkowski J (1990) Psychologie des Todes. Wissenschaftliche Buchgesellschaft, Darmstadt

Wolpoff MH (2009) How Neandertals inform human variation. Am J Phys Anthropol 139:91–102

Wunn I (1999) Bärenkult in urgeschichtlicher Zeit. Zur religiösen Deutung mittelpaläolithischer Bärenfossilien. Z Religionswissenschaft 7:3–23

Wunn I (2002) Naturreligionen. In: Antes P (Hrsg) Vielfalt der Religionen. LHV, Hannover, S 263

Wunn I (2005) Die Religionen in vorgeschichtlicher Zeit. Kohlhammer, Stuttgart

Wunn I (2009) Entstehung und Evolution der Religionen aus religionswissenschaftlicher Sicht. Die Kunde. Z niedersächsische Archäologie 60:293–303

Wunn I, Klein C (2012) Evolutionary processes in early religion: the psychological interpretation of the earliest indicators of a religious sentiment. Braunschweiger Naturkundliche Schriften 11:127–138

Wunn I, Petry M (2006) Kognitionswissenschaftliche und ethologische Modelle der Religionsentstehung. Religio 1:3–18

Zupanc GKH (2010) Behavioral neurobiology: an integrative approach. Oxford University Press, Oxford

Index